CREATING THE WITNESS

Documenting Genocide on Film, Video, and the Internet

LESHU TORCHIN

Visible Evidence 26

 University of Minnesota Press

Minneapolis

London

A version of chapter 1 previously appeared as "Ravished Armenia: Visual Media, Humanitarian Advocacy, and the Formation of Witnessing Publics," *American Anthropologist* 108 (March 2006): 214–20.

Published by the University of Minnesota Press
111 Third Avenue South, Suite 290
Minneapolis, MN 55401–2520
http://www.upress.umn.edu

Library of Congress Cataloging-in-Publication Data

Torchin, Leshu.
 Creating the witness : documenting genocide on film, video, and the Internet / Leshu Torchin.
 (Visible evidence ; 26)
 Includes bibliographical references and index.
 ISBN 978-0-8166-7622-4 (hc : alk. paper) — ISBN 978-0-8166-7623-1 (pb : alk. paper)
 1. Documentary films—History and criticism. 2. Genocide in motion pictures.
 3. Genocide in mass media. I. Title.
 PN1995.9.D6T63 2012
 070.1'8—dc23

 2012023462

Printed in the United States of America on acid-free paper

The University of Minnesota is an equal-opportunity educator and employer.

20 19 18 17 16 15 14 13 12 10 9 8 7 6 5 4 3 2 1

CONTENTS

ACKNOWLEDGMENTS

WRITING CAN BE A SOLITARY EXPERIENCE, but the work on a project involves many people, and I am grateful for all of them and their input. New York University provided a fruitful starting ground for this book. To begin, I must thank Toby Miller and Robert Stam from Cinema Studies. Crucial help came from Barbara Kirshenblatt-Gimblett (of Performance Studies) and Faye Ginsburg (of Anthropology) whose generosity with their time, contacts, and information made this project possible the entire way, from early research to its completion and publication. Through Faye I came to participate in the Working Group on Human Rights, Religion and Media in the inaugural year of the Center for Religion and Media at NYU and had the good fortune to workshop earlier versions of this book with Meg McLagan, Tom Keenan, Elizabeth Castelli, Allen Feldman, Angela Zito, Anne Cubilé, and Sam Gregory, who has been most generous with his time and contacts at WITNESS. Early research and writing was also made possible by a Fellowship at the International Center for Advanced Studies at NYU during the second year of their three-year project, the Authority of Knowledge in the Global Era. Participating in the session entitled "The Politics of the Unprivileged" afforded me numerous insights as well as the friendship and support of Nivedita Menon and Arzoo Osanloo.

The materials of WITNESS, the United States Holocaust Memorial and Museum, and the Center for Holocaust and Genocide Studies at the University of Minnesota enhanced this study. I am grateful for their generosity and their collections.

Since then, Frances Guerin, Roger Hallas, Mette Hjort, Jeffrey Shandler, Liesbet Van Zoonen, Barbie Zelizer, and Patty Zimmermann have provided ideas, critiques, conversations, and other forms of support that have bolstered this project. The preparation of the manuscript was significantly

aided by the feedback of Patricia Speyer and Mick Broderick; by the guidance of my University of Minnesota Press editor, Danielle Kasprzak, who tolerated my many questions; by Sue Breckenridge, who carefully looked over the manuscript with a keen eye and heartening engagement; and by a grant from The Carnegie Trust for the Universities of Scotland. Thanks also go to my colleagues at the Department of Film Studies at the University of St Andrews, and to Dina Iordanova in particular for her guidance and support.

Friends and colleagues who have provided ears, guest rooms, food, drinks, conversation, and company over the years—all of which are necessary to the completion of any project—cannot be forgotten. To that end I thank Mariana Johnson, Sky Sitney, Grant Pezeshki, Kate Collignon, Christine Chen, Kelly Britt, Heather Hubbart Murray, Rahul Hamid, Ragan Rhyne, Doug Dibbern, Chelsea Wessels, Matt Holtmeier, Will Brown, Liz Ashford, Michael McCluskey, Alayna Waldrum, and Eliane Corrin (in whose studio I write this now). Social utility networks deserve a measure of credit for their capacity to keep me connected to friends whose virtual support I have felt in actual ways: Sally Bachner, Alice Crawford, Julien Devereaux, and Chris Roth.

Finally, I am grateful for the support of my family. In particular, I wish to thank my grandmother, Molly Torchin, and my great-uncle, Abraham Schneider, who have looked after me throughout the years. Their willingness not only to support me but also to read what I produced is a staggering demonstration of love.

INTRODUCTION

Screen Media and Witnessing Publics

In *The Interpreter* (SYDNEY POLLACK, 2005), United Nations (UN) translator Silvia Broome (Nicole Kidman) overhears a plot to assassinate the leader of the fictional African nation of Matobo, her childhood home. In the ensuing investigation, she learns genocide is taking place. At the film's end, she stands before the UN among a group of protestors and discloses this information by reading aloud the names of those who have been killed and a brief description of their fate. Her voice echoes through the halls of the UN building, and the scene concludes with the promise of the Security Council to prosecute Matobo's head of state in the International Criminal Court. Her performance simultaneously makes a case that genocide has occurred and mobilizes political actors.

This sequence points to the Enlightenment-style faith in the power of knowledge that underpins not only the sentiment of popular film narratives but also the hopes of journalists and human rights workers: if people know, they will act accordingly.[1] "We investigate and expose human rights violations," reads the Human Rights Watch mission statement articulating the confidence in visuality that is embedded in the organization's name. The faith in the model of revelation leading to action has only been enhanced by the proliferation and development of audiovisual media technologies, whose mimetic capacities make claims of visible evidence and whose circuitry facilitates witnessing at great distances. Journalist Johanna Neumann writes of media's promise, arguing that the advancement of communications technologies has yielded speedier policy responses.[2] Amnesty International president William Schulz (AI USA) describes the function of this organization as "the eyes of the world shining on the prisons and into the dark corners of police stations and military barracks all over the world to try to bring international pressure to bear upon governments which

are committing human rights violations."[3] Schultz's statement invokes the paradigm of exposure to action while employing metaphors of extended visuality, suggestive of visual media technologies. As Thomas Keenan has observed, these shining eyes of the world conjure up the cameras, gleaming with the lighting devices that illuminate and expose what happens in those dark corners.[4]

Such expectations permeate the scholarly literature on human rights and genocide. In "Testing Theories Brutally," noted genocide scholar and sociologist Helen Fein advocates the comparative study of genocide to better understand the processes that launch violence. Such a study, she suggests, should yield results in terms of intervention and prevention. Her optimistic language perpetuates the model of exposure to justice. Fein writes: "This focus on process (as well as structure) also suggests a new approach to the detection and prevention of genocide: to expose the propaganda of the mobilizers of hate and to support counter-media, such as a human rights international broadcasting network, which could unmask disinformation and propaganda, unveil the motives of agitators of hate and promote respect for human rights and peace."[5] Within this formulation, a proposed human rights broadcasting network harbors the power to "expose" propaganda and misinformation, to "unveil" the work of perpetrators, and to promote the clear ideal of human rights. Here, media circuits are transparent conduits for information and human rights, a self-evident category of meaning—an ideal that can be both shown and promoted.

However, publicizing human rights abuses and genocide is hardly a straightforward enterprise. Silvia's presentation of names in *The Interpreter* may presume a transparent display of information and the inevitability of political response, but, in fact, a constellation of factors drives its efficacy, both in promoting recognition and in activating response. First, her performance takes place within activist practice: a protest in process, and one outside the UN, no less. Second, a robust visual culture provides an interpretive grid, making the speech meaningful. Prior to this sequence, the narrative establishes the conditions of genocide: the story has provided flashbacks, survivor testimonies, and modes of exposition that declare the atrocities to be genocide, a crime subject to international prosecution. Moreover, Silvia's reading of the names relies on cultural codes that signal political loss. The Vietnam Memorial in Washington, D.C., perhaps best exemplifies this trend, as it marked a significant shift from figural representations of war dead to the more figurative evocations of massive

loss enabled through lists of names.[6] The names of villages are etched into the glass passageways of the United States Holocaust Memorial Museum. Names of the dead are engraved on walls at the Memorial of the Shoah in Paris, France. And today, commemorations of 9/11 have included bereaved families reading aloud the names of loved ones lost. Grounded in the narrative context, familiar commemorative frameworks, and the social space of a protest, this performance becomes an effective form of political expression. The crime is rendered recognizable and actionable through these strategies.

This example illustrates the concerns of this book, which takes up cases across the last century in order to explore how screen media—namely film, video, and the Internet—have worked to visualize human rights law and its transgressions for purposes of promoting popular awareness and response. Drawing on the frameworks provided by the notions of testimony and witnessing, the study explores the production of witnessing publics, a productive term that Meg McLagan defines as "a subject position that implies responsibility for the suffering of others."[7] The book investigates and outlines how the testimonial encounter hails audiences, encouraging them to take both responsibility and action. Film and audiovisual media, especially broadcast news and documentary, carry a heavy ontological burden of visible evidence, with broadcast news further weighted by the immediacy and ostensible urgency of its delivery. However, film—both docudrama and documentary—has also served a witnessing function, producing eyewitness testimony, a narrative of suffering, trauma, and injustice in encounters designed to summon politically, morally, and socially engaged publics. Through their study, the book builds on explorations of the impact of realist media in structuring relationships to the lived world, whilst acknowledging the substantial difference from (as well as reliance on) the flow of reportage.

The focus on genocide is due in no small part to the prominent role of two catastrophic events, the Armenian crisis (a term I use to encompass a range of events from the Hamidian Massacres of 1894–96, the genocide in 1915, and the conditions of expulsion and extreme privation that continued until 1923) and the Holocaust, in launching a broader international human rights regime governed by supranational apparatuses, such as the UN. The status of genocide as mandate as well as law further contributes to its significance in the study. Recognition becomes obligation to act. Article 1 of the UN Convention on the Prevention and Punishment of the Crime of Genocide suggests as much, if obliquely: "The Contracting

Parties confirm that genocide, whether committed in time of peace or in time of war, is a crime under international law which they undertake to prevent and punish."[8] However, instead of inspiring swift and effective action, this interpretation of the article has generated skittishness and indolence. In the case of Rwanda, the obligation embedded in the utterance led the U.S. State Department to recoil from using the word, fearful that it would "inflame public calls for action,"[9] and that "it would harm U.S. credibility to name the crime and then do nothing to stop it."[10] While numerous documents exposing American and UN reluctance to action have since been released, the feet-dragging was popularized in the infamous Reuters radio interview with Christine Shelley, a State Department spokesperson, whose tortured efforts to avoid the charge of "genocide" would have been comical if the stakes had not been so high. On June 10, 1994, then Secretary of State Warren Christopher grudgingly conceded in light of the constant pressure, "If there is any particular magic in calling it genocide, I have no hesitancy in saying that."[11] Not necessarily magic, the word nevertheless carries considerable legal and political force as an utterance that demands response. Since then, genocide has been declared in Darfur to differing effect, although an effect still mired in debates over required courses of action.[12]

Even if the Genocide Convention signaled only an international commitment to protect communities from this law, until recently there were no treaty bodies assigned to monitor global compliance. In this absence, monitoring duties have fallen predominantly to journalists, filmmakers, and human rights organizations from international NGOs to local grassroots social movements, all who use cameras to represent abuses and appeal to action. In addition, audiovisual media play key roles in the official realms. As discussed in chapter 2, film was used in the Nuremberg Trials in order help create a visual record of "crimes against humanity." The UN Office for the Coordination of Humanitarian Affairs has developed a film unit, IRIN. And in its early years, the International Criminal Court (ICC) has sought assistance and training from a media activist organization, WITNESS (discussed in chapter 4), with respect to the reading and use of video.[13] Since then, the ICC has launched a YouTube channel and a Twitter feed to broadcast information to a wider audience and provide "transparency" to the proceedings.[14] Throughout the twentieth century and into the twenty-first, film and video have been burdened with transformative expectations: revelation contributes to recognition, recognition demands action, and representations throughout transform

audiences into witnesses and publics. But while these media have certainly contributed to the development of popular, political, and legal understandings of genocide, the process is hardly straightforward or inevitable.

Witnessing

Witnessing and testimony provide useful theoretical frameworks for understanding the work of film as producing information and transforming audiences. Historically understood as a truthful first-person narration of suffering to transform the world, testimony relates to the rhetorical efforts of film projects that portray distant atrocities with the intention of ending them. The term is probably most often associated with the courtroom wherein the person sworn in as witness testifies to an occurrence in order to bring about justice. Testimony resonates with Christian meaning as well, invoking the martyr ("witness" in Ancient Greek) who testifies to Christ in order to usher in the new world or the second coming. It is a tradition rich in performance and iconography, much of it centering on the bodily experience of suffering, whether in the Passion plays or the richly rendered martyrdom of saints, whose own physical ordeals testified to their faith.

Shoshana Felman and Dori Laub make explicit these transformative features within their performative and therapeutic models of testimony; here, testimony is a "speech act" that occasions beneficial change. The transformation lies in both the recovery of the experience and in the creation of a community conducive to listening and responding. "To testify is thus not merely to narrate, but to commit oneself, and one's narrative, to others . . . to take responsibility for the truth of an occurrence."[15] Bearing witness is a process, an encounter that implicates speaker and listener alike. The transformative and ethical possibilities of testimony reach well beyond the therapeutic to multiple social and political venues.

The Latin American phenomenon of *testimonio,* described as a genre that "records the cry against oppression,"[16] makes manifest the political value of testimony. This genre also embraces the value of the popular voice as an expression of social urgency and a plea for change. George Yúdice writes, "Emphasizing popular, oral discourse, the witness portrays his or her own experience as an agent (rather than representative) of a collective memory and identity. Truth is summoned in the cause of denouncing a present situation of exploitation and oppression or in exorcising and setting aright official history."[17]

This transformative potential of testimony was certainly engaged within the genre of the slave narrative, typically a live recitation or written communication (novel or pamphlet) that related the experience of slavery and mobilized for the cause of abolitionism. Based on real-life experience, the narratives seized on a variety of discursive mechanisms to make their case. Dwight McBride describes slave narratives as situated within a "discursive terrain" of intersecting political ambitions (e.g., abolitionism, the racial politics that required a "humanization" of the African slave) and literary aesthetics (e.g., British and American romanticism), all of which informed the articulation of the otherwise unknowable truth of the experience of slavery.[18] In this light, his notion is useful in thinking through the act of film's witnessing work in the human rights context. His "discursive terrain" resonates with this book's interest in a field of witnessing, where existing frameworks of cultural expression and political and juridical discourse help to produce film testimony to genocide. A consideration of the terrain opens up investigations of rhetorical strategy and questions of intended audiences and contexts of delivery: a context of activism and entertainment. After all, the slave narrative offered a commercially successful (and popular) genre as well as an effective mobilizing tool. And, as I maintain throughout the book, popular films and strategies associated with entertainment culture are not incompatible with activist programs.

Admittedly, the popular and the legible can appear to be at odds with the ways in which witnessing to atrocity has been traditionally understood, especially in the case of Holocaust witnessing, which has come to stand as a limit case for representation. Within this case, impossibility and crisis characterize the attempt to witness, accounting for the traumatic effects of the experience—effects that impede the capacity to fully recall or narrate the event, or even to have completely experienced the event as it happened.[19] Language and images are deemed inadequate to the task of accurate representation of trauma, which itself is an "unknowable truth" of the experience for both survivor and listener.[20] Fracture and fragmentation supply the favored aesthetics for their ability to hint at the violence of the event upon self and expression. Miriam Hansen's analysis of *Schindler's List* (Steven Spielberg, 1994) highlights the scholarly discomfort with its spectacular qualities, realist aesthetics, and neoclassical narrative, and in doing so, observes what could be considered a double Adornian bind: a discomfort with the culture industry as well as with representation of the Holocaust.[21]

The crisis in witnessing posed by trauma—receiving only a cursory accounting here—ought not to be dismissed. These impossibilities, silences, and fragmentations can infuse the production of testimony with even greater moral and social urgency if a public is to be hailed. How can one negotiate these difficulties in the testimonial encounter so as to ensure the recovery of the self or of the community? How can one negotiate these challenges to prompt effective and immediate action? *Testimonio* relies on an interlocutor, a "journalist, writer, or social activist" who aids in the transmission of the experience to an audience.[22] What I propose here is that this third party witnessing need not be relegated to a single participant in "the media" but can more broadly be ascribed to media or media witnessing. Building on this proposition, I look to the more popular and mainstream media modes, moving away from those more experimental films that wrestle with the challenges of witnessing in language, image, or sound. This is not to champion the mainstream films and films from the West, but to explore their contribution in producing a popular media witness.

Media Witnessing

Radically enhancing the testimonial encounter, media witnessing works in three ways. Paul Frosh and Amit Pinchevski describe this tripartite function as witnessing *in, by,* and *through* the media. That is, witnesses can be seen on screen; media (journalists, amateur video) can bear witness to events; and audiences can become witnesses through watching.[23]

In the first instance, media technologies can extend the reach of the original enunciation in both space and time. Audiovisual archives of Holocaust testimony strive to preserve survivor testimony while also allowing for continued replay and dissemination. This includes their repurposing for Holocaust documentaries such as *Witness: Voices from the Holocaust* (Joshua M. Greene and Shiva Kumar, 1999) or *The Last Days* (James Moll, 1998), produced by the Fortunoff Video Archive for Holocaust Testimonies and the Survivors of the Shoah Visual History Foundation, respectively.[24] As one traces the movement of the witnesses across platforms, one could also take note of the alchemy between testimony and context of delivery. This interaction helps to confer meaning onto the testimony, forging a relationship of ethical and even political obligation between speaker and listener. Chapter 1 teases out this relationship through the witnessing figure of Aurora Mardiganian, a survivor of the Armenian genocide whose testimony began as advertisement, continued in a serialized format, and

was eventually produced as a film accompanied by live performance. The infrastructure of a Christian relief organization supplied means of production, distribution, and exhibition as well as an aesthetic sensibility, the discursive terrain for her testimony.

Such interaction develops in the second understanding of media witnessing: media bearing witness. Although Felman highlights the witness as "radically unique, non-interchangeable and solitary,"[25] she equally allows for the ability of art "to take the witness's stand," a possibility made literal in the deployment of film in the Nuremberg Trials. This sort of witnessing introduces a significantly more complicated position as the technologies open up a multitude of expressions beyond the oral, spoken narrative traditionally associated with testimony, while at the same time providing an act of seeing that is intimately connected with the witnessing.

Bearing witness in this context can involve the transmission of events captured as they unfold (however rare) or "effects footage," the images of aftermath that often include the nonspeaking bodies of victims. Like slave testimony, these expressions are also filtered through language, operating on a discursive terrain of visual culture and media practice. In news reports and documentaries, the images are anchored and given expression through an array of strategies, including voice-over, chyron inscription, and narrative ordering. Meanwhile, the seeming indexicality of the photographic image and the associations of the documentary or news genre contribute to the ontological presence demanded of the "non-interchangeable" witness. Assumptions of visible evidence aside, the authority of the media witness is further secured through on-screen and off-screen tactics. Television news benefits from the "illusionary feeling of presentness . . . [and] constructed presence of immediacy" supplied by "scripted spontaneity, " liveness, and flow, and an experience of shared time and space across distance.[26] In the text, presence can be established through sets of verbal cues, with statements like "We are driving through a war zone."[27] Such cues provide the immediacy that confers transparency to the mediation; moreover, these gestures suggest the singularity and unpredictability of events, even as they invite an audience into a shared witnessing perspective.

Visual cues are used in both documentary and docudrama, where the use of handheld camera, for instance, recalls the strategies of direct cinema and efforts to capture life as observed. Docudrama receives further imprimatur of authority through the use of the legend "based on a true story" as well as through casting strategies. Films like *Hotel Rwanda, Sometimes*

in April, and *100 Days* have publicized the role of survivors in the making of the film, hinting at the film's function as an extension of their testimony. *Schindler's List* secured its own truth-claims through a myriad of strategies, on screen and off. The use of black-and-white film and the hand-held camera participated in a cinematic grammar of actuality, gesturing to films of the period as well as newsreel footage. Meanwhile, publicity materials positioned Steven Spielberg as witness, with Spielberg appropriating survivor identity. "Sentimentality, that's my tattoo. It's like the media have tattooed sentimentality on my forearm and now I can't get rid of it," read one interview.[28] In another interview, Spielberg declared, "I have for so many years a sort of Good Housekeeping Seal of Approval stamped on my forehead. I sort of wear that the way the Jews wore the star."[29] These claims help to promote an authority for the film as testimony, with Spielberg as survivor capable of bearing witness.[30] Rhetorics of sound, image, and production economy play crucial functions in the simultaneous cultivation of authority and testimony, whether in documentary, docudrama, or even the art film.[31]

Film and video deploy these rhetorical strategies not only to secure the authority of the utterance, but also to lend meaning and urgency to that which is expressed. Images, both moving and still, draw on a discursive terrain of extant visual culture and legal discourse in order to make affective and effective genocide and human rights claims. Christian iconography, for instance, continues to provide a powerful frame for reading distant horror as unjust suffering, producing the events as a moral cause for concern. Photojournalist James Nachtwey's book *Inferno* demonstrates the potency of this interpretive grid, which was applied in the text and extra-text alike. The book, taking its name from Dante's *Divine Comedy,* a poetic rendering of the Christian afterlife, presents 382 black-and-white photographs of genocide, war, and famine. The books share the same epigraph, "Through me is the way to the sorrowful city / Through me is the way to join the lost people," positioning the text as Virgil to the reader's Dante.[32] And the message was decoded as encoded: one reviewer commented, "It's a guided tour of hell."[33] The literary reference supplies a Christian foundation as well as a hint of redemption or transformation within the encounter. Describing his mission as one of "bearing witness," intending his readers to "make connection on a human level," Nachtwey relies on Christian allusions: "The scene of a pietà, the scene of a mother weeping over her child is something universal."[34] Another reviewer demonstrated this seeming universality, stating, "One of his portraits from Somalia is a

pietà in black and white."[35] The visible testimony drew on a Christian frame, anchored through association or legend, and bolstered by extra-textual discourses. Notably, such observations can arrive even without the prompting from the original exhibition strategies. When the Museum of Modern Art in New York presented the installation *Photographs from S-21: 1975–1979*, photographs from the Tuol Sleng prison camp taken during the Cambodian genocide, a reviewer drew on the visual history of martyr-doms, writing, "The wrenching detail is the number safety-pinned straight into his bare chest: he is like St Sebastian."[36]

The visual memory of the Holocaust, much of it produced through mediations of photos, documentaries, and docudramas, supplies another powerful frame for reading distant atrocities. Barbie Zelizer addresses the role of print journalism, focusing on the photographs of the liberation in cultivating a shared memory of the Holocaust through schematic processes that formalize meaning. Such processes create photographic "sign-posts" or visual cues that relay viewers to "preferred meaning by the fastest route."[37] She writes, "The Holocaust cues atrocity memory in three ways—through the words that guide us through the images, through parallels in the images, and through a pattern of substitutional representation."[38] The coverage of Bosnia provides multiple examples, as images of emaciated men, many behind barbed wire, were accompanied by headlines stating "Ever Again" or "Never Again, Again," words that allude to the mandate of memory and prevention associated with Holocaust representation. Activ-ists seeking official recognition of the Armenian genocide as genocide frequently deploy Holocaust tropes. A commemorative segment on *ABC World News Tonight* broadcast April 24, 1999, and preserved on the web-sites TheForgotten.org and Genocide1915.info highlight connections, re-ferring to the "Armenian Holocaust" and describing perpetrator Talaat Pasha as "the Turkish Hitler."[39] Images of corpses in rows and people in boxcars take the screen while Peter Jennings's voice-over refers to the "prim-itive gas chambers"—caves where Armenians had been burned alive. The comparisons not only animate the profound sense of loss and outrage, but also advance claims of the political status as genocide.[40]

Although such interpretive frameworks help make legible and meaning-ful spatially and temporally distant events, they risk diminishing their polit-ical urgency. Christian allusions can produce easy Manichean narratives that depoliticize portraits of the world. As in the aforementioned cases, these paradigms are imposed on Christian and non-Christian communi-ties alike, enacting a morality play of the innocent victim and redemptive

suffering. Focusing on a Christian narrative of noble suffering can remove the victim from a larger social and political context, denying him or her coevality and a place in the world.[41] Likewise, the symbolic reliance on the Holocaust as a visual cue for atrocity diminishes and simplifies the detail of the present-day context, reducing complexity and relegating the present to the past.[42] Acclimation to the symbolic use of bodies brings about additional problems, including the depersonalization of the victims and a "cultural anesthesia" that contributes to the loss of identification and affiliation.[43] The symbolic frame risks overtaking the represented subject and reduces political urgency, sustained interest, and awareness of new geopolitical scenarios.

The risks associated with meaning-making and exposure highlight many of the challenges that come with the third type of media witnessing: the production of virtual witnesses through media. The capacity of film to do something to the spectator is a longstanding concern of film study. Whether in apparatus theory, psychoanalytic theory, or the politically charged dialectic of film form (the "agitational spectacle"), the scholarship suggests that the encounter with the screen does something to the viewer—shaping him ideologically or provoking her into response.[44] This notion of inevitable transformation carries into assumptions or demands around viewing distant suffering, where audiences are made responsible for what they have seen. No longer can one argue that one did not know.[45] This expectation for transformation or ethical response is implicit within the language of dismay, which finds overexposure alternately responsible for inappropriate affect, such as a voyeuristic response to "disaster pornography" (a significantly charged phrase) or dampened affect, such as in Allen Feldman's "cultural anesthesia."[46] This latter idea is echoed in Arthur and Joan Kleinman's suggestion that habituation to and commodification of images allow "moral sensibility . . . to become unhinged from responsibility and action,"[47] as well as in the popular phrase "compassion fatigue." It is telling that this popular phrase has its origins in clinical diagnosis of secondary post-traumatic stress disorder, often suffered by caregivers after prolonged exposure to pain and suffering. That is, prolonged exposure to mediated images of suffering may generate similar emotions to real-world interaction. Yet, as Susan Moeller explains, this virtual secondary PTSD is brought about by overexposure and sensationalist treatment, as well as by journalistic strategies that work to excite and distract simultaneously.[48] Significantly, in addition to the expectation of response, the discussion of tactics comes to the fore. For these reasons,

this book explores the strategies of usage as well as the discursive terrain of testimony so as to better understand how media can produce witnesses and witnessing publics, the audiences hailed and made ready to act.

Witnessing Publics and the Field of Witnessing

The notion of witnessing publics is particularly productive, as it invites ways of conceiving of audiences to distant suffering and the ways the audiences are generated through testimony. The concept relies on the idea that media technologies play a role in social formation. Such an approach calls upon the fundamental work of Benedict Anderson and Jürgen Habermas, for whom media played critical roles in constructions of nationalism and civil society. Anderson's concept of "imagined communities" addresses the ways in which print media contributed to the construction of nations, binding together those who may never see one another.[49] Meanwhile, Habermas's notion of the "public sphere" is particularly appealing as a discursive space, a form of publicity, through which society can hold the state accountable.[50] It is, as Nancy Fraser notes, the "theater in modern societies in which political participation is enacted through the medium of talk."[51] Originally cultivated in discursive arenas as literary salons and as journalism, these sites of interaction and decision-making operated outside state apparatuses.

As useful as the notion of the public sphere is, it is nevertheless necessary to push at its limits. Arjun Appadurai disperses the statist focus of these arenas and communities by situating mass media as a place for imaginative engagement within a larger, global context characterized by increased migration, transnational media flow, and global technological growth.[52] This approach effectively addresses the transnational and supranational aspects of the genocide law and media circuitry. It also accommodates the complex landscape of the international human rights regime that allows nongovernmental organizations (NGOs), transnational activist networks (TANs), and local grassroots organizations to appeal to supranational organizations such as the ICC or the UN, in order to intervene into the workings of the nation state. These publics unite across national borders by articulating their concern for groups targeted for persecution and annihilation within another set of national borders.[53] As Mark Philip Bradley and Patrice Petro observe, "the interplay between the local and the global in these novel human rights claims is fundamentally redrawing

the boundaries among the rights of individuals, states and the international community."[54] These interactions rely on visual media technologies that similarly transcend, complicate, and redraw borders. The imagination, "a key component of the new global order," aligns dispersed publics across nations under the sign of human rights.

Critics of the public sphere have further troubled the otherwise rigid boundaries of the original formulation to equally beneficial and productive ends. The exclusion of the popular from the political realm is neither productive nor quite accurate, particularly in light of the blurring of boundaries with such phenomena as the celebrity politician and celebrity diplomacy.[55] However, the mistrust of mass culture seems to be deeply entrenched and longstanding. This suspicion reaches back to Max Horkheimer, Theodor Adorno, and Habermas, carries on through Daniel Boorstin and Neil Postman, and lingers in dismissive terms like "charitainment," or Clifford Bob's concern that the promotional tactics of NGOs impede their moral agency.[56] Within these frameworks, mass culture trivializes and commodifies. And yet popular culture is not simply a vehicle for false consciousness and passive consumption, but it can serve as an active site for engagement, political debate, and the practice of citizenship.[57] The technology and medium of the Internet alone challenges this perspective, although fan creativity and voice has preceded the availability of the computer network.[58] It is no accident that this book includes multiple instances of the popular within the field of witnessing: the collusion of a relief organization with a proto-Hollywood Studio response to the Armenian crisis; the contribution of Hollywood talent to the Office of Strategic Services and the films used in the Nuremberg Trials; the savvy navigation of the media ecosystem by human rights organization WITNESS; and *Crisis in Darfur,* a mapping initiative launched by the United States Holocaust Memorial Museum in partnership with Google Earth. An exploration of popular culture and its varied interventions reveals the overlap of the arenas of the market, the state, and civil society, between public and private, and even between fiction and nonfiction.[59]

The popular is only one of many exclusions. The liberal bourgeois public sphere was founded on numerous exclusions organized around axes of gender and class. Questions of inclusion have troubled the ostensibly universal or generalized character of the public sphere in the face of other, competing public spheres, publics, and counterpublics.[60] And this field demands even further complication given the composition of civil society and modes of publicity in the late twentieth and early twenty-first centuries,

an era characterized by a radically accelerated globalization. Responding to these concerns, scholars have introduced questions of demographics, "participatory parity,"[61] and access: "how are the material resources necessary for that communication made available and to whom"?[62] What is the nature of these social formations and how are they brought into being? Attempting to locate the origin of publics Michael Warner advances the centrality of speech: "They exist by virtue of their address."[63] This claim not only establishes the importance of examining text and rhetorics in order to better understand how audiences are hailed, shaped, alienated, or inculcated, but it also points to the contingency of publics. These are temporary and conditional formations, predicated on address. Similarly, witnessing publics are not an enduring, eternal, or general formation, but temporary and contingent collectives hailed through address and encouraged into an active engagement and responsibility with what they see. This understanding is enhanced by Craig Calhoun's suggestion that we "think of the public sphere as involving a field of discursive connections" with clusters "organized around issues, categories, persons, or basic dynamics of a larger society."[64]

Calhoun's territorial metaphor for the public sphere and its publics dovetails with the idea of witnessing as field, an understanding that draws on Pierre Bourdieu's field of cultural production. This framework broadens our understanding of the testimonial encounter, accounting for the situated character of witnessing, enmeshed in social lives of the actors and tied to the available capital, whether financial, symbolic, political, or cultural.[65] This field meets the discursive terrain in the shaping of human rights and genocide claims for the purposes of exciting political change. Sensitivity to the broadcast messages and content is necessary, to be sure. However, there are additional questions beyond imbuing the image with meaning; namely, how can one navigate the media ecosystem to provide an effective message that is not lost in the noise. The human rights practitioner, explains WITNESS program manager Sam Gregory, is faced with a dilemma that "can be framed in terms of questions of *what* is distributed, and *how* it is distributed."[66] Circuits of exhibition and distribution, as well as imagined audiences at all registers, from editors to viewers, play roles in this landscape. Steven Livingston describes the scenario in Sudan, where "[clusters] of people form upon the arrival of a Westerner, with older men pushing forward the more malnourished of the group, often children. The SPLA guerrillas, who themselves tend to be relatively well fed, sometimes instruct people to arrange themselves differently for better photographic effect."[67] In her study of Tibetan activism, Meg McLagan

draws on similar issues, in particular, the mobilization of essentialized images of otherness within the activist spectacle, in order to outline the more complicated practices of meaning-making and -remaking for purposes of engaging audiences in social justice movements.[68] These examples do not so much justify the perpetuation of problematic themes and icons as they gesture to the tensions and complexities that inform the navigation of the media ecosystem: its aesthetics, its rhetorics, its circuits, and its gatekeepers.

Although a concern throughout the book, these navigational concerns come to the fore in chapters 3 and 4, which cover periods wrestling questions of witnessing. Chapter 3 examines a cycle of films from the turn of this past century made about the genocide in Rwanda and the ethnic cleansing in Bosnia. Incorporating technologies of witnessing into their landscapes, these films take a reflexive turn in order to question the effects and efficacy of the visibility afforded these crises. An active culture of Holocaust representation helped to cultivate expectations around witnessing as evidenced at the close of chapter 2, which reviews the reuse and repurposing of the film *Nazi Concentration Camps,* which was originally produced for the Nuremburg Trials, in a range of films. The scenes highlighted the interaction between viewer and film, suggesting an inevitability of recognition and ensuing action. Any faith in the seamless efficacy of virtual witnessing was dashed in the face of the 1990s, where genocide took place on the world stage and was reported to sluggish if any action. To varying degrees, such films as *Before the Rain* (Milcho Manchevski, 1994), *No Man's Land* (Danis Tanovic, 2001), *100 Days* (Nick Hughes, 2000), *Hotel Rwanda* (Terry George, 2004), *Sometimes in April* (Raoul Peck, 2005) and *Shooting Dogs* (Michael Caton-Jones, 2005) identify the various agents in the field of witnessing, complicating, and interrogating the relationship between visibility and action.

Chapter 4 continues the study of the field of witnessing in the study of WITNESS, a U.S.-based international human rights organization that navigates the complex media environment and negotiates the perceived failures of visual media and desensitization. WITNESS does not undertake a specific rights issue. Rather, WITNESS aids its core partners (human rights organizations across the globe) in using video technology within an advocacy campaign. Such training extends well beyond technical instruction and incorporates training in visual storytelling techniques and in political economy. WITNESS understands that exposure is not enough and that what matters is the manner in which the suffering is treated, the

identity of the audience of this suffering, and the mobilization of audience sentiment in practical ways. These concerns lead WITNESS to draw upon a vast array of cinematic logics, from formal textual strategies to multitiered distribution and exhibition platforms. Drawing on cases from WITNESS partners, the chapter shows how the claim is produced for different arenas, and how plans for distribution and exhibition inform the shape of that claim. This organization has invented new processes of using video to form a relationship to human rights advocacy, but it is unique in explicitly codifying and clarifying the work that has taken place across the century, as exemplified in earlier chapters.

In order to understand how these projects have worked to transform audiences into witnessing publics, I deploy a two-pronged analytical framework. First, I examine the formal, textual, and aesthetic strategies, exploring the ways in which the claims are shaped through visual strategies that draw on a discursive terrain of potent, if problematic, iconographies. In the process, I trace the development of a popular genocide imaginary: images and understandings of the crime that have come into being over the past century, one that has dovetailed with a broader human rights imaginary. Second, I examine the social practices, focusing on the way filmmakers and media activists have put the films to work in justice movements designed to achieve response. Such an examination includes processes of production, distribution, and exhibition, as these media processes are enmeshed in both the relative efficacy of the message as well as its appearance. Intended outcomes can determine audiences and content, as well as distribution and exhibition plans.

Indeed, film rarely functions alone within the scheme of a larger campaign: more often than not, multiple platforms combine to promote a message to multiple parties as well as to sustain interest. Henry Jenkins's concept of "transmedia storytelling" provides a useful way of combining these two methodological components. "Transmedia storytelling," he writes, "represents a process where integral elements of a fiction get dispersed systematically across multiple delivery channels for the purpose of creating a unified and coordinated entertainment experience."[69] The framework lends itself to thinking about the "transmedia campaign," which refers to coordinated publicity efforts that draw on a concatenation of delivery systems and platforms to produce awareness of an issue within a context of taking action. Although the word "transmedia" evokes contemporary preoccupations with new digital technologies and social media, one can find evidence in earlier activist programs, such as in Near East

Relief's integrated publicity campaign for Armenia discussed in chapter 1. Their activism took place across multiple platforms, combining text performance and film, as in the deployment of survivor Aurora Mardiganian's testimony. Near East Relief even offered an experiential entry point for audiences, combining dinners of orphanage meals with films about the missions in Armenia. Even when not part of a focused or deliberate campaign, collective memory of an event can be built through transmedial means. This is discussed in chapter 2, which explores the ways the film *Nazi Concentration Camps,* both in its original usage and its repurposing and reuse, functioned to produce an iconography of genocide and to cultivate expectations of virtual witnessing at a distance. Meanwhile, the multiplicity built into the term "transmedia" encourages the consideration of witnessing as field, drawing attention to the combination of factors in cultivating response, from production to exhibition. And exhibition is key: The choice of delivery system, venue, and aesthetics can provoke the sentiment, but a next step is needed to both harness and direct the feeling into productive action. Offering this step, too, is part of the larger arena of media practice, whether in establishing fundraisers or letter-writing programs for casual audiences, requesting policy changes to audiences of decision makers, or a legal decision from an audiences of jurists.

The Internet significantly enhances and complicates thinking about this field of witnessing and its publics. Technology, tool, and medium combined, it enables the convergence of multiple media forms—text, photographs, moving images—and provides the means for exhibition, circulation, and action—both real and virtual. Increasingly central to social advocacy projects, the Internet amplifies and extends testimony, offering sites for upload, viewing, and comment, even connecting visitors to means for action, such as letter writing campaigns and fundraising. Because viewers can share videos and upload their own video responses, the Internet harbors the capacity to transform audiences into distributors and producers, in effect turning witnessing publics into witnessing publicists. Here, one can see clearly the ways in which witnessing is not simply a presentation or transmission of the testimonial image, but a matter of practice and engagement.

Pierre Levy's concepts of knowledge space, collective intelligence, and the *cosmopedia* provide ways of thinking about this relatively new field of witnessing and its capacity to activate publics. Defining collective intelligence as "universally distributed intelligence, constantly enhanced, coordinated in real time, and resulting in the effective mobilization of skills,"[70]

Levy hints at the witnessing potential of cyberspace, wherein testimony is circulated, and whereby this testimonial encounter promotes participation. The dynamism within his description, involving real time configurations and reconfigurations of information and self flourishes in the *cosmopedia*, the electronically augmented knowledge space that constructs identity around images, unites disparate publics, and brings together "static images, video, sound, interactive simulation, interactive maps, expert systems, dynamic ideographs, virtual reality, artificial life."[71] Describing the *cosmopedia* as a "virtual agora," Levy introduces the possibility of a Habermasian public sphere in cyberspace. The analogy gathers strength within his discussion of the knowledge, or intellectual communities that inhabit this virtual space, as the "members of this thinking community search, inscribe, connect, consult, explore," using the knowledge space "a site of collective discussion, negotiation and development."[72] Levy's description carries much of the promise and excitement of cyberspace as site for human rights work: information and engagement are present, and audiences are poised as publics. At the same time, this new site for witnessing and human rights work requires a critical eye. Internet technology offers new possibilities for access, exchange, engagement, and participation, but with this spreadability comes risk, as exposure feeds surveillance of restrictive governments, or as images become disarticulated from their context, sloughing off one meaning for another. With these concerns in mind, chapter 5 explores some of the human rights work conducted online with a focus on Darfur, the first acknowledged genocide of the twenty-first century. The subjects range from the emergence of online video, particularly enhanced by the appearance of CitizenTube, the political arm of YouTube, to newer forms of documentary expression including the *Crisis in Darfur* "layer" of Google Earth produced in partnership with the United States Holocaust Memorial Museum, as well as *Darfur Is Dying*, an online video game developed by Take Action Games. The figures in this chapter, as well as in those in chapter 1, will, at times, bear the marks of continued remediation, looking degraded and pixelated. Similarly, issues of screen size and resolution will take their toll on the quality of the image. Although unfortunate, these images are retained (as opposed to seeking print-ready materials from original, off-line sources—something not necessarily possible in the Armenian case) as a gesture to the conditions of the online encounter and the challenges of extenuated witnessing.

The chronological logic of chapter organization does not posit an evolutionary trajectory, suggesting an inevitably sanguine outcome in the mutual

development. Nevertheless, attention to the enmeshed twin histories sheds light on the role of film, video, and the moving image culture of the Internet in producing a public relationship to genocide and international human rights law. In addition, the chronology heightens sensitivity to a developing discursive terrain of genocide representation, and the fluctuating expectations of virtual witnessing. The combined approach of formal-textual analysis with examinations of political economy and social practice reveal the numerous devices that produce recognition and foster transnational ethical communities of witnessing publics.

This book cannot provide a holistic historical overview. Indeed, when it comes to the Internet and new media, such a promise would be both futile and hubristic given the rapidly developing technologies and attendant media practices. Nor does it address all genocides. There is no case history involving the Holomodor, the famine in the Ukrainian SSR considered by many to be a result of Soviet orchestration (1932–33), nor is there one addressing the 1988 Anfal campaign waged against Iraqi Kurds.[73] The Cambodian genocide and the Stolen Generations of Australia comprise two notable absences given the existence of screen media materials and the ways these materials have enhanced popular understanding of genocide while contributing to political action. The works of Rithy Panh provide powerful explorations of testimony from victims and perpetrators in numerous films, most notably in *S-21, la machine de mort khmère rouge* (*S21—The Khmer Rouge Killing Machine;* 2002).[74] *Enemies of the People* (Thet Sambath and Rob Lemkin, 2010) shows journalist and survivor Thet Lambeth extracting confessions from former Khmer Rouge officials and grassroots genocidaires. The aforementioned traveling photographic exhibit of the S-21 prisoner portraits demands that we ask who witnesses and how. Taken by the perpetrators for record keeping and possibly terrorizing purposes, both provenance and the repurposing from prison to exhibition give rise to important questions about the creation of witnesses.[75] Meanwhile, a relative wealth of films—documentary, docudrama, and fiction—have been made to explore the removal of Aboriginal children from their homes and its traumatic impact on the communities and the nation.[76] With these media tied to the highly visible campaigns for recognition and the plea for a national Sorry Day, this subject would have been an essential inclusion in a comprehensive project. These absences, and the others made more absent by their lack of mention, are difficult to reconcile, but in some ways they call to mind some of the challenges of witnessing as different campaigns battle for media space and

attention. Access to materials, narrative structure, and the restrictions of the exhibition space all come together in these considerations. However, the mapping project and methodological testing engaged throughout the book lend themselves to analyses of these cases, and provide a start to the work that remains to be done.

1 TO ACQUAINT AMERICA WITH RAVISHED ARMENIA

IN SEPTEMBER 1896, *The Ram's Horn*, a religious magazine from Chicago, published a political cartoon entitled "Tears, Idle Tears!" (Figure 1). The drawing depicts a swarthy Muslim, indicated by the crescent atop his turban, standing over a pale, fallen woman, identified by a nearby banner as Armenia. In his hand, the attacker holds a dagger poised to plunge into the prostrate figure. Meanwhile, an anthropomorphic globe, clad in military gear, sheds tears at the violence before him, bemoaning, "Oh!! This is aw-ful! Ain't it?" The cartoon refers to the Hamidian massacres, the slaughter of Armenians that took place in the Ottoman Empire between 1894 and 1896 and a culmination of violence spurred by anxiety over reforms and an effort to maintain a pan-Islamic Ottoman Empire, dubbed the "Sick man of Europe." While otherwise straightforward in its use of caricature and anthropomorphization to refer to world events, the cartoon is striking for its depiction of global witnessing. Here, a world watches distant events, has its sentiments aroused, and bemoans the horror it encounters—horror that had been made familiar to the average reader through prior reports and illustrations. At the same time, a legend functioning as greater conscience scolds the audience for the idleness of the emotion alone. What are these tears compared to a world that is clearly capable of acting (it is in military gear) and observing action before the dagger sinks to finish the job? Tropes of Orientalism dramatize the scenario, enhancing the claims of unjust and outrageous suffering, and producing a narrative of the massacres complete with cast of characters: the villain, the victim, and the possible savior.

This image speaks to the concerns of this chapter: the global witnessing facilitated by a variety of early media. The media technologies enabled broadcast and networking at an unprecedented rate, while mediating

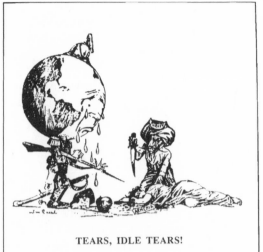

TEARS, IDLE TEARS!

The Weeping World—*"Oh!! This is aw-ful!! Ain't it?"*

—*Ram's Horn* (Chicago), Sept., 1896

Figure 1. "Tears, Idle
Tears." Image courtesy of
The Center for Holocaust
and Genocide Studies,
University of Minnesota.

strategies transformed information—the reports from overseas—into
knowledge, and more importantly actionable knowledge. In other words,
how were these images and accounts of distant atrocities made compre-
hensible and how did they encourage the audience to political or social
response? The present-day understanding of the Armenian genocide as
forgotten overlooks how widely reported it was at the time, an aspect real-
ized in this cartoon's global witness. From the Hamidian massacres of
1894–96, to the genocide in 1915, to the conditions of privation, homeless-
ness, and expulsion that continued into the 1920s, the Armenian crises
were widely reported. Articles in newspapers and magazines, diplomats'
letters, missionary reports, and refugee testimonial performance attracted
significant attention, contributed to international political debates, and
facilitated massive transnational relief efforts, or what Peter Balakian calls
"the first international human rights movement in American history."[1]

Technological advances in photography and publishing united images with the dramatic testimonies. Sketches and photographs accompanied the reports in weekly magazines while editorial cartoons offered commentary. Relief organizations used both photographs and sketches in their posters and pamphlets. The turn of the twentieth century also saw the rise of film as mass entertainment and a source of information when the Lumière brothers presented actual footage from every continent, giving "audiences an unprecedented sense of seeing the world."[2] The American-based Near East Relief sought to harness the potential of these new media in their campaign to raise both awareness and funds.

To best understand the relationship among visual media, global witnessing, and the production of response, I combine analyses of aesthetic, formal, and genre properties of the texts with the social scaffolding developed around the texts designed to enhance meaning and animate action. I focus on the publicity activity of Near East Relief (NER), placing it in the wider context of reportage and response to the Armenian crisis. NER's campaign for aid relied on a number of media platforms from print to performance, and, most notably, film with *Ravished Armenia* (1919). Coproduced with Selig Polyscope studios, the organization adapted the testimony of genocide survivor Aurora Mardiganian and put this silent film to use in its major fundraising campaign. In effect, the committee deployed the film as testimony, providing a personalized narrative of suffering to engage and mobilize audiences that made use of text and elements beyond spoken or read language. Moreover, this performance did not work in isolation; rather, it was made effective through a convergence of the available performance platforms, delivery systems, potent iconographies, and a robust history of reportage from the Near East region. Through this cooperative action, a campaign story was told across media and built on a scaffold of existing projects, narratives, and images. Much of the publicity, for instance, elicited concern and outrage by highlighting the religious dimension of the atrocities, with Muslim Turkish perpetrators and Armenian Christian victims combining popular images of a mysterious and dangerous East with a Christian iconography of martyrdom. To enhance the affect, the images traveled through a sophisticated transnational network responsive to and dependent on these modes of expression: commercial media and missionary organizations.

NER, the coproducer of this film, was an organization born from one of the largest American missionary organizations, the American Board of Commissioners of Foreign Missions (ABCFM), a Protestant Evangelical

network with headquarters in the United States and numerous schools, hospitals, and churches in Turkey. NER provided a Christian matrix, supplying both the necessary transnational infrastructure for distribution and exhibition of testimony and the formal tropes for comprehending suffering and a context for moral engagement.[3] In both rhetoric and structure, the relief effort around the Armenian crisis brought together emerging humanitarian and human rights frameworks with an established mode of Christian organizing. This chapter opens up these intersections of the media and Christian networks in the field of humanitarianism in the early part of the last century. Over time the domains have come to be considered increasingly discrete and specialized, but the pre–World War I and interwar periods are marked by the intertwining of these discourses. A mapping out of the film campaign yields not only a consideration of transnational media circuitry and its activist uses, but also the reliance on a convergence of multimedia performance platforms to produce truth-claims and sentiment while mobilizing response—a transmedia campaign for the developing transnational concept of human rights.

Context(s)

By the time *Ravished Armenia* was released in 1919, reports of horrors in the Ottoman Empire had long been reaching Western publics and animating a sense of collective obligation for international action. Newspapers, missionaries, and diplomats provided accounts and images of violence that trained a Western eye on Turkey, while simultaneously training the Western eye to read images of humanitarian abuse and to recognize a common moral bond in shared humanity. Alongside the global network of information rose an interest in the possibilities of intervention ostensibly on humanitarian bases alone. Although investments of international relations and imperial interests can and do underpin humanitarian concern, this period equally saw players with minimal political and commercial aspirations in the territory advocate on behalf of persecuted Christian communities.[4]

Concerns over the treatment of Christian subjects emerged in the early part of the nineteenth century, leading to governmental reforms, including a decree of the Hatti-I Sherif, which guaranteed rights to all subjects of the empire, and the 1856 Treaty of Paris, which recognized an international obligation to care for one's subjects.[5] The persecution of Christians persisted, however, and stayed in the public eye, as the Balkan states

revolted in the 1870s, and the Ottoman Empire reportedly retaliated with slaughter and destruction. According to Paul Gordon Lauren, newspapers provided sketches of "Turkish troops burning homes, riding over dead bodies and massacring innocent women and children."[6] An image from the *Illustrated London Times* (1876) shows dark-skinned Turks atop horses, menacing an apparent family of three: a light-skinned mother and child cradling a fallen father. Articles appearing in the journal that year detailed the violence.[7] Reports proliferated, likely aided by the telegrams that accelerated the traffic in information. Meanwhile, William Gladstone published *The Bulgarian Horrors,* which described the horror of people "murdered, or worse than murdered, by thousands." Lauren notes both the book's success—forty thousand copies sold in three days—its contribution to the discourse of rights, and "a global responsibility 'for the deep interests of humanity.'"[8] The Russian-Turkish war of 1877–78 provided the occasion for more violence, and additional images. Images of Armenians fleeing a burning background frequently graced the illustrations of *The Graphic* (London), possibly for their powerful link to biblical stories of exodus and expulsion.[9] In response to the horrors, the 1878 Treaty of Berlin that followed not only divided the states but also conferred a protected legal status on the Christian minorities.

Although the Treaty of Berlin attempted to secure safety, international pressure and the threat may have also deepened anxieties around imperial sovereignty of the Ottoman Empire (which, as noted above, was already called "the sick man of Europe"). In addition, the promise of safety excited Armenian nationalist sentiment, leading to political rallying; internal pressure for reform likely contributed to the unease. Not so long after, in 1894, Sultan Abdul Hamid launched attacks against Armenian populations, attacks that have come to be known as Hamidian massacres. News of the violence traveled and found its way into newspapers around the world. The front page of the *New York Times* in September 1895 leads with the headline "Another Armenian Holocaust" before detailing the burning of five villages, the torture of Armenians, and the organization of "an anti-Christian society to slaughter Christians."[10] The degree of reportage and awareness is signaled in the cartoon "Idle Tears." Joining the reports were books chronicling the violence, which found a ready market in England and North America. Frederick David Greene and Henry Davenport Northrop published *Armenian Massacres; or, The Sword of Mohammed: Containing a Complete and Thrilling Account of the Terrible Atrocities and Wholesale Murders Committed in Armenia by Mohammedan Fanatics* (Philadelphia

and Chicago: International Publishing, 1896), providing reports of the violence under what appear to be promises of Orientalist excitement. *Turkey and the Armenian Atrocities: A Graphic and Thrilling History . . .* (1896) by the Rev. Edwin M. Bliss, told of the Hamidian massacres and included stories of rape of women, decapitation of children, and the burial of men alive. The latter book continues the promise of titillation and highlights the Christian affiliation with an observation that "Armenians more closely resemble Christ physically than other races."[11]

Images, sketches and photographs, supplemented the numerous reports and attempted to make comprehensible the distant events of profound violence. In a Stuttgart paper (no date given), the political cartoon "The Only Throne Left to Him" (Figure 2) shows Sultan Abdul Hamid as a dark hunched figure, sitting atop a mountain of skulls and bones. The image both articulates the extent of the violence and presents the perpetrator as distinctly Oriental and foreign. *Harper's* offered tableaux of savage Turks atop horses threatening cowering figures below. A drawing from *Saturday Club* (New York) shows the Sasun massacre (1894) with Turkish soldiers bayoneting Armenians—one held aloft on the pike in the background.[12] The German Assistance Association for Christian Charity Work in the Orient holds a considerable archive of images including a massacre in Constantinople (September 30, 1895). Bodies are strewn throughout the streets while sword-wielding Turks pull women and children from their homes and attack kneeling figures in the background.[13] And throughout 1895, *The Graphic* of London covered these massacres using illustrations and photographs to augment reports.

However, as much as the images enhanced the written information, they were nonetheless dependent on anchorage, the process Barthes describes as the way "text directs the reader through the signifieds of the image."[14] "The Attack on Armenians by Softas (Theological Students) near St Sofia" and "The Police Taking Armenian Prisoners to the Grand Zaptie Prison, Stamboul" rely on the legends for information and receive legitimation from the statement "from a sketch by an eye-witness."[15] This attenuated authorization does have its logic as the first-person experience of suffering combined with a pictorial rendition may still hold more evidence than a professional's adaptation. Yet, photographs also demand this textual anchorage, as is demonstrated in the photographs of the living wounded in the same issue. One image offers a group portrait of approximately fifty bandaged men sitting and staring stoically ahead, while the caption identifies them as "A Group of Wounded Armenians in the Hospital

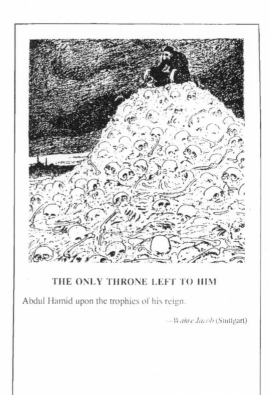

THE ONLY THRONE LEFT TO HIM

Abdul Hamid upon the trophies of his reign.

—*Wahre Jacob* (Stuttgart)

Figure 2. "The Only Throne Left to Him." Image courtesy of The Center for Holocaust and Genocide Studies, University of Minnesota.

after the Riot." Another image, or rather, its description, offers greater detail. Three women sit, identified as "Wounded Armenian Women in the Hospital." A lengthy description follows: "A girl of fourteen whose parents were killed, and who was herself badly beaten; A woman, with a bayonet wound through the lung, who cannot live; A woman suffering from cuts on her head and legs from bruises."[16] The December issue offers a photograph of "The Trench Dug for the Bodies of the Victims" (December 7, 1895). Registers of signification guide the reader through the atrocity. The picture shows a mass grave in a wide shot that emphasizes the many bodies lined up in a row, in a ditch deep enough to harbor more corpses. While the framing and mise-en-scène contribute to the staggering sense of mass death, the legend both emphasizes the scope and provides specific data: "Two rows of dead, thirty-five deep, had already been laid down and partially covered . . . [in] a huge grave fifty-three feet square for the reception of slaughtered Armenians."[17]

This photograph may resonate today for its familiarity as a scene of mass violence; however, all it shows are multiple bodies that demand identification (they are Armenian) and context (they were slaughtered). Moreover, the text itself, for its seemingly straightforward description, contributes the presentation of neutrality already engaged by the photograph's presumed ontological link to reality. In photographs as well as sketches, word and image provide mutual reinforcement of meaning and affect, often conjuring up extant visual tropes—a biblical exodus or a marauding Muslim, for instance. In words and in pictures, Orientalism and Christian tradition would provide keys to understanding the information. A context of reportage and invocations of extant visual traditions provided the interpretive grid through which communities began to mobilize on behalf of a beleaguered humanity.

The reports of violence against Armenians appeared to stimulate international concern and sense of obligation. "Foreign Affairs in the Senate," a report in *Harper's Weekly*, reads, "The massacres in Armenia very justly aroused a feeling of horror and indignation throughout Christendom, and excited a widespread desire to protect and aid the unfortunate victims."[18] In 1895 Democratic senator Wilkinson Call of Florida pleaded for U.S. intervention into the Hamidian massacres. Speaking before Congress, he stated, "In the name of religion, humanity, and the principles on which all civilization rests . . . the United States should use peaceful negotiations or by force of arms if necessary, to stop the cruelties inflicted on the Armenians."[19] Deeming intervention too radical, Senate Foreign Relations Committee chairman Shelby Moore Cullom presented a tamer alternative wherein the United States merely condemned the actions of the Ottoman Empire. Although one could readily dismiss this conclusion of this debate as the lethal inaction that characterizes response to genocide today, these pleas are significant for their request of political action across borders outside of war.[20] For both Call and the anonymous *Harper's* reporter, this common obligation was forged under the signs of religion—Christendom in particular—and humanity.

The massacres subsided without intervention from outside, but persecution of Armenians persisted, even when the liberal reform movement of the Ittihadists, also known as the Young Turks, replaced the Sultan. Although it was hoped that the platform of liberal reform would have favorable results for the Armenians, this was not the case. The years after the Ittihadists' installment were followed by multiple acts of aggression, including the massacres at Adana in 1909, which within forty-eight hours

had left two thousand Armenians dead and fifteen thousand as refugees in need of aid. In this period before the First World War, foreign wars, namely the Balkan Wars (1912–13) afforded Armenians an opportunity to seek international intervention. Balkan states revolted against Ottoman rule, leading to great losses and threats to Turkey's European presence. At the London peace conference that followed the first armistice, terms of peace included a provision that the Empire relinquish its European states. The war resumed, eventually leading to Turkey's loss of 85 percent of its European territory. It was at this time that the Armenians sought the help of European nations for protective measures, leading the Armenian Reform Agreement of February 8, 1914. This international agreement provided for European observers to be stationed in the Armenian provinces, a decision that likely exacerbated Turkish anxieties over its dominion and status.[21] Although these efforts do constitute intervention, these were accomplished within broader schemes of foreign wars and not on behalf of "humanity" alone. Nevertheless, up until 1915, the Ottoman Empire's persecution of Christians, and particularly Armenians, received attention in the press and from politicians, creating a longstanding interest that laid the foundation for continued interest in intervention and prosecution of crimes against humanity.

When the First World War began, protections for Armenians dissipated and the community was left vulnerable. Although the genocide against the Armenians during this period has been characterized as wartime violence, the Ittihadist government maintained an infrastructure that supported systematic murder and deportation. Acts of legislation dispatched death squads. Between 1915 and 1918, the Armenian people suffered abduction, rape, torture, massacres, extreme privation, and expulsion into Syria, where many perished from dehydration and starvation. An estimated one and a half million Armenians died between 1915 and 1923. These events would come to be known (even if contentiously) as the Armenian genocide.

Although the war impeded the channels of information, news of the gross violations did travel to the outside world and continued to elicit moral obligation that appeared to extend beyond borders. A joint declaration issued to the Ottoman Empire by Russian, French, and British governments observes that '"for about a month the Kurd and Turkish populations of Armenia has been massacring Armenians with the connivance and often assistance of Ottoman authorities." The statement also accuses Turkey of crimes "against civilization and humanity" and announced the intention

"to hold personally responsible [for] these crimes all members of the Ottoman government and those of their agents who are implicated in such massacres,"[22] both providing a threat of legal repercussions and introducing new legal terminology into an international juridical lexicon.

American ambassador Henry Morgenthau sent dispatches to both the U.S. State Department and newspapers and magazines describing the forced exile and extermination of Armenian subjects; he would also enclose reports from American consuls stationed elsewhere in Turkey.[23] Morgenthau's telegrams refer to "continued report of persecution, plunder and massacres of the Armenians,"[24] and the grand vizier's anger at the European powers for "attempted interference by foreign governments with the sovereign rights of the Turkish government over their Armenian subjects."[25] He sought advice from Secretary of State Robert Lansing, who suggested connection with German ambassadors in hopes they could exert pressure as nonhostile observers still welcome in the Turkish state. However, things were escalating already. A telegram dated July 16—the same day as Lansing's cable was sent—reads, "deportation of and excesses against peaceful Armenians is increasing and from harrowing reports of eye witnesses it appears that a campaign of race extermination is in progress under a pretext of reprisal against rebellion." Morgenthau despaired of the possibilities: "Protests and threats are unavailing," and that "nothing short of actual force," an option unavailable to the United States, could serve as a deterrent.[26] In September 1915, Morgenthau sent a telegram suggesting that they establish a committee for providing aid to those exiled and in need. The situation was dire; "the destruction of the Armenian race in Turkey is rapidly progressing."[27] The State Department forwarded the message to James L. Barton, foreign secretary of the American Board of Commissioners for Foreign Missions (ABCFM), who agreed that a relief committee was in order. Near East Relief (NER) was formed in October 1915 and worked to raise awareness and funds at home while administering aid overseas.[28]

The appeal to a Christian missionary organization is hardly surprising. ABCFM, a Protestant Evangelical organization, was the largest American missionary operation in Turkey, with hospitals and schools stationed throughout the territory. While the dispersed missions enabled a wide-ranging global circuitry for information exchange, the missionaries could continue to provide aid and protection to the Christian Armenians. The committee included a more multidenominational (if still predominantly Christian) membership, with rabbis occasionally taking part in official

activities.[29] Philanthropic and educational institutions also joined in, allowing the overall membership to express its concern, not simply for the Americans and American interests overseas, but for the non-Muslim populations in the Near East.[30]

The Christian character of the network ought not to be overlooked, as it would provide the committee with the affective and moral elements needed to produce a transnational community of affinity. Barton couched his advocacy directly in the language of social gospel that had informed the Protestant Evangelical mission. "The Armenians have no one to speak for them and it is without question a time when the voice of Christianity should be raised," Barton wrote in a letter to philanthropist Cleveland H. Dodge, whose family had inhabited the missionary field for three generations.[31] This voice of Christianity is multivalent. The Christian voice identifies the publics: the persecuted communities overseas, those who give testimony, and those who receive it. The phrase suggests a Christian key, a discursive grid that shaped reports and their adaptations into testimony, sketches, photographs, and film. And finally, the invocation of a voice serves as a reminder of the necessity and value of publicity.

Publicizing the Crisis

Meg McLagan and Tom Keenan have asserted the centrality of publicity— or the making public of abuses—in political movements and activism.[32] An examination of NER's work underscores this importance, even prior to the more immediate transmission and wider broadcast of information of the past few decades. In his chapter entitled "Letting the Public Know," Barton expands on the value of publicity (what he calls "public appeals") explaining, "The task before the Committee was to make the need for relief in the Near East known to the people of America, to secure the confidence and approval of the organization itself, and then to persuade by letter, personal solicitation, or through organizational channels" to contribute funds.[33] The written appeals relied on the eyewitness testimonies coming from the missionaries of the Near East.[34] This privileged access came not only from the missions overseas, but from the State Department, which granted NER "permission to read and use all dispatches and documents bearing upon the religious, social, and physical conditions in the disturbed area."[35] This particular provenance bestowed legitimacy onto the information, making it, in Barton's words, "factual" and "authenticated."[36]

The press played an essential role in broadening the scope from a direct-to-donor campaign and offering a platform for these reports.[37] Chronicling the initial discussions around publicity, Barton explains that the committee did not wish to pay for advertising, but instead "trust[ed] the loyal and spontaneous support of the press,"[38] which had demonstrated a solid record of reporting events in Turkey. Nevertheless, other elements, beyond loyalty and spontaneity, contributed to the wealth of reportage. Contacts with editorial staff of magazines, journals, and papers were widely sought. Merrill D. Peterson observes the combination of newspaper and NER interests in the figure of John H. Finley, editor of the *New York Times* and occasional member of NER's board of trustees.[39] When noting that 1915 saw 145 stories on Armenia in the *New York Times,* Samantha Power suggests "it helped that Morgenthau and *Times* publisher Adolph Ochs were old friends."[40] And as if to augur the appearance of Video News Release in the latter part of the century, NER prepared articles for their contacts in order "to enlighten the general public upon subjects bearing upon the Near East peoples and conditions."[41]

The religious press were also key allies, according to Barton, "sympathetic and co-operative, backing the work of the Committee editorially and with specially prepared articles." This union, initially generating short bulletins, soon developed into a monthly magazine sent to contributors, which contained photographs, reports, and appreciations of the work done so far. The magazine was clearly intended to maintain a donation base for the committee and sustain a witnessing public in relation to the Near East. Barton writes, "An interested and sympathetic giving constituency was developed by this regular informative service."[42]

Speeches

Organized meetings provided a more focused means of broadcast and outreach. Within a month of the initial meeting, NER arranged a public assembly in the Century Theatre in New York City. Prestigious speakers and leaders of religious communities—many of whom served on the NER Board—spoke to an audience of thousands. They presented eyewitness testimony and reports that were repeatedly subject to additional, verbal authentication on stage. The *New York Times* reported on the event. "Dr. Barton held up a great mass of papers, all copies of official reports to the State Department. Excerpts were read telling of terrible tortures, in thousands of instances causing death."[43] The call to action, the speaker list

seemed to imply, was not one of state or even religious politics, but a matter of humanity. Rabbi Stephen Wise personified this with his claim to be present, "not as an opponent of Turkey, nor as a champion of Armenia, but to protest against inhumanity." The group of speakers put forward a resolution, published in the *New York Times* along with a report of the gathering, declaring "the civilized world to be shocked by massacres and deportations" that "find no justification, viewed either in the light of law or humanity" and urged every effort be taken to "rescue and repatriate" the Armenians. The steps to action were facilitated. According to the report, "In all the seats were petitions, with blanks for signature, addressed to the Kaiser and the people of Germany, imploring them to use their good offices to end the atrocities in Armenia."

Barton praises the capabilities of the testimonial performance to transform the audiences into witnesses: "Scores of speakers during the years have transferred with appealing effectiveness the tragic scenes from distant East into the hearts of a sympathetic and responsive public." Their power, Barton argues, lay in their capacity to make these stories "reality to any audience" and in the speaker's power to visualize "in living words the mass-agony of the refugees from Turkey and Persia struggling for life."[44] Individual cases not only personified mass suffering, but also moved audiences and, again, served to maintain the donating base, as these performances "profoundly impressed contributing friends throughout the country." Not to be neglected here, however, are the ways in which the mission organizations facilitated this encounter and the spread of information across the country. They brought in guests from abroad, refugees, and missionary representatives (educators and doctors); they provided a venue for the encounter and a space for the responsive public. More importantly, in this space they could convert the interest into donations, much as the meeting above sought to convert emotion into signatures. In both cases, the money or the signatures were put to use within the established network: signatures were placed on letters and petitions to be mailed; money helped to fund the relief systems already in place.

Visual Publicity

NER supplemented the press and performance campaign with posters and placards. Mostly drawings, as photographs were in short supply due to the censorship of the war years, these images built on the "word pictures" provided through earlier reportage and testimony. From 1916 to

1918, many of the posters (which served the American Committee for Relief in the Near East [ACRNE]) focused on images of women and children. "The Child at Your Door" offers a sketch of a young child wearing a head-scarf tied at the chin. Looking directly at the imagined spectator, the hands are folded at the chest, in a gesture of combined protectiveness and suppli-cation. The legend below provides further information: "400,000 Orphans Starving" tells us who this child is, while "Campaign for $30,000,000" fol-lowed by an address for ACRNE, tells how to help. "Give or We Perish" pro-vides a straightforward explanation of what is needed, while a portrait of a woman, clutching a shawl and headscarf over her bosom and looking over her shoulder, recalls the accounts of rape, presenting a posture of looming peril.[45] "They Shall Not Perish" offers a more definite outlook secured by the image: Columbia holds a sword aloft in one hand, while the other arm, draped in an American flag, clasps a young woman, hud-dled at Columbia's feet and looking over her shoulder at danger nearby. Unlike the world that stood weeping at a distance as a young female Arme-nia was savaged in "Idle Tears," this personification of America enfolds the Armenian people into her care.

Crucial to the maintenance of this campaign, Barton notes, was the practice of adapting the campaign to the changing conditions. This was particularly important when the armistice threatened to diminish the urgency of the Armenian crisis. The images in the posters became harsher in order to portray the severe conditions. "Hunger Knows No Armistice" (1919) offers a high-contrast portrait of three people. An older woman leans against a brick wall with her eyes rolled upward, half her body in shadow. A child, eyes looking up in seeming terror and with mouth agape in a possible scream, clutches at the woman. Below them, another child lays still, eyes-closed, and most likely dead. Another poster is gentle by comparison: "Give the boy a chance; 249,999 other homeless orphans like him" shows a barefoot young boy, clutching a threadbare blanket around his frail body. He stands on a desolate landscape, looking directly at the viewer, the only other person around, even if off screen. Despite the avail-ability of photographs of relief stations and portraits of orphans en masse, many of these posters trained their attention on depictions of individual suffering, fostering a more personal interaction between viewer and sub-ject. Each figure, whether the young cowering girl or the savior Columbia, combined the individual and the communal, creating a manageable sphere of public responsibility. These posters aimed to heighten and maintain a sense of moral duty that may have been aroused in earlier periods where

reportage of extermination persisted, and where war increased feelings of international solidarity. These images appeared in multiple public spaces, as "car card and outdoor advertising space that could not have been rented for thousands of dollars was contributed free."[46]

Photographs of the conditions in Armenia were in smaller supply due to the censorship restrictions of the war years that prevented easy circulation. Armin T. Wegner, a German soldier, took numerous photographs of corpses, deportees, and executions; he smuggled these, along with notations and accounts, through secret mail systems, sending the photos to the United States and Germany. John Elder, a NER aid worker, took numerous pictures of the orphans and orphanages, but the use of his photographs (beyond their present function to provide archives to the genocide) is uncertain.[47] His photos, however, capture many of the devastating effects of privation by depicting the emaciated bodies of the orphans. In the postwar years, images of relief stations appearing in newspapers frequently showed wide shots. Vast landscapes of tents appeared on the pages of the Sunday magazine of the *New York Times,* impressing upon the viewer the scope of the crisis. James L. Barton's *History of Near East Relief,* published later, offers an assembly of these photos, showing both small groups of starving, collapsed children and portraits of orphans in their care. Pictures also emphasized the magnitude, with one photograph depicting a claimed six thousand orphans posing in star formation—a gesture of need, success, and gratitude.

Photographs illustrate Henry Morgenthau's narrative of events, *Ambassador Morgenthau's Story,* published in 1918. This autobiographical account of his experience in Constantinople redirects the reports once intended for the State Department to a wider audience. The purpose, it seems, was one of testimony and evidence for the possibility of future legal action. The preface begins, "By this time the American people have probably become convinced that the Germans deliberately planned the conquest of the world. Yet they hesitate to convict on circumstantial evidence and for this reason all eye witnesses to this, the greatest crime in modern history, should volunteer their testimony." The book carefully chronicles the history, highlighting the nature of the crimes. One chapter, entitled "The Murder of a Nation," details the reports of mass murder, systematic starvation, deportation, torture, and sexual violence. The descriptions are vivid:

> They would pull out his eyebrows and beard almost hair by hair; they would extract his fingernails and toe nails; they would apply red-hot irons to his

breast, tear off his flesh with red-hot pincers, and then pour boiled butter into the wounds. In some cases the gendarmes would nail hands and feet to pieces of wood—evidently in imitation of the Crucifixion.[48]

And:

The hot sun of the desert burned their scantily clothed bodies, and their bare feet, treading the hot sand of the desert, became so sore that thousands fell and died or were killed where they lay. Thus, in a few days, what had been a procession of normal human beings became a stumbling horde of dust-covered skeletons, ravenously looking for scraps of food, eating any offal that came their way, crazed by the hideous sights that filled every hour of their existence, sick with all the diseases that accompany such hardships and privations, but still prodded on and on by the whips and clubs and bayonets of their executioners.[49]

Photographs augment the graphic language, but nonetheless rely on further notation for meaning and impact. "Those Who Fell by the Wayside," a photograph reminiscent of images from *The Graphic* in 1895, shows rows of corpses in a sparse wood. A more lengthy caption notes, "Scenes like this were common all over the Armenian provinces in the spring and summer months of 1915. Death in its several forms—massacre, starvation, exhaustion—destroyed the larger part of the refugees. The Turkish policy was that of extermination under the guise of deportation."[50] The language clearly directs the decoding process making the bodies express more than their own deaths; instead, they represent multiple forms of death that persisted over a period of time and that are attributable to Turkish policy. Another photograph entitled "A Relic of the Armenian Massacres at Erzingan" shows a stack of skulls and bones left in a field. The title anchors the image in a historical event, massacres at Erzingan, while the word choice, "relic," a word that can equally refer to the remains of a martyred saint, summons the Christian imagination. The caption explains, "Such mementos are found all over Armenia," allowing the picture not only to represent, but be representative.[51] While this photograph relies on text to identify the meaning of these contents—these are Armenian remnants and evidence of massacre—it also resonates with additional, tacit information that influences the reading. The bone pile creates visions of disgrace, both to the once living, who have now fallen by brutal means, and to the dead, who will not receive a proper burial. In addition, this photograph recalls the cartoon of Sultan Abdul Hamid on

his throne of remains, a gesture that places this image within the context of a (iconographic) history of violence committed against Armenians, while producing reportage (and its history to follow). This context bolsters the claims of the off-screen activity: these bones are the result of a massacre not caught on camera, and they are representative of other bones not photographed.

What is off-screen looms large in photographs. A figure given the descriptive title "Refugees at Van Crowding around a Public Oven, Hoping to Get Bread" receives further explanation: "These people were torn from their homes almost without warning, and started toward the desert. Thousands of children and women as well as men died on these forced journeys, not only from hunger and exposure, but also from the inhuman cruelty of their guards."[52] In some cases, the evidentiary function of the photograph seems to be at utter remove. A landscape of Harpoot, a view of a sizeable town from the hills, bears the legend, "Where massacres of men took place on a large scale."[53] The picture reinforces the imaginative capacity of the reader to envision the site of the atrocities, and possibly, for its innocuous and near urban appearance, to foster a sense of proximity to distant suffering. The function however, is more illustrative than evidentiary.

Film: *Ravished Armenia*

It was in this context of reportage and representation that *Ravished Armenia,* a cinematic adaptation of survivor testimony, functioned. In 1917, sixteen-year-old Aurora Mardiganian, née Arshalus Mardigian, arrived in America. Hoping to find her brother, she placed advertisements in local and national newspapers. These advertisements were followed by newspaper interviews, which further publicized her story and eventually brought Mardiganian to the attention of screenwriter Harvey Gates. Recognizing the potential appeal of her story, Gates and his wife approached Nora Waln, Mardiganian's legal custodian and the publicity secretary of NER— then called the American Committee for Armenian and Syrian Relief (ACASR)—and asked to become the girl's guardians. In their combined charge, Mardiganian delivered her testimony, which appeared as a serial in *The New York American.*[54] Around the same time that Morgenthau's account was published in book form, so too was Mardiganian's, as *Ravished Armenia* in the United States and as *The Auction of Souls* in the UK. While no numbers are available for the earlier printing, a reprint in 1934 boasted an alleged circulation of 360,000 copies.[55]

Mardiganian's experience, already subject to filters of adaptation, through name change, interview, serial, and book (whose front matter boasts as "Interpreted by H. L. Gates"),[56] underwent further mediation when film entrepreneur and studio-owner Colonel William Selig (Selig Polyscope Pictures) optioned the story for adaptation. The success of the book (and subsequent personal revenue) may not have been the sole impetus, as an announcement inside the text states, "This story of Aurora Mardiganian which is the most amazing narrative ever written has been reproduced for the American Committee for Armenian and Syrian Relief in a TREMENDOUS MOTION PICTURE SPECTACLE."[57] The notice attributes direction to Oscar Apfel (a future associate of Cecil B. DeMille) and the scenario to non–film professional Nora Waln. The shared provenance of the film—a combined effort of studio and relief organization—manifested itself in the distribution of revenue. Proceeds from the film, declared the "official photo-drama of the National Motion Picture Committee of the American Committee for Relief in the Near East," were to be split by Selig and NER.[58]

The profit was hardly insignificant. *Ravished Armenia* contributed to the $30 million NER campaign in a twenty-one-city tour of special screenings with ticket prices ranging from $2.50 to $10.00, more than ten times the average ticket price at the time.[59] In the case of New York City alone, screenings ran twelve days, with afternoon and evening showings. As the venue seated almost a thousand, this run could have raised as much as $240,000. Other cities such as Los Angeles, Chicago, Boston, and Indianapolis also hosted screenings in tandem with special events, luncheons, and performances, and introduced the guests to relief workers and diplomats.

Mrs. Oliver Harriman, socialite and chair of the National Motion Picture Committee, delighted in the possibilities of the film, pointing to value beyond the fundraising potential:

The whole purpose of the picture is to acquaint America with ravished Armenia . . . to visualize conditions so that there will be no misunderstanding in the mind of any one about the terrible things which have transpired. It was deemed essential that the leaders, social and intellectual, should first learn the story, but later the general public shall be informed. It is proposed that before this campaign of information is complete, as many adults as possible shall know the story of Armenia, and the screen was selected as the medium because it reached the millions, where the printed word reaches the thousands.[60]

Testimony

The value of *Ravished Armenia* lay in its capacity to broadcast the information and to actualize the reports that had come out of Turkey for the previous few years. Thus, like the speakers NER had deployed to create "word pictures," and like the prior publications of Mardiganian's narrative, the film was to function as a testimonial performance: to provide a true account of suffering in order to make political and ethical claims on an audience. But unlike the slave narratives and testimonial performances of past activism, the clarity of the first person "I" was filtered and possibly diminished through the third-person narrative of the camera "eye," the absence of sound (and the voice of the witness), and multiple (but not necessarily collaborative) authorship. Moreover, as much as the visual promised to deliver clarity ("so there will be no misunderstanding"), its quality as visible evidence was fraught. *Ravished Armenia* provided reenactments of interpretations of violence as related by eyewitnesses. Scenes of deportation, attempted rape, and mass slaughter were recreated in southern California, with Santa Monica's beaches becoming desert landscapes and Santa Barbara's Mount Baldy standing in for Mount Ararat. Contributing to the challenge of making the information meaningful and actionable, the film would also have to resolve the seemingly diffuse origins, returning them to an evocative and true personal story that would then both speak to and represent multiple others.

Substantiation of a testimonial performance's evidentiary value was not required of film alone. Testimony in any format wrestles with the double burden of providing evidence and an affective narrativization of a traumatic experience guaranteed to rupture easy and smooth retelling. The book version of *Ravished Armenia* comes with an acknowledgment that affirms the veracity of Mardiganian's story. H. L. Gates, the interpreter of the narrative, thanks Lord (Viscount) Bryce, one of the first to appeal to British Parliament on behalf of the Armenians; Dr. Clarence Ussher, author of *An American Physician in Turkey* (1918); and Dr. Mac Cullum, the man who rescued Aurora. These men, Gates explains, verify the accounts within: "You may read Aurora's story with entire confidence—every word is true."[61] Nora Waln's foreword further testifies to the truth of the account, but also warns, "This is a human living document." This is the work of neither a diplomat nor a historian but a testimonial encounter with a girl who "has lived through one of the most tragic periods in history." The purpose is to present her story "to the American people that they may understand

something of the situation in the Near East during past years, and help to establish there, for the future, a sane and stable government."[62]

The filmic *Ravished Armenia* supplied corroboration in abundance, both on screen and off. Guest speakers—relief workers, diplomats, and military representatives—confirmed the content in their speeches, much as the illustrious speakers at rallies both animated and verified the contents of the reports they read aloud. The on-screen introduction ensures that "each scene and incident has been carefully verified by Lord Bryce, former Ambassador to the United States, and others . . . including former Ambassador Morgenthau." On occasion intertitles cite official reports to secure both interpretation and evidentiary value. One title reads, "After having massacred the entire male population of the District of Bitlis, the marched [*sic*] 9,000 women and children to the banks of the Tigris, killed them all and threw the bodies into the river. (Official Report)" (reel 5, title 14). The invocation of the "official report" reframes this dramatic reenactment as certified statement in the process of verification. Like the captions of photographs in newspapers and books, the legends anchor the image in verified historical events, further ensuring that the meaning is read as intended. And much like the captions of the photographs, these titles add to what is seen by referring to what transpired before or after. The text tells us both what we see and what we don't see, giving the image a seemingly secondary function of illustrating and supporting the narrative.

The "based on a true story" components were enhanced by the presence of non-actors, namely Ambassador Henry Morgenthau and survivor Aurora Mardiganian playing themselves. These figures on screen functioned to personalize and return a first-person "voice" and testimonial encounter to the film. Morgenthau, a vocal supporter of the Armenians and recognized eyewitness, functions to further authenticate the printed reports by playing himself in the place whence the dispatches originated. Similarly, Aurora, rendered silent both through technological constraints of filmmaking and multiple mediations of her testimony, provides the semblance of a first-person performance of suffering through reenactment as opposed to narrative. Here, the cinematic testimonial performance refers not to an interview or narrative recorded on film, but a personal recreation of the experience. Like those speakers who visualized distant suffering for church audiences, Aurora could visualize distant suffering for audiences across America, into Britain, and in later years, in the Near East.

Aurora Mardiganian continued the work off screen when she toured with the film throughout the country, making numerous appearances as

the "Joan of Arc of Armenia."[63] While this title recalls Christian heroines of times past, her physical presence continued to enhance the truth-claim and individuality of the cinematic testimony as it sought to diminish the distance between the audience present and the horrors abroad. Because she had broken her ankle during the shoot, she occasionally made an entrance while carried by a relief worker. The affliction of the shoot may have well contributed to a sense of damage wrought abroad. Her body became representative of mass atrocities, both as symbol and as envoy. Yet even this body was subject to diffusion in distribution. The constant touring schedule was, unsurprisingly, exhausting for Mardiganian, and more to the point, the number of appearances had mushroomed to a level that challenged the abilities of any one person. To give relief to the girl and cope with the continuing demand, seven Aurora Mardiganian look-alikes were hired.[64] These bodies became representative of the representative, producing a radical attenuation of the witness, with the body as representative of an already representative body. At the same time, this seeming limit case for testimony illustrates its internal contradictions, whereby it requires a fiction to manage the turbulence and destruction of the traumatic event, not merely to the psyche, but to any attempt to narrate.[65] The fiction is needed in the truth-based narrative.

A discussion of *Ravished Armenia's* fictional elements refers not to the falseness of the claims; the existence of the genocide and the attendant massacres and privation are not in question here. Rather, the fictional refers to the narrative demands and to the filtering of deeply horrific traumatic truths through interpretive grids that render tales of suffering more palatable, although equally outrageous and worthy of compassion and action. In the case of *Ravished Armenia,* Aurora Mardiganian's story was framed in Orientalist and Christian tropes in order to transform the information of appalling violence into a case of unjust anguish and distant foreign publics into clear enemies or allies. By actualizing the accounts with which the audience was likely familiar thanks to a context of ongoing reportage and campaigning, the film sought to produce communities of affinity, united by shared identity, shared enemies, and shared obligation.

Orientalism

Gaylyn Studlar claims the period 1916–26 as significant in Hollywood Orientalism, characterized by images of a mysterious East.[66] Such images are well known. Edward Said, noting the discursive function of this practice

as a means of exoticizing and taming, lists among the distinguishing features "the sensual woman, the harem, and the despotic—but curiously attractive—ruler."[67] Ella Shohat has observed the same expressions, and includes the "rapacious ruler" and "desert odyssey" among them.[68] These images were a commonplace in the world where *Ravished Armenia* was released, as the sexualized violence manifested in many representational forms: there was Ingres's painting, *The Turkish Bath* (1862), stories like *One Thousand and One Nights,* and early films such as Selig Polyscope's own *In the Sultan's Power* (1908), which showcased Turkish villainy, and the pornographic Babylon of D. W. Griffith's *Intolerance* (1916).

This commercial popularity was likely influenced by and in turn influenced the reports of violence in the Near East. Said has posited that Orientalism arose in response to anxieties around the Ottoman Empire and a desire to rhetorically claim the Near East; and indeed, the Armenian crisis was frequently mapped out as a conflict of Muslim sexual depravity and inhumanity levied against a Christian population. An essay in *Harper's Weekly* covering the debates over American intervention couches the interventionist position within these seductive terms: "Prominent Senators proclaim that if *they* could determine the course of this government, American guns would soon send their shots 'crashing through the Seraglio' and in short metre put an end to Turkish barbarism."[69] The phrasing casts Americans as Western saviors in the Orientalist melodrama, a scenario that calls to mind the cartoon "Tears, Idle Tears" (Figure 1), depicting Armenia as a fallen woman savaged by a Turk ready to penetrate the prone figure with his dagger (with a militarized world capable of intervention). And as noted above, reports of rape and kidnapping abounded in the popular press throughout the crisis, from the Hamidian massacres to the release of *Ravished Armenia.*

The title, *Ravished Armenia,* speaks to the threat of sexual violence, both of the reports and the Orientalist fantasy.[70] Although deportations, massacres, and starvation were also components of the horrors overseas, it was the sexual dimension of the violence that was emphasized, and it was this aspect that excited press and public interest. The story begins with the Turkish governor wanting Aurora for his harem; later, she and her sister are taken to a slave auction. Although she escapes, slave markets, lustful Turks, Bedouin tents, and harems persist throughout the film. Title cards emphasize the rapaciousness of the "Unspeakable Turk" who was "steeped in murder, rape and pillage." The original poster for the film shows a brutish, dark-skinned Turk brandishing a sword dipped in blood

with one hand, while under his arm dangled a markedly white woman, contorted in mid-swoon (Figure 3). Although such devices dehumanized the Turkish people, they engaged audience sympathies within a familiar frame, and they also served to arouse and stimulate interest in stories of Armenian suffering. The film's press kit promised such visions as "real harems," noting how "with other naked girls, pretty Aurora Mardiganian was sold for eighty-five cents." The press fixated on this aspect. The *New York Times* wrote of these harems and slave markets. The British title (for both book and film), *Auction of Souls,* emphasized the slave markets and trade of bodies. The trade press called the film "A Sensational story of Turkish Depravity."

These scenes of titillation underscore the commercial dimension of this film that has been lamented and denounced. "As is often the case with Hollywood, a supposedly well-meaning highlighting of an important issue was little more than a commercial venture," notes scholar Gregory Topalian.[71] But does the commercial aspect of the venture necessarily undermine the

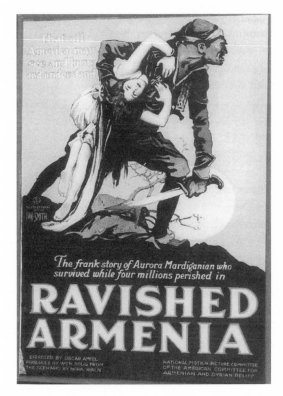

Figure 3. Movie poster for *Ravished Armenia* (1919). Text reads: "That all America may see and know and understand" and "The frank story of Aurora Mardiganian who survived while four millions perished in *Ravished Armenia.*"

advocacy mission? If Orientalism was used as a strategy to market goods, could it not also function to market a cause? Moreover, by intercutting such scenes with stories of slaughter and forced expulsion, the film's structure mapped a landscape of horror too vast for human imagination or sympathy onto the intimate landscape of the human body. Even as the mention of an "auction of souls" or a slave market excited prurient desire, it may have equally excited memories of the earlier abolitionist movement, painting these events as mandating intervention and interest.[72] By expressing the stories of violence in recognizable forms, the film could best direct the audience interpretation of the spectacle before them. Clearly, these tropes are fraught with their racist and exploitative aspects, and these observations do not endorse their use; rather, this discussion looks at the function of such images in transforming distant reports into a cause for concern.

Christian Persecution and Biblical Topography

The motif of the persecuted Christian figures largely in *Ravished Armenia*. In addition to the governor's vow, "I intend to kill every Christian man and woman and every child over three years" (reel 2, title 4), the film frames the attacks as theological battle in which Muslims overtake the land, forcing Christians to join or be slaughtered. In reel 2, an Armenian man is enjoined to "swear the Moslem oath" so that "your people will be saved" (title 19). The assailant coaches him, "There is but one God, and Mohammed is his prophet—say it!" (title 20). The Armenian responds, "There is but one God—" (title 21), "and Jesus Christ, his son, is my savior" (title 22). Although titles make no mention of the Armenian man's demise, it seems a likely outcome. Even without knowledge of the accompanying image, the pause indicated between titles 21 and 22 accentuates the suspense, producing a narrative cliffhanger that indulges the twin risks of conversion or death. Within this exchange, the policy of the extermination of Armenians is recast in religious terms, and more specifically within the familiar domain of the martyrdom of early Christians—those who chose death over emperor worship and pagan rituals.

The martyrdom scenarios continue throughout the film. In reel 3 Armenians herded into the city square are told, "Those who accept Mohammed will be allowed to go with their Children" (title 16). In reel 8, Armenian women on the road to Moush are threatened, "It will happen to you if you refuse to accept Mohammed" (title 8). Although, as noted above, reports

of the massacres often emphasized the religious dimension of the violence, the forced conversions of the film function more to evoke a familiar victim of religious, and even political, persecution than to accurately convey the policies of the secular Turkish nationalism that characterized the Young Turk government.[73]

Toward the film's end, a spectacular scene inscribes the genocide against Armenians as mass martyrdom by depicting a row of sixteen naked Christian girls, raised on crosses to be crucified (Figure 4). As the film is an amalgam of various concerns, so too is this scene which combines Orientalist sensation with the suffering Christian. A long shot supplies the dynamic image of women pinned to crosses, writhing in salacious agony. The shot articulates the scope of the destruction as the crosses recede into the horizon with the women in the foreground signifying what happens in the far off and unseen distance. A medium-close shot follows, showing a single woman, her eyes upturned to the heavens, while a vulture sits poised on her left (Figure 5). She is the very model of the martyred saint. To some extent, these spectacular martyrdoms warrant note, as an organization born from Protestant Evangelicals deploys a predominantly Catholic iconography in order to foster concern about an Eastern Orthodox community. At the same time, this combination suggests the more broadly ecumenical

Figure 4. Still from *Ravished Armenia* (1919).

Figure 5. Medium-close-up of a crucified woman. Still from *Ravished Armenia* (1919).

appeal of the project in which the visual and narrative traditions of Christian suffering convert the far away violence into a shared cause for injustice, compassion, and concern, simultaneously hailing a multidenominational Christian audience into affinity with the Armenians.

In this case these tropes may lend an interpretative framework that is not only recognizable, but palatable as well. While the mass crucifixion is detailed in the published testimony, interviews with Mardiganian suggest that these images derived from her account of the brutal impaling of Armenian women. According to Mardiganian, "The Turks didn't make their crosses like that. The Turks made little pointed crosses . . . and after raping them, they made them sit on the pointed wood."[74] Instead of this gruesome horror, the filmmakers supplied their own more sanitized, and possibly more familiar, shape of suffering. Sometimes, however, the scenes were not as recognizable: immediately prior to the crucifixion sequence, the extant footage shows women being thrown onto stakes buried in the sand—a very different impaling.

The persecuted Christian offers a compelling vehicle for communicating and understanding mass violence. And more importantly, their constant presence in the film's para-text—the published testimony—and context— the reportage, dispatches, photographs, and sketches that predated the

film—bolstered the interpretations of the filmic testimony. In the foreword to the published testimony, Nora Waln writes, "In face of persecutions which have no parallel elsewhere, these people have clung to their early Christian faith with the utmost tenacity . . . surrounded by backward people of hostile religion and hostile race. Their long existence has been one of unending martyrdom."[75] Christian iconography had also surfaced in pictorial reports of the violence. For example, two editorial cartoons, "Via Dolorosa" (Figure 6) and "Raising Their Monument" (Figure 7), explicitly place the violence against the Armenians within the framework of martyrdom. "Via Dolorosa" rewrites Jesus Christ's march to Calvary as thousands of Armenians making their way under the guidance of a Turk's whip. While this image reflects the mass deportation that had found its way into photographic reports, the title nevertheless reinscribes these scenes within the familiar terms of Christ's morally outrageous suffering

VIA DOLOROSA

—(KIRBY) *New York World*, Dec., 1922

Figure 6. "Via Dolorosa."
Image courtesy of The
Center for Holocaust
and Genocide Studies,
University of Minnesota.

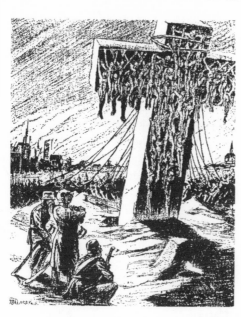

RAISING THEIR MONUMENT

—*The Chicago Herald*

Figure 7. "Raising their Monument." Image courtesy of The Center for Holocaust and Genocide Studies, University of Minnesota.

at the hands of an unjust Roman occupation. "Raising Their Monument" completes the Passion play with masses of Armenians crucified on a single, enormous cross. Although martyrdom imagery risks justifying the suffering depicted, it also conjures a distinctly Christian victim group, promoting recognition of shared humanity where Near Eastern affiliations and distance may have imposed a sense of detachment. Martyrdom, in its earliest form, acted as a form of testimony: a spectacle of a suffering body intended to communicate a truth to the viewer, and, if effective, transform the viewer. Drawn into the present tense, it functioned to create concerned publics out of the audience.

The notion of the suffering Christian as a present figure, subject to the actions of the witness, is present in an earlier cartoon, "Waiting the Signal?" (Figure 8). The drawing portrays the Armenian case within the gladiatorial arena. Here, as figure of Turkey stands above a prone Armenia,

Figure 8. "Waiting the
Signal?" Image courtesy
of The Center for
Holocaust and Genocide
Studies, University of
Minnesota.

WAITING THE SIGNAL?

—*Punch* (London), Oct. 17, 1896

arm outstretched to the crowds as both await the thumbs up or thumbs
down from the audience that determines the outcome. Like "Idle Tears,"
the cartoon highlights spectatorship and ties it to action. In each case, the
spectacle invokes an interpretive grid that facilitates the understanding
of the situation presented. While "Idle Tears" relies on the fantasy of Ori-
ental violence to make the case for intervention of an otherwise moved,
but inactive world, "Waiting the Signal?" presents the gladiatorial arena
invoking the world stage and potential for action as well as the martyr-
dom of Christians in the Coliseum. The trope of the persecuted Christian
and its strategic deployment has a long history that reaches into the pres-
ent.[76] Elizabeth Castelli argues that the memory of Christian torment and
persecution has informed many of the institutional and theological foun-
dations of the church and functions today as a mobilizing mechanism for
building transnational solidarity.[77] Even if this suffering had been marketed

as commodity, a source of horrific pleasure, the interest would benefit the film, which functioned as a fundraising strategy for NER. If audiences were hungry for suffering, they might buy entry into *Ravished Armenia*, and in turn donate needed funds.

The commercial appeal of these combined traditions—the prurience of Orientalism and the noble yet outrageous suffering of Christian martyrdom—was not lost on the producers. When the film was up for rerelease in May 1919, the *Moving Picture World* presented a full two-page spread depicting the mass crucifixion of young women in order to advertise the film under its British title, *Auction of Souls*, a title that underscores the slave-market and harem fantasies. The campaign for *Auction of Souls* stressed not only the Christianity of Aurora, but also the sexual violence of the Turks, framed by an existing Orientalist fantasy. The advertisement uses both images: the wide shot of the row of women, and the close-up of one in particular. If the images themselves did not carry significant anchoring potential, the text accompanying the ad ensured no mistake would be made: "These martyred Armenian women are paying for their Christianity with their lives. Their crucifixion is but the climax of previous sufferings declared by Aurora Mardiganian to be worse than death itself."[78] The excitement promised is tempered by the next section, which assures audiences of its moral value in the form of the National Board of Censors, the president emeritus of Harvard University, "distinguished churchmen of all Christian sects; Jewish rabbis, and leading citizens from all walks of life" who "endorse the picture for all the good it will do." The promise of excitement and moral excellence is followed by the most important information given in an exhibitor's magazine: it was a financially viable investment. "It has broken all theater records wherever shown," reads the advertisement. The complicated provenance of the film manifests in this advertisement, which combines titillation with martyrdom, excitement with enlightenment, and all of it with commercial success.[79]

Biblical imagery helped map out a Christian topography and shared origin for Western humanity, a civilization still predicated on "Christendom." Balakian observes, "In the European imagination Armenia would be continuously associated with the place and landscape of the Bible,"[80] and *Ravished Armenia* ensures this association from the outset. An opening title card informs the audience that Armenia is "the first nation to adopt Christianity. Within this land was located the Garden of Eden . . . and here, on the summit of Mt. Ararat, the ark of Noah landed when the

deluge subsided. Here beneath the cradle of infant humanity, where dwelt four million peaceable and industrious souls." Editorial cartoons reinforced this link. One cartoon, "The Human Race" (Figure 9), presents its story in two panels. In the first, Noah's ark arrives at Mt. Ararat, a moment in the Bible narrative that speaks to the salvation of the human race. The caption reads, "There was a time when the whole human race was interested in Armenia." In the second frame, frantic figures wave from atop Mt. Ararat, begging "save me!" at a passing ship containing Allied Powers (United States, France, Russia, and Britain). In the first panel, the boatload expresses relief and excitement at the sight of Ararat; in the second panel, each figure refuses aid to the Armenians with a simple "No thanks." The denial is not simply denial of a people in need, but a denial of a shared origin and memory of deliverance from destruction. The illustration draws upon the biblical memory of Armenia as the salvation of humanity and new home of civilization. It thus yokes humanity and Christianity and projects them onto a birthplace inhabited by Armenians, asserting their crucial place within the heritage of the Western Christian spectator. These claims produce an interpellatory mechanism for ethical responsibility while they map out a distinctly Christian world that transcends present-day national borders. James L. Barton underscored the potential of the Bible as a moral and conceptual base for activism, claiming that "the Sunday schools, because of their interest in Bible lands and their purpose to translate the ideals of life into action, were naturally interested in the suffering of the children in the Near East.'"[81] This biblical topography and affiliation function to assert the personhood of the victims, to work as a hailing mechanism, and even to offer the possibility of biblical affiliation as land claim—a legitimate reason to be involved in a land subject to foreign rule.

The press response indicates the possible efficacy of these affecting images—at least that they would be decoded as encoded. Hanford C. Judson's review of the later release offers: "One would think the scenes in *Auction of Souls* had been pictured in Armenia at the time of the persecution of this Christian people. They are given the chance to declare for Mohammed, but are true to Christ, and from this comes their martyrdom, burnings, starvation, outrage beyond relief and torture beyond the power of the mind to realize."[82] The *L.A. Evening Express* remarked on the modern rendition of old themes: "Now the producers have broken with tradition and in stage setting, costume, and action have reproduced not a conventional Arabian nights slave market and harem scene, but they

THERE WAS A TIME WHEN THE WHOLE
HUMAN RACE WAS INTERESTED IN
ARMENIA

BUT NOW THE HUMAN RACE IS INTERESTED
ELSEWHERE

—(MC CUTCHEON) *Chicago Tribune*, June, 1920

Figure 9. The image depicts boats sailing with Mount Ararat, Noah's landing site in view. The text at the top reads, "There was a time when the whole human race was interested in Armenia." At the bottom: "But now the human race is interested elsewhere." Image courtesy of The Center for Holocaust and Genocide Studies, University of Minnesota.

have taken as their models these places as they actually exist today."[83] In addition to ensuring the truth of the images and their meaning, reviews emphasized the function of the film as "a frank straightforward exposition of the sufferings of Armenia which makes a sincere and powerful appeal to every drop of red blood in America's manhood and womanhood."[84] Another review states that "the appalling sights and tragedies created not only a feeling of hatred and detestation for the abominable Turks, but an unquenchable determination to relieve the suffering and despair of innocent Armenian and Syrian women and children."[85] The British Foreign Office's attempt to manage and quell the potential for anti-Turkish sentiment aroused in the film further indicates the capacity to provoke response. The reviews guided interpretation and positioned the film as testimony: a truthful rendition of distant suffering that made claims upon the witnessing audience.

About Christian Identity

The emphasis on the religious dimension of the denunciation leads to the question: what if the Armenians were not Christian? It is quite likely that the absence of a Christian victim group could have minimized the European interest and certainly complicated the production of humanitarian appeal, so clearly intensified by a shared Christian identity. However, it is possible that the Christian affiliations may be more helpful than mandatory. The visual tradition of Christian suffering seems to have become so prevalent as to be secular, or at least, not dependent on a Christian actor at all (and indeed, deployed by Protestant Christians with a less iconographic tradition). Early biblical associations appealed to a Jewish public as much as a Christian one. Moreover, the model of Christian suffering is so familiar as to be commonplace, thus conjuring up an idea of a noble, righteous, and innocent victim of unjust rule, whether the Roman occupation or the "Unspeakable Turk." The martyrdom imagery helps to create a suitable villain, contrary to values of religious freedom, a component of American mythology and formative in a shared identity. In effect, Christian suffering may have continued to supply a framework for understanding and evaluating the violence, even outside of the identities of the actors.[86]

The fact of a Christian victim was indeed convenient, but it may have been the Christian identity of the observer that was more important. Even then, the actual Christian identity of the observer may have been as unnecessary as the actual Christian identity of the victim, or a more generalized Christianity as rubric for transnational affinity. Christianity, while invoking actual publics, also offered a mechanism of imaginary solidarity. When Ambassador Morgenthau arrived in Constantinople to meet with the American community (predominantly missionary-educators and representatives of the American Board of Foreign Missions) and the Young Turks, Talaat Pasha questioned his interest in the Armenian people, "You are a Jew; these people are Christians." Morgenthau responded, "You don't seem to realize that I am not here as a Jew, but as the American Ambassador. My country contains something more than 97,000,000 Christians and something less than 3,000,000 Jews. So in my ambassadorial capacity, I am 97 per cent Christian."[87] Christianity offered a mechanism for engaging in a national identity and a transnational alliance, bonds that function on both moral and political registers. As Morgenthau stated in this same conversation, "The United States will always resent the wholesale destruction of Christians in Turkey."[88]

Exhibition Context: The Prologue

Bolstered by the connotative force of the interpretive grids of extant visual practices, the message was crystallized in the exhibition context. In the decades before the film's release, the variety of media platforms from reportage and dispatches to speakers to photographs, illustrations, and placards mutually reinforced the truth of the information and provided strategies for reading and interpreting the data to produce a case for humanitarian intervention. The shared strategies across media—in this case, joint iconographies of Christian suffering and Orientalist threat—aided in the manufacture of a common humanity and attendant obligation. While some of the media convergence was an unintended phenomenon, there were cases of joint performances. In its initial run, before the film program, screenings of *Ravished Armenia* opened with a number of presentations, including musical programs, recitations, and guest speakers (including diplomats, missionaries, and survivors). Such a mixed-media presentation was hardly surprising at a time when films had just recently become features. Only a few years earlier, films—running in short affairs, one reel compared to the eight of *Ravished Armenia*—were screened in a context of live performance. However, in an age of the epic, this kind of performance was becoming less typical. And more notably, *Ravished Armenia* came with a live dramatic piece that served as a component of the filmic presentation—it was, in fact, listed as "Prologue."[89]

The prologue began shortly after the opening credits but before the main feature, combining live performance with cinematic experience. Stage directions point to the intended solemnity of the production, refusing the possibility of any disruption, "the audience should be settled immediately after the opening of the Musical Introduction. During the six minutes given over to the prologue no one should be admitted into the auditorium."[90] In the prologue, a conversation (penned in verse) between "the Spirit of America" and Armenia takes place against the backdrop of a Syrian desert, with "crumbling ruins silhouetted against the left background and an oasis in the right foreground." This mise-en-scène encapsulates the narrative of the film and the mission of the campaign: read from left to right and back coming forward, the stage manifests the journey from destruction to salvation. And indeed, it is in the left, where Armenia begins, lying prone and vulnerable, while America stands "barely visible" in the right foreground, "listening to the howl of desert winds."[91]

At first, America struggles to recognize the wailing "Hello" from Armenia as human; America wonders if it comes from "some wretched creature of the wild?" Armenia assures America of its humanity, and upon approach is revealed as a woman, one who speaks for the millions of women slain "since first the Moslem crescent left its crimson stain on the cross."[92] The first exchange expresses the goals of the film and its use in the campaign: to render human this distant, unseen, yet howling Armenia and to personify her as well—one woman who will speak for all. The dialogue and casting also introduce the tropes of Christian persecution and Eastern threat, a theme that carries through the script. Armenia describes, "The bone of my bone, hacked and slain / And mutilated on the cross / By men of Moslem, Hating God. / The flesh of my flesh—crucified—Armenia ravished by the fiend."[93] The litany of sexual and gruesome violence continues, uniting the ravished women, the martyred Christ, and all the other "martyred" Armenians that elicit the common Oriental enemy to humanity and emphasize the Christian frame for interpreting the violence. The exchange explicitly signals a Christian alliance when Armenia concludes the recitation of suffering with "O Pax vobicum" ("Peace be with you") and America answers in the custom of church ritual, "Et cum spiritu tuo." Bells ring in the background, sounding in punctuation for each statement and suggesting the call to services. With these wishes of peace, the audience is summoned to church and to Christian community.

The Spirit of America's antiphonal response hints at the need to listen to the testimony given and to respond. Armenia explains that she has come on a "holy errand" to tell this story that cannot be captured in speech or in drawing—the thousands that fall each day challenge these limits. "No tongue could clothe in human speech / Or picture with the pen" this tale "of monstrous sin," Armenia declares. The speech recasts the film to come as holy errand, and as either a means of capturing what defies communication; despite the horrors it contains, the film can only scratch at the surface of truth. America, in response to Armenia, demonstrates the appropriate response of the witnessing public, the recipient of this testimony, stating, "Thy hist'ry wakens within mine / A strain of mingled love and woe" and asks what action to take. "Wouldst thou my hand to smite the fiend / And free thee of thy crimson yoke," brings a suggestion of military intervention. Armenia, however, demurs and emphasizes what NER can offer: humanitarian aid. In the final explanation, Armenia pleads with America to "pay heed, in sooth, to yonder scroll / That paints in moving imagery / Armenia's tears and bleeding soul." In this archaic King James–style

language, evocative of biblical text, Armenia implores the viewing of this film; and after one "pays heed" to "give to eager waiting hands." With this hyper-explicit instruction, the expectations for the film's testimony and this witnessing public are set.

Other performances further directed interpretation. At the New York premier of the film, guests heard a poem by Irma Prichard Hopper.[94] The recitation provided a catalogue of horrors as it excited expectations of the film to come, with promises of "licentious deeds," "decadent vice," "illicit passions," "bestial horrors," "souls of women foully slain / Debauched and Tortured, Crucified," and babies "murdered and mangled / Slaughtered, Butchered, Desecrated"—all this brought on by "strange beliefs." With these and other claims, Christian persecution and Orientalist perils come together in titillating atrocity. But this was not pure entertainment to be passively appreciated; it was a request for aid. Action was expected here, as it was also expected in the prologue, and would be expected in response to *Ravished Armenia*. The poem concludes, "Armenia begs restoration—Deny her not, Great Christian Nation."[95]

Grassroots Advertising

Aid came not only in form of donations and relief, but also in the grassroots advertising of NER branches throughout the United States. Certainly *Ravished Armenia* traveled through commercial channels. Selig held exclusive worldwide distribution rights, and professional distributors advertised the film in trade journals. However, members of the relief organization took up responsibilities for publicity by setting up screenings and conducting their own ground-level advertising campaigns. An article in the *Motion Picture Herald* announces "remarkable public support" given to *Auction of Souls*. C. P. Sites of the North Texas branch of NER allegedly sent thousand of letters to "influential persons in [the] district urging them to see the picture."[96] Sites, "through the courtesy of the management of the Old Mill Theatre," had seen a "special preliminary showing" and sent a letter giving the film "his most hearty endorsement." The cinema granted NER an additional screening, and the committee was inviting "society people" to attend and contribute to this cause at ten dollars per seat. Although it is not clear if the venue was secured through donation or hire, it is clear that the committee was actively participating in a direct advertising campaign in order to build an audience and raise funds. The letter, like the advertisements in the past, gives assurances of both

truth and titillation. Sites swears that he "heard a number of speakers of national reputation . . . and for the past two years [had] read every informing book or magazine article bearing upon the Armenian atrocities as practiced by murderous, lecherous Turks" and that "scenes as depicted in this picture are not at all overdone."[97] Apparently, this North Texas effort was not singular; the conclusion reads, "This direct propaganda of local committees all over the country bids fair to give the film one of the most remarkable voluntary advertisements in the history of motion pictures."

Film after *Ravished Armenia*

The success of *Ravished Armenia* within the context of this fundraising drive inspired more film work for the NER campaign. The film activism was further aided by lifts in censorship bans and an increased media presence in the area. The missionary and relief presence in the Near East played a crucial function, not only for the administration of aid but also in their role as gatekeepers to desirable material. James Barton describes mutual arrangements struck by the committee and newsreel producers: the aid workers granted access to filming locations, and in return, the news media provided footage and films for fundraising. According to Barton, "the Committee, because of its contacts with the people and the officials, was able to give these photographers access to unusual material and the companies in turn graciously permitted their operators to take special pictures of the relief conditions and the children for exclusive use of the Committee."[98]

In this interwar period, the news media wishing access to abject images provided services for the committee. The entrenched Christian missions produced a network through which images were taken, exchanged, and circulated; they brokered photo opportunities, which would continue to witness on their behalf. In exchange for access, newsreel photographers helped to produce short films for the NER campaign. Short and silent, and often screened as "fillers" in between features at the cinema, the films depicted the organization's work, highlighting the misery they sought to alleviate. Bearing the imprint of NER, the films showed orphanages and refugee camps and provided information about local campaigns, letting audiences know where they might donate their money or labor.[99] While many of the films are no longer available, the titles are provocative, often highlighting stories of starvation, such as *Alice in Hungerland* (1921), and

suffering children, such as *One of These Little Ones* (no date available) or *Investment in Futures* (no date available). Titles like *What the Flag Saw* emphasize visibility and the role of witnessing, much like the political cartoons addressed above. *Seeing Is Believing* avers the truth of the images as well as their transformative potential and shares a title with Katerina Cizek and Peter Wintonick's 2002 film about handicams and human rights activists (including the organization WITNESS discussed in chapter 5). Visibility produces another register of the testimonial encounter that hails the viewer into obligation; *Stand by Them a Little Longer,* pleads the title of another picture, one that likely depicted the orphans who relied on the continued aid of NER and its donor public.[100]

Although the titles hint at the inevitably transformative and interpellatory properties of the filmic content, the practices designed around the films suggest otherwise. A crucial part of the film-based campaigns appears to have been plans that incorporated context and provided direct action routes in tandem with the film presentations. These films were shown widely in schools, churches, and public gatherings. Yet, while churches continued to supply an excellent action site and an audience ready to be called into service, NER explored the commercial venues of the movie house as well as celebrity-based publicity. In 1924, the committee enlisted child actor Jackie Coogan in a national milk campaign. Cinemas screening Coogan's films required a can of condensed or evaporated milk in addition to a ticket as the price of admission. "The milk was collected, packed and shipped to New York. Coogan himself accompanied the shipload of contributed milk to Greece."[101] Many of these trips were documented on film, in such movies as *Jackie Coogan in Athens,* which would show him interacting with children in relief sites and orphanages. These films put on display the success of the relief program in movie theaters across the nation. He served as proxy for the audience: a witness on screen who expressed interest in the world overseas and took part in a program of relief. At the same time, his appeal as celebrity offered a focal point of public interest and a means of generating interest. Already a vehicle for selling pictures, he became a vehicle for selling the NER campaign.

Nontheatrical venues screened the NER films within an array of other events intended to stimulate interest. For example, NER launched Golden Rule Sunday, which was often advertised with posters of sketches of children in bedraggled clothing, hands outstretched to the viewer.[102] On these days, American families were asked to think of the life of the child in the Near East, and to perform the conditions for themselves. At home or in

church, families would eat a "simple orphanage meal" and donate the cost of an average dinner to the program. These seemingly simple occasions soon became huge affairs that transpired on a wide scale. "Local committees organized special campaigns, interesting the local community by arranging Golden Rule luncheons and dinners at which the simple orphanage menu was served. Hotels co-operated by gratuitously offering their banquet rooms. The local merchants contributed food supplies . . . Often more than a thousand people would attend these simple meals at which moving pictures were shown and the work of the Near East Relief was presented by speakers from overseas."[103]

The sight of distant suffering was an effective supplement to an already extant campaign, but it rarely, if ever, functioned on its own to animate sympathetic sentiment and occasion change. Rather, the display was embedded in a matrix of familiar tropes and multimedia performance platforms that constructed a coherent narrative of suffering that engaged and energized audiences. The exhibition contexts of these performances harnessed and cultivated the emotional sensation—even drawing on a bodily performance of affinity as in these Golden Rule luncheons. And all took place within a system of activism already in place, whether the humanitarian relief of NER or its form of Protestant diplomacy that continued to advocate on behalf of the Armenians.

Transitions

In the years that followed, NER continued to administer aid and engage in fundraising campaigns while the international community attempted to find political and legal means of restoring the peace. Although the committee avoided overt political positioning within its relief campaign, it nonetheless supported the Wilsonian Armenian Mandate, which aimed to stem the refugee crisis by repatriating Armenians and securing a homeland. At the same time, the League of Nations entertained the notion of international tribunals to prosecute Turkish authorities for profound aggressions levied against the Armenians.[104] A need for diplomatic relationships with Turkey impeded these plans. A Turco-American treaty of amity and commerce ensuring safe passage for U.S. ships curtailed further political plans, and continuing geopolitical instability encouraged an alliance with Turkey. Even James Barton, the one-time champion of Armenia and the Armenians, took the pro-Turkish stance, viewing it as a means to keep Turkey affiliated with the West instead of the Communist

East. International legal and political response to mass murder would wait until next time.[105]

Nevertheless, one cannot disregard the work of NER in mounting a massive humanitarian campaign that helped to create witnessing publics to the Armenian crises. The cases of *Ravished Armenia* and the later film advocacy of NER illustrate the intersection of media, humanitarian advocacy, and Christianity. This triangulation reveals the Christian underpinnings of the human rights project; particularly the ways in which this network constituted a model of shared humanity that invoked a cause for ethical and political response. These forms of cooperation also demonstrate the convergences upon which this campaign relied: cooperation between global systems of commercial media and Protestant missionary activity and storytelling practices built on multiple performance platforms. Some testimonies, like Mardiganian's, were repeated across multiple media— newspapers, book, and film—and others were built on a sturdy scaffold of historical reportage, dispatches, testimonial performances, and illustrations. The vast amount of information and the practices of dissemination provided a solid ground for individual testimonies to be representative, not to mention legitimate and meaningful. Aesthetic tropes, both moderately secular (Orientalist, sexual) and explicitly Christian, proved effective means of conferring legibility and moral heft on events both distant and vast and animating the sentiments of a witnessing public. At the same time the contexts of the screenings proved crucial to converting moral outrage and compassion into response; without the infrastructure for applying pressure to state officials, or providing relief to those in need, the sympathy evoked may have flared and dissipated. The work of NER yields considerable insight into the strategies and processes necessary in using media to produce witnessing publics who can understand and act upon the information presented.

2 WITNESS FOR THE PROSECUTION

Films at Nuremberg

THE PREVIOUS CHAPTER mapped out the convergence of developing visual media technologies—namely, cinema and its contexts of operation, and graphic weekly magazines—with nascent transnational humanitarian and human rights concerns. The interests took the form of Near East Relief and their campaigns and of the articulations of a budding international political community that identified and decried the events in Armenia as crimes against "humanity," "civilization," and "Christendom." The novel acts of witnessing suffering at a distance and the actions that followed did not happen in a vacuum. Rather, the circuits through which these images traveled shaped the testimonial performances and the advocacy that took place. In the case of *Ravished Armenia*, Orientalism, a popular motif in commercial media, excited viewers while an iconography drawn from the tradition of Christian martyrdom called upon the moral obligations of a predominantly—although not exclusively—Christian audience to act on behalf of the persecuted and starving Armenians. As the aesthetic components aroused sentiment, the conditions of exhibition channeled these feelings into action—most frequently, donations to sustain the relief organizations abroad.

This chapter turns to the role of cinematic technologies in the performance of international justice and, more specifically, the role of three films in the first set of International Military Tribunals (IMTs) in Europe, also known as the Nuremberg Trials.[1] These documentary films contributed to the creation of a visual understanding of "crimes against humanity," an unprecedented indictment and antecedent for the UN Convention on Genocide and the Universal Declaration of Human Rights. In the context of the first major trial, these films helped to establish the horrific events not simply as misfortune, but as a distinct crime, and thus legally and

politically actionable. While chapter 1 addressed the role of film in producing witnesses, this one looks at the role of film *as* witness. The examination of the process reveals the work involved in the space between exposure and justice, or more precisely, the work making images actionable. Indeed, the charge was not simply unprecedented, but as yet unformed and most certainly controversial, as was the newly formed international tribunal where it was tried. Presenting unbelievable atrocities, these documentaries not only inspired a range of emotions, including horror, disgust, and outrage, but they also helped to articulate the new crime, if not for the legal audience, certainly for the popular one. As Lawrence Douglas argues, these trials offered performances of a new form of rational order, thus serving goals beyond the limits of the courtroom.[2] Unlike the media of Near East Relief, which relied on transnational moral obligation, shaped and hailed through Christian devices such as the "Golden Rule" and biblical imagery, the IMT relied on notions of an international rule of law and "humanity," and the films would have to shore up the understanding of these concepts. The ontological status of the photographic image would seem to confer immediate legitimacy, suggesting rational, if not scientific, management of appalling past events. However, these images, like those deployed in the Armenian crisis, developed on a discursive terrain. This time, however, legal and political factors combined with a film language associated with Classical Hollywood, reflecting both the period's style and the films' producers, who included a range of Hollywood talent working for the Office of Strategic Services.

Clearly, no report, testimony, or evidentiary proffer can claim exclusive rights to the work of the courtroom; a concatenation of factors produced this new international law and legitimized this international political-juridical regime. Nevertheless, the use of films in the courtroom requires us to consider what they bring to the proceedings, and by extension, to the world for which they were performed. To paraphrase Paula Rabinowitz, criminal prosecution is dependent upon documents, so where does documentary fit?[3] Concerns about the use of films and photographs as legal evidence abound, making the court of law an intriguing place to unpack issues of visible evidence. Photographs and films without the filmmakers, or without affidavits from the image takers, are little more than hearsay, for instance. The photograph requires a framework of supplementary materials in order to become evidence, to legitimize the truth-claims of the image and assure meaning and usage. Films introduce something a bit more complicated, smuggling in tactics of truth-telling in tandem with

strategies that guide interpretation. These factors, in combination with the narrative elements of the film, introduce a new way of understanding the work of these documentaries: as both witness and testimony. The camera eye had seen and recorded a variety of images. The ensuing films offered an assemblage of this footage, crafted into a narrative of suffering and injustice, and then presented in the courtroom in order to define a crime, to prove it, and to punish the offenders. In other words, these documentaries bore witness to the truth of an occurrence for the purposes of engaging the responsibility of the listener and transforming the world. Even if not within a strict legal sense—they were not subject to cross-examination, for instance—these films provided testimony.

To better understand the testimonial work of these films, this chapter conducts formal analyses within consideration of the context of their usage. A study of transcripts and media coverage of the trials sheds light on the expectations that accompanied the work of film as witness. The expectations become clear in the uses of footage at the time of the trial as well as in the particular interest journalists and bystanders took in the response of people, especially the accused, to the footage. Furthering this line of exploration—the cultivation of expectations around media witnessing—the chapter includes consideration of the future of these films, namely *Nazi Concentration Camps*. Repurposed in feature narrative films for years to come, the shifting usages call attention to assumptions about how media witnessing functions and how these assumptions are contingent on shifting rhetorical and cinematic strategies. Notably, the crystallization of Holocaust images into shorthand is accompanied by heightened expectation of witnessing and the immediacy of recognition and response—a conviction that reifies the model of exposure, revelation, and justice. Yet as this chapter demonstrates in the formal and functional analyses, this process was hardly so automatic, even in the face of appalling catastrophe. Rather, multiple strategies contributed to rendering the atrocities legible and to legitimizing the system of managing the crimes, not only morally, but also legally and politically.

Image as Witness

As in the case of the Armenian crisis, developments in technology enabled media reportage to play a significant role in popular witnessing. Immediately following the liberation of the camps, reports and photographs flooded British and American newspapers and magazines while

newsreels projected atrocities in the cinema. Although the capacity to view faraway horror was not new, the scope of the inundation was. The photowire, a transatlantic cable, greatly enhanced the speed and reach of photographic circulation.

Contributing to this deluge was General Dwight D. Eisenhower's command for the mass witnessing of the sights that he declared "beggar description." Walking through a camp, shaken and appalled by what he saw, Eisenhower gave himself the task to visit each camp, "because I felt it my duty to be in a position from then on to testify at first hand about these things in case there ever grew up at home the belief or assumption that 'the stories of Nazi brutality were just propaganda.'"[4] He determined that this burden of witnessing was not to be his alone, so he ordered congressional delegates, soldiers, and newspaper editors to join him in this program. Seeking to further extend the reach of witnessing, Eisenhower ordered "photographers and reporters stationed within a one-hundred mile radius . . . to change their destination so as to provide coverage."[5] Photojournalists, camera operators for commercial newsreel companies, and members of the U.S. Army Signal Corps served as the principal means through which the American public became acquainted with what would come to be known as the Holocaust. Barbie Zelizer notes the function of these camera operators as "professional witnesses," stand-ins for the viewers at home, while Jeffrey Shandler observes, "Liberation footage came to be seen as extending this uniquely privileged moment of witnessing and testifying 'at first hand.'"[6]

Photographic media played a crucial function in the extension of witnessing. Many others, including professional wordsmiths, shared Eisenhower's loss for words. Edward R. Murrow's report from Buchenwald is riddled with the failure of language to capture the full sensory experience of the camp. "The stink was beyond description." Upon viewing two inmates crawling toward the latrine, he states, "I saw it, but will not describe it." His report concludes with an entreaty for the listener, "I pray you to believe what I have said about Buchenwald. I reported what I saw and heard, but only part of it. For most of it, I have no words," and a suggestion that this aural witnessing was necessary, "If I have offended you by this rather mild account of Buchenwald, I'm not in the least sorry."[7] Such oral accounts, even if mild when compared to the startling and graphic images, were necessary in helping to make sense of the sights, which, even in actuality, "beggared description." These horrific images demanded explanation, requiring broader systems of signification, specific and symbolic.

Although characterized by errors and absence of reference information, including names and places, mass witnessing played a significant role in producing the popular memory of the Holocaust.[8] Coming through the wire and projected on screen at movie houses, the depictions focused on bodies and objects. The skeletal, scarred survivors peered from behind barbed wire, and the stacks of corpses gestured toward the scope of violence and inhuman treatment. Meanwhile the relics of barracks, boxcars, ovens, and showers sought to illustrate the modes of violence. The relentless onslaught of these images and their ongoing repetition in these early days of liberation contributed to the iconography of the Holocaust (and later genocide), soon becoming "an indelible reference point of the Western imagination."[9] Over time, the images would filter down into select images that would come to function as visual cues, enabling ready recognition without struggle for meaning.

Expectations around witnessing began to be cultivated at this time. Eisenhower demanded these tours to ensure the truth of the events, to prevent accusations of exaggeration, and to form public opinion. Others enlisted film in the aid of social and moral pedagogy. The use of atrocity footage to pedagogical purpose is perhaps best reflected in the failed Project F3080. In April 1945, Sidney Bernstein sought the aid of British Movietone News in the procurement of camp footage, and in particular, footage with Germans viewing the remains. He then proposed an Anglo-American coproduction: three separate motion pictures of German atrocity footage intended for three separate audiences: German citizens, German prisoners of war, and an undefined audience, "perhaps specialized, in neutral, liberated and Allied territories."[10] The purposes for these viewing were multiple, and often audience specific: to serve as proof; to dissipate lingering Nazi affiliation and possible insurgency in Allied occupied territory; and to remind Germans of their complicity, thereby "promot[ing] acceptance of the justice of Allied occupation measures."[11] Alfred Hitchcock was called in to direct the project, which was eventually shelved for a variety of possible reasons. For one, other Allied films were being produced, including the American film *Die Todesmühlen* (*The Death Mills*), directed by Billy Wilder and exhibited in the American zone. Perhaps more important, a project designed to "shake and humiliate" Germans was viewed as less than congenial and thus not conducive to building cold war alliances with the conquered population.[12]

Legal uses of the footage united the documentary record with the pedagogical aims. The Russians filmed the liberation of Auschwitz and the

aftermath of the horrors for submission to the Nuremberg Tribunals.[13] At the same time, the chief of the Office of Strategic Services (OSS), William Donovan, advised producing a photographic record of Nazi war crimes for future legal proceedings. He instituted a documentary film unit under the command of Navy captain and noted Hollywood filmmaker John Ford, with other Hollywood craftsmen and military personnel carrying out many of the duties. Many of these now-famous men filmed the liberation and compiled documentaries for the military. Among those who would prepare the documentaries for the Nuremberg courtroom were screenwriter and Navy lieutenant junior grade Budd Schulberg, best known then for the novel *What Makes Sammy Run?* and today for such films as *On The Waterfront* (Elia Kazan, 1954) and *A Face in the Crowd* (Elia Kazan, 1957); 20th Century Fox effects man and Navy lieutenant E. R. "Ray" Kellogg; and U.S. Army Signal Corps lieutenant colonel George C. Stevens, a director known today for *Shane* (1953), *The Diary of Anne Frank* (1959), and *The Greatest Story Ever Told* (1965).[14]

The documentary film unit provided three very different documentaries for the trials. Two were *Nazi Concentration Camps* (dir. George Stevens), a documentary film of the liberation footage, and *The Nazi Plan,* a four-hour assemblage of Nazi propaganda and newsreel footage edited into a narrative of the rise and fall of the Third Reich (dir. Ray Kellogg, ed. Budd Schulberg). The third film differs from the others as it was neither shot nor edited by professionals and merits note, if only as counterpoint. *Original German Eight Millimeter Film of Atrocities against Jews,* a ninety-second fragment of found footage, depicted the real-time liquidation of a ghetto. Its treatment in the courtroom calls attention to the film witness's need for context. Bringing together photographic evidence and a variety of rhetorical devices, the films aided in the articulation of a legal framework that sought to define crimes that exceeded law, language, and morality; they articulated crimes against humanity in both legal and popular spheres.

Nuremberg Trials and Crimes against Humanity

The Nuremberg Trials refer to a set of military tribunals that took place after World War II from 1945 to 1949. The trials prosecuted a range of Nazi officials held accountable for their actions under the Third Reich. The first and best known of these trials was the Trial of the Major War Criminals held before an International Military Tribunal (IMT), which tried

twenty-four of the highest ranking Nazi officials, including Albert Speer, Hitler's friend and architect; Hermann Göring, commander of the Luftwaffe; Rudolf Hess, Hitler's deputy of the Nazi Party; Joachim Von Ribbentrop, Nazi minister of foreign affairs; Julius Streicher, publisher of *Der Stürmer*, the Nazi propaganda outlet and anti-Semitic paper. The United States oversaw the other trials, known as the Nuremberg Trials with the trial of Nazi jurists likely being best known, courtesy of its dramatization by Abby Mann for both the *Playhouse 90* teleplay and the theatrical film *Judgment at Nuremberg* (Stanley Kramer, 1961). There were eleven sets of trials in all.

The IMT was chaired by the Allied powers. The chief prosecutors were Robert H. Jackson for the United States; Sir Hartley Shawcross and Major Sir David Maxwell-Fyfe for Britain; Lieutenant-General R. A. Rudenko for the Soviet Union; and François de Menthon and Auguste Champetier de Ribes for France. This trial and the ones that followed took place in the Nuremberg Palace of Justice, a location selected for reasons both practical—it was one of the few buildings still standing in Germany—and symbolic—it was host to the notorious Nuremberg rallies over a decade prior and depicted in Leni Riefenstahl's 1934 film *Triumph of the Will*.

Initially almost all Allied parties considered executing Nazi officials without trial. Britain's Lord Chancellor John Simon introduced the possibility, seconded by an impassioned Stalin, who recommended the summary execution of fifty thousand general staff officers. Speaking for the United States, President Franklin D. Roosevelt and erstwhile ambassador to Turkey Henry Morgenthau (then secretary of the treasury), agreed, albeit to a significantly smaller number. The legal process provided multiple challenges, including the burden of evidence (some of which would prove embarrassing, as nonaggression pacts were bound to surface); the difficulty of finding witnesses, who, as the Yalta Memo observed, were "dead, otherwise incapacitated and scattered"; the accusation of victor's justice and ex post facto proceedings (the prosecution of acts made criminal after their occurrence); and, on a philosophical level, the limits of law. Hannah Arendt declared these acts to be so monstrous that any punishment would prove inadequate, and claimed that what transpired was beyond the capacity for legal representation. "We are simply not equipped to deal, on a human, political level with a guilt that is beyond crime."[15] Nevertheless, this is precisely what the Nuremberg Trials attempted to do: to deal on a human political level with this guilt, and, as Douglas argues, to function as "orchestrations designed to show the world the facts of astonishing crimes and to

demonstrate the power of law to reintroduce order into a space evacu-ated of legal and moral sense."[16] The proceedings would imbue the gov-erning system with legitimacy. One key strategy for rationalizing these unbelievable events was to criminalize them within a set of legal accusa-tions. More than merely a justice-making device, these trials contributed to the production of a historical record. Thanks to information amassed in the period of legal discovery, Raul Hillberg could write much of his comprehensive first histories of the Holocaust.

The IMT and the criticisms that plagued it were not without precedent. Soon after the First World War, the League of Nations, the precursor to the United Nations, sought to prosecute offenders for the atrocities perpe-trated against civilian populations. Two offenders in particular excited these efforts. Kaiser Wilhelm II's "Rape of Belgium," the invasion and fifty-month occupation of a nation during peacetime, had resulted in mass murders and deportations, and also resulted in abundant reports of infanticide, rape, and well poisonings. The other party, the Young Turks, captured the bulk of the attention for their highly publicized campaign against the Arme-nian population. Indeed, they had already been accused of "crimes against humanity," in the joint declaration of France, Britain, and Russia in 1915. The trials, however, failed to materialize. Certain nations, Japan and the United States in particular, were reluctant to participate, fearful that en-dorsement of these proceedings would leave their own governments vul-nerable to future prosecution. The efficacy of the process itself was also questioned: Would it not be better suited for the nation that had custody of the criminals to administer justice? Substantiating the stories of the Rape of Belgium proved near impossible. Cases of enhancement and clear embellishment incurred a failure of evidence. The changing geopolitical landscape also had its influence: rapidly shifting alliances in the face of a potential world war, and, in the case of Turkey, both a nascent cold war and oil concern contributed to the dropping of charges.

Possibly as troublesome for these post–World War I proceedings was the imprecision of the code of conduct upheld for use in the tribunals. The Commission on the Responsibility of the Authors of the War and on Enforcement of Penalties (taking place at the Preliminary Peace Confer-ence in 1919), defined this code as "the principles of the law of nations as they result from the usages established among civilized peoples, from the laws of humanity and from the dictates of public conscience."[17] This con-cept struck many as nebulous. The religious terminology that had been invoked in the prior cases, that which called upon Christendom to act,

was not summoned in this venue, where humanity offered the guiding principle. And this principle brought challenges. As legal scholar Timothy McCormack observes, "The laws and principles of humanity are not certain, varying with time, place, and circumstance, and accordingly, it may be, to the conscience of the individual judge. There is no fixed and universal standard of humanity."[18] Nations worried over the universal jurisdiction that would be granted to this indistinct legality and vague morality. Aborting the first set of trials would only postpone the demand to clarify these terms.

Crimes against Humanity: A Limit Case of Legal Representation

At the London Conference in 1945, the Allied delegates composed the constitution that governed the IMT: the Nuremberg Charter. The agreement charged the Nazi defendants with war crimes, crimes against peace, crimes against humanity, and conspiracy to commit all three aforementioned crimes. The first charge, war crimes, referred to the violations of laws and customs of war and was least problematic for its precedent within the Hague Conventions of 1899 and 1907, where protections of civilians against forms of violence had been established. Crimes against peace, or plans to wage wars of aggression, had an antecedent in the Kellogg-Briand Pact of 1928, which condemned war as an answer to hostilities between sovereign territories.

Unlike war crimes and crimes against peace, two charges that drew on precedent and political rationale, the charge of crimes against humanity posed a significant challenge. Defined as "Murder, Extermination, Enslavement, deportation and other inhuman acts committed against any civilian population, before or during war, or persecutions on political racial or religious grounds . . . whether or not in violation of the domestic law of the country where perpetrated,"[19] the charge risked reincurring the angst of participating states. This indictment, much like the context of the international tribunal itself, eroded the legitimacy of national sovereignty, submitting it not only to the newly minted Allied political-juridical framework, but to a universal jurisdiction of "humanity" that had already struck so many as hopelessly vague.

Robert Jackson was aware of these debates as he entered the London Conference. In preliminary definitions of charges and the numerous revisions that followed, "crimes against humanity" was nowhere to be found, until July 31, 1945, in a submission from the American delegation.

Immediately before this entry, Jackson had consulted with legal scholar and jurist Hersch Lauterpacht, who later became a judge in the International Court of Justice at the Hague (1955–60) and would distinguish himself by advancing the individual as a subject of international law, a notion formalized in the European Convention on Human Rights as well as in the Universal Declaration of Human Rights. Sadly, there is no record of their exchange. According to David Luban, "they decided to leave their deliberations unrecorded, apparently to avoid courting controversy."[20]

The absence of open debate likely contributed to the ambiguity that lurks in the terminology, particularly within "humanity," which struggles under the burden of over-signification. Does humanity refer to an innate quality of the human (those qualities that separate us from the animals) or to the human being who is violated?[21] The choice of the phrase "inhuman acts" points to the definition of conduct, but the later explications in the Nuremberg Council Law maintain the oscillation. One statement reads, "Humanity is the sovereignty which has been offended,"[22] while a later one justifies the trials for demonstrating "how humanity can be defended in court." This term, invoking both a sovereign and a subject for defense, returns the ambivalence, and leaves its care to the proceedings of the courtroom.[23] The assumption is that the meaning will be developed and refined in usage—and one such space of practical usage would be the films.

The uncertainty embedded in the terminology, combined with the lack of precedent for both indictment and proceedings, makes the charge of crimes against humanity almost as much a challenge to legal representation as the Holocaust posed to artistic and literary representation. Douglas observes a constant struggle in the use of this legal idiom within the courtroom. He argues that rather than clarify this concept, the U.S. prosecution collapsed crimes against humanity into crimes of war; the focus, he notes, remained on the attacks of foreign nationals rather than on a directed campaign against domestic citizenry. But what may prove impossibly entangled, opaque, or unresolved at the doctrinal level could be mitigated by the contribution of film. Clearly, numerous documents, reports, and even some eyewitness testimonies (although not many, as they were deemed too unreliable) were put to use in the ministrations of justice and the setting of legal precedent, but film could bring in the curious mix of evidence and argument amenable to managing the multiple goals of the trials. The photographic images could accommodate the legal demands of evidence while the rhetoric could promote this new form of Allied justice; and finally, the multitrack capacity of film and its dialogism was well

suited to the articulation of issues that elude fixed meaning in the legal idiom.

Shoshana Felman advances two poles in the "vocabularies of remembrance": law and art. The former, composed of "trials and trial reports," is designed to "[bring] conscious closure to the trauma of the War, to separate ourselves from the atrocities and to restrict, to demarcate, and draw a boundary around a suffering that seemed both unending and unbearable." The latter seeks "to mourn the losses and to face up to what in traumatic memory is not closed." Law totalizes while art allows for apprehension. The Holocaust becomes accessible, she argues, "in this space of slippage between law and art."[24] The invention of poles inevitably invites question and their deconstruction, especially as the place of slippage is the one that grabs attention. In the case of this study, both poles—and their slippage—come together in the use of film in the Nuremberg Trials. The law rationalizes and manages the crime with legal terminology, while film illustrates and animates the concepts that elude the language. The apparatus, as a tool of scientific inscription, lent itself to the rationalizing functions of the trial—to manage the unruly events under the rule of law—while the cinematic aspects of the films contributed to powerful and eloquent testimony that aided in the production of the case.

Film as Witness, Film as Testimony

The prosecution from the four allied nations submitted twelve films as evidence. At the time, the use of film as proof of criminal wrongdoing was unprecedented; however, the Nuremberg Charter, which set forth the rules of the trials, favored expeditiousness and relaxed the rules of evidence in order to allow any item with sufficient probative value. This lenience, combined with the illustrative potential of the film (bolstered by its claims to truth) facilitated the submission of these filmic proffers into evidence. At the same time, the treatment of the films indicates an ambivalence regarding their evidentiary function. In February 1946, the Soviet prosecutor, Colonel Smirnov, submitted numerous reports testifying to atrocities that could hardly be readily imagined: the mass slaughter of children and families, extermination through gas vans, the industrialization of murder that included the trade in remains (selling of hair, use of bones as compost for gardens) and the attempted concealment of these hideous crimes. Photographs and a film, *Kinodokumenty o Zverstakh Nemetsko-Fashiskh Zakhvatchikov* (*Cinema Documents of the Atrocities of the German Fascist*

Invaders; screened on February 19, 1946), corroborated the reports, which, taken upon the departure of Germans, could only provide effects footage, the remnants of horror. Indeed, as has come to be recognized, footage from the Katyn massacres was no proof at all of German war atrocity, but documentation of a Soviet crime.

The film itself functioned to bolster and illustrate the reports; indeed, throughout the presentation, Smirnov cut short the reading of reports (still submitted into evidence) with mention of the film to come. The film concluded the presentation of evidence, which suggests its emotional power in the tribunal's narrative, but it nonetheless relied on the reports to be made comprehensible. "The text of the documents will serve as an explanation to the movie films which will be shown today," promised Col. Smirnov.[25] In the event that the documents could not be recalled at the time of the screening, a voice-over named subjects, dates, and places, deploying a verbal register to secure the evidentiary function. As Zelizer observes, citing William Saroyan, "'one picture is worth a thousand words, but only if you look at the picture and say or think the thousand words'; the image 'invites the written information which alone can specify its relation to localities, time, individual identity, and the other categories of human understanding.'"[26] Meanwhile, film contributed the illustration of magnitude, visualizing the scope of the atrocity while simultaneously personalizing the tragedy. Victims were named as families wept over the bodies and mothers stroked the hair of their children. The now familiar stacks of shoes, luggage, glasses, and clothing emphasized the numbers, while the move from wide shot to close-up provided detail, reintroducing the mundane into the unbelievable.

The added potency of film—the value beyond evidence—was reflected in the U.S. prosecutorial prefaces. Colonel Storey's introduction of *The Nazi Plan* begins matter-of-factly enough: "The United States next offers in evidence some captured moving pictures." Commander James Donovan follows, describing the film as "photographic evidence of the history of National Socialism." He explains, "German proficiency in photography . . . [has left] a complete chronicle of the rise and fall of National Socialism as documented in the films made by the Nazis themselves."[27] In this last case, the truth status of the film is enhanced by its provenance; this is how the Nazis opted to represent themselves. The original German remains throughout, providing sonic confirmation of its authenticity. Joel Sayre, a Nuremberg correspondent, viewed the submission as "all the more dependable because the Nazis made the pictures themselves."[28] At the same

time, these films carried extralegal and extra-evidentiary value. Commander Donovan notes that *The Nazi Plan* "enable[s] us to re-live those years in which the Nazis fought for and obtained the power to rule all life in Germany." This film, he continues, "is in simple and dramatic form the story of how a nation forsook its liberty."[29] The film offered more than authentication; it provided a compelling spectacle to ground the prosecution's case and win over the gallery.

The description that highlights both evidence and drama recalls the central tensions of the documentary film. The mode offers "discourse of sobriety," producing knowledge about the historical world,[30] encouraging a respectable "epistemephilia" (a love of knowledge) in the face of cinema's otherwise perverse "scopophilia" (voyeurism). Yet, documentary is not immune to what Elizabeth Cowie calls the "more disreputable features of cinema usually associated with entertainment film, namely, the pleasures and fascinations of film as spectacle."[31] The indexicality of the photographic medium imparts ontological status and a suggestion of evidentiary value, but the documentary remains a representation of lived reality, and its claims to truth are made manifest through a vast array of cinematic strategies. Bill Nichols describes the documentary as *"discourse about* the world" (his emphasis) and an argument made through "rhetorical strategies and stylistic choices" often occluded by the spectacle of reality.[32] Formal mechanisms and symbolic frameworks secure the interpretation and the meaning of this unbelievable and overpowering world.

This tension between truth and fiction, or evidence and narrative, is not singular to the documentary but is also an ongoing feature of testimony. Truth and fiction, write Anne Cubilié and Carl Good, "are inextricable within any testimony."[33] Already associated with historical trauma, access to the past and ready expression are elusive at best. At the same time, as Shoshana Felman, Dori Laub, and Janet Walker observe, this imperfect memory may be most apt to express historical truth, particularly in the case of the Holocaust, an "event without a witness."[34] Moreover, the events themselves, even when experienced and recalled, may be deemed too terrible for expression, encouraging fiction to render the horror palatable and within the realm of apprehension. Like documentary, testimony inhabits a space in between the truth it relates and the means through which it relates this truth. Geoffrey Hartman explains: "What I meant is, one mustn't think that because they are authentic—in the sense that they came from that person and they are the best eye-witness recollection of that person—that therefore everything in it must be taken as the absolute truth.

With that, in fact, we're coming back to the literary."[35] And, back to the cinematic. Film bears witness and offers testimony that is simultaneously dramatic and truthful; the visible invests the medium with additional claims to truth, but cinematic strategies render the events comprehensible.

It is appealing, then, that legal scholar Jessica Silbey argues that film is possibly better understood as testimonial evidence.[36] With this designation in mind, she suggests that it is a mistake to view film as like photography: solely "demonstrative" and thus dependent on explanation by interlocutor.[37] Instead, she posits that film, with its rhetorical capacity, can communicate a distinct point of view (or more than one) and in that way, it works as testimonial evidence. Film is not subordinate to another testimony but introduces its own. For this reason, Silbey suggests that judges become film critics (or rather, theorists) by acquainting themselves with the implications of genre (is it crime-scene footage, surveillance footage, a reenactment?) and the cinematic rhetoric that makes this visible evidence a "discourse about the world." Even if these doctrinal concerns do not map out precisely onto the landscape of cinema, it is nonetheless worth analyzing the films submitted in order to consider how they helped to function as witnesses for the prosecution.

The following section examines three films submitted by the U.S. prosecutorial team: *Nazi Concentration Camps* (screened November 29, 1945), *The Nazi Plan* (screened December 11, 1945), and *Original Eight Millimeter Film of Atrocities against Jews* (screened December 13, 1945). Conducting formal analyses, I outline how these were made to bear witness in service of multiple ambitions. First, they aided in making the case for the prosecution, relating events that supported the four charges: crimes of war, crimes against peace, conspiracy, and crimes against humanity. Second, they sought to create a visual register for crimes against humanity, a legal concept lacking clarity at the time of the prosecution. And third, the films legitimated the processes of this new international court and rule of law whose authority was not yet established.

Films for the U.S. Prosecution

Nazi Concentration Camps

Executive trial counsel Thomas Dodd's introduction of *Nazi Concentration Camps* hints at the film's contribution to more than demonstrable proof. "This is by no means the entire proof the prosecution will offer with respect to the subject of concentration camps, but this film which we offer

represents in a brief and unforgettable form an explanation of what the words 'concentration camp' imply."[38] Its value lay also in its capacity to provide a horrifying tour of Nazi crime scenes with footage from the liberated camps. Screened only eight days into the trial, the documentary shocked and galvanized a courtroom with its images of mass death inhabiting an unimaginable scale. Only one hour in length (six reels) extracted from more than a hundred thousand feet of footage, the film advanced images that have since become visual cues of the Holocaust and genocide, appearing in documentaries such as *Night and Fog* (Alain Resnais, 1954) and *The Sorrow and the Pity* (Marcel Ophüls, 1976), and in feature films like *The Stranger* (Orson Welles, 1946), *Judgment at Nuremberg* (Stanley Kramer, 1961), and, more recently, the television miniseries *Nuremberg* (Yves Simoneau, 2000, TNT). Even the limitations of the Nuremberg courtroom have worked to cast the Holocaust imaginary in black-and-white. The capacity for color film was available at the time (and such films were taken by George Stevens when liberating the camps) but the courtroom did not possess the three-track projection system that allowed Technicolor projection, thereby limiting the options for the U.S. Army Signal Corps and the photographic film unit of the OSS. Available footage was screened in black-and-white. The repercussions are longstanding. "I have no color reference for that period," explained Steven Spielberg regarding his choice to film *Schindler's List* in black-and-white. "My only experience with the Holocaust has been through black-and-white documentaries. I've never seen the Holocaust in color."[39] More than determine the color of collective memory, the film and its reuse have fused the images of the camps with meaning, creating readily identifiable signs of genocide, crimes against humanity, and the Holocaust. At the time, the understanding was not so immediate, as the testimony of the film endeavored to build the prosecution's case, proving and illustrating the charges, setting out the stakes of the tribunal, and legitimizing its process.

The film's position as witness as well as evidence was secured after the introduction. In order to authenticate the materials, Commander Donovan introduced several affidavits and, in a fairly typical procedure, he also asked that the reading of these materials be waived. However, a reading of at least two affidavits did occur. Auguring the contemporary anxieties over photo-manipulations, the film begins with a projection of two affidavits from the filmmakers, Lieutenant Colonel Stevens and Lieutenant Kellogg, with a voice-over reading out the text.[40] Stevens's affidavit attests to the "truth of the representation," while Kellogg's verifies "that the images

of these excerpts from the original negative have not been retouched, distorted or otherwise altered in any respect." At first one presumes these are the voices of the filmmakers themselves, but when the movie starts, the reader is revealed to be the voice-over narrator of the film. This performance literalizes the function of film as witness when the film appears to testify to its own authenticity, in essence promising to tell the truth, and nothing but the truth. As Douglas suggests, "this gesture of self-authentication supports a novel understanding of the documentary as a privileged witness independently competent to swear to the truth of its own images."[41]

A reading of the film as testimony rather than evidence is facilitated by its now dated format, bearing the signs of construction later to be eschewed by the American Direct Cinema movement. The narration combines facts and details with moving pictures and provocative strategies that aim to secure meaning while conveying enormity and emotion. *Nazi Concentration Camps* opens in traditional ethnographic documentary form with a map and a voice-over narrator, who anchors and explains the images that simultaneously frustrate and demand representation in law and word. On the map of prewar Europe, names of concentration camps begin to appear and proliferate with a force that overwhelms the screen and threatens to overtake all available space with a blurred inky-white force. A vision of furious invasion merges with the educational trope of the map and the dry instructional tone of the narrator in a manner that sets up the overall project of the film: to promote both rational and affective cases. The camps on the map first appear in Germany and soon extend beyond its borders. The film focuses on twelve of these camps, all of which reside in Germany and Western Europe (Eastern European camps fell under the purview of Soviet liberators). The narrator assures the viewer that the sights are representative of all camps throughout the occupation.

The first episode, set in Leipzig, establishes many of the motifs and modes repeated in the subsequent visits, as physical remnants are to be transformed into proof of Nazi accountability and into evidence of the charges: crimes of war, crimes against peace, crimes against humanity, and conspiracy to commit all of the above. The sequence begins with a title card and then a wide shot to announce the location, in this case, the remains of a burnt barrack. The narrator, in a clipped and hurriedly efficient tone, provides an aural report, stating the number of prisoners as well as the number of those slain—burned alive or shot—by the Nazis upon the arrival of the Allies. Following two wide shots of the landscape comes

a three-shot (a shot with three figures in the frame) where two inmates appear to be speaking with an American solider. "The atrocity story is told by these two inmates," the narrator informs the viewer as the camera cuts to a two-shot of these men, speaking but without sound. These silent witnesses find expression through the film as the narrator fills in their missing account, both giving testimony and securing testimonial authority. The voice-over explains that the "SS officers and Gestapo agents lured 220 starving prisoners into a big wooden building at this camp . . . doused it in a flammable liquid . . . and then applied the torch." Accompanying this narration are images to be entered into evidence: a wide shot of a burned corpse stationed by an unidentified barrel, then two close-ups in close succession, punctuating the story of escalating violence, from liquid to torch, and each bringing the story greater intimacy through proximity.

The account continues with a description of the "mowing down" of those who tried to escape. The wide shot presents a landscape of charred corpses strewn about an open road. An explanation that those who evaded bullets met with their deaths on the electrocuted wire—"the final hurdle for those fleeing the flames"—accompanies the following close-up shot of one figure holding onto a barbed wire fence. The voice pauses, and the film introduces a montage that opens with wide shots of mangled corpses and moves into closer shots. One shows a man seemingly frozen in the process of a getaway, on his belly, one arm outstretched. Others mirror this startling image. The editors maintain axis at all times, allowing the initial wide shot with the man on the fence to articulate the direction of freedom to the right of the screen, uniting the figures in a graphic narrative of their failed escape.

The final segment of this sequence announces the nationalities of the Leipzig victims: Russians, Poles, Czechs, and French. A three-shot of women in babushkas standing behind barbed wire accompanies this announcement. The shot is relatively tight and soon cuts to a wider shot that reveals the object of their gaze: the charred corpses of the earlier presentation. The women hold handkerchiefs over their mouths (a visible gesture to what film cannot convey) as a voice-over explains that these Russian women viewing the scene had been liberated from slave labor. The sequence concludes, again offering both testimony and testimonial authority bolstered by the presence of witnesses on screen.

Because there is no available footage from the event itself, the photographers rely on aftermath footage, drawing upon the recognizable human form to reveal the profound damage done. From its opening shot, the

episode draws on the theme of physical and bodily remains in what Douglas calls a motif of scarification that affects land and body. The wide shot shows a snow-covered ground marred by black soot; the charred figures draw out this scarring to the human landscape. The familiarity of the body allows it to express history through itself as the remnant of violent forces. "The imprint of history registers on the flesh," observes Nichols. These moments, he notes, "bring us face to face with the fragility and mortality of the body."[42] Rabinowitz draws on Nichols's work, noting that the body is the star text of the documentary, whether as a character who gives voice to an issue in speech or action, or in the "creatureliness" Nichols perceives.[43] The body supplies the ultimate referent, imbuing the documentary with authoritative urgency.

Charred remains are only the beginning. Privation is written on the bodies of each survivor, as skeletal limbs, protruding ribs, and jutting bones of every body part are brought to our attention. Figures walk uneasily, with their nudity underscoring a vulnerable humanity that stands out against the heavily clothed Allied soldiers—both protectors and protected. The camera follows the treatment of inmates by Red Cross and Allied medics. Bandages are removed and wounds and scars are placed on display, as are the bodies of the victims, fragile and emaciated. These people can hardly move, struggling even to lift their heads or look at the camera while medics palpate the bodies. Gangrenous wounds become the subject of examination, beginning with a close-up of a damaged foot, and continuing with full body shots of inmates, such as a woman bending over, and then a close-up that reveals a solider lifting her skirt to reveal a backside speckled with black marks. In Breendonck, Belgium, bandages are removed and skirts lifted to reveal wounds: cigarette burns, scars from beatings, and infections aggravated by violence and severe privation. This strategy of revelation offers miniature narratives of the atrocities. On the one hand, the gaze seems to penetrate any veil of propriety, as victims are subjected to continued humiliation. On the other, once covered up, they are now revealed for all to see. These gestures legitimize the context of the Nuremberg Trials and the device of the camera as a mechanism for exposure and revelation in the service of justice.

Although the body can visualize and document the crimes of the Nazis, the cameras do not provide images of the Nazi in action, making culpability a challenge to prove. On-screen testimony played a role beyond the silent witnesses reliant on the narrator for a voice. In other episodes, an American prisoner of war and a Russian doctor provided verbal accounts

in rare sequences of synchronized sound, allowing their testimony to be heard. Yet the compelling aspect of the voices is possibly lost in puzzling expressions, such as the doctor who recalls cannibalism and a Nazi officer's theft of candy from child inmates in the same breath. The technologies may have been in place, but survivors were likely too traumatized to provide testimonies in keeping with the requirements of a tribunal reliant on documentation. Instead, testimony was delivered predominantly through the voice of the film, whether through voice-over, reenactment, or the formal organization that presented its documentation with dramatic force. Moreover, the technology possessed the capability to bridge the distance between past brutality and the present damage. Unlike the still image, film's kinetic capacity allows for the reanimation of camp operations. Former prisoners, skeletal bodies in the uniforms or in states of undress, create an effect of a camp as it once was. A twitch of a body in one of the mounds conjures up the dehumanizing treatment of the living. It may be the liberation, but it also appears as an act of torture: to be left for dead in a pile of corpses.

The testimonies of torture are presented in on-screen demonstrations and reenactments with voice-over narration. These displays rely on continuity editing and cinematography to illustrate the crime and impart emotional urgency. One testimony to torture begins with a man wrapped in rope. A close-up follows as another man taps a billy-club in his palm, waiting impatiently for the first man to be immobilized. The next shot, a low wide angle that captures the bound man, small, helpless, and naked beneath a vast sky, as he receives the blows from the club. Another reenactment walks the viewer through the system of mass murder at Dachau. The sequence begins in the changing room, where clothes still hang on pegs, and then moves to the showers, showcasing the gas vents and dummy heads. The camera then delves "backstage" to reveal pipes, pushbuttons, and a canister of poison gas. Here a close-up of a hand turning a crank mimes the release of toxins and the practice of murder. The process of murder is completed with the move to the crematory, the opening of an oven, and the display of human remains.

The acts of burial in the present provide a compelling case for the charges of criminal mistreatment. In almost every camp, the camera chronicles the rushed efforts to tend to the masses of dead. The purpose was to curtail the spreading of disease and transform the camps from concentration camp to refugee camp, but within the film, these images serve additional functions. They incorporate a schema of justice within the film.

While the Allied forces come in to administer care to the living—taking the role of rescuers and heroes—the Germans and Nazis undergo punishment—which presumes the guilt to be proven in the trials. These sequences of mass burial demonstrate a sickening brutality enacted on these bodies. German officers carry the bodies, depositing them in mass graves. In one shot that comes to be used in many later films, a woman's corpse, rendered nearly unrecognizable by emaciation, is slung into a pit and the camera follows her descent down the walls. The moving picture reanimates the interaction between Nazi and inmate, allowing the Nazi to enact violence against the fragile body as he sends it plummeting into the chasm. Such scenes continue and escalate, leading to the images of mass brutality of such moments as the one at Belsen, where a bulldozer pushes a pile of countless bodies into a trench. A British soldier helms the machinery, but the film does not identify him as such. This omission combined with the kerchief that covers the soldier's face contributes to a vision of an anonymous, faceless figure pushing and violating bodies en masses. This sequence does more than convey mass brutality; it incorporates the dehumanizing process of this destruction, both in the use of technology and in the scope that boggles the mind. The perfunctory behavior of all those moving the bodies underscores the absence of humanity in the perpetrators who handle the bodies.

Intensifying the depictions of criminality and justice is the contrast in conduct. Allied forces—liberators—give aid to the survivors and demonstrate humane treatment, while Nazis and Germans treat the dead in ways that divest the perpetrators of humanity—or human behavior. Germans toss the bodies onto flatbed trucks and throw them into ditches, while Allies and the Red Cross offer comfort and care to the suffering living. This differing treatment of the human body summons a distinct ethical code for human and humane behavior. Life and care reside on one side, death and destruction on the other. The dual concepts of humanity—the physical human subject of law and the moral system of conduct—while unresolved in legal doctrine, reside here together, animated for the courtroom that deliberates over the charges.

The film mounts its case in a strategy of accumulation, opening with the relatively small numbers of dead scattered in the landscape of Leipzig and developing though Mauthausen, Buchenwald, and Dachau, where bodies are stacked in boxcars, trenches, and sheds, and culminating in Belsen where bulldozers are necessary for managing the mounds of the dead. This narrative strategy maps out a chronology of development upon

this topography of terror. As the litany of horrors escalates, the film's overall structure and appearance is one of constant, near relentless repetition, which presents a compelling case for the conspiracy charge. Each camp sequence is editorially, cinematographically, and narratively uniform, beginning with the block-letter titles that signal the change in location. The sequence opens with a wide shot of the camp, moves to a medium shot, and then a series of close-ups. The narrator notes the number of inmates, the types of prisoners at the camp (mentioning nationality, the case of political or religious prisoners, sometimes specifying the Jewish identity of internees), and describes the tortures, horrors, and atrocities that took place. Departures from the standardized form exist, typically to emphasize the barbarism. Such scenes include the Russian doctor's recollection of cannibalism and the notorious images of lampshades, tattooed skin, and shrunken heads. Nevertheless, the overall presentation is overwhelmingly similar: barracks, emaciated inmates, and stacks of corpses. The recurrence of content and the editing pattern do not reflect a lack of imagination in filmmaking; rather, these decisions contribute to the production of uniformity: wherever the camp, no matter how dispersed, and no matter who ran it, produced the same dreadful results.

The emergent charge of crimes against humanity likely found affectively convincing expression in the depictions of "inhuman" treatment and the appalling cruelty written on the bodies of the victims. But the legal articulation was less clear. In his analysis of the film, Douglas wonders if the film accomplishes its case for the charge, suggesting that the documentary, like the legal doctrine surrounding it, collapses the distinction between crimes against humanity and crimes of war. Listing the inmates, the narrator makes only the scantest mention of Jewish victims and German political prisoners, more often listing the other nationalities composing the camp population. This listing of foreign nationals makes the case for crimes of war, which governs the treatment of the civilians of invaded and occupied nations in wartime; crimes against humanity focuses on the domestic conditions and the persecution of people on religious grounds. According to Douglas, the reasons are two-fold. The charges of crimes of war retained the gravitas of precedent and were best suited to "create a coherent and judicially manageable narrative about crimes so radically alien that they seemed to defy rational and juridical explanation."[44] Nevertheless, on an affective register, *Nazi Concentration Camps* could produce a regime of humanity that covered a conduct of behavior and represented the violated subject, a human stripped of all other identities.

Almost two weeks later, the U.S. prosecution screened a substantially different film: a four-hour compilation of Nazi-produced footage entitled *The Nazi Plan*. Submitted in the service of the conspiracy charge, the film also aided in making the case for crimes against humanity, crimes of war, and crimes against peace (launching a war of foreign aggression). Schulberg had assembled newsreels and excerpts from propaganda films including the well-known *Triumph of the Will* (Leni Riefenstahl, 1933); the lesser known *Campaign in Poland*, a chronicle of the Wehrmacht's exploits in their movement of eastern expansion; and *Campaign in the West* (1940), which depicts the fall of Western nations under the German occupation. The film derived its legitimacy from the status of the footage as Nazi artifact. Produced under the direction of Propaganda Minister Joseph Goebbels, these served as the history, aims, and accomplishments of the party as the Nazis chose to tell it.

As Commander Donovan attested, and as the recitation of director Ray Kellogg's affidavit confirmed, the footage within *The Nazi Plan* had not been manipulated or retouched by the U.S. military or prosecutorial teams. However, these claims do not account for the ways in which editing, and even the context of exhibition, contributed to the transformation of Nazi self-celebration into a clear plan to commit the crimes in the indictment. The "self-evident" meaning of propaganda footage was to be repurposed, and thus resignified as evidence of criminal wrongdoing. The chronological arrangement aided in the creation of a historical narrative, while strategic juxtaposition of existing footage (combined with explanatory intertitles) established connections between the rise of the Nazi Party, the enactment of racial policies, and the violence that took place within and without national borders, as well as on and off screen. *The Nazi Plan* presented a scheme, intent to divide a nation with Aryan supremacy and anti-Semitic persecution—a component of the charge of crimes against humanity—that led to wars of foreign aggression, and did so without the atrocity footage that would come to hold popular imagination as proof of this legal charge.

The film is in four parts, from "The Rise of the NSDAP [Nationalsozialistische Deutsche Arbeiterpartei or the Nazi Party]: 1921–1933" and "Acquiring Totalitarian Control Germany: 1933–1935," to "Preparations for Wars of Aggression: 1935–1939" and the invasions themselves. The parts are marked by titles in English to guide the Anglophone viewer. Instantaneous

translation was otherwise made by the contribution of IBM, which provided this service throughout the trials.[45] The rise begins with small, relatively tight shots as support for the Nazi Party is still nascent; as the film progresses, the shots become wider and offer numerous pans, communicating the rising enthusiasm for the Nazis. By the second part, the scenes of accession are presented as forceful and grandiose, with Hitler's first speech as chancellor interrupting the silence of the earlier newsreel footage, dependent on intertitles and pictures of newspaper headlines for explanation. The cheers and applause from the audience signal their support. Leni Riefenstahl's footage makes the most significant contribution in this way, blending sound, massive crowd sequences, and Hitler's oratory with the close-ups of adoring youth, looking upward in a mixture of awe and dedication. The fervor of crowds and the growth of cinematic contributions—from silent footage to sound, from modest cinematography to ostentatious settings and crowd scenes—advance in tandem.

From the earliest moments, the rise of the NSDAP and its attainment of control are linked to violent suggestion and anti-Semitic persecution. Election Day in Bavaria begins with a scene of marching bands, followers to the side carrying torches. Soon, however, the torches overwhelm the nighttime scene, creating an image more akin to the mob of torch- and pitchfork-wielding villagers of *Frankenstein* (James Whale, 1931), an image of persecution that evokes the horror film and marshals pity for the hunted. The manifestation of persecution is presented in the second part, which begins with "Opening of the Official Anti-Semitic Campaign 1 April 1933."[46] A wide shot reveals a fervent cry of a crowd shouting their allegiance to Goebbels as he proclaims a boycott of Jewish shops. There is a cut to the streets, where storm troopers drive by chanting "heil" in an echo of the crowd's earlier shots. Warnings are delivered to the Jewish denizens, as the soldiers drive by shops that have been closed and painted over, and bear signs that read "Achtung Juden," some with death's head insignias scrawled alongside. By the scene's conclusion, the storm troopers shout passionately to the camera, and the bystanders—although not all with equal enthusiasm—join in. Newsreel footage of a book burning (May 10, 1933) continues this narrative of intensifying menace. A bonfire burns as Goebbels urges an end to Jewish intellectual domination before an excited crowd. There is a cut to the tossing of books on the fire, while Goebbels's voice-over continues; the orders from the unseen Goebbels are fused to the violence on screen and forge a link between commands and action. By the end of the sequence, the newsreel affirms the association,

drawing a long slow pan that moves from the still sputtering Goebbels over the crowd and settles on the bonfire. As if to associate these acts with the military violence to come, Schulberg follows the book-burning sequence with the christening of an aircraft.

The exhibition context of the screening enhanced the force of these images. By this point, courtesy of news media, images of crematoria had invaded the popular imaginary; in addition, the screening of *The Nazi Plan* took place after that of *Nazi Concentration Camps,* whose atrocity footage articulated the end goals of these earlier persecutions. Given this awareness, the symbolic violence of book burning (and the destruction of Jewish thought) summons the actual violence that took place in the camps. The viewing context resignifies this footage as the knowledge of the crematoria informs the film's argument about the dangers that lurked in the regime from the beginning. A narrative of worsening brutality is tied to the Nazi Party's acquisition of power. While Jews are revealed as the target, the films reveal the destruction of the German citizenry as well, transformed into a wild throng ready to destroy.

The constant rallies serve as a motif, presenting an escalation of the frenzy; it is almost as if the size and agitation of the crowds mount in direct proportion to the bombastic pageantry of the events. Scene after scene tells a story of mounting Nazi control and the vehemence of the German people. An announcement of a state advance, whether roads or laws, is followed by scenes of emphatic public response, whether in cheers of "Sieg Heil," the Hitler salute, or, in the case of many scenes involving the Hitler Youth, the brandishing of knives. These characterizations did not escape the notice of the Nuremberg reporters. The special correspondent from *The Times* (London) refers to "frenzied rallies" of "mass hysteria" that intensify in "one of the prosecution's most incriminating exhibits."[47] The *Washington Post* refers to a "grinning Hitler strutting before his hysterical followers,"[48] while Tania Long of the *New York Times* notes "hysterical crowds and a ranting Hitler."[49]

The Nazi Plan triangulates the political fervor with Jewish persecution and plans for foreign invasion. The historical narrativization creates a suggestion of causality strengthened by the logic of the montage. For example, a series of scenes in the opening of part 3, concerning the preparation for offensives, unite Nazi policy with internal and external aggression. Baldur Von Schirach, head of the Hitler Youth, exhorts the boys to follow the principles of Hitler's anti-Semitic manifesto, *Mein Kampf,* a book whose ideas are thought to have culminated in World War II. The setting

of this nighttime oration is lit with torches, providing a mise-en-scène that once again conjures up horror-movie images of angry villagers preparing for the hunt. In this section, Göring reads aloud the Nuremberg laws that eradicated Jewish citizenship, and Hitler addresses the Hitler Youth and watches their military exercises. Intercut with these domestic scenes of control and persecution are scenes of Göring announcing plans to rearm Germany, accompanied by goose-stepping soldiers and followed by displays of weaponry and combat exercises that suggest war in action. The military reviews continue through this sequence; it is a veritable parade of armory, marches, and Hitler Youth making its way through the narrative before finally arriving in Düsseldorf and concluding with a reoccupation of the Rhineland.

Arranged in this order, the scenes produce a narrative in line with that set out by the prosecution. The Nazi Party grows in power, captures the minds of the German populace, and enacts racist policy against the Jewish denizens, all the while preparing for an external war of aggression and a crime against peace. The later reels of the film are devoted to the occupations and conquests of European nations in a relentless procession; scenes of bombed landscapes and Hitler's visits to acquire control of the land feel endless. Propaganda footage that once triumphantly reported the occupations and invasions of European nations, from East to West, now produce a compelling case for wars of aggression against foreign nations. The earlier footage of policy announcements, public rallies, and multiple military processions and increasing armaments function, in retrospect, as a clear precursor and cause. This is indeed the story of "how the German Nation was led by militaristic regimentation to preparation for aggressive war."[50]

As the aggression broadens from the domestic to the international arena, so too does the persecution of Jewry. The final part of *The Nazi Plan* opens with Hitler's January 30, 1939, speech to the Reichstag, a speech that was filmed for and used in the notorious anti-Semitic propaganda film *Der ewige Jude* (*The Eternal Jew;* Fritz Hippler, 1940). The hate-mongering oratory lays responsibility for future war at the feet of "international finance-Jewry," declaring there will be no peace without a solution to the "Jewish problem." The speech ends with the announcement that should there be another world war, "the outcome will not be the victory of Jewry, but rather the annihilation of the Jewish race in Europe!" Even as the speech may have intended to accuse Jews of starting whatever war would occur, suggesting defense rather than aggression, the retroactive screening

casts these claims within intent. These were within Hitler's plan, and all those who helped enact the policies and rile the crowds (many of the Nazis seated on the defendants docket) were part of this design.

Concentration camps were a component of this plan, as the film suggests by showing a Nazi visit to a camp in Minsk. The Nazis survey the territory, walking past a number of young Russian men standing behind barbed wire. The camera tracks with them to reveal a large number of detainees, some of whom stand, but many others sit and lie down. The Nazi officials signal their approval with nods. When this film was screened at the tribunal, the gallery had already viewed the liberation footage of *Nazi Concentration Camps,* which again allowed context to inform interpretation. The visit demonstrates approval of the camps, while the film's origin as propaganda signals the efforts to conceal the crimes—crimes that are revealed by the legal and cinematic technologies of the Allies.

The juridical legitimacy of the Nuremberg Trials was considerably strengthened by a depiction of the trial against the remaining participants in the July 20 plot of 1944, which was an attempted assassination of Hitler that has been commemorated on film many times since, most recently in *Valkyrie* (Bryan Singer, 2008). Filmed for private record rather than newsreel footage, the proceedings of the "People's Court" appear as a carefully orchestrated production that maximizes all possibilities for dramatic effect. A camera stationed behind the judge imposes a high-angle viewpoint, allowing both spectator and judge to look down on the hapless defendants, clad in civvies, surrounded by policemen. The sound quality of the voices augments this perception as Judge Roland Freiseler's voice booms in contrast to the softer voices of the defendants. The manipulation of the film did not escape notice, as Nuremberg correspondent Joel Sayre noted that "the Nazis edited the picture to make the defendants look as cringing as possible."[51] Meanwhile, reporter Long saw "a prisoner wincing as a Nazi judge screamed imprecations and insults at him."[52] The context contributed to these readings and to the interpretation of the defendant as underdog protagonist instead of guilty party. "I thought about the many murders . . . in Germany and abroad," Long summarizes before speculating, "it was the Nazi brutality he [the defendant] had witnessed in Poland that had turned him against Hitler and his regime."[53] Sworn into a farce of a trial, this figure's testimony extends into the juridical context of these military tribunals.

Little of this Nazi trial corresponds to its Allied counterpart. The rush to trial on screen contrasts with the months of Allied preparation and the

meticulous presentation of evidence. The treatment of the defendants on screen, dwarfed and surrounded by booming military figures, is nothing like that off screen, where the Nazi defendants sit among themselves on the dock. The stark contrast of due process justifies and legitimizes the Nuremberg proceedings, which continued nonetheless to be rendered as a suspect form of victor's justice. Others noted the legitimating effect. *The Times* correspondent wrote, "For the accused at the Nuremberg trial, however, the most vivid contrast was between the justice they are now receiving and that meted out by the 'People's Court.'"[54] In addition, the appearance of the Nazi trial footage validates the Allies' own use of film. The trial on screen, filmed for secret as opposed to public purposes, reveals a heavy-handed manipulation that bespeaks the self-aggrandizement of the party witnessed throughout the film. Sound quality and shooting angles assault their targets so that the form reflects the perversion of decency in representation, legal or cinematic. The Allied processes gain authority by comparison.

To be sure, both of the prosecution's documentaries, *The Nazi Plan* and *Nazi Concentration Camps,* rely on cinematic interventions to build their case; yet their gestures are less garishly rendered. The editorial contribution of Budd Schulberg tells a story of Nazi culpability and criminality, but untouched sound and image efface the awareness of prosecutorial involvement while giving the impression of impartiality. The performance of Nazi perversion of justice and misuse of film serves to advance their criminality while simultaneously authorizing the Nuremberg Trials and its technologies of law.

Original German Eight Millimeter Film of Atrocities against Jews

Amid the many reports and testimonies, the U.S. prosecution submitted a film fragment found by the U.S. military in an SS barracks in Augsburg (*Original German Eight Millimeter Film of Atrocities against Jews*). Shot by an SS officer and lasting no more than ninety seconds, the clip depicts a rare glimpse of Nazi crimes in process, more specifically the liquidation of a ghetto. In spite of the damage, the OSS did nothing to retouch or restore it. Commander Donovan declared it as "undeniable evidence made by the Germans themselves, of the almost incredible brutality to Jewish people in the custody of Nazis, including German military units."[55]

By today's standards, the film bears multiple markers of authenticity. The celluloid wears the scars of its near destruction, suggesting a proximity to violence itself. This appearance, along with the story of recovery,

upholds the capacity of film and trials to expose concealed transgression before the international publics of the tribunal and newsreaders. The concealment—suggested in the trope of recovery—produces an awareness of wrongdoing that led to the initial suppression. The aesthetic of the film carries on the appearance of salvage as a handheld camera struggles to capture and record the action as it happens. The movement is shaky, uncertain, and characteristic of the unprofessional cinematographer struggling amid mayhem, not knowing what to shoot first. The amateurish appearance offers a visual disclaimer of any authorial calculation or manipulation. Meanwhile, as the camera responds to social space, it produces the "you are there" aesthetic coveted by the Direct Cinema pioneers and so often reproduced in docudramas seeking to heighten realism, such as Paul Greengrass's *Bloody Sunday* (2001).

Given the absences of affidavit or participation of the OSS Film Unit, this film may be most like demonstrative evidence. Certainly for contemporary eyes, the clip effectively shows Nazi crimes: these are images we have seen before in a style that has become familiar, if not a requisite marker of historical truth. Even in the past, the photographic image would have made powerful ontological claims. However, at the time, the film was seen as less than clear, its murkiness testing the evidentiary function of the motion picture proof. The on-screen action may have produced a powerful impression, but the treatment of the film in the courtroom points to its illegibility. To mitigate the challenges of an amateur photographer, short running time, and the "confusion on every hand shown on this film," which impaired the tribunal's ability to "properly view the evidence," Commander Donovan requested permission to screen the film twice. He then read from a shot list in between projections "in order to direct the Tribunal's attention to certain of the scenes."[56] The shot list, submitted into evidence, comprised more than forty-five scenes; Donovan opted to highlight thirteen of these.[57] The strategy supplied the extrafilmic interpretive guidance necessary for viewers unfamiliar with this history and with this style of footage. The scene of this rousting is today familiar thanks to photographs in museums, or reenactments of ghetto liquidations in popular films. But then, viewers had no framework, legal or popular, to make sense of this spectacle.

Donovan's selective reading points to the legal aims of the screening, making a case for crimes against humanity. As with *The Nazi Plan,* this deployment possibly better advances the case for the charge than *Nazi Concentration Camps,* whose images today serve as popular icons for this

charge and that of genocide. The counselor developed an emotional case by highlighting the most vulnerable of any population: the elderly, and the women and children. He called attention to the acts of physical brutality, such as blows delivered to one bleeding man (scene 37), the "manhandling" of another (scene 5), and the dragging of a woman by her hair. Donovan also singled out scenes of nudity, most likely to highlight the vulnerability as well as the humiliation of the residents. Drawing attention to these moments underscores their civilian and human status while encouraging the affective response of the gallery. But here too, it is not simply the creatureliness of the body that confers a broad humanity subject to violation: this is a distinctly Jewish victim group, as indicated by their dress. And Donovan remarks on the clothing, signaling the skullcap worn by the man brutalized in scene 37. In effect, Donovan drew attention to the specifics of the crimes—European Jewry attacked by Nazis—which fit the defining qualities of the indictment.

Reports from the Nuremberg correspondents make little mention of this screening. The absence suggests a minimal impact or at least an uncertain status ascribed to this filmic document. The fragment offers a glimpse of a ghetto liquidation that has since been rendered multiple times in dramatic reenactments of the Holocaust. The aesthetics, meanwhile, provide the truth-claim of life caught unawares. But what today might have served as a juridical or, more likely, cinematic centerpiece for its portrayal of violence in action performed under the watch of the German military, proved too small and too illegible for full comprehension at the time.

Interpretive assistance was provided at all times, whether through the vocal contributions of the counselors, the reports that preceded the screenings (and indeed, the screenings that preceded the other screenings), or through cinematic language. In all cases a symbolic framework helped to secure the meaning and function of the films, helping them to bear witness to historical events that beggared comprehension while bolstering the case for the prosecution.

The Spectacle of Witnessing: On and Off Screen

At the same time the films were made to bear witness, they reflected a preoccupation with what witnessing could accomplish. The act of witnessing plays a significant role in Donovan's reading of the eight-millimeter film, as he calls attention to the number of German soldiers watching the attacks. As an old woman is pushed, "a man in an S.S. uniform [stands] at

the right of the scene" (scene 3), "A soldier in German military uniform, with a rifle, stands by as a crowd concentrates on a man coming out of the house" (scene 39), and "Soldier with a rifle, in German military uniform, walks past a woman clinging to a torn blouse" (scene 44). At one point, Donovan offers "A man in German military uniform, with his back to the camera, watches" (scene 18), although what precisely he watches is left out of the description. The placement in the verbal listing suggests eye-line matches with the scenes that closely precede and follow this listing: scene 16, the dragging of a man, or scene 24, the street scene of fleeing women and numerous dead. The accentuation on spectatorship opens the double meaning of humanity: it suggests not only the humanness of the victims on screen, but the inhuman conduct of the soldiers present. They stand by without intervention and survey the violent scene, allowing this pogrom to take place on their watch. Such moral culpability stands in direct contrast to the act of viewing this clip in the courtroom. Here, viewing holds the potential for action—not intervention, but punishment and, with the acceptance of this tribunal and the charges, prevention as well. In addition, the theme of witnessing supports the claims of the prosecution: that one can be complicit in crimes even if one does not physically commit them. From civilian under occupation to solider to SS to the high-ranking officials on trial, awareness is signaled throughout. The chain of observational command on screen reaches out to the Nazi defendants, the engineers of Nazi policy and heads of military that sit before the courtroom's screen.

The on-screen spectacle of witnessing contributed extralegal and extra-evidentiary forces that invested both the apparatus and the proceedings themselves with a legitimacy to carry out their work in administering justice, producing a record, and managing the unwieldy events of the past.[58] Displays of witnessing pervade *Nazi Concentration Camps,* from the Allied generals, GIs, and congressmen surveying the landscape, to the ministrations of forced tours of Germans from neighboring towns. One sequence shows hundreds of civilians from Weimar as they walk into Buchenwald, smiling at the camera and displaying an unsettling cheeriness, only to exit later with handkerchiefs clutched to their faces. Both the editing and the gesture capture the transformative capacity of witnessing, although the nature of this transformation is uncertain; the handkerchief could be blocking out the stench, stifling the sobs, or enabling the women to look away. Although the mandate to witness is implied through the proliferation of these scenes of compulsory visits, the intention behind their presentation

remains unclear and unstated. These scenes appear to perform a function both punitive and pedagogic, performing and mirroring the framework of justice in which the film was screened. Faced with the atrocities perpetrated by Nazis, these German women, blithe, well dressed, and well fed, are transformed into distressed, confused figures.

A sequence misidentified as taking place at Arnstadt (it was later corrected as Bergen-Belsen) develops the possible significance of witnessing as townspeople are made to look upon evidence of supremely debased acts: the lampshades made of human skin and shrunken heads. While making the case for Nazi barbarity that augments the claims of "inhuman acts,"[59] the tour offers the opportunity to examine the German response. The people look on as the camera moves across their faces and the narrator explains that the "camera records the changes in facial expressions." The camera here serves as more than a recording device, but one of analysis, as if intensive study will yield greater understanding regarding degrees of complicity, culpability, and possibly even evidence of humanity, rendered in the performances of witnessing—appropriate and inappropriate. The camera scrutinizes the faces for evidence of remorse or shock. This act of conscious inspection suggests that witnessing both accomplishes something and reveals something. What exactly it reveals is another matter.

The questions of witnessing's function took place off screen as well, with reporters directing their attention to the responses of the Nazi defendants. When the *Washington Post* reported on the day's proceedings, the title read, "Nazis on Trial See Horror Camp Film." The lead confirmed the interest suggested in the headline, focusing on the response of the Nazis over that of others present: "Twenty Nazi overlords viewed films of the horrors of German concentration camps with reactions ranging from tears to curt indifference"[60] The *New York Herald Tribune* ran the headline "Atrocity Films in Court Upset Nazis' Aplomb," and the description of the scene made further notice of the preoccupation with Nazi witnessing: "The place was darkened except for the screen and the defendants' enclosure, and dim footlights shone on the faces of the Nazis with a fluctuating radiance. Half the spectators in the room were looking at the screen and the rest were watching the defendants."[61]

The observers recorded the various responses. G. M. Gilbert, the Nuremberg prison psychologist, noted the refusal of many to watch as they opted to look downward or to physically turn away from the screen. Franz Von Papen, the German minister to Vienna, refused to look.[62] "'No I'll get

sick,' cried Schact when a guard nudged him toward the screen," the foreign affairs correspondent at *Newsweek* reported. The nudging of the guard, meanwhile, enforces the notion of requirement and expectation. Were the defendants to watch as punishment or for revelation? "Funk cries bitterly," observes Gilbert.[63] *Newsweek* reports, "Rudolf Hess leaned forward, fascinated. Reichsmarshal Göring's fat face reddened. Field Marshal Wilhelm Keitel covered his eyes and mopped his brow. At the end, the presiding judges forgot even to adjourn the court as they walked out in horrified silence. When Hans Frank and Arthur Seyss-Inquart got back to their cells, they vomited."[64] The *New York Herald Tribune* provided a somewhat milder account: "As the lights went on, Hans Frank seemed to be gagging a bit. . . . It was reported that afterward both of them, Frank and Seyss-Inquart, became nauseated in their cells."[65]

In spite of the many observations of the Nazis' rattled composure, including Frank's and Seyss-Inquart's visceral reaction, the coverage seemed equally determined to present the Nazis, or at least some of them, as maintaining an unaffected and unrepentant posture. Gilbert reports on Göring's casual demeanor as characterized by his complaint, "It was such a good afternoon . . . and then they showed that awful film, and it just spoiled everything."[66] In *Newsweek,* just below a graphic summary of the film sits a photograph of Hess, leaning back in a relaxed stretch. The legend reads, "Hess: Now he remembers all," in reference to his November 30 confession that he had faked his amnesia. This case reflects a conflicted understanding of witnessing. The combination of stories with one another and with the image triggers a curious effect: the viewing of the film fails to inspire great response from Hess, and yet it precedes an admission of guilt. He is simultaneously blithe and transformed. At the same time, the giddiness with which Hess ostensibly delivered his declaration suggests that, in fact, nothing can change this man, irresolute and uncaring, even before the most graphic evidence. A combination of reportage and photo illustration in the *New York Times* perpetuates this suggestion, as a photograph of Hess eating vegetable stew accompanies the article "War-Crimes Court Sees Horror Films." This photograph comes with its own title: "Hess has not forgotten how to eat."[67] The Nazis' responses—sick with remorse or criminally unashamed—nonetheless differ from the responses of the jurists. As *Newsweek,* the *New York Times,* the *Washington Post,* and the *Herald Tribune* noted, all left the room without a word, ostensibly too shattered to continue.

The preoccupation with witnessing and response continued with the screening of *The Nazi Plan.* Here, the Nazi defendants' delighted response

to the film served as a performance of inappropriate spectatorship at odds with the protocols of the courtroom and the responses of others in the gallery. It seemed only to bolster the characterization of gleeful criminality, one made all the more horrific in the face of growing knowledge of the atrocities (and the earlier screening of *Nazi Concentration Camps*). Long directs the entire force of her report, "Nazis Glory in Film of 'Good Old Days'" to this observation. She marvels at the lack of regret and remorse, which "was more than amply confirmed by the enthusiasm with which the twenty top Nazis watched the film . . . Glorying in scenes of marching men, flying banners, hysterical crowds and a ranting Hitler surrounded by his chieftains, the defendants acted like excited school children seeing their pictures flashed across the screen. They nodded and nudged one another."[68] The *Washington Post* observed Hess to be "enraptured" with this film, tapping his feet to the musical accompaniment of the tune "Horst Wessel" and clapping when Göring read the Nuremberg Laws. Most reveled in the film, especially Von Ribbentrop, who was brought to tears on a number of occasions and reportedly commented, "Can't you really feel the terrific magnetism of [Hitler's] personality?"[69] Even G. M. Gilbert, the prison psychologist for the defendants, noted, "The generals gloated as they saw themselves in their pristine glory."[70] The only dissent came from Hans Frank, legal adviser to Hitler and governor of occupied Poland, who expressed disgust with their devotion to this "tin man," and Schirach, who complained that the film presented only the worst moments.

The preoccupation with response to the films suggests an inchoate expectation of what media or film witnessing could accomplish outside of providing testimony to past atrocities. Embedded in the reports and their moderate interpretations are convictions of a transformative or revelatory potential, although again, the expectations are unclear and unformed. It is not certain how telling such responses are, and what they tell, if anything. Does the mobilization of shame or disgust or remorse serve an evidentiary function? Do these emotional reactions, or indeed, the absence of reaction, demonstrate moral deficiency and criminality? These questions inhabit the reports of film viewing, as if to determine the function of looking.

Footage on Film: Representations of Witnessing

Over the years, the irregularities of the events—the new tribunal with its relaxed rules of evidence and disputed sovereignty, the new controversial

charge, and the images that demanded explanation—have been smoothed away. With the reuse and replication of liberation footage, much of it introduced through the recycling of *Nazi Concentration Camps* in feature films, pictures of bodies, boxcars, crematoria, and emaciated figures behind barbed wire have become iconic reference points for charges of crimes against humanity and genocide. As visual signposts, the images cue understanding and expectations of response. A presumed witnessing function attends this imaginary, even as the original usage was beset by contradictions and confusion. Hess would confess to faking amnesia but view atrocity with aplomb. Nazis were simultaneously rattled and unrepentant. Later manifestations, however, suggest an inevitable relationship of viewing to revelation, transformation, and calls to action.

The Stranger features Edward G. Robinson as Mr. Wilson, a federal agent of the War Crimes Commission, in pursuit of fugitive Nazi war criminal Franz Kindler, played by Orson Welles. Wilson finds him in a small town in Connecticut, where Kindler has assumed the identity of Professor Charles Rankin, married to Mary Longstreet (Loretta Young), the daughter of a Supreme Court justice. Needing Mary to cooperate and aid in her husband's arrest, Wilson invites her into a meeting, where he screens liberation footage—some from *Nazi Concentration Camps* and some from the Soviet military footage. At times he describes what he sees, explaining the function of gas chambers and lime pits. At others, when bodies are on screen, the terminology broadens. As a survivor is placed on a stretcher, Wilson refers to it as "genocide," which he defines (incorrectly) as "the mass depopulation of occupied countries." More problematically, Wilson describes the on-screen horrors as the product of one mind, declaring Franz Kindler to be the mastermind behind the "theory of genocide." While he links these images to the new concept of genocide, his "great man" theory of genocide erases a past history of events that could also be called genocide (such as the Armenian genocide) and, oddly, might limit the culpability of the other architects of the Holocaust. Although Mary is reluctant at first, the horror of these images shakes her faith in her husband, and leads her, eventually, to assist the prosecution. The sequence begins to knit together the viewing and response, the images and genocide.

It will come as little surprise that *Nazi Concentration Camps* appears in feature films about the trials, namely *Judgment at Nuremberg* and the television miniseries *Nuremberg*. The first film centers on the jurists trial of 1947 and puts forth accusations of crimes against humanity and genocide. As in *The Stranger*, a combination of *Cinema Documents of the Atrocities*

of the German Fascist Invaders and *Nazi Concentration Camps* makes an appearance. Although understandable within the context of the American noir film, this union becomes more problematic in a depiction of the U.S. prosecution and a gesture to actual trials. Provenance of evidence is no longer an issue. Unlike either the Soviet and American documentaries, there is no voice-over. Instead, the figure of prosecuting counsel Colonel Tad Lawson (Richard Widmark) collapses justice, image, and testimony, providing a curious combination as he takes the witness stand to testify to the veracity of the images on screen and to provide narration. On screen appear the now iconic rows of corpses and the bulldozer at Belsen, pushing the piles into mass graves. The Soviet footage provides pictures of Auschwitz and children baring their arms to show the tattooed numbers. Lawson's narration is heartfelt and poetic, describing, for instance, the violence to the human heart, but the legal definitions make no appearance here. Detailed evidence and reportage is less important than the moving image and its accompanying testimony. Over the previous years, the liberation footage had entered the public imagination, and it had been recently reanimated by news of the Eichmann trial. Douglas writes, "In the 15 years since its first screening in a trial setting, the meaning of *Nazi Concentration Camps* had radically changed. No longer a document about the Nazis' war crimes against prisoners of war and civilians alike, the documentary now was seen to provide visual proof of the crimes of the Holocaust."[71] Its evidentiary and legal burdens had been lightened.

While the film-within-a-film contributed to the codification of images, the film outside explored the response to this evidence. The trope of appetite in particular offered a means of expressing the transformative or revelatory powers of media witnessing. Immediately following the screening, two scenes of lunch take place. In the first, the Nazi defendants sit together in the mess hall; most eat, claiming disbelief in the images, but some are clearly upset and lack all appetite. One man asks how such a thing could be possible, a question that evokes both practical and philosophical aspects: how could humanity commit such horrors? Another defendant, identifying himself as having worked with Eichmann, answers his question by casually outlining the processes of mass murder. In his answer, the question loses its philosophical inflection and reduces the question of how thousands of humans can be killed on a daily basis to a matter of practical routine. The problem, he notes mid-mouthful, is not with the killing but with the disposal of the bodies. Throughout the matter-of-fact exposition, he eats, undisrupted. In contrast, the American judge, Dan

Hathaway (Spencer Tracy), lingers in a beer hall, unable to bring himself to eat; he is shattered by what he has witnessed, and his shock registers in the moral center of his gut. The dramatization of the trial, the screening, and its effects enable a clearer expression of the expectations placed on the filmic testimony as the transformation is registered on the body of the spectators, whether in remorse, shock, or unrepentant guilt.[72]

Coming almost forty years later, the television miniseries *Nuremberg* amplifies the shifts in function—both juridical and witnessing. The use of footage demonstrates the way the images from the liberation have become eminently significant and immediately recognizable as depicting a crime subject to prosecution on an international level. It equally demonstrates the way witnessing is expected to effect moral and legal transformation. Midway through the film, which chronicles the IMT, Chief U.S. Counsel Jackson (Alec Baldwin) expresses frustration with the trial, suggesting that the numerous documents have stultified jurists and reporters alike and will hinder successful prosecution. An unnamed character bursts into the room, announcing there is something they all must see. The film cuts immediately to the next court session, where lights are dimmed and projector reels begin rolling. The pictures on screen are clearly drawn from *Nazi Concentration Camps,* and yet this film bears little resemblance to the original. There is no voice-over, neither on screen nor in the form of prosecutorial testimony as in *Judgment at Nuremberg.* There are none of the awkward smiles, reenactments, or strange spoken testimonies of the survivors. Instead, the movie removes all traces of continuity editing, preferring a fragmented montage aesthetic, as if these are scraps of visible evidence, recovered for this crucial purpose; as if this were the *Original German Eight Millimeter Film of Atrocities against Jews,* a film that demanded interpretation at the time of its screening. The most iconic of camp images appear: skeletal survivors, mounds of bodies, boxcars, and barbed wire. The selected images display a distinct hand-held quality, using the rhetoric of the amateur and the observational film. Close-ups and medium shots are retained in the maintenance of this amateur voice, while jettisoned are the wide shots and aerial shots that suggest a more established cinematic operation. Each aesthetic choice gestures to a cinematic authenticity that postdates the time of the original film screening: this is more the absent apparatus of direct cinema, or more likely, the clumsy and utterly innocent gaze of the amateur photographer as bystander, recording but lacking craft. These images are more akin to those of the eight-millimeter film that defied comprehension and demanded

two screenings, a printed shot list, and a selected reading in between. But because the images of this film have become icons of the Holocaust, because liberation photographs have become "lasting iconic representation of war atrocity and human evil,"[73] their meaning is treated as self-evident; this is proof, not a document or testimony. The work of *Nazi Concentration Camps* in producing the notion of the crimes is absented like the apparatus: within *Nuremberg*, film did not contribute to the production of popular, legal, and political understanding, but merely functioned as a revelatory tool—a surprise witness—providing evidence and a call to action.

The expectations of witnessing, as well as the images themselves, are treated as self-evident and straightforward. During the screening, the gallery emits gasps and cries, but the greatest attention is paid to Jackson's secretary (Jill Hennessy) as the film adopts a shot-reverse-shot structure, producing a relationship between the spectator and screen. As she watches, the camera draws nearer to reveal a single tear, trailing down her cheek. The impression here is that the images have a clear meaning, both in the courtroom and on the psyche, and affective response—beyond uncomprehending shock, horror, and revulsion—is inevitable. Now these images can readily induce simple pity and compassion. Following the screening, the miniseries attends to the defendants whose responses are drawn from Gilbert's memoir. This includes Nazi architect Albert Speer's concern that all Germany would be held accountable for this horror, one that eventually led him to change his position and plea. Within the narrative, this decision is quickened, as if impelled by the screening. The links between viewing and response are not only strengthened, they are rendered near immediate.

Conclusion

The use and appearance of *Nazi Concentration Camps* within *Nuremberg* obscures the processes through which these images came to be this "indelible reference point" for the crimes of this horrific history by naturalizing the images and the act of witnessing. As I have discussed above, almost every stage of the process was fraught with complications. The IMT was an untested and controversial mode of jurisprudence. The charge of crimes against humanity was itself a legal limit case: the concept was vague and the jurisdiction disputed. Beset by irregularities, nonstandard procedure continued with the submission of films as evidence. In the process, efforts were made to illustrate the stakes of the charge and to legitimize the trial

while others contemplated the consequences of witnessing. By the time *Nuremberg* aired on TNT, these struggles—some of which are chronicled in this chapter—appear to have been forgotten. As with the film screened in *Judgment at Nuremberg*, this document was now unassailable, visible proof of a recognizable crime with set expectations for response.

Iconic shorthand has its uses. These images can cue recognition of atrocities, genocides, and human rights abuses, aiding in claims-making processes and attracting attention to an activist campaign. For instance, contemporary Armenian genocide recognition campaigns frequently rely on references, visual or verbal, to the Holocaust as a means of ensuring legal likeness.[74] News reportage on Bosnia featured emaciated men behind barbed wire, using such legends as "Never Again?" to promote recognition of contemporary war atrocity. At the same time, such strategies carry risks. The use of the Holocaust as framework for understanding and recognizing present-day atrocities risks privileging the West over the East, and the Global North over the Global South. In addition, the practice has the unfortunate result of relegating the events to the past, allowing collective remembering to aid in forgetting. By exchanging referentiality for universality, the connotative for the denotative, these tactics risk disarticulating the events from a historically contingent context for practical action. These visual shortcuts help us to lose sight of the procedural challenges in making unbelievable horrors into an emotional, ethical, legal, and political issue subject to international juridical management. However, by recalling the singularities of the IMT, and the use of the films therein, the many mechanisms that facilitate recognition and action are revealed, and enhance the ways witnessing is conducted and witnesses are produced.

3 REFLECTIONS ON THE WORLD STAGE

Imagining Fields of Witnessing for Rwanda and the Balkans

IN SEPTEMBER 2002, Vojvodjanka–Regional Women's Initiative, the Center for Education in Politics, and MEDIAPACT brought the photographic exhibition *Blood and Honey* to a gallery in the Serbian city of Novi Sad. Originally organized by the documentary center Wars 1991–1999 and the cultural center Rex (and supported by Freedom House and USAID) this collection of photojournalist Ron Haviv's pictures from the wars in Croatia, Bosnia and Herzegovina, Kosovo, and Macedonia had been launched in Sarajevo, then was mounted in Zagreb, before moving to Serbia, where it met with controversy. Groups collected in each city on the exhibition tour. They frequently wore T-shirts featuring either Radovan Karadžić or Ratko Mladić with the legends "Serbian Hero" or "With the Faith in Good and Homeland" as they decried the "anti-Serb character" of the exhibit, leading to cancellations in the cities of Užice, Kragujevac, and Čačak. These events led the organizers of the Novi Sad exhibition to make some changes. Photographs appeared without commentary. In the place of instructional legends that anchored the meaning of the images were blank sheets of paper where visitors provided their own written responses, posting their own photos and documents, and entering their own comments into the "Book of Impressions." The short documentary *Vivisect* (Marija Gajicki, 2002) depicts this exhibit and, more importantly, the varying responses of the visitors. Although principally intended to facilitate discussion in a number of arenas, including investigations into local attitudes on war crimes and suitable models for truth and reconciliation in Serbia, this project also addressed the challenges of media witnessing.[1] The idea that images speak for themselves was challenged, both by the exhibitors' decision to remove anchor text and by the varied responses of the visitors. So too was the idea that one could readily mobilize either shame or empathy

with a photograph of suffering. If the model of seamless recognition and response seen in the miniseries *Nuremberg* (Yves Simoneau, 2000, TNT) had ever really existed, it was once again disrupted.

Between 2002 and 2004, *Vivisect* received domestic and international attention, broadcast on both Serbian and Croatian television before screening at human rights–oriented film festivals in the United States, Serbia and Montenegro, Spain, Poland, and Switzerland. This documentary was indicative of a trend that developed around the turn of the millennium in which witnessing—and media witnessing—became part of the presentation of wartime violence, genocide, and ethnic cleansing. This reflexive trend is not necessarily new. *History and Memory: For Akiko and Takashige* (Rea Tajiri, 1991), for instance, uses newsreels, popular film, and amateur photography to explore the interaction of official and personal memory of the Japanese American internment during World War II. Raoul Peck's *Lumumba: La Mort du Prophète* (1992) incorporates the recognition of the costs involved in using newsreel footage, gesturing to the political economy of film memory. Most notably, there is *Shoah* (Claude Lanzmann, 1985), which refused archival footage as it explored the question of witnessing for the event without a witness. However, this kind of reflexivity had been linked, predominantly, to the modernist experiment—documentary or otherwise. Popular feature narrative films, on the other hand, rarely problematized archival and actuality footage, more often drawing on the media as a vehicle for communicating historical truth. Steven Spielberg, for example, used black-and-white shooting and references to other Holocaust photography and films to imbue *Schindler's List* with authenticity. Ironically, given Lanzmann's refusal of imagic mastery, *Shoah* supplies an intertextual and legitimating reference in Spielberg's film when a young boy watching the train pass draws his finger across his neck. As he does so, the boy gestures to both the characters' impending fate and to a lengthy sequence of corroborated testimony of survivors and bystanders in the nine-hour documentary. However, what had been typically present within experimental and peripheral documentaries emerged as a shared theme in the feature films depicting the crises in the Balkans and the genocide in Rwanda. Not necessarily demonstrating the same interrogation of formal qualities or the differing registers of truth possessed by film or video, these films nevertheless take on the question of witnessing. *Before the Rain* (Milcho Manchevski, 1994), *No Man's Land* (Danis Tanović, 2001), *100 Days* (Nick Hughes, 2000), *Hotel Rwanda* (Terry George, 2004), *Sometimes in April* (Raoul Peck, 2005), and *Shooting Dogs* (Michael Caton-Jones,

2005) feature the presence of bystanders: the UN Peacekeepers, international monitors who were witnesses to violence; and the mass media who reported the events and in turn aided in the production of virtual or attenuated witnesses.

The incorporation of the act of witnessing and its technologies does more than present a depiction of events in keeping with common wisdom; this reflexive turn invites an interrogation of expectations around media witnessing. Despite the global media technologies that provided wide-ranging and immediate reportage of ethnic cleansing in Bosnia-Herzegovina and Kosovo and genocide in Rwanda, the events were seen to transpire on the world stage to sluggish and minimal response. Such overwhelming failure raised powerful questions regarding the "peculiar post-modern combination of instant transparency and vividness together with instant deniability and disappearance."[2] This angst hinted at the persistent faith in the benefits of visibility and exposure, presuming that witnessing should have inspired response. By representing the technologies, agents, actors, and operations that structure the testimonial encounter, these films stage a necessary intervention into the understanding of visual media and their relationship to the production of testimony and action. Dramatizing the presence of mass media practitioners not only calls attention to global witness and indicts inaction, but also highlights the ways in which mass media are composed of a variety of actors, economies, knowledges, and practices that have an impact on the stories that are told and the types of response that ensue.

The previous chapters have taken up these struggles and negotiations, mapping out a landscape of witnessing much like Pierre Bourdieu's "field of cultural production."[3] In each case, actors and institutions have drawn upon available resources and capital—whether technological, symbolic, or political—in order to produce responses to distant suffering. Near East Relief harnessed the potential of global circuitry enabled by film and Christian missions, producing victim groups and transnational alliances drawn together through Christian affiliations. The Nuremberg Trials literalized the role of film as witness, using documentary footage to prosecute Nazi officials and to develop a visual register for a new crime: crimes against humanity. At the same time, this system of management was burdened with complications and controversy, as both the crime and the international jurisdiction were untested.

Despite these clear challenges, a conviction in the transparency and transformative power of images reigns. The *Nuremberg* example from the

previous chapter demonstrates this presumption of immediacy, as images that have only now become shorthand for genocide were portrayed as recognizable and accessible, and capable of ensuring guilt. In the sequence, the fragments become evidence, rather than a component of a larger witnessing framework designed to produce meaning and response. This sequence, it might seem, draws more on the work of Susan Sontag, whose famous recollection of liberation photos speaks to the visceral quality of the photographic image, as well as its self-evidence and transformative capacity. Even the understanding of genocide, as it came to emerge, has been equally fraught with competing notions of self-evidence and expectations of action. As discussed in the introduction, the UN Convention on Genocide promises prevention and punishment of the crime. The mandate affixed to the convention, the expectation of action to follow recognition, was reflected during the Rwanda genocide, when the United States refused to use the word, concerned that it would "inflame public calls for action,"[5] and that "it would harm U.S. credibility to name the crime and then do nothing to stop it."[6] The development of global media circuitry has only amplified these expectations, as atrocities can be seen across the world, reported live, or (now) posted online almost instantaneously. In spite of the questions and complexities that attended these previous cases of visual witness, the certainty in the power of visibility and knowledge, and the attendant rational outcome seemed to persevere.

It was this faith that was shaken when profound human rights catastrophes in the Balkans and in Rwanda took place with little response from the international community—a concept that had gained some currency following the International Military Tribunals and with the development of the United Nations. The scandalized tone in the description of this failure highlights this faith, and the staggering blow dealt to it in the 1990s. David Rieff writes of Bosnia: "Two hundred thousand Bosnian Muslims died, in full view of the world's television cameras and more than two million other people were forcibly displaced." Meanwhile, "there was no will in the international community to do anything," and the UN looked on "'like eunuchs at the orgy.'" The trope of visuality continues as Cushman and Meštrović write in the tellingly named *This Time We Knew*, "the West . . . played an important role in the Balkan War: the role of voyeur. The West has been a silent witness to some of the worst atrocities and crimes against humanity to occur in Europe in this century."[8] Thomas Keenan notes Cardinal Jean-Marie Lustiger's observations of the "strikingly public or visible character of the carnage," writing, "Lustiger's bold and uncompromising

position, as rare as it was at the time, has now achieved a status of common sense. Among the too many would-be 'lessons of Bosnia' this one stands out for its frequent citation: that a country was destroyed and a genocide happened, in the heart of Europe, on television, and what is known as the world or the West simply looked on and did nothing."[9] This characterization of visibility attended descriptions of the Rwandan genocide, even as journalists were evacuated from the country early in the crisis. The charges were enhanced by the recognition of racism that informed the neglect of Africa. Unintentionally recalling the editorial cartoon "Idle Tears" discussed in chapter 1, President Paul Kagame (Major General of the Rwandan People's Front) described the witnessing world as "[standing] around with its hands in its pockets."[10] On January 11, 1994, Lieutenant General Roméo Dallaire sent a fax to the UN peacekeeping office. The message reported a discussion with an anonymous informant who "had been ordered to register all the Tutsi in Kigali. . . . He suspects it is for their extermination. . . . Example he gave was that in 20 minutes his personnel could kill up to 1,000 Tutsis."[11] The fax, however, failed to inspire response. Samantha Power writes, "But instead of testing the major powers or attempting to shame them by leaking the alarming news, Annan [Kofi Annan who at the time ran the UN peacekeeping office] buried the 'genocide fax.'"[12] Although this story does not conjure up images of the television cameras, it does invoke the presence of transnational media communications and the disastrous failure to respond. Each one of these descriptions resonates with the expectations of witnessing: seeing and knowing was supposed to have encouraged action—or mobilized shame, as Power's account suggests—but instead profoundly disappointed.

Crisis of Witnessing

This crisis of witnessing, inaction in the face of visible suffering and atrocity, dovetails with the scholarship tackling media's numbing capacity. As noted in the introduction, concerns over a lack of feeling (or inappropriate feeling) inhabit the terms "compassion fatigue," "cultural anesthesia," and "disaster pornography." These terms refer to the dulling of public sensitivity by practices and modes of news presentation: there are audiences, but no politicized witnesses. Susan Moeller attributes "compassion fatigue" to overexposure as well as sensational treatment—a relentless flow of singular and spectacular events that horrify but defy engagement.[13] For Allen Feldman, cultural anesthesia comes from rendering another's, or rather

the Other's, incomprehensible pain, both exceptional and inevitable.[14] And as Stanley Cohen has observed, this constant barrage of imagery may result in the normalizing and routinizing of distant suffering, while Arthur and Joan Kleinman suggest habituation to these images diminishes obligation for political or social response.[15] Tensions permeate these explorations, as news media strive to make distant events comprehensible and consumable, and thus filter events through near standardized dramas that compartmentalize and simplify. At the same time, the news media demand reasons for coverage, and thus aim for scale and sensation that can overwhelm: one of many flares on an already fiery landscape.)

Such commodification and management of distant events has given rise to questions of reality or hyperreality. These concerns have been around a while, as evidenced by early mistrust of mass culture as purveyor of false consciousness and convictions that visual media culture eroded authenticity (producing "pseudo-events" in lieu of the real").[16] However, they were certainly aggravated by the television news coverage of the first Gulf War in 1991, a carefully managed televisual conflict whose erasure and control were predicated on strategies of realism. The U.S. government, seeking to maintain public approval, harnessed news media technologies to tell the story of a largely bloodless invasion. The machinations that sought to align viewers with the government position were so evident that Jean Baudrillard described the war as "a figment of mass-media simulation techniques without real world referents."[17] Later in 1991, as the aggression came to a close, Baudrillard famously claimed that "the Gulf War had not taken place," a reference to both the uncertain political status of the conflict (no conclusion was reached) and its highly mediated aspect.[18] This sentiment, unfortunately, does not account for the profound impact of this nonexistence on the ground or in the airwaves. Suggesting the carry-over effect of previous news cycles, Scott MacKenzie argues that the coverage of the Gulf War enhanced the cultivated skepticism in news reportage and informed the reception of reports from Bosnia-Herzegovina. What resulted was diminished sentiment and urgency to act.[19]

Conversely, one could argue that these machinations aided in choreographing a response from their audience, a position suggested by the film *Wag the Dog* (Barry Levinson, 1997) and its on-screen union of Hollywood producers and political spin-doctors. Although all wars are imbricated in "logics of perception" whether through military technologies, reportage, or cinema,[20] the representation of the first Gulf War threw these logics into relief. Marita Sturken posits that the representation of the atrocities of

the Vietnam War, which led to political protest in the 1960s and 1970s, prompted a shift in news coverage in the 1990s. The Pentagon became co-anchor in order to contain evidence of human cost and suffering—assumed to provoke dissent—and to suture viewers into a grand narrative of nation. She writes, "The image icons of the Gulf War are of weapons and targets, not of human beings. Military censorship kept reporters and their cameras where they often had access only to distant images of bombers taking off and weapons in the sky. Images of the dead, incinerated bodies on the road to Basra . . . were shown only selectively by the U.S. Media."[21] News programs sanitized the battleground in order to marshal national support for the war. "Unlike the fragmented body of the American military during the Vietnam War, the body of the military in the Gulf War was perceived as a whole, moving forward in a single mass."[22]

Although the reportage diminished confidence in images and minimized their power to foment response, this effect was not an accident of overexposure, or of commodification, or even of a move to simulacra. Carefully designed campaigns influenced reportage to align the spectator with the U.S. governmental position. Moreover, these campaigns were born from a suspicion that viewers would respond to images of suffering. The Pentagon intervened precisely because it was assumed media images produce relationships of compassion and responsibility. Images of Iraqi suffering and U.S. military losses risked producing resistance to the war, much as had happened during the Vietnam War. News coverage was thus managed to contain dissent and marshal support. These interventions suggest that mediated witnessing does accomplish something; these achievements, however, cannot be reified or placed into absolute categories. It is not simply that watching numbs or offers pleasure. Rather, the responses result from media strategies and practices designated to promote particular emotional impact—including numbness.

Whatever thorny relationship exists between representation and lived experience, the signifier is not completely unanchored from the referent. The issue, rather, involves the ways in which experiences are filtered through the visual apparatus and cinematic mechanisms. The model of representation organized around the binary oppositions of authenticity and artifice, signifiers and referents, or compassion and numbness, is ineffective in addressing the complexity of the witnessing landscape. So, too, is the view of news media as monolithic operations with singular effects. The work and impact of news media—and other visual media witnesses—deserve attention, and many films about the genocides of the 1990s grant

just that. Although some of the films in this chapter rely on relatively basic dramatizations of news media work in order to perform the complicated conditions of bearing witness, many deepen the exploration by incorporating news footage, put to use as both exposition and critique. In this way, they disaggregate media and media impact by presenting the array of players and technologies—journalists, editors, footage (raw, televised), and political and corporate economies and institutions—that shape the testimonial encounter for global publics. By introducing a more nuanced discursive terrain, these films provide an understanding of witnessing that presses beyond the immediate correspondence of visibility and action, and finds practices of witnessing (and potential for failure) beyond image and audience. In order to examine this reflexivity, this chapter shifts its focus from the field of witnessing off screen to the ones depicted on screen.

Before the Rain

Before the Rain (Milcho Manchevski, 1994) uses an elliptical narrative to tell the story of a disillusioned war photographer, Aleksander Kirkhov (Rade Šerbedžija), and a localized violent outburst in Macedonia. The structure embeds witnessing—its players and its conditions, institutional and otherwise—in a complexly rendered discursive terrain. Throughout, events take place that question Aleksander's observer status in order to introduce the issue of responsibility: what role does the photographer play in the theater of war?

The film, told in three parts, opens with the section "Words," which introduces the case of a domestic skirmish between Christian and Albanian Muslim families that escalates into near civil war. When a man attempts to rape the teenaged Zamira (Labina Mitevska), she kills him and then flees as her own family worries for her honor, while the man's family seeks revenge. Seeking sanctuary, Zamira asks the protection of a young monk, Kiril (Grégoire Colin), who has taken a vow of silence that he can no longer keep. The violence, however, escalates, and before too long claims the life of Zamira.

The second part, "Faces," removes us from the site of conflict and places us in the economy of conflict representation: a news agency. Anna (Katrin Cartlidge), an editor, casually thumbs through war photographs as she listens to news on the radio. This sonic aspect depicts the producer within a field of cultural production where she is both news media agent and audience.[23] The collected stills evoke images of Bosnia and political loss.

There is a scrawny man, a civilian soldier with an automatic weapon, a young man with a swastika armband, two children lying dead in the street, a soldier holding a portrait photograph, and a woman, collapsed over a seemingly fresh grave marked with the date 1992. The montage returns to the first man, and the camera pulls in to reveal his emaciation and shorn head. The close-up and return call attention to the double resonance of the picture: the prevalent images of Bosnia predicated on Holocaust iconography. The privileged attention the photographs receive on screen does not extend to the diegetic world. Anna tosses the photographs onto a desk already covered with stacks of pictures. She almost spills coffee on these photos, but rescues them by throwing them into a drawer already crammed with photos, aligning the uncertain landscape of survival with the uncertain landscape of representation. The sequence highlights the human aspect of the players within the journalistic field; there are actors caught up in the same terrain, subject to accidents and distraction. The excess of images and their tangential ties to actual violence (suggested through the overall structure of the film that binds these words and faces), are only a few factors in representing distant suffering.

A later sequence magnifies the complicated interactions between events and their representation. Anna returns to her work scanning photographs. This time, included in the depictions of violence and carnage is a photograph of Zamira, dead from automatic gunfire. Another photo shows Kiril, disconsolate, sitting on his suitcase. The families stand around with automatic weapons. The images disengage the figures from their stories: they can now be anyone caught in gunfire, or left lost and homeless thanks to civil war; only the film, a context beyond the photographic encounter, provides anchorage and understanding. At the same time, the practical connections between image and lived world—a world that includes Anna—deepen when the phone rings. It is Kiril looking for his photographer uncle, Aleksander; Kiril needs his help. The elliptical temporal structure of the narrative suggests that action is both still possible and a foregone conclusion.

The fatalism of this structure expresses the seeming relentlessness of violence that exhausts and demoralizes Aleksander. However, there is also an event that precipitates Aleksander's departure from the field of war—an event that challenges the otherwise facile "cycle of violence" by questioning the possibility of neutral observation. In "Images," the final section of the film, Aleksander describes the encounter that prompted his earlier confession, "my camera killed a man." The confession sequence

becomes its own commentary on testimony and the role of communications technologies as Aleksander composes a letter on his computer. His voice-over narrates the conditions of the static photographs that illustrate his memoir, deepening the audience knowledge of their context while emphasizing the need for words with images. There are two photographs that accompany his first admission. One shows a Serbian militia leader, shooting a man execution style, point blank to the back of the head. The second follows the moment of execution, showing the victim recoiling in mid-collapse. Both invoke the infamous filmed execution of the Viet Cong prisoner.[24] Aleksander writes, "I got friendly with this militia man, and I complained to him I wasn't getting anything exciting. He said, 'No Problem' and pulled a prisoner out of line and shot him on the spot. 'Did you get that?' he asked me. I did." A third photograph takes the screen; this one depicts a man falling to the ground. A fourth photograph shows the next stage of collapse. Aleksander continues: "I took sides. My camera killed a man." He prints out the letter and places it in an envelope with the pictures.

The confession disrupts the simple formulation of neutral transmission. While the photographs illustrate the events Aleksander narrates, bound in this confessional sequence, they also suggest the function of Aleksander and his camera in the Serbian militiaman's drama that the images chronicle. The sequence places Aleksander into the terrain he represents, and asks what work he accomplishes. Contrary to the human rights formulation that dictates fear of exposure and mobilization of shame as chief mechanisms of management, the Serbian acts for the camera presence. This atrocious display recalls the baffling images captured by BBC and ITV news crews of Serbian soldiers waving brightly at the cameras as they conducted the looting and burning of a village.[25] Do they do this for the camera, or in spite of it? The scene points to the unintended consequences of a photojournalist's physical presence. What exactly does the photojournalist accomplish as witness? Assumptions of neutrality, accusations of inefficacy, or even Baudrillard's charge of derealization cannot account for the full, rich terrain of media that requires human players, recording technologies, and economies of distribution, circulation, and exhibition. Nor can charges of fatigue or derealization account for the ways in which these dramas play out and the human cost they can incur. Manchevski's film does more than illustrate the cycle of violence: it asks us to consider what practices of visual mediation mean in terms of fostering connection and helpful response.

No Man's Land

The dark comedy *No Man's Land* (Danis Tanović, 2001) engages more explicitly with the operations of news media, but directs the bulk of its ire to another set of first-hand witnesses and on-screen surrogates for the concept of "global civil society": the UN. Set in 1993 Bosnia-Herzegovina, the film relates the story of three men trapped in a trench in the no-man's-land between the Serbian and Bosnian lines. Serb soldier Nino (Rene Bitorajac) and Bosnian Čiki (Branko Đurić) both fight and talk when Bosnian Cera (Filip Sovagović), initially left for dead, awakes atop a "bouncing mine." Nino and another Serb solider (now dead) had placed him there as a form of booby-trap, to kill those collecting the body. The situation is untenable: Should Cera move, the mine will detonate and destroy everything within a fifty-meter radius. Seeking relief from this intolerable situation, Čiki and Nino get their respective armies to seek assistance from UNPROFOR, the UN Protection Force. UN officials and news crews convene around this explosive situation, producing a carnival of impotence as the pressures of global attention yield management of perception in lieu of meaningful intervention. The film concludes with a violent outburst that leaves both Čiki and Nino dead, and Cera in a state of anxious limbo, between a mine and certain death.

Following in the tradition of *Dr. Strangelove* (Stanley Kubrick, 1964), *M*A*S*H* (Robert Altman, 1970), and *Catch 22* (Mike Nichols, 1970), *No Man's Land* presents a case for the absurdity of war. However, the players in this theater of the absurd are no longer limited to the military players of each side, as global observers, the UN, and the television news media are brought in to be lampooned. The UN in particular becomes the target of Tanović's indictments for failed intervention: they were there, they had the means to respond, and yet they did nothing. Tanović recalls: "I don't think it's understandable. I don't think, for you, it's even understandable to feel what I feel when I talk about 9,000 men from Srebrenica who were under protection of United Nations forces—okay?—who got slaughtered in one day. And, during that time, United Nations peacekeeper soldiers who were there and supposed to protect them were playing football with Serbian soldiers."[26] Such a clear presence and failure of inaction becomes a legitimate, institutional target for the film's satire. In a milder form of fun that reflects the attitudes in Bosnia at the time, characters refer to the UNPROFOR as "smurfs" for their blue helmets. But Tanović reserves his more biting criticisms for Colonel Soft, the head of UNPROFOR

(Simon Callow), whose name reflects his inefficacy. Soft is craven and self-interested. He receives much of his information by watching the television news from his office. He plays a game of chess, refusing to tend to the trench and interrupting his game only when he realizes his reputation is endangered by his inaction. When his plan to rescue the men fails—Nino and Čiki kill each other, and the "bouncing" landmine cannot be defused—he turns his attention to a cover-up. A body wrapped in tarp is carried away; it serves a decoy to lead away the news teams from the trench that still contains a hopeless Cera. The film returns the suffering body to the logistics of perception.

The character of French UN Peacekeeper Sergeant Marchand (Georges Siatidis) complicates what could be the easy condemnation of Soft's comic foil. Marchand articulates his frustration and desire to help, and in doing so dissipates the notion that institutional postures of neutrality and inaction are universal. He dramatizes the angst of knowing and the angst of being a professional witness barred from acting. When he learns that two men are trapped in no-man's-land (Nino and Čiki who have stripped down to their underwear in order to hide their national and military affiliations),[27] Marchand requests permission to respond and investigate but is refused by his superior, Captain DuBois. The exchange inspires his angry outburst, "What the fuck are we doing here?" to which a colleague responds, casually, "I reckon it's simple: to stop the locals killing each other. Except that we can't use force or get into dangerous situations." Marchand chooses to act nevertheless. "I'm sick of watching," he mutters, heading for the tank. For Marchand, listening and watching have inspired compassion and the urgency to act.

Marchand's first move takes him to both fronts, where he struggles to communicate his concerns and to learn of the conditions in the trench. What was already challenging is made more so by the veritable Babel of the situation: there is no shared language. This aspect calls attention to the international character of the crisis, as the entire scene recognizes the complications of marshaling a unified and coherent global response. The heteroglossic aural landscape intervenes into the myth of "global civil society" as a tangible and manageable entity.

Language issues meet practical ones when Captain DuBois orders Marchand to leave immediately. Fed up, Marchand turns to a mechanism of communication and action: a television news crew (the Global News Network). Although he first tells them to leave, he recognizes their potential to trigger a response from the UN. He invites head reporter Jane Livingstone

(Katrin Cartlidge) into his tank to interview DuBois via radio regarding the situation in the trench. When DuBois tells her that a cease-fire has been called and negotiations are taking place, Marchand points out the lie, prompting Livingstone to pursue her questioning. Livingstone concludes her frustrated attempts at an informative interview with a threat: if the UN does not respond to this minor crisis, she will file the report as she understands it. The threat calls up the human rights practice of mobilizing shame, a tactic generally directed to perpetrators, thereby suggesting a complicit role for the UN and the impossibility of neutrality among professional bystanders. The exchange between Marchand and Livingstone renders explicit these ideas. When Livingstone asks him why he has intervened, Marchand answers, "I am sick of being a bystander. I want to stop the madmen who are ruining this country . . . You can't stay neutral in the face of murder. Doing nothing to stop it is taking sides."

That television news presence can accomplish something is readily established. Marchand manipulates interview circumstances to apply pressure to his superior. In turn, the report that follows both agitates Colonel Soft and elicits his response and ensuing intervention. These sequences, it would seem, bring hope, as they indicate the capacity of media to activate viewers. However, the responses of these characters do not spring from compassionate sentiment, but from another social emotion: shame. Martha Nussbaum recognizes the social and moral work of this emotion, but warns of its capacity to stigmatize.[28] And indeed, Soft's action rises from fear of injury to his reputation. But this fear, as we see in the film, leads the men to manage the perception and to cover up that which they cannot rectify. By the trench, the UNPROFOR officials arrange briefings, cordoning off the area and controlling access to the view. The mine expert arrives to defuse the mine, but there is bad news: it is a "Bouncing Betty" landmine, notorious for its exceptional capacity for destruction and for its inability to be deactivated. (The fact that this mine is produced in both the EU—a character observes earlier in the film—and the United States provides another indictment of the damage wrought by "the West."). "If the journalists get a whiff of this, they'll crucify us. Go into the trench and pretend to be busy," DuBois instructs the munitions man. In the meantime, they design their plan: they will remove another body, wrapped in tarp, to distract the journalists. By the time the evening press conference occurs, they will announce that Cera has died. "I'm very pleased, gentlemen" declares Colonel Soft as they stand above the trench where Cera lies.

Response, Tanović seems to argue, is the result of public relations management. He says as much in an interview. "Even when they came to save us in 1996, 1995, I was wondering who did they come to save? Us, the Bosnians? Or did they come to save their image, which was blown to pieces, because everybody saw what it was all about."[29] This pronounced concern over spin generating a war of images conveys Tanović's ambivalence: media do accomplish something (Marchand, for example mobilizes the initial intervention through news media presence), but these accomplishments, as Soft's actions demonstrate, are just as readily turned around to save tarnished images. At the same time, however, Tanović's own film can articulate this multiplicity and address both the potential and shortcomings of visual media.

In addition to critiquing image management, Tanović calls attention to the economy of suffering in which news media (and others) traffic. While the media teams and UNPROFOR stand around, awaiting the next briefing, Čiki creates a distraction and grabs a gun. At first, he directs his vitriol at Nino, who had stabbed Čiki with his own knife. But the journalists grab their equipment and hone in on the action prompting Čiki's outburst: "Don't come any closer! You are all the same! And you vultures film it? You get good money? Does our misery pay well?" His anger could be dismissed as frustration and dismay, and yet, the following sequence underscores his accusation. Nino tries to grab a gun from a peacekeeper; Čiki shoots Nino and the peacekeeper shoots Čiki. The sounds of clicking camera shutters join the gunfire, equalizing the mechanisms of violence on the sonic landscape. "Did you get that?" asks Livingstone as silence descends. There is a cut to the distant GNC headquarters as the news professionals look into off-screen monitors, hands over their mouths. The capacity for global witnessing is presented as the first order of witnessing agents, and the journalists appear callous—shooting cameras while others shoot guns. The shock these witnesses experience is genuine. But also genuine is Čiki's question regarding the economies in which suffering circulates: there is the political suffering intended to inspire action, the news item intended to produce knowledge, and the commodified and spectacular suffering intended to generate cash.

It is the final economy, this search for the sellable news item, that provides the bitterly comic last moments of the film. As everyone decamps, leaving the trench for the next place of news, the cameraman asks Livingstone if she would like a shot of the trench. "No, a trench is a trench, they're all the same," she responds. The suggestion is tacit: if a trench image is

needed for this story, one can surely be procured from stock footage, or shot anywhere. This careless economy, able to exchange one image for another, risks missing historical specificity. This last moment conveys Tanović's fundamental ambivalence regarding the relationship between images and response the camera carries the potential to bear witness to horror and transmit it to a global audience; the physical news presence can pressure action; and yet economies of self-interest and commerce can diminish political possibility. These last economies encourage the management of perception over the management of crisis and conflict.

At the same time, Tanović seems to remove *No Man's Land* from the field of witnessing he depicts. His is a privileged viewpoint, with cameras stationed at all relevant points of the narrative, providing the audience with a coherent and complete story. Courtesy of the last shot, looking down on Cera, lying on a mine, waiting for help that will no longer come, the audience knows that this trench is not the same as others. Any gaps or difficulties in directing this international coproduction (France, Slovenia, Italy, UK, Belgium) or negotiating a multilingual script (English, French, Bosnian, German) are absent. The film's appeal seems to linger mostly in a standard narrative that emphasizes the absurdity of war and expresses the frustrations around "media," which, although ostensibly plural, seem to be shockingly monolithic in behavior. While Tanović rightly investigates the questions of journalistic and political witnessing, one wonders about the role of this film as witness. To what does the film bear witness and to what ends?

Footage on Film: Bearing Witness to Genocide

Despite its place in a legacy of comic war films, *No Man's Land* offers something more. The issues of genocide, ethnic cleansing, and crimes against humanity are not absent. The costumes of the protagonists, Nino and Čiki, indicate that what occurs here is more than a civil war. The mise-en-scène of the Serbian side is strictly military. There are forts, gear, and uniforms. Nino first appears in fatigues and carries a survival kit. At the same time, however, his bungling and inefficient management of the gear suggests that he, like many other Bosnian Serbs, has been forced into service against his will. By contrast, the Bosnians seem unprepared and confused: the relief squad from the film's beginning is dressed in flannel and T-shirts. While Čiki's Rolling Stones T-shirt provides comic incongruity with Western pop culture making an appearance in southeastern

European fighting, the costume also hints at the disparity in fighting forces: Serbian paramilitary forces backed by the Yugoslav Army (JNA) versus a slapdash assembly of civilian soldiers.

The sartorial laxness emphasizes the unpreparedness of the Bosnian force demonstrated throughout the story. The film opens in a thick fog, itself signaling a distinct lack of clarity. But the confusion also belongs to the Bosnians. They are lost and led by a man whose constant alerts to danger point more to his incompetence than to any combat acuity. "Fuck him if he knows where he's going," says Čiki to one of his companions. The fact that the man leads this team straight into the front lines underscores this sentiment.

While the depiction of combat between military and civilian forces introduces the potential for viewing events within a framework of crimes against humanity, Tanović's use of actual news footage, presented as a news item, makes a more explicit case for the charge of genocide. The item supplies helpful exposition as it suggests that the Republika Srpska enacted ethnic cleansing against Bosnian Muslims. The item begins with footage of Radovan Karadžić threatening an assembly of voters in Bosnia-Herzegovina. He warns them against voting for self-determination (as opposed to accepting the governance of Republika Srpska) and declares that if they should vote for independence, "You're pushing Bosnia-Herzegovina to follow the same path of horror and suffering as Slovenia and Croatia. You'll lead Bosnia into hell and this may end up exterminating the Muslim people." The speech calls to mind Hitler's final oration in *The Eternal Jew,* repurposed for *The Nazi Plan* and initially presented before the Reichstag in 1939. Therein, Hitler warned European Jewry against actions—he accused them of planning a war—that would result in their inevitable demise. The leaders couch otherwise explicit threats in the language of a warning.

The scenes of tanks overrunning and firing upon local towns actualize the threat and the emplotment of events in the mini-narrative makes the argument for intent, a key component of the genocide claim. An English voice-over ensures the temporal order and interpretation of events: "Radovan Karadžić didn't wait long to carry out his threat. Bosnian Serb paramilitary forces, largely helped by the Yugoslav Army, furiously attacked Bosnian cities that were defended only by armed Bosnian civilians and the rest of the police forces loyal to the Bosnian government." Video of tanks, cities, and major explosions indicate the use of heavy artillery, again emphasizing the disparity of military against civilian. The voice-over continues: "Serbs

started massive attacks against civilian targets, spreading fear and terror and introducing a new term, 'ethnic cleansing.'" The phrase "ethnic cleansing" introduces the atrocity footage of bodies, bloodied, wounded, and dead. With this sequence, Tanović conveys an essential piece of information—this is not merely a war, it is an international crime akin to genocide and crimes against humanity. The state has intentionally launched a violent campaign against ethnic communities in the civilian population.

The extended news footage critiques the UN and the response to crimes that fall under their jurisdiction. The reporter continues to enumerate the horrors of ethnic cleansing, massacres of civilians, and the siege of Sarajevo, while the attendant footage increases in bloodiness. "The world community finally decided to do something after Serb artillery massacred people waiting in lines for bread," notes the voice-over. "The UN Security Council decided to send to Bosnia 9000 troops supported by the American 6th fleet." Although the on-screen arrival of armed UN peacekeepers would suggest the arrival of much-needed intervention, this is not the case. The report continues with the appearance of French president François Mitterand in Sarajevo; there he meets with Karadžić and determines a new course of action: humanitarian aid action. In this new plan, UN troops do not intervene, but serve only to "protect and follow the UNHCR relief convoys without any right to interfere in the conflict." Throughout the sequence of Mitterand's visit, sound and image tracks operate in an economy of direct exchange: the word "airport" is accompanied by pictures of planes; the words "humanitarian aid action," are accompanied by soldiers unloading boxes and placing them in the relief convoys. Meanwhile, a scene of corpses strewn throughout a road illustrates "without any right to interfere." The shocking interruption into this filmic economy is multipurpose. The disruption calls attention to schisms between report and situation—what one learns is not what happens. More importantly, however, situated within this economy of direct exchange, this pairing of word and image advances its own claim: there is violence and suffering embedded in the policy of nonintervention. There is no neutrality; one always chooses sides.[30]

Most striking, and most potentially problematic, about this interlude is that Tanović employs the very medium he critiques in his narrative. The footage, built from actual news reports, adopts the news format to provide exposition, make genocide claims, and levy criticism of UN policy. Although the narrative of the film questions the economy and impulses of mass-media coverage, Tanović nonetheless values the contribution for

these history-making purposes. The report format and the texture of video serve as truth-claims, anchoring his argument within the gravitas of the lived world, covered by news and governed by men like Karadžić and Mitterand. Using atrocity footage in this actuality mode may not only augment the truth with the recognizability of the human form, but it also shocks and expresses the limits of the cinematic while upholding Tanović's role as master witness. The bodies, this atrocity, and the suffering remain outside the bounds of possible narrative representation, although this unwieldy media world can be made sensible and useful under the control of this director. The realism of the clips interpellates the spectator into Tanović's point of view, priming the viewer for the criticisms of the UN— the surrogate witness in the text.

The use of this footage does not undermine Tanović's critique of news media, whose presence throughout the film oscillates between effective and ineffective in generating political response. Rather, this footage maintains the promise of the media witness, even in the face of potential and apparent failures. Visual media retain the capacity to testify for a global audience, but the on-the-ground actors can be led astray, buying into cover-ups or participating in an economy that profits from the suffering depicted. Tanović's cinematic ambivalence does not lament failed compassion or the loss of authenticity but instead renders the multiple registers of mediation and the many technologies of witnessing that present distant suffering and political horrors for a global audience expected to respond.

The Rwandan Genocide

Tanović broadens his terrain of witnessing in a scene at the Bosnian front, where two soldiers stand guard. One of the men reads a newspaper and shakes his head, "What a mess in Rwanda!" The outburst is playful, yet rich in meaning. The events in Rwanda, like those in Bosnia, are taking place on the world stage, courtesy of mass media communications technologies. *No Man's Land* has, by this point, addressed first-order witnesses of UN peacekeepers, government officials, and the news media (on the ground and at headquarters). Now he introduces another: the "average" news reader, the one who exclaims, who shakes his head, but who may very well lack any means of responding to the distant crisis.

The feature narrative films about Rwanda—including *100 Days* (Nick Hughes, 2002), *Hotel Rwanda* (Terry George, 2005), *Sometimes in April* (Raoul

Peck, 2005), and *Shooting Dogs* (Michael Caton-Jones, 2005)[31]—continue the exploration of global witnessing. Television news teams and UN presence are again an unavoidable (if ineffective) presence. The film *100 Days*, directed by photojournalist Nick Hughes and produced by Eric Kabera, repeatedly depicts camera crews and reporters as a part of the landscape; they relentlessly film the horrifying events and stop only when made to retreat with the UN peacekeepers. Anticipated audiences and the UN presence hint at the existence of global witnessing publics, and their responsibility to and participation in the vague entity of "global civil society." The inclusion of media and UN presence are clearly elements of any realistic portrayal of the genocide in Rwanda; they were there, after all. But as in the case of the films discussed earlier, the inclusion of media and UN presences affords the filmmakers an opportunity to interrogate how these media failed to inspire response (Greatly enriching this exploration is the inclusion of the media technology that did activate political publics: Hutu Power Radio. Also known as Radio Mille Collines (RTLM), the radio station fomented ethnic hatred, incited the genocidal massacres, and facilitated to the work of the Interahamwe (Hutu extremist militia) by giving out tactical details and locations. These inclusions again complicate the simple formulation of visibility or knowledge leading to action; in some cases witnessing, visual or aural, accomplished action, in others witnessing accomplished little.)

The Presence of News Media

The inclusion of news media in the diegesis enables both commentaries on and interrogation of the visual communication technologies and their work in bearing witness. Each film presents journalists as characters, and *Sometimes in April*, much like *No Man's Land*, deploys news items as mechanisms of exposition and reflexive critique. At times, the criticism is straightforward, as in *100 Days*, where journalists and news teams behave in a callous manner, intruding and retreating without much thought of those caught in this wave of horror. In one jarring scene, a young man walks into the home of his neighbors, who have been slaughtered. He looks around, horrified by his discovery and fearful for his own safety. He hears a noise, and jumps, ready to flee, when a news crew descends. A reporter throws a microphone into his face, and another directs camera and light into the eyes of the bewildered man. The barrage of questions is as intrusive and overwhelming as the technology: "Were they Tutsi?" the reporter

asks. "I don't know ... yes ... they were Tutsi." "Is that why they killed him?" Still confused, he struggles, "I don't know, I don't think so." The questions continue with the reporter seeking information but the man stammers in response, too traumatized to provide a clear testimony.

The scene captures a familiar scenario: cameras in the face of a victim of fresh trauma, lost and uncertain. However, the enormity of the violence casts the act into an even harsher light. The lack of empathy is startling. The presence of news crews depicts both the processes of their witness-ing and their capacity to enable witnessing for the world. But at what cost? In order to make sense of the confusion, they engage in a near assault on a terrified, imperiled man. Moreover, this sequence captures the challenge of witnessing. The very first order of witness, the survivor, is too caught up in his own emotional response and desire for self-protection; mean-while, the crew must make sense of events, and they rely on this man for information. All the characters are in an event that has yet to be narra-tivized. What seems familiar and simple—a question about the news media treatment of survivors and victims—develops into a complicated land-scape that interrupts the seamlessness of representation with each step. This news team does not merely carry a camera, capture images and a ready testimony, and broadcast the information without trouble: the team members are active participants in the production of information; their work in shaping the presentation and the survivor's own contribution are rendered visible. Meanwhile, the depiction of this near hostile intrusion allows for a gesture to the witnessing through the film, hinting at the ways the trafficking in African crises in so many popular films may enhance and extend the trauma.

Hotel Rwanda tenders a similar critique and challenges simplistic assumptions about the seamless circuitry of mediation in its otherwise unproblematically triumphant (and some argue ahistorical) account of Paul Rusesabagina (Don Cheadle), who used his position as house man-ager of the luxury Hotel Mille Collines to give safe haven to twelve hundred Rwandans.[32] In one scene, Jack (Joaquin Phoenix), an American photo-journalist (likely based on Nick Hughes, one of the few prominent pho-tographers to remain in the area) dashes Paul's hopes for international intervention even as he seems to hold the key for action. Jack bursts into his hotel room, where his colleague, David (David O'Hara), edits footage of an interview with Colonel Oliver (Nick Nolte), a UN peacekeeper most likely based on the real-life Colonel Roméo Dallaire. He inserts a tape into the cassette player, and Jack, David, and Paul watch the footage on the

monitor. The footage is of a massacre: Tutsis fill the street, seated, as a crowd approaches; two militia men emerge from the crowd, slashing their way through the bodies, delivering blows onto the kneeling figures as others attempt to escape.[33] As they watch, David picks up the phone, "Fred, it's David. I've got incredible footage. It's a massacre. Dead bodies. Machetes. If I get this through right away, could you make the evening news? Yeah. You have to lead with this . . ." Jack's palpable enthusiasm and David's quest for the lead story suggest less a concern about the tragedy, and more excitement in an item that carries value in a news economy. The exchange asks us to consider the high public demand for images of atrocity. "If it bleeds, it leads," or so the cliché goes. It may be this issue that contributed to minimal reportage: despite the depicted presence of photojournalists on the filmic landscapes of the Rwandan genocide, there was little footage of the actual genocide. As with *No Man's Land, Hotel Rwanda* asserts itself as the privileged witness, providing images of suffering within a context of presumed moral superiority. These images not only tell the story of the genocide, but also of the genocide marginalized in news media yet treated in cinema.

This exchange does more than highlight the traffic in suffering. It reflects the diminished political possibility of the image. When Paul sees the footage, he is horrified and elated, "I am glad that you have shot this footage—and that the world will see it. It is the only way we have a chance that people might intervene. . . . How can they not intervene—when they witness such atrocities?" Jack quickly disabuses him of this notion. "I think if people see this footage, they'll say, 'Oh my God, that's terrible,' and they'll go on eating their dinners." The entire sequence weighs the capital of atrocity images. In two cases, they hold high value within the economy of reportage: a bloody icon for an otherwise "dry" report, and within the economy of cinema, a bloody icon to illustrate a relatively unseen history. Within an economy of witnessing, of global political action, such stories are merely lost in the flow of reportage and everyday life. The scenario ties together every one of these players on a continuum of witnessing, from the camera operator, to the editor, to the decision-makers in the news headquarters, to the home viewer. This continuum also includes the images captured, the bystander that is Paul, the filmmakers, and the audience in the theaters. A question does remain, though: where in this chain is action expected to occur?

Such questions linger in *Shooting Dogs*, where questions of bystander witnesses and response surface on multiple levels. Teacher Joe Connor

(Hugh Dancy) seeks out television reporters to visit Kigali's École Technique Officielle, where Tutsis and Europeans hide from the violence outside the gates. "Nowadays, nothing exists if it's not on TV," he tells the priest, Father Christopher (John Hurt). "So we get the cameras in here, the rest of the world sees what's happening, and they have to do something." When Father Christopher asks him "how are we going to achieve that?" he refers simply to the challenge of securing a news team; however, the sequences that follow raise more questions about achievable action. The BBC reporter, Rachel (Nicola Walker), is initially reluctant to go along with Joe, and an economy of the field comes to the fore: she has plenty to report on already, and is given only three minutes each night. But the promise of imperiled Europeans (forty in the compound) turns her head, and they are off. Their way back to the school is marked with significant events. At one point, the group is stopped at a roadblock where Joe helplessly witnesses the murder of a Tutsi man; he cannot look away but he is not in any position to respond. Released, they continue before stopping to film the remains of a slaughtered family, children mostly; even so, they doubt this will ever make it past the editors. Rachel's interview with Captain Charles Delon (Dominique Horwitz), a Belgian peacekeeper for the UN, shows the impediments to action for the professional bystanders. Why can't they act? Rachel asks. His parameters, the captain explains, were clear, their mandate was to observe. In a move counter to actual history—the BBC did not describe the events as genocide at the time—she outlines the mandate to intervene should they deem this genocide. Delon expresses his frustration: in this system, he cannot act, and if she wishes to take it up, she ought to ask the UN Security Council. Whether in sympathy or not, the landscape of professional witnesses—UN peacekeepers and media practitioners—is deepened: the habitus of each actor is depicted in ways that complicate the simplicity of the chain of action from seeing to acting.

Sometimes in April, whose action takes place in Rwanda and Washington, D.C., in 1994 and in 2004, grants greater nuance to the news media terrain, to questions of action, and to the work of bearing witness in a larger story of genocide and its traumatic aftermath. After Hutu president Juvenal Habyrimana's plane is shot down—an event largely considered to have set off the genocide—the U.S. State Department, including Prudence Bushnell, deputy assistant secretary of state for African affairs (Debra Winger), convenes an emergency meeting in order to determine what has happened. The scene of this deliberation opens with establishing shots of Washington, D.C., with radio news filling in the sonic landscape with items

on the suicide of Kurt Cobain and the weather, and closes with the introduction of an actual NBC Nightly News item where Brian Williams reports on the fighting in "the tiny African nation of Rwanda." This segues into a montage of archival news reportage on the escalating violence and the difficult position of the UN. The initial plan of this news outline seems to be one of exposition. However, the items rapidly overlap to create both a sense of confusion and a mounting presence of concern. For a brief moment, Rwanda stories seem to overcome the "noise" of constant reportage; but this is only for one moment as the minutiae soon return. When Bushnell receives a visitor to discuss Rwanda policy, a television screen in the background broadcasts the Nancy Kerrigan and Tonya Harding ice skating affair. The scene captures television flow, where trivia frequently dominates.

The sonic portraits of televisual flow make *Sometimes in April* both kinder and harsher in its criticism than *Hotel Rwanda*. The constant barrage of information that both informs and distracts suggests how an audience could fail to apprehend the gravity of a situation, let alone maintain concern. The story comes through, but in what circumstances? How does it look and sound on the other end? This is not a case where, devoid of empathy, the audience returns to their dinner; rather, this relentless flow of information threatens to impede the formation of witnessing publics—especially if one is not the deputy of African affairs.

Global Witness: Measures of Complicity and Blame

The failure of political intervention inevitably becomes a topic in the films about the Rwandan genocide. As these productions complicate the

Figure 10. Jack (Joaquin Phoenix) interviews UN Colonel Oliver (Nick Nolte) in *Hotel Rwanda* (2004).

simple formulation of witnessing and inaction, they introduce multiple registers of complicity and culpability. The explorations invite questions regarding a more general notion of global civil society, from television audiences to political states and supranational organizations, namely, the UN. When *Hotel Rwanda* calls attention to the import of Chinese machetes (the principal weapon of the genocide) and *Sometimes in April* recalls French support of the Hutu government, the films spark questions of responsibility on a global landscape of trade and political alliances. The documentary *Shake Hands with the Devil: The Journey of Roméo Dallaire* (Peter Raymont, 2004) further questions mismanagement in the story of a UN peacekeeper whose appeals for aid and intervention were not heeded. The film also calls attention to the UN's disastrous decision to bring in Belgian peacekeepers, an action that reflects gross incompetence: the UN usually avoids placing former colonials into former colonies, as their presence typically aggravates the tensions the peacekeepers are intended to pacify.

Colonialism, past and present, dominates as a factor in the conflagration as the films recall how the former Belgian rulers, by privileging Tutsis over Hutus, both reified ethnic categories and fostered ethnic tensions. *Sometimes in April* incorporates historical footage of the colonial era, which depicts a young African undergoing physiognomic measurement taking; the sequence invokes the practices of visual and scientific classifications of human value, a race science that invokes colonial genocides and the Holocaust alike.[34] Colonialism bears a legacy of ethnic violence on multiple levels: internally among tribal affiliations, and externally on a global level of invasion that justified colonization and violence with the science of racial distinction. *Hotel Rwanda* allows the story of colonialism and the formation of ethnic antagonism to introduce the drama; however, the film prefers to question categories of human worth through the lens of global racism. In one scene, Colonel Oliver gives voice to these themes of devaluation and abandonment. Sitting at the bar, accepting a drink from Rusesabagina, he decries the withdrawal of the peacekeeping forces: "You ought to spit in my face. You are nothing. You're dirt. We think you're dirt, Paul. . . . The West, all the superpowers. . . . They think you're dirt." He explains that although the international community is aware of this genocide, they will abandon the Rwandans because they are African, and Africans hold little value in the global political economy. Other sequences provide this perspective with less bombast. During a rainstorm, white hotel guests are being evacuated as the hotel employees hold umbrellas above their heads.

This compelling image expresses the legacy of colonialism that not only demands the continued service of the Rwandans, but which will also abandon and relegate them to their deaths. And these deaths, as well as these sorrowful images, become fodder for Western eyes, trained on a constant economy of African suffering. Indeed, there is a missed opportunity here for self-reflexivity, as these popular films, produced by strong North American and European film industries, drown out the voices and films of the nascent Rwandan film industry.[35]

Instead, questions of racism and global complicity are largely invoked to answer for the evacuation of Americans and other expatriates, as well as the retreat of the UN troops following the murder of ten Belgian peacekeepers. The fact that the mass departure was facilitated by various national armies who refused to remain or to aid in the evacuation of Tutsis further illustrates the striking imbalance in the value of human life. Once the peacekeepers and the other soldiers departed, eight hundred thousand Rwandan lives were lost. Director Nick Hughes commented on this abandonment, finding it repellent:

I think that's exactly what happens. You had UN soldiers from the West; you had aid workers; you had ex-pats; you had journalists—all of them betrayed the Rwandan people. The media took absolutely no part in the genocide (and in?) [sic] exposing it to the international community [they] brushed it off with clichés, caricatures. The aid workers, 99 percent of them, just got on the plane and left. The ex-pats just left their servants to be slaughtered and evacuate—while they evacuated their dogs. And the UN who were there brought in to protect the Tutsi population—to keep the peace—just ran away![36]

The problems are far greater than compassion fatigue or excess simulacra; the problems invoked here suggest the lived practice of devaluing human life, first at the level of those deserving reportage, then at the level of those deserving protection, and then, of course, the horrifying repercussions of such practices. The global community fails on many levels: the West contributed to the conditions of this genocide and then neglected to intervene despite apparent obligations.

The issue of obligation, moral and political, has been raised in every film about the Rwandan genocide. It may be that the films on Rwanda have functioned to enmesh this moral obligation with the political mandate by producing a popular knowledge of genocide—one not so present in the news media of that period, which preferred to cast the events as a

case of eternal tribal warfare. In this way, Rachel's interview of Captain Delon in *Shooting Dogs* may be counterfactual, but it nevertheless outlines the implicit demands of the treaty: if this is genocide, the UN and its representatives are duty-bound to intervene. Meanwhile, *Hotel Rwanda, Sometimes in April,* and *Shooting Dogs* all incorporate the now notorious interview between U.S. State Department spokesperson Christine Shelley and Reuters journalist Alan Elsner. The broadcast (filtered over the radio in *Hotel Rwanda* and *Shooting Dogs* and presented on TV in *Sometimes in April*) features Shelley stringently avoiding the word "genocide" and performing all manner of verbal gymnastics to avoid the term. Instead, she makes vague comments about "acts of genocide" that "may have occurred." The equivocation continues, prompting Elsner to intervene: "How many acts of genocide does it take to make genocide?" Her quibbling functioned to forestall the responsibility and mandate to act embedded in the terms of the UN Convention on Genocide. The avoidance had reasons beyond the political. Barbie Zelizer writes, "U.S. officials at first refused to append *genocide* to Rwandan barbarism, so as 'to avoid the rise of moral pressure to stop the mass killing.'"[37]

The inclusion of the actual broadcasts of these interviews imports similar ironic complications engaged by Tanović's use of news footage. First, the appearance of the broadcast demonstrates the efficacy of electronic communications media within overall narratives that call attention to media limitations. Nevertheless, media can be mobilized to make a case: they can educate and they can inspire indignation and moral outrage when couched in an effective context. Second, they can indicate the ways in which knowledge of events—the U.S. State Department interview takes place outside of Rwanda—is not enough to accomplish action although it does succeed in creating skittish political actors.

In *Sometimes in April* the past trauma of the battle of Mogadishu, Somalia, is invoked to explain the foot-dragging of the United States. This specter is rife with media implications, for indeed, one of the horrors of Mogadishu was that it was widely seen. In October 1993, a failed attempt to capture Somali general Mohammed Farah Aidid resulted in a highly bloody conflict leaving hundreds (or thousands) of Somali civilians and militiamen dead. In the midst of the battle, the bodies of dead U.S. servicemen were dragged through the streets, spit upon, and kicked by onlookers. The dragging was broadcast on CNN, extending the trauma of the events to an American audience. Echoing the traumatic broadcasts of the Vietnam War, the battle of Mogadishu came to be regarded both as a tactical and as a

public relations fiasco, even though in terms of losses, far fewer American servicemen lost their lives when compared to the Somali population. The costs of this battle and its broadcast appeared in the Clinton administration's foreign policy. Military disengagement followed, as did reluctance to intervene in foreign conflicts, namely, the genocide in Rwanda. Invoking Mogadishu not only returns the genocidal conflict to a geopolitical and historical context, but it deliberately engages the question of what media accomplish. In this case, the broadcasting of American bodies brought about a swift response to contain further trauma—bodily and psychic.

The battle of Mogadishu and its attendant repercussions raise an issue discussed earlier in this chapter: the devaluation, or disparate evaluations, of human worth in a global context. *Sometimes in April* demonstrates the privileging of American life in a press conference, where reporters display a concern over the number of Americans in danger as the conflict in the region escalates. Numbers provide the tangible point of comparison. Hundreds of thousands of Rwandan lives are endangered, while by contrast, Americans number in the hundreds (254), and as Bushnell repeatedly stresses: the Americans are not the ones in danger. Every effort to brief these reporters and to provide political and social context is thwarted as the reporters turn the questions back to the status of Americans. The scene invokes the other economy of reportage, as American bodies are valued in stories more than African bodies. The urge to simplify the news and portray it in broad brushstrokes readily digested by newsreaders and newsmakers alike is rendered in the comic confusion of the correspondents. One journalist cannot get the names clear, and stumbles over Hutu and Tutsi, by saying "Tutus" and "Hutsis," before he relents, and asks for the simple breakdown: "Which ones are the bad guys?" Again, the economies of reportage are presented for the film's viewer. First, American bodies in potential peril merit more attention than African bodies in physical danger (an arithmetic also invoked in *Shooting Dogs*, where forty Europeans merit the news team's attention, whereas the hundred-odd Rwandans do not). Second, stories must be simplified and readily digestible (good guys versus bad guys), able to travel in circuits that limit information to a few hundred words, or two minutes at best.

This observation is not intended to criticize the need for narrative frameworks in making distant suffering meaningful. As the previous chapters have demonstrated, interpretive grids of popular culture and legal terminology are vital components of the genocide claim that produces

political publics. What I do note, however, are the limitations of the news report in generating action. These films enable the expansion of genocide awareness and the repercussions of inaction in ways that are not entirely accessible to the news item. They present the history in a variety of ways, indicate the expectations of the UN genocide convention, and most notably, create narratives where inaction is replayed as violence. Scenes of expatriate, media, and UN official evacuations precede scenes of slaughter, producing a narrative logic between flight and massacre. The films dramatize the abandonment of the Rwandans to highlight the cruelty of nonintervention. In scenes that reflect the actual news footage of Rwandans begging to be evacuated with the others (this footage appears in the documentary *Shake Hands with the Devil*), *Sometimes in April* and *Shooting Dogs* both stage the encounter between the seemingly impassive soldiers and frantic citizens about to die. The films highlight the immediacy of impending death and the legitimacy of the pleas by presenting the advance of the Interahamwe, the Hutu paramilitary organization that carried out the genocide. As the convoys drive off, almost immediately Hutu extremists arrive, brandishing guns and flaunting the machetes that they sharpen on the street as they approach.

Possibility of Action

While depicting the impediments to action, the films nonetheless hint at the work of media in alerting and mobilizing publics: new reports function both as exposition and as means of inflaming outrage; the broadcast of the violence at Mogadishu triggered a shift in foreign policy; and the films themselves serve to educate on the subject of genocide and to educate audiences about the complicity of inaction. The capacity for media to facilitate the making of ethical and political claims and to mobilize response is presented in more practical terms in *Hotel Rwanda,* when Rusesabagina deploys the potential of small media. Learning of the impending horror, Rusesabagina calls his distant employer, Mr. Tillens (Jean Reno), the president of Sabena. The conversation takes place on speakerphone, allowing the camera to stay in the Belgian office and register the response of Tillens as Paul gives his farewell speech. Paul's oration of thanks in the face of imminent slaughter clearly moves the listeners—Tillens and the other men present exhibit the horror of recognition; the distant message has been received. Although Tillens is unable to compel the intervention of the French and the Belgians, he has managed, from a distance,

to force the immediate withdrawal of a Hutu lieutenant who had demanded the hotel registry as a means of winnowing official guests from Tutsis in hiding. This moderate success emboldens Rusesabagina into further action, and he encourages the hotel residents to call and fax everyone they know who holds even the smallest bit of power; they must be polite as they tell them goodbye and give thanks. "Make them feel as if you are reaching through the phone and holding their hand. Let them know if they let go of that hand, you will die. We must shame them into sending help."

This invocation of shame once again invokes this human rights model of the mobilization of shame, whereby revelation shames perpetrators into ceasing their crimes.[38] *Hotel Rwanda*'s scenario suggests an alteration in this model, whereby one mobilizes the shame of the bystander, compelling the spectator to recognize the dangers of inaction. Global media technologies are a decisive component of this project. However, it is not the phone alone that generates response: there is the type of speech, the moral emotions generated (compassion, shame, duty), and the audience equipped to hear the speech and to act.

RTLM, or Hutu Power Radio

The capacity of media to stimulate response and action has a sinister flip-side in propaganda and hate speech. During the Rwandan genocide, a key means of fomenting genocide was RTLM, Hutu Power Radio, which rallied publics around the imagined threat of the Tutsi "cockroach." Every film about the genocide depicts the radio and its effects. *100 Days* opens in a town square as a DJ shouts his invective to an excited crowd while simultaneously broadcasting his live performance over the radio. "The Tutsi came here; they refused to live with us, to marry us, or to share power with us. There is only one solution . . . They must go!" The energized cries of the crowd, combined with the mise-en-scène of a radio broadcast in public space, animates the connection between transmission and the emotional response in the physical world. *Sometimes in April* brings RTLM into the foreground in the story of two Hutu brothers, Augustin (Idris Elba), an army officer and moderate who has lost his family to the violence, and Honoré (Oris Erhuero), an RTLM DJ on trial in the International Criminal Tribunals (ICT) for his role in fomenting genocide. The film alternates between presentations of RTLM in the genocide and meditations on the implications of this hateful medium. Announcers implore their listeners to "exterminate the cockroaches," and transmit the names and addresses

of intended victims to facilitate the butchery. On the American front, State Department official Prudence Bushnell wonders if the United States should jam the radio transmissions despite the prohibition of international law: do rights of speech extend to this exhortation to genocide? In the ICT, although a jurist defends the radio broadcasters with a freedom of speech argument, Honoré nonetheless declares himself guilty; he changes his plea to acknowledge his part in the genocide that took the lives of his brother's family.

An RTLM broadcast opens *Hotel Rwanda,* allowing the reenactment of hate radio to activate the dramatization of the genocide. Privileging the power of the sonic, the film opens with a whispering voice-over narration over a black screen. The voice outlines the history of ethnic hatred in Rwanda, beginning with the Belgian colonial preference of Tutsis over Hutus, continuing with tales of discrimination and then escalating into accusations of historical injustices and demands for retribution through extermination. This use of mass media as a means of exposition is nothing new. As has been discussed, the incorporation of the news item offers an effective means of situating the viewer and introducing important questions about the capacity of media to do something. The broadcast media bears witness within a context where witnessing and its technologies were regarded to have failed. The use of sound over image only enhances questions of expectations: the visual media of the West failed to activate political intervention, while the small media of radio fomented mass murder that took place with unprecedented alacrity. Furthermore, the use of RTLM as exposition demonstrates the seduction of this medium: the voice initially providing our historical outline is revealed to be unreliable to say the least.

As in *Sometimes in April,* the Hutu Power Radio in *Hotel Rwanda* plays an active role in facilitating genocide. Moreover, the radio here provides a practical means for listeners on the ground to mobilize. The radio in other films reveals how names and addresses were transmitted to direct militias to their next victims. In *Hotel Rwanda,* the radio becomes broadcast mechanism and headquarters when listeners call in an evacuation convoy's location for broadcast. Because of this, Tutsis who sought escape— including Rusesabagina's family—are stopped; fortunately, they are not executed but forced to turn back to the hotel compound. The film continues to highlight the prominence of radio in the genocide by allowing it to remain a constant presence in the sonic landscape. When we cannot understand the hateful broadcasts, we hear them as a threatening background hiss; the physical world is not free from the radio's effect.

The brazen declarations of RTLM confront the human rights practice of "mobilizing shame," which presumes perpetrators cease violence under the threat of exposure. The work of RTLM by broadcasting hateful invective and practical directives to exterminate populations does not conceal the intentions of the Hutu extremists. The refusal to cover up these practices suggests the utter absence of shame to be mobilized for justice. (At the same time, the lack of visibility in radio may enable such audacious transmissions, as can the oft-invoked schism between speech and action.)

Despite the seeming contradiction of RTLM, *Sometimes in April* and *Hotel Rwanda* advance a tool that can be wielded against perpetrators: a juridical mobilization that resides in the threat of future prosecution. This is the promise of international justice embedded in the International Criminal Tribunal. At the Hotel Diplomat, *Hotel Rwanda*'s General Bizimungu (Fana Mokoena) threatens to take Rusesabagina to the new headquarters, which would abandon Rusesabagina's family and the Tutsi refugees to certain slaughter. Rusesabagina begs to retrieve his family, but the general refuses, until Rusesabagina promises to help him in "these difficult times." The general is perplexed, what possible help could Rusesabagina offer? "You are a marked man. You are on the list. The Americans have you on their list as a war criminal." Rusesabagina promises that should the general help, he will testify on his behalf: "You need me to tell them how you helped at the hotel. They blame you for all their misfortunes. They said you led the massacres." His promise of future testimony is what activates Bizimungu's response. Moreover, it suggests the international political work of the juridical framework: even if the justice meted at the ICT is a retroactive form of action, the ICT as threat can be mobilized to mitigate the horrors that take place in the present.

In *Sometimes in April*, Bushnell wields the threat of retributive action in a phone conversation with Colonel Bagosora (Abby Mikiibi Nkaaga). She calls to inform him that they, the U.S. State Department, have received reports from the UN regarding the violence. She demands that he take action to change the course of events. In response to his defense that what the UN has observed are merely firefights occasioned by the civil war between the Rwandan military and the RPF (the Rwandan Patriotic Front or, for Bagosora, "Tutsi rebels"), Bushnell persists: "We know who is perpetrating these killings." She continues by requesting they stop the "hate radio" and warns him, "If you do not stop the killing, there will be

consequences." To this threat, he responds with contempt and questions its validity, noting the absence of U.S. interests (e.g., oil and diamonds) in the region. She repeats and clarifies: "If you do not cease the killings, I promise you, you will be held personally responsible." "I will see what we can do," the colonel answers. While not as explicit as the exchange in *Hotel Rwanda*, the words "personally responsible" wields the threat of account-ability in a tribunal. The sequence captures the many concerns that un-dergird political action: the media that inflame public response (RTLM), economies of interest (which can play out in news media or in the finan-cial interest in a territory), and frameworks of justice and action (in this case, the ICT). The discursive terrain that produces media testimony and guides sentiment into action is shaped by all these factors.

As much as the ICT is elevated as a mechanism of action, it is equally problematized, especially in *Sometimes in April*. Unlike *Hotel Rwanda*, which offers a more popular narrative with the individual hero and appar-ently happy ending communicated in a freeze frame of the Rusesabagina family evacuating Rwanda, *Sometimes in April* addresses the future of a traumatic episode and questions the idea of satisfactory closure. The alter-nation between temporal periods, the genocide of 1994 and the ten-year anniversary in 2004, refuses closure on trauma, allowing the past violence to repeatedly resurface in the present. Moreover, the attention to the after-math allows for the dramatization of the ICT in Arusha and enables char-acters to struggle with the uses of the tribunal. Augustin, in fact, rages when he witnesses perpetrators in the prison, well-fed, sheltered, and receiving the drug cocktail AZT denied to the victims of the genocide—victims of rape who now suffer from AIDS and HIV.

While the practical operations of the ICT invite questions, *Sometimes in April* foregrounds the necessity of testimony for political transforma-tion and community (and personal) recuperation. Honoré's confession to his brother inspires his change of plea to guilty: the speech signals that he has come to terms with his past and accepts his accountability in order to move forward. Augustin and an unseen woman communicate between the walls of their hotel; there, they share their experiences and thus provide each other comfort. His support also encourages her to give her harrow-ing testimony of her rape and the murder of her family to the ICT. During the dramatic speech, the camera focuses on the faces of the jurists. In ear-lier scenes, shots of the jurists had been limited to close-ups that isolated this witnessing public, but as the woman speaks, the camera, still close, now tracks across the room, connecting the jurists to one another. This

communal dimension of testimony appears outside the boundaries of the ICT, when *Sometimes in April* depicts the Gacaca tribunals, a local grassroots form of restorative justice.[39] Here, survivors, defendants, and bystanders give testimony in this participatory forum aimed at national reconciliation, whose collective function is articulated through wider group shots. It is here that the film concludes as Augustin's girlfriend, Martine (Pamela Nomvete), stands to give her story of loss and suffering. The conclusion does not so much advance Gacaca's local justice over the international framework of the ICT, as it speaks to the broader necessity of bearing witness to transform the world.

Films That Bear Witness

At the same time that these films reflect upon the act of witnessing—and more specifically, media witnessing—they bear witness to the Rwandan genocide in their own right. They produce historical (and occasionally ahistorical) accounts of the one hundred days of violence, referring to key points and issues that include the death of President Habyrimana, the incitement of the RTLM, the Interahamwe, the many murders by machete, and the overall disinterest of the world watching. In effect, they produce a narrative of a historical, if general, truth, for a larger audience, and in a way that implies responsibility for speakers and listeners. Nick Hughes, director of *100 Days* and a former photojournalist, describes his mission of filmmaking as one of bearing witness, of taking responsibility for the trauma he photographed, and ensuring its memory. He notes, "I felt I had betrayed those I had filmed; I felt I had the responsibility as a witness, what if the world wanted to forget. There was only betrayal, betrayal by the international community, betrayal by the humanitarian agencies, betrayal by the Church, betrayal by the media."[40] Although he was a bystander witness, it is not history he tells. Rather, he "listened to the survivors tell their stories and [he] wrote them into a screenplay," thus producing a form of generalized or collected testimony from individual narratives. Despite its problematic focus on Europeans as protagonists, *Shooting Dogs* offers a range of witnesses through scenes in which people come to the school and give accounts of brutal, horrifying events they have seen and experienced. These characters are not central; they are not even secondary; they arrive solely for the purpose of telling one of the many stories not fully covered in this film. Rwandan president Paul Kagame has since commented about *Shooting Dogs:* "The film as such is going to be a continued

part of our memory relating to the genocide and I think that memory needs to be kept."[41] These generalized stories of a recent past take responsibility for that past and for the future: the films bear witness to the truth of an event in order to bring about responsibility in the listener, even if the responsibility is to a memory.

As dramatizations they both reflect and aggravate the concerns around testimonial truthfulness and testimonial voice. Testimony already poses a limit case as a translation of traumatic experience, an event that defies ready integration into narration.[42] As noted earlier, documentaries have experimented with forms of traumatic expression; however, as documentaries, even if experimental, they assume a privileged relationship to the truth, even if this link can be tested or questioned. The mode may well enable the sort of experimentation and departures from realism not typically found in a feature narrative historical film. Meanwhile, docudrama and historical dramatizations may be grounded in actual events, but their mode of expression places them at a distance from the atrocities to which they bear witness. Filmic and extrafilmic technologies are thus enlisted to promote authenticity and to legitimize the testimonial voice of the film. The legend "Based on a True Story" and familiar images, whether news footage or replication of news footage, aid in securing the truth status of these testimonies. The real Paul Rusesabagina toured with *Hotel Rwanda* as part of its promotion (as well as his own). *100 Days, Shooting Dogs,* and *Sometimes in April* touted their use of actual locations and survivors in cast and crew. Nick Hughes, for instance, filmed at the church in Kibuye where the actual massacre pictured in his film took place. In addition, he employed "Rwandan actors and crew, all of whom stand in the shadow of their common experience."[43] The press materials for *100 Days* also call attention to the survivor status of producer Eric Kabera, who lost more than thirty-two family members in the genocide. The film blog for *Shooting Dogs* noted the criticism of a survivors group, which accused the filmmakers of retraumatizing the survivors in the reenactments. Ostensibly negative, this report encouraged reflections on the truth of the event and the potency of the past in the present while naturalizing the film's own topography of terror. The blog deployed the complaint as a marker of the film's truth and value, citing President Kagame, who remarked in response, "If it is a film built on what happened here in 1994, naturally it recreates the scenes that affect people."[44] Within the promotional materials, the films are presented as not only truthful, but also imbued with the capacity to affect people, to mobilize sentiment, and possibly then to effect change.

This may be where the reflexive impulse ends, as the films do not so much question their ability to witness and produce action nor do they locate themselves within a political economy of witnessing. They do not take on the relative absence of a Rwanda cinema culture (albeit one that is growing), nor do they identify themselves as predominantly American and European screens for representing Rwandan suffering. In this regard, an entertainment culture's traffic in suffering continues, only emboldened by a depiction of its dismay around the more sober discourses, namely, that of news reportage.

Conclusion

In terms of textual mechanisms alone, one can see the films discussed in this chapter as having two effects. First, these dramatizations of the crises in Bosnia and Rwanda contribute to a reshaping of the genocide imaginary, bringing genocide into the present day. The Holocaust certainly persists as a frame and is invoked in the films. In *Shooting Dogs*, for instance, a character explains that the Hutus are doing to the Tutsis what the Nazis did to the Jews, reframing the early news media depictions of tribal warfare as genocide. However, these introduce new devastating images into the iconography: bodies strewn along a road, murder by machete, and the skulls piled before churches join the images of mass graves, concentration camps, and boxcars as images of genocide.[45] These dramatizations repeatedly aver the genocidal character of the events and familiarize the audience with the terms and expectations of the UN Convention on Genocide. When I began this project, the mandate to act upon this legal utterance was considerably less known. Today, it seems to have become popular wisdom—even if a troubled one.

The second effect is that the films broaden the popular depictions of media witnessing with the richly rendered media terrain of the dramatizations. The trend of depicting the news media presence opens the issue of the global audience and witness; more importantly, it opens the question of how so many could watch and fail to act, particularly in light of the mandate of the UN's genocide convention. If recognition demands response, and if global visibility was possible, what generated the failure of action? By showing news media operations, and by incorporating news items—actual or reenacted—the films complicate the simple formulation and its presumptions of transparency. Economies of presumed interest and time contribute to the production of overly simple, dehistoricized,

and drastically brief reports. Human life, too, participates in these economies of value: nationality and ethnicity inform screen time, as does the degree of violence (although interest in the bloody and bloodless vacillates wildly among editorial gatekeepers). Televisual flow facilitates the fleeting dimension of the news item. Journalists are subject to manipulation, basic human failings, and the conditions of their social, historical, political, cultural, and industrial contexts. Although the broadcast of the stories may fail to inspire action, the physical presence of journalists can yield unintentional and unanticipated consequences.

Despite this attention to the complexity of media witnessing, the films are less concerned with critiquing their own function as witness. The off-screen publicity materials and press kits assert the films' roles as historical witness, and the on-screen devices suggest this witnessing to be fairly straightforward. One might find a degree of self-reflexivity in the narrative structures of *Before the Rain* and *Sometimes in April,* but even these elliptical narratives, by their conclusion, ensure a complete understanding for the viewers through corroboration of information and impossibly privileged flashbacks. They do not acknowledge their own gaps in the storytelling, even as they acknowledge those of the news media. And while films like *Hotel Rwanda* and *Shooting Dogs* question the colonial and racist legacy that inform the genocide and its neglect in the West, they do not consider their own economy of attention. These films focus on Western protagonists or offer individual heroes within triumphalist narratives; and more importantly, these popular films traffic in the suffering of African bodies for the benefits of American and European cinema industries. Moreover, if these are historical witnesses, what transformation do they seek and how are they mobilized? As will be discussed in the following chapters, *Hotel Rwanda* has been put to work in various campaigns, including Rusesabagina's political mission in Rwanda and as a response to the genocide in the Darfur region of Sudan.

Even given these lingering questions, the on-screen activity of the films proposes a view of witnessing as a process informed by numerous economies, actors, technologies, and strategies. The films recognize that witnessing takes place on a field of cultural production that informs representation of an event and the capacity of the visual to inspire or enact change. In doing so, these films intervene into the prevalent theories of "compassion fatigue" and into Baudrillard's simulacra. This is not to say that such effects of numbness and derealization don't exist; they are potential effects of media usage, but they are by no means a matter of fact. The

ways in which testimony of genocide is presented has an impact on the formation of political actors and witnessing publics. The exhibition and consumption contexts of these testimonies matter. Through their multimedia approaches and semireflexive turns, the films argue that while visual media can contribute to disengagement, visual (and other) media offer considerable means of engagement. News reportage merits criticism for the forms of coverage, but when the same coverage is deployed as cinematic exposition, this usage invites explorations of the values in media witnessing. The landscape is neither straightforward nor static, but dynamic and complex. The field of witnessing matters if film and video are to be useful.

4 THE WORK OF WITNESS

Negotiating the Challenges of Video Advocacy

Techniques of collecting information might be modern and sophisticated, but human rights organizations are motivated by the old-fashioned Enlightenment faith in the power of knowledge: If only people knew, they would act accordingly. This is just the faith that is undermined by the daily practice of human rights work.

STANLEY COHEN, "GOVERNMENT RESPONSES TO HUMAN RIGHTS REPORTS: CLAIMS, DENIALS, AND COUNTERCLAIMS."

AUDIOVISUAL MEDIA TECHNOLOGIES and the genre of documentary have long been enmeshed in practices of state propaganda, scientific study, civic promotion, and social justice movements.[1] Throughout the twentieth century, these technologies developed at an ever-increasing rate, allowing for information and images to travel at unprecedented speeds and to reach greater numbers of dispersed and distant publics. As discussed in previous chapters, film and video provide useful tools for raising consciousness and funds, facilitating aid to victims, or meting out justice to perpetrators. However, the occurrence of catastrophic human rights crises on the world stage aggravated anxieties over media effects and possibilities; there were bystanders to the genocide in Rwanda and to the ethnic cleansing in Bosnia, but the place of publics and communities aligned in programs of political change seemed less than clear. Audiovisual technologies played a significant role in developing discourses of humanitarian obligation and human rights law, exciting the promise of "Never Again" and yet, in the 1990s the promise appeared to be broken.

The previous chapter outlined the ways in which dramatizations of the genocides in Bosnia and Rwanda addressed this failure and how, in doing

so, they enhanced the portrait of the contemporary media terrain. The films moved beyond questions of what showing and watching accomplish and turned their attention to the multiple players and influences in this field of cultural production. This chapter turns to this field as inhabited by media activists and social justice movements: those who employ film and video in human rights campaigns. In particular, I focus on the work of WITNESS, a human rights organization that recognizes the intricate terrain depicted in these films.[2] WITNESS actively negotiates the perceived failures of visual media and the attendant angst over desensitization and derealization by acknowledging the expectations and procedures of the various actors. Training activists in the use of video in a human rights campaign, WITNESS moves beyond technical instruction and incorporates training in visual storytelling techniques and in extrafilmic strategies of circulation, exhibition, and promotion—all of which are marshaled with the goal of forming witnessing publics.

Media Witnessing: Obstacles and Challenges

As I observed in the previous chapter, the profound disappointment in the failure of audiovisual media to produce action generated multiple interrogations into their efficacy, with attention to news reportage and its economies of suffering and attention. These questions come together with longstanding concerns over popular and mass culture articulated in previous chapters, such as the suspicion that popular or mass culture destroys high culture, critical thinking, and the political potential of the public sphere, replacing these noble activities with false consciousness and propaganda. Meanwhile, the role of the spectacle in politics, with its attendant features of overexposure, sensationalist treatment, and commodification of suffering animated concerns over inappropriate affect, whether numbness, exhaustion, or even pleasure, as suggested in such terms as "disaster pornography.[3] Carolyn Dean attributes this semantic phenomenon to an anxiety around "the marketing of the Holocaust," which reduces "human beings to commodities," and around a perceived (and possibly related) "deficit of proper empathy."[4] E. Ann Kaplan observes that the narratives of historical traumas that seek to edify and entertain may give way to sensations of "vicarious trauma" and result in "empty empathy"—affect that satisfies but does not necessarily mobilize.[5] The anxieties over the merging of commercial or entertainment cultures and cultures of ethical–political concern reach back even earlier. In her study of the eighteenth-century

emergence of (Anglo-American) humanitarianism, Karen Halttunen notes a similar thread of anxiety as the literatures of sentimentality and sensation intertwined. The very images intended to inspire revulsion and the impulse to reform were caught up in a culture of sensationalism that deemed such images a source of pleasure.[6]

In addition to the pleasure generated by such images, the market in which these images circulate is seen to compromise the purity of political and compassionate intent. For John Berger, the work of publicity transforms the viewer into a spectator–consumer, turning "consumption into a substitute for democracy." Recalling the work of Berger, David Levi-Strauss notes how the layout of advertisements opposite atrocity images produces disturbing disjunctures allowing indulgence to meet with suffering. In 1972, Berger observed that such "unfortunate juxtapositions" led advertisers to move to more muted presentations, so as not to distract the consumer from his business. Today, Levi-Strauss notes, advertisers use all manner of leverage to prevent the appearance atrocity images.[7] For these critics, the sphere of popular entertainment and culture diminishes the effects and affect of politics, cultivating inappropriate emotions rather than a drive to change the world.

There is no question regarding the salience of these points. Corporate ownership informs the nature of news coverage, limiting access and representation of suffering. This institutional provenance can pose a threat to democracy by regulating permissible discourse and minimizing participatory culture. As consolidation occurs and financial stakeholders wield power, there are distinct risks that minor voices are lost and marginalized.[8] Decisions around layout and presentation can yield pleasures that inspire both narcissistic and voyeuristic delights in the viewing of suffering. Or, conversely, this consumer context can work to minimize the potential for impact. Daya Thussu has rightly expressed concern that the use of entertainment strategies such as reportage based on demographic appeal risks depoliticizing publics.[9] The rise of television news media has justifiably inspired a good deal of suspicion of the practices that alternately sensationalize distant suffering and render it bloodless.[10]

Too often, this discourse of disenchantment arises not from the uses of popular culture but from a discomfort with its existence. Practice appears to be less an issue as the class of media imposes unnecessary limits on investigation and critique. As Jon Simons notes, "The breadth of suspicion, if not hostility, towards popular culture from critics claiming to uphold democratic values is a strong indication that such suspicion is not based

only in a Marxist critique of the commodification of culture, but also in a certain disdain for the very forms of popular culture."[11] These critics privilege high culture forms of producing publics and public opinion, the literary or typographic cultures that enable civil engagement and dialogue with political powers. But publicity, typically associated with these lower cultures—most likely for its affiliation with marketing—is a key component of the human rights process.[12] Theodore Levitt credits publicity with the visibility and effectiveness of activists in his somewhat condescending 1973 publication, *The Third Sector: New Tactics for a Responsive Society*.[13] Nearly thirty years later, in the case of Tibetan activism, Meg McLagan observes the intersection of political mobilization and publicity that call into question the distinctions between the political and the popular. In fact, as suggested in the previous chapters, this alliance between the political and popular may not lead inevitably to apathy but can promote "the widening of the spaces in which politics can be conceived and performed."[14]

Video and popular culture have opened the terrain for witnessing, not only in terms of visuality, but also in terms of visibility, enabling forms of cultural activism wherein marginalized people use media to respond to "the structures of power that have erased or distorted their interests and realities."[15] Such efforts at self-determination and self-articulation are not simply a matter of accessing the traditional or the peripheral forms of expression, but can involve the strategic use of mainstream, commercial formats. The Kayapo in the Amazon have used video as a mediating strategy. They mobilized video as a means of articulating concern, but in noting that the spectacle of natives with cameras draws the attention of Western media, they were able to bolster their platform for their protest against the World Bank funding of a hydroelectric dams in Brazil (although unfortunately, in December 2011, this fight was lost despite recognized opposition).[16] The attention-seeking devices associated with publicity can aid in the navigation of a noisy media world, and the use of video can help provide access to political action. The competition for attention is indeed lamentable, as those without the ability to market themselves frequently remain without aid,[17] but to fault audiovisual media and popular culture is to risk losing sight of how public opinion is formed and how response can take place.

Popular entertainment and publicity tactics not only aid in the mounting of social justice causes, but in the cultivation of audiences, and more importantly, publics. Margaret Scammell wonders if marketing might not provide a "solution for citizen disengagement."[18] Amid concerns that consumption displaces democracy, Scammell finds a potential position

of empowerment in the citizen–consumer who, once isolated from the possibility of action in politics, finds interest, commitment, and a means of interaction. Consumer activism has its limits, particularly for its gestures to "corporate utopianism"; however, these calls to action retain a capacity to orient groups of people to political thinking and participation.[19] In addition, there is a populist appeal in embracing popular culture as a site for building public opinion. Simons suggests that the popular has diminished the elitist limitations of earlier configurations of the public sphere, enabling significant potential for inclusion. Poplar culture has broadened the meaning of the public, allowing for a wider array of classes to participate.[20]

For example, in 2005, Bob Geldof announced Live 8, a set of concerts to take place worldwide on Saturday July 2 in anticipation of the upcoming G8 Summit in Gleneagles, Scotland. Unlike Live 8's predecessor, Live Aid, two concerts that took place in the U.S. and the UK two decades prior, the Live 8 concerts were not benefit performances. Rather, according to Geldof, these were to function as "rallying points for the largest political constituency ever mobilized to call for justice for Africa and the world's poor." Although his statement would not make it so, websites promoted activities around the concert designed to encourage forms of political participation and expression. When visitors came to the website in search of tickets, they would learn of rallies and attendant projects, such as the White Band project. The white band was selected as the symbol of the global fight to end poverty. Concert and rally attendees were encouraged to wear white T-shirts so that the collective could form a human white band; participants were also encouraged to wear white bands (50 × 7 cm) that contained written messages to G8 Summit leaders. In addition, they were asked to hold special events in which friends, family, and community came together to make these bands. "Invite the local media too," urged the website, suggesting that this performance of belonging could, in itself, become a media event and a means of publicizing the rally and the Millennium Development Goals. Since then, multiple related organizations continue to advocate for this mission, such as ONE (http://www.one.org) or the Global Call to Action Against Poverty (http://www.whiteband.org). I would certainly temper any rushes to celebration, as such exercises are not necessarily effective, and as such strategies can serve as broader invitation those who seek violence as well as justice. However, there is legitimacy in this point: media technologies and the attendant entertainment culture may contribute to passive, apathetic audiences, but can also hail the audiences into publics, ready to address the political world.[21]

Navigating Media Worlds: WITNESS

Advocacy organizations frequently use video in their campaigns, deploying storytelling strategies, targeting specific demographics, and assessing tactics of distribution and exhibition best suited to eliciting the desired response. In order to focus on the strategic dimension of this work, I look at the work of WITNESS, a U.S.-based not-for-profit human rights organization, whose remit and practice best illustrates the demands of the field of witnessing. Unlike NGOs and grassroots movements that undertake specific rights issues within their mission, WITNESS has dedicated itself to aiding its Core Partners (human rights organizations across the globe) in using video technology within an advocacy campaign. Media training extends beyond the mechanics of operation as WITNESS instructs its partners in the deployment of film language that transforms human suffering into an affective appeal and an ethico-political rights claim. WITNESS recognizes that the process does not end with production, and for that reason the organization advises on distribution campaigns. This advisement considers the role of corporate and editorial gatekeepers, the dangers of televisual flow that can drown a claim, seemingly endless sources of information, and the overall complexity of the media landscape. WITNESS understands that exposure is not enough and that what matters is the manner in which the suffering is treated, the identity of the audience (choosing a target demographic), and the mobilization of audience sentiment in practical ways. These concerns lead WITNESS to draw on a vast array of cinematic logics, from formal textual strategies to multitiered distribution and exhibition platforms—strategies more often affiliated with marketing and commercial strategies associated with mass and entertainment media. Indeed, the very publicity practices that Berger suspected eroded democracy play a significant role in activating political publics.

In 1988 Amnesty International, in honor of the fortieth anniversary of the Universal Declaration of Human Rights, launched the Human Rights Now! Tour, which traveled through nineteen countries and featured such artists as Youssou N'dour, Sting, and Peter Gabriel. Moved by the stories of trauma and requests for help, Gabriel helped to establish the Reebok Human Rights Foundation, an organization that would support and award people under age thirty for their human rights advocacy work. Gabriel was struck by the degree to which perpetrators carried on in their activities and by how "many of these human rights abuses were being successfully denied, buried, ignored, and forgotten despite many written reports."[22]

Words were not enough; for Gabriel, photographic and film evidence proved unassailable modes of documentation: "I met people who had watched members of their family being murdered in front of them and then found that their government was effectively able to deny that those people had ever been murdered . . . There was this sense of powerlessness. I thought that if there were strong video footage, it would be so much harder to bury the facts."[23] Armed with that conviction, he met with the Reebok Human Rights Foundation to propose an initiative to grant human rights observers and activists video equipment so they might document abuses. He praised the power of video to bring truth: "A camera in the right hands at the right time at the right place can be more powerful than tanks and guns . . . We are watching so that they can no longer keep their deeds hidden."[24] The goal itself seemed naïve, invested with the faith in transparency of the photographic image, the inevitability of justice, and even the expectation that such abuses, typically taking place behind closed doors, could be caught on video. As Stanley Cohen has noted about this promise, "life is not so simple when Enlightenment beliefs face late-modern reality."[25]

Ironically, the proposal gathered strength in 1992 with the videotaped beating of Rodney King, an event often associated with the failure of video to bring justice. The videotape drew national attention to the issue of police brutality and energized the possibilities of video in the promotion of action. The video and its mythology catalyzed funding and gave rise to a vision of a world of people armed with video cameras shooting for justice. The foundation granted seed money to realize Gabriel's initiative, while the Lawyers Committee for Human Rights volunteered both space for offices and umbrella coverage of a new human rights program, WITNESS, which bore the slogan "SEE IT / FILM IT / CHANGE IT." Although the phenomenon of the tape galvanized funding for WITNESS, the events that followed also exposed the fault lines in these convictions; the notion of visible evidence—the truth and efficacy of the photographic image—was put into question. But these complications did not quash the work of WITNESS; rather, they energized the organization into thinking through how video could be used more effectively.

The Rodney King Tape

Testing out his new camcorder in March 1991, bystander George Holliday filmed the arrest and beating of Rodney King, and then sold the footage

to a Los Angeles television station for five hundred dollars. This footage played throughout the United States, seeming to serve to most viewers as indisputable visible evidence of police brutality and racial injustice. This apparent evidence gathered strength in its endless replay, allowing the vulnerable body of King to sustain repeated blows, suggesting only justice in the courtroom would bring an end to the unceasing assault. But what appeared to be clear evidence of wrongdoing for a general public did not function as such in the courtroom, where jurors who saw the video acquitted the defendants. Multiple factors likely contributed to this decision, such as the change of venue to Simi Valley (a predominantly white city whose composition was reflected in the jury) and the introduction of a new "audience," while the variation in the viewing conditions may have factored into the disparity of response. News media played the clips nightly, often highlighting the peak of the beating; within the context of the courtroom, the video was parsed frame by frame, producing new experiences and new meanings from the tape. The polysemy of the image became manifest. When in April 1992, the verdict of "not guilty" was announced, an incensed public responded with outrage. The verdict and the riots that followed became an expression of the different interpretations of this photographic evidence that was deemed unassailable and clear: for one group, this was clearly and obviously an injustice and an act of extreme violence; for another, this represented a controlled activity within the limits of the law.

These events inspired two observations. First, the investment in the ontological status of the photographic image persisted with a strength unimagined in a postmodern era characterized by the prevalence of simulacra and desensitization. Emotional response to this ostensible visible evidence was not lacking. Second, in spite of this seeming clarity, images do not speak for themselves but rely on film strategies and exhibition contexts to aid in the production of meaning. Even when dismissed as a battle in the realm of images, actuality footage and documentary pictures held a potent force as visible evidence and in producing meaning for and of the historical world.[26]

Sam Gregory, program director for WITNESS, explains that the King situation elucidated the possibilities and limitations of media; namely, audiences, exhibition venues, and action goals informed the shape of the video. To use the King case as an example: one clip played endlessly on the news managed to circulate enough to rouse a broad spectator public around a perceived injustice, although it gave little instruction on what to

do or how to respond. In the other case, the circumstances of presenting the video for a twelve-person public within a field that limited the evidentiary potential of the video and whose viewing strategy involved a frame-by-frame breakdown that sufficiently minimized the affective appeal of an ongoing beating. The meaning was controlled: it could be terrible, but perhaps not so terrible; it could be violent, but was it a criminal act? Viewing conditions, audiences, narrative context, and the very shape of the video contributed to registers of efficacy (one could say the tape became "effective" for the defense) and failure as these devices found different ways of anchoring an otherwise indeterminate image. There was a lesson from this event: what was necessary was not merely the exposure of abuse, but strategies to place video within a promotional movement that took into account multiple factors in order to best direct attention and to produce action. The 2005 WITNESS Report reads: "WITNESS is more than a provider of technology. We know that images are important, but footage alone is not enough to stop human rights violations. WITNESS makes a difference because we work with our partners to make compelling testimony and images into powerful human stories and strategic advocacy campaigns."

Making Public Opinion—Making Public Opinion Useful

Making "powerful human stories" is not simple, particularly within a global, or alternately transnational, context. Notions of a transnational public sphere are sometimes treated as a new phenomenon related to the development of a post-Westphalian geopolitical landscape, with supranational governance and international partnerships between NGOs and local grass-roots organizations that traverse national borders. Yet, as suggested in both the trans-Atlantic abolitionist movement and the Armenian humanitarian efforts, these are not entirely new phenomena. This new landscape is not one of utopian or universal agreement, even under a supposed international human rights law. One must still ask how these iterations are made meaningful in the array of contexts, and how this public opinion, if successfully forged, is marshaled to effective political purpose.[27] The work of WITNESS reveals that their filmic interpretations of powerful and compelling stories are hardly static and that the look of human rights changes depending upon the audience. WITNESS relies on the practice of what Gregory has called "smart narrowcasting." This term draws on the legacy of commercial television practices, where "broadcasting" refers to the efforts of certain channels to reach as wide an audience as possible, whereas "narrowcasting"

refs to specialized programming that appeals to a more limited demographic but in turn allows a more specifically targeted advertising strategy. WITNESS recommends actively tailoring videos to the potential audience in order to best develop an impetus to act through the animation out of conviction, shame, empathy, or moral imperative. Selections are made regarding appropriate (persuasive) storytelling methods, visual style, and sound design. Public opinion is a situated creation, even if united under broader signs of human rights. As to the efficacy of public opinion: distribution campaigns maintain and develop the emotional affect in order to hold the attention of audiences. The tactical video package is united with the advocacy goals of the organization, which direct this public to action.

The understanding of these video appeals to human rights as situated and contingent expressions challenges the two-fold assumption of self-evidence that lingers in human rights work. Although ontologically and epistemologically privileged, photographic media are not transparent delivery systems for truth. As noted earlier, media appeals are by no means straightforward but enmeshed in a variety of logics and practices enrolled in the service of making human rights claims. Even as human rights can be thought to be "inherent and out there,"[28] they are constituted through a variety of discursive practices.[29] Technologies of witnessing participate in these practices by visualizing the violation of these rights, the rights-bearing subject, and in this way, the understanding of rights themselves.

WITNESS: SEE IT / FILM IT / CHANGE IT

Although WITNESS makes explicit use of the field of witnessing, drawing on political, economic, and symbolic contexts to mount claims and campaigns, the visual nevertheless stays at the forefront. The WITNESS logo, which boasts the phrase "SEE IT / FILM IT / CHANGE IT," offers the image of two pairs of eyes: one set closed, one open with the word "WITNESS" as the transition point between the two (Figure 11). The 2005 report underscores this visuality, explaining, "WITNESS uses the power of video to open the eyes of the world to human rights abuses" and "WITNESS empowers human rights defenders to use video as a tool to shine a light on those most affected by human rights violations, and to transform personal stories of abuse into powerful tools of justice."[30] Vision remains the key mode for stimulating compassion and sentiment, much as it did for eighteenth-century moral philosophers.[31] Even the name "WITNESS" resonates with the potential of seeing and doing. The term not only invokes the act of

Figure 11. The WITNESS website bearing the slogan "SEE IT / FILM IT / CHANGE IT." On the right, the section in black explains "WITNESS uses video to open the eyes of the world to human rights violations." Other options on the site include information on improving safety for human rights media makers, the WITNESS store, following WITNESS on Facebook and Twitter, and signing up for a newsletter.

viewing, but also draws on the act of bearing witness or giving testimony. As I have discussed elsewhere in this study, testimony is frequently regarded as a performative act that occasions beneficial change in Christian, therapeutic, juridical, and political arenas. Thus, WITNESS benefits from its name: it draws on the metaphor of visuality that holds primacy among the senses as generator of sensation, and it draws on a legacy whereby bearing witness transforms the world. And, ironically, this name, the motto, and occasionally the videos themselves obfuscate the amount of work

involved in producing a human rights claim and mobilizing the audience to action.

An early WITNESS public service announcement (PSA) highlights the model of exposure, revelation, and justice as it simultaneously illustrates the ways in which cinematic strategies produce meaning and affect. The short video calls attention to the appeal of bearing witness to transformation while demonstrating the ways in which the act of bearing witness is constructed. The thirty-second spot opens with a black screen and ominous pulsing hum. A title rises, "You can say a story is fabricated"; it is followed by grainy video footage of people running in the streets. "You can say a jury is corrupt," reads another title; this time a disfigured body holds center screen before the camera pulls out to reveal the military figures standing about. "You can say a person is lying," the text continues, followed by a young woman standing among skulls in ruins of a building. "You can say you don't trust newspapers," meets with the raw footage of a demonstration date and time stamped to inform that the beatings by policemen took place on June 21, 1996, at 7:10 P.M. "But you can't say what you just saw never happened" reads the last set of titles, this statement interrupted by images of violence, military force, sobbing civilians.

The PSA expresses a fundamental oscillation between visible evidence and the discursive terrain of witnessing. The diegesis of the spot presents an argument that verbal reports are subject to dispute, whereas images provide irrefutable information. However, this strategy relies on the intertitles as anchorage for the image meaning. The language that images are claimed to override is in fact what grants the images their meaning in this context, even in this oppositional discourse. Moreover, each clip carries with it a particular cinematographic strategy that confers truth on the footage. A date and time stamp gives evidentiary force through factual precision; a zoom out allows the body viewed in close-up to be placed seamlessly within a militarized context. When the clip continues, and text implores the viewer to "Help WITNESS give cameras to the world"; claims of "exposing injustice" are met with the visual act of a forensic excavation of a mass grave, the exposure of the skull given meaning by the relationship with the text. When the text exhorts us to "reveal the truth," the spot moves into the realm of action, a move articulated in the image of a South Asian women's rally, shot at a low angle so that the subjects command the presence of the screen. This cinematographic gesture enforces the sense of the potential articulated in the final text: "Show us what's wrong with the world . . . and maybe we can help . . . make it . . . right."

A closer reading of this PSA throws the work of WITNESS into relief. The value of visuality comes to the fore, and excitement in evidentiary and activist potential of the image is developed. Seeming to rely on image alone, the spot makes its argument through the orchestration of sound, text, image, shot selection, and shooting styles. These choices are not to be underestimated, as they are the strategies that enable video to work within the context of an overall advocacy mission.

How WITNESS Works

As noted earlier, WITNESS does not take on a specific issue. Rather, it works with human rights organizations worldwide, aiding them in the use of video within an advocacy campaign. The forms of aid include equipment, training in camera techniques, and instruction in video editing, as well as access to editing resources, critical feedback on documentaries, and planning for incorporating video into an action plan. In this last function, WITNESS assists in the production of multipronged campaigns with variegated broadcast and distribution platforms. These include plans for screenings to the general public, grassroots community activists, and decision makers in the UN or specific national congresses, as well as NGOs and other potential collaborators. WITNESS occasionally acts as distributor and exhibitor by offering "Rights Alerts" on its website, which includes a video, contextual information, and, as its "Act Now" component, instructions for action that include telephone scripts, web-faxes, letters, and other prompts to action from home. Over time and with the help of its partners, WITNESS has also developed a significant media archive, whose holdings have been put to multiple uses, such as evidence in the International War Crimes Tribunal for the former Yugoslavia (ICTY); supplementary footage for documentaries by Amnesty International and Human Rights Watch documentaries; clips for broadcast media (CNN, ABC, BBC, Deutsche Telecom, and Telemundo, among others); and video for presentations at the UN and in U.S. Congress.

Video is the primary medium in these campaigns and thus the one discussed here. Affordability and portability contribute to the appeal of the medium. Its capacity to provide sound and temporal duration not only produces a speaking subject in the present, thus rescuing the subject from a frozen past, but it also contributes an additional immediacy that can be put to use—the suffering appears in progress. And video augments the

truth-claim. Although subject to manipulation, mashup, repurposing, and recontextualization, digital video has become the chief medium of the documentary and of the home movie, the amateur footage that hints at innocence. This association has only grown in recent years, with the development of the technology of the camera phone, which conjures up notions of the accidental witness poised to record and transmit what she has seen. Distribution platforms for video are many: DVD/VHS, theatrical release, television broadcast, the Internet, and even replay on news as television networks solicit user-generated content to supplement reportage. Video's migratory capacity is a source of great potential but also concern, as it risks losing attribution, context, and meaning along the way. With the Internet and mobile technology, witnessing can go viral, but to what end?[32]

A thorough survey of the WITNESS partners' video advocacy projects reveals a wide range of genres. Although most fall into the category of documentary ranging from raw footage to public service announcements to documentaries for television broadcast on public television or *Oprah*, WITNESS partners and advisors have also used flash animation cartoons (in earlier, pre–Web 2.0 campaigns), soap operas, and music videos for public education programs.[33] Nevertheless, documentary persists as the primary mode of outreach and advocacy. The presumption of transparency and political agency granted on this "discourse of sobriety" makes it an appealing counterpoint to the infotainment of present-day news reportage and the "advotainment" of social issue films.[34] At the same time, one must remember the cinematic elements of a documentary that make it a "fiction (un)like any other,"[35] where stories and characters work to uphold arguments about the world; since the appearance of Michael Moore, the entertainment value of documentary has become common knowledge. Moreover, the documentary, as film, operates within a media terrain. News items provide economic narratives for the argument while receiving extended play in this alternative platform. Mainstream entertainment grants pockets of opportunity for awareness and capacity building. It is this activity that challenges the assumption that popular culture and practices of commercial entertainment diminish advocacy potential.

Choosing a Partner: Building an Advocacy Network

At any given time, WITNESS has thirteen to fifteen Core Partners, with an average period of engagement ranging from one to three years. Their partnership evaluation criteria includes: "Credibility and capacity of the

applicant organization; Salience of the issue they are addressing, and the understanding/imagination with which they are envisioning the use of video; WITNESS capacity to support the work, and to leverage the impact of our partners' work; Fit of the applicant organization with our existing partnership network."[36] "Fit" refers to a variety of intersecting concerns as WITNESS seeks to maintain a diverse partnership base, working with a variety of issues and regions, as well as with a variety of organizations from community-based movements to professional human rights NGOs. In the midst of this diversity, WITNESS seeks to promote partnerships among these organizations, what they call "synergy." If an organization has a record of success in an area, there may be a sustainable action plan in place, and a means of producing the desired change. Within this seemingly entre- preneurial model, another component arises, what they call "News Cur- rency and Media Interest," which suggests the ability of this issue to be mobilized and maintained within the mass media. Can these tools be de- ployed for this issue? Goals of sustainability, synergy, and media potential inhabit the other three criteria.

The applicant or potential partner, whether a grassroots social move- ment or an international NGO, must be a well-respected, nonviolent human rights institution "representative of the constituencies it serves." Such a request, WITNESS clarifies, does not mean the most established, oldest, or largest, but rather, an organization that is considered responsi- ble and already has infrastructure and resources to be an effective advo- cate. Resources, such as a strong support system, practical methods, and strategy for circumventing such political constraints, as repressive govern- ments and restrictive (and restricted) press contribute to the organiza- tion's efficacy. With these tools, there is the possibility for a solid campaign and access to decision makers. Strong resources also position the partner to provide assistance to other partners. WITNESS asks if the applicant has "potential interest and capacity to training other future partners in their region, so that they can support locally-based replication of video advo- cacy models." Sustainability and synergies are appealing, primarily for the imagined future of a global advocacy network, but also because WITNESS does not have the funding to support the organization any more than in their capacity as advisors, collaborators, and facilitators. They offer train- ing, equipment, and resources, but no financial aid.[37]

The potential partner needs to demonstrate the suitability of video for the campaign. In addition to plans and stated purposes (e.g., fundraising,

documentation, training), there needs to be a realistic understanding of what video advocacy entails. Gillian Caldwell, former executive director of WITNESS, notes, "Video isn't right for every campaign or organization. For one thing, it is very time-consuming and potentially expensive endeavor. Additionally, at WITNESS we often talk about whether or not an issue lends itself to being conveyed convincingly with images and compelling human stories."[38] Safety emerges as a factor in suitability, providing an ethical question that takes into account the risks of filming and being filmed. Heightened visibility may not be a desirable feature of a particular campaign, particularly if those interviewed may fear for their lives should government officials or oppressors see this video. Even the act of filming places one in the line of danger: in the past, cameras have been mistaken for weapons, with journalists and monitors viewed as (or mistaken for) threats meriting violent response.

Apart from risk assessment, the issue is cinematic. "A video is only as powerful as its ability to touch the people that watch it," explains Caldwell.[39] The documentary demands effective and appealing characters, and the community will need to find these spokespeople. Telling an effective and compelling story is a skill—and telling one before the camera increases the challenge. The stakes are high, as the presentation of testimony contributes not only to the emotional connection, but also to the perception of truth. Traumatic experience can disrupt the capacity for straightforward narration and can result in uncertain expression, and even fantasy. Janet Walker's article on "traumatic paradox" outlines this problem, in which the articulations that best illustrate the impact of trauma fail to meet the standards of testimony required in courts of law—and in advocacy documentaries.[40] Without emotional connection or confidence in factuality, political action becomes an unlikely outcome. A popular approach may thus serve the production of a case more than an experimental investigation into trauma and the ability to represent it. Good characters and storytelling abilities become particularly important when graphic images are not available, which they rarely are, even in this era. Growing access to video and digital media technologies enhance the speed and reach of images (which can be mailed as soon as taken) and enable peer-to-peer participation. Yet even so, the proliferation of cameras and distribution technologies does not guarantee the filming of abuses that typically take place behind closed doors. And even if recorded, the atrocity images rely on the anchorage of testimony to direct meaning and action.

The Video Action Plan: Narrowcasting for Advocacy

Increased visibility alone accomplishes little if not channeled into a clear plan for action, the final and most crucial criterion for selecting a partner. Does the organization have a clear advocacy goal that will be advanced through the use of media? No longer is a vague promise that visibility will contribute to action enough; instead, the campaign must center on an issue and offer direction to action. This goal, in turn, informs the development of the Video Action Plan (VAP), a questionnaire which functions as a starting point for the project.[41] The VAP directs partners "through the process of thinking about advocacy tactics, logistical preparations, skills and visual literacy required to successfully create a video advocacy project."[42] It functions much like a pitch made to producers, and like producers, WITNESS will help to adjust and perfect the plan.

Objectives and Audience

The first step of the VAP asks the new partner to list objectives, advocacy tactics for each objective, events of relevance (bills on the dockets, NGO gatherings), and other stakeholders in the process. The partner needs to note the specific policy or "change" objectives, as well as the ways in which the partner would measure success. Explicitly defined objectives enable the identification of the best audience(s) who "should have the ability to influence your advocacy objectives, either directly or indirectly." The audience here is not a theoretical abstraction, a broadly configured moral constituency that may or may not act—even if they wish to; instead, this process of identification produces a concrete demographic for outreach, a narrowly defined public for this presentation of opinion. Audiences for advocacy videos can include judicial bodies, legislative bodies, NGOs, community organizations, news media, and local, regional, and national publics.

Audience analysis plays a key role in the planning process, much as a demographic analysis may enable marketers to determine the best strategy for sales. Storytelling and distribution tactics depend on the audience's awareness level (how much do they know?) and perspective (predisposition to the issue), and the intended message of the video (what message will inspire the audience to action?). To aid the partner, WITNESS provides a sample analysis regarding a campaign to secure "financial and policy commitment to support landmine victims" (*action sought*). In this case,

the intended *audience* is the Senegalese president, whose *awareness* has been stimulated thanks to ongoing advocacy work in the region. His *perspective* has been determined as neutral, but given the lack of policy or legislation; the intended *message* will underscore the regime's ability "to provide support to landmine victims by adequately funding support services." To accomplish this, the *story* will center on the "human impact of landmines, the urgency of the need to assist victims and the illegality of non-assistance." The *voices* deployed to produce this story are landmine victims (the voice of human cost) and "informed neutral experts recommending action" (the voice of authority deploying standards and expertise as pressure points). In this case, a private screening was the primary *distribution* forum, "organized with other NGOs in our anti-landmines coalition."

Shaping the Video for Audiences and Objectives

The above example represents only one of myriad possibilities. Video strategies are as varied as the goals and the audiences. There are videos determined to sway a vote among decision makers in order to pressure for the ratification of a law or the withholding of funding. Such videos frequently alternate between the powerful testimony that animates the human dimension of the story and the voices of expertise and exposition. These latter voices include both professionals and the documentary tactics of graphs, maps, and other visible markers of authoritative, scientific knowledge. For example, Amazon Watch, a WITNESS Partner that advocates for the interests of the environment and indigenous people in the Amazon Basin, launched a campaign to apply pressure to the Export-Import Bank of the United States (Ex-Im) to refuse financing to the Camisea Gas Project in Peru (2003). The video brought in the measured tone of a voice-over narrator who invokes the Smithsonian when observing the havoc to be wrought on the biodiverse region. He outlines the ways the plans would contradict both Ex-Im's own explicitly stated ethical standards as well as U.S. environmental regulations. Maps, logos of the company, and animations accompany these observations, evoking the standard format of an instructional video, with the rhetoric of authority and neutrality that bolsters legitimacy of the claim. Testimonies give life to those imperiled by the plans, underscoring the human stakes of the issues at hand. This video could function to reach both bank officials and publics who could apply pressure to officials (shareholders, journalists).

Video collected for a juridical context must meet the stringent requirements of the court and accommodate both rules of chain of custody and cinematic expectations of authenticity. "Chain of custody" refers to the official handling of material evidence and specifically the documentation of its custody from its seizure to its use in court. All transfers must be logged and all persons in contact with the evidence must be recorded. These extrafilmic bureaucratic processes ensure the authenticity and legitimacy of the evidence in court. Within the film, temporal and spatial establishment is necessary. A date or time stamp will function to locate the events temporally, while wide shots will locate the events in space and close-ups of distinguishing landmarks will establish location. The cinematographic decisions are joined with editorial ones: the transitions in a video designated for the courtroom should not be interrupted by a cut, lest the edit compromise the integrity of the video evidence. While raw footage may seem conceptually appealing, its collection should be informed by anticipated usage: each context of viewing, each audience, brings its own demands of authenticity and its own notions of affective appeal. The video, shaped by the processes of narrowcasting, will be tailored to the concerns of the target audience and to the demands of the exhibition venues. The intended use of the video informs the production process.

Sometimes, however, the plan must adapt. With the aid of the late Joey Lozano, a longtime WITNESS partner and journalist, NAKAMATA, a Philippine indigenous people's organization representing more than a thousand families on the island of Mindao, took up video in the production of lands rights claims (within the purview of the 1997 Indigenous Peoples Rights Act, a national law). According to Gregory, the process of land surveillance and documentation of claims procedures was violently interrupted by attacks that resulted in the murder of three leaders and the destruction of a village. Because local law enforcement failed to act, Lozano and NAKAMATA took it upon themselves to use the documentation process to achieve another form of social justice. Present at the events, Lozano and NAKAMATA captured the aftermath of the attack—the bloodied and injured victims struggling helplessly as others attempted to carry them to aid. Most strikingly, the clip included a dying man and his son, who, while hiding in the sugarcane, witnessed his father's murder. These upsetting images were joined by testimony of witnesses, survivors, government officials, and local police, as NAKAMATA produced videos "shown to multiple broad and targeted audiences, nationally and internationally, in several different registers of human rights discourse." In other words,

the footage was assembled and exhibited in multiple ways to accomplish the intended action.[43]

Raw footage was submitted to local police authorities as evidence, and also offered as part of a deal to *Probe Team,* a Philippine investigative news program, marking the first time that video shot by an indigenous group was broadcast nationally. Lozano and NAKAMATA also produced their own short documentary video entitled *Sugarland: Rule of the Gun* (Joey Lozano, NAKAMATA, WITNESS, 2001) where they placed testimonies collected from police and state officials—most denying the violence of these actions—in dialogue with images of the slaughtered men, the surviving child, and the grieving villagers. The contrast of physical suffering and death with official inaction became the primary mode through which the video advocated for action. The documentary circulated among international human rights organizations and was posted, in shorter form, as a "Rights Alert" on the WITNESS website. In the NAKAMATA case, visitors wrote to Philippine authorities, asking for further investigation and protection for NAKAMATA in their project. Following this deployment, a video was delivered to Philippine president Gloria Macapagal-Arroyo, who also received letters produced through the campaign. The collected footage was put to work in a variety operations, from local law, to local broadcast publicity, to international campaign. This multitiered and sequenced distribution strategy applied enough ongoing (and developing) pressure that the Philippines National Bureau of Investigations established an inquiry, resulting in murder charges and subsequent arrests of the responsible parties.[44]

Distribution/Exhibition

The NAKAMATA story reflects the role of distribution within the campaign, in particular the way in which each venue for exhibition (and mode of reaching target audiences) influences the shape and appearance of the video. Among the distribution strategies WITNESS identifies are public screenings (community screenings, film festivals, theatrical distribution), tape and DVD distribution (making the materials available through retail outlets, advocacy networks), private screenings (before an audience of decision and policy makers, legal process), broadcast media (TV and radio documentaries and news), and Internet applications (streaming video, websites—including the WITNESS Hub—e-mail campaigns). "Small" electronic media are also enlisted in such projects, such as video transmitted via cell phone.[45]

Each venue demands different form, content, and style for the video, as editors determine the needs and expectations of their own audiences. Submission to a broadcast news agency may need to fulfill the editorial board's demand for violence but without presenting something too graphic for the station's standards.[46] Additionally, the activist will need to account for the possibility that the footage can be reedited and possibly resignified through the broadcast practices; in such cases WITNESS notes that advocacy groups will supply video news releases (VNRs) to television stations. These video press releases mimic the news format with short compilations of expert testimony, victim testimony, and voice-over narration combined with relevant video images or B-roll. Often deployed by public relations agencies for promotional purposes, VNRs have generated a great deal of anxiety for their similarity to traditional news clips and for their lack of attribution, which creates the suggestion that these items were subject to the same vetting processes considered the hallmark of journalistic legitimacy.[47] Moreover, the use of VNRs by the Pentagon and the White House in order to promote administrative agendas has legitimately inspired numerous objections. In addition to violating federal law, this practice allows the government to report on itself and to do so without disclosure. In this case, the government hijacks the work of the journalistic media, whose duty is to scrutinize the work of the state, which already has multiple venues of expression. By contrast, human rights organizations frequently require the aid of news media as platform. The VNR format—appealing to the economy of time and simplicity—facilitates the video's entry into this circuitry, and improves the chances that the issue will receive coverage. The discomfort with any use of VNRs in the news is warranted, to be sure, but the differing goals, projects, and organizations suggest an ethical continuum and the need for case-by-case assessment.

Perhaps less controversially, such venues as the Internet contribute to the shape of the video. While the Web holds its appeal for reaching dispersed global audiences at a relatively low cost, the strategy can be limited by issues of access; not all communities are wired, nor are all connections strong enough to support video. For those that do (predominantly in North America and Western Europe), the technological features still produce formal demands. Filmmaker and activist Katerina Cizek notes, "Online broadcasts need to be short, clear, engaging, and give a clearly defined vision and concrete ideas on how to get involved."[48] Shorter is better in such cases, since a short piece risks fewer buffering interruptions

and holds onto audience attention. "WITNESS finds most viewers will spend no longer than three minutes viewing online videos."[49] Beyond the length, the limitations of streaming video affect the look of the media. Because the image is small and of compromised quality, excessive camera movement can be distracting, while title cards and subtitles are inefficient communication devices. Dubbing or voice-over become preferred modes, particularly as sound quality will remain superior to the image, even in a slow connection. Interviews and testimony continue to be efficient strategies for communication, as images are stable and will stream well with the sound. At the same time, ethical implications proliferate in near direct ratio to technological development as manipulation and sharing increase risk to safety of those depicted and to the intended interpretation.

Exposure is neither simple, nor direct. Rather, it is a process determined by desired goals, potential audiences, and technological limitations. Moreover, these factors and contingencies inform the cinematic strategies that are taken up when presenting a case. How do videos create a human rights issue and an ethico-political claim on screen? In order to better understand how decisions are made, and how these decisions affect the appearance of a video, I take as a case study Books Not Bars, which mobilized a variety of video tactics in the service of differing goals under an overall program of prison reform.[50]

Case Study: Books Not Bars

The U.S.-based Ella Baker Center for Human Rights (EBC), founded in August 1996 and one of WITNESS's core partners, challenges human rights abuses within the United States criminal justice system, by using video and the Internet to produce policy reform, influence voting and funding decisions, and mobilize grassroots communities. In 2001 they launched Books Not Bars, a campaign to draw attention to and challenge increasing youth incarceration. This youth-centered movement reaches out to communities most affected by this system to combat both practices of incarceration—particularly the excessive imprisonment of youth of color—and to advocate funding education rather than prison spending, shifting governmental attention away from incarceration and punishment and toward rehabilitation and education. In addition to fighting the implementation of California's 2000 Proposition-21, which enabled fourteen-year-olds to be tried in adult courts and sixteen-year olds to be placed in

adult jails, in 2001, EBC decided to take on the proposed "Super-Jail for Kids" in Alameda County, California, which threatened to become the largest per-capita youth jail in the country.

This project reflects the numerous and significant interventions of WITNESS. WITNESS's contribution consists of two video coproductions, *Books Not Bars* (2001) and *System Failure* (2004). The appearance, distribution, and exhibition of each video illustrates the cinematic strategies deployed to activate audience sentiment and action. The campaign also reflects an intervention into the misperceptions of human rights presented through the mass media. Citing a study by the International Council on Human Rights Policy, Gregory observes a tendency for dominant mass media (or more coarsely put, Western media) to view rights within a frame of conflict or politics, while absenting issues of economic, social, and cultural rights.[51] He notes that "there is confusion about where human rights are, especially among journalists and editors in the global North, so that stories close to home that could be placed in the context of human right standards are usually not."[52] In this project, what might typically be represented as a civil and local concern is recast as a human rights issue. The significance of this project rests not only in its tactical deployment of film language and distribution strategies for the mobilization of witnessing public, but also in its presentation of these abuses within a human rights frame.

Books Not Bars

The video *Books Not Bars,* a coproduction of WITNESS, the EBC, and Columbia Law School Human Rights Institute, became a key aspect of the campaign. Intended as both an educational and an outreach tool, the video documents the youth-led movement against the prison industry, drawing attention to the harmful effects and racial disparities of its for-profit machinations. The youth focus directs the sound and appearance of the video, as music by Dead Prez accompanies youth testimony decrying the public misperceptions that criminalize young people of color. The rhythms of the speech are matched to the rhythms of hip-hop, producing a spoken-word inflection as James Bell, an attorney for the Youth Law Center of San Francisco, California, confirms the testimony. Characterized by the quick cuts and cinematographic shifts in tone, texture, and grain, and stylistics including a graffiti font, the presentation evokes the music video appearance popularized (and often reinvented) by MTV.

The appeal goes beyond stylistics, as the video validates and prioritizes youth experience through the extensive use of testimony. These figures articulate the frustration and outrage inspired by the misperceptions that criminalize youth and increase the interest in funding prisons over education and a possible future. The first goal is to present this case in the frame of child rights, even for the incarcerated. Conditions in the prisons are described as hopeless, violent, and ineffective. The testimonies of treatment in the youth prisons, of beatings, of rape, of hopelessness are punctuated by text that cites the UN Convention on the Rights of the Child: "Every child deprived of liberty shall be treated with humanity and respect." A young man offers his thoughts on the sentiments that lead to zealous prison production and the dearth of education funding: "That black boy is not going to make it because he doesn't think like us. They treat me like an animal." His observation animates the text: being treated like an animal—and not "with humanity"—rests at the heart of these policy decisions. Teachers, attorneys, and statisticians authorize and support the youth position in this forum, granting them the heft and legitimacy that combat possible doubt in the viewing public and even in the teens themselves. Statistics of incarceration noting the disproportionate imprisonment of black and Latino youth in comparison to white youth are presented in text and voice-over, followed by two sequences. The statistics are interpreted by an attorney's voice-over as telling black and Latino families that "your kids matter less than white kids." Black and Latino teenagers exit a school on screen, seen to be enjoying a life of safety and education endangered by the unequal and unfair valuation that leads to excessive imprisonment and social marginalization. Far more than an issue of fairness, this is an issue of rights: the next clip offers a long shot of imprisoned adolescents to emphasize the numbers, while a text imprint informs the viewer of a premise of the Universal Declaration of Human Rights: "All are equal before the law and entitled without any discrimination to equal protection." The video casts the situation in terms of human rights, combining youth testimonials of frustration and injustice with authoritative figures and statistics that transform their concerns into human and civil rights issues. This is not a matter of criminality or the penal system alone. The video legitimizes the concerns expressed and possibly shared by youth viewers while arguing that these are issues subject to political and legal treatment.[53]

After framing the problem, the video offers solutions in the form of action. The documentary contains footage of the youth-led movement

and their public activism. The film shows Van Jones, one of the directors of Books Not Bars, addressing his audience, inciting them to action, telling them they have rights to which they are entitled, but for which they must fight. One of the young women interviewed explains, "I have to fight for myself, otherwise who will?" invoking both the frustration already articulated while introducing potential for change. This is followed by shots of protests, young people filling the screen, involved and engaged. The presentation of these excited, active youth, and the opportunity to relate their success can animate and edify the potentially disaffected. Jane Gaines refers to such an effect as "political mimesis." Here she draws both on Eisenstein, whose idea of the "agitational spectacle" suggests a sensuous capacity of film to lead the body, and on Linda Williams, who argues that there are genres that "'make the body do things' (horror makes you scream, melodrama makes you cry, and porn makes you 'come')."[54] And for Gaines, documentary, which shows the politicized body, inspires action. For youth who feel and are more often penalized by the political system than engaged by it, this vision of politically active young people may provide an inspiring vision, inviting them into a realm of possibility.

However, the formulation that the documentary inspires action, like the formulation "porn makes you 'come,'" could stand expansion: while arousal or excitement is made possible by the visual experience, social activism, like physical climax, is a result that may be more attributable to the material practices that accompany watching. The inspirational capacity of such spectatorship, while appealing, is sadly not so simple. The content and form of the video contribute to the bodily excitement, presenting testimonies, sounds, and images that arise from a context of viewership and experience. The use of hip-hop music and pacing draws on established and appealing modes of expression. The sensuous appeal of the video is enabled through aesthetic and textual selections. But without finding a way to channel the excitement into action, the piece produces a passive experience, one that advocacy filmmaker Peter Wintonick associates with entertainment alone.[55] Such an experience may well factor into the aforementioned problems of hopelessness, numbness, and fatigue, emotional states particularly detrimental to the youth to whom this is directed. For this reason, WITNESS instructs its partners to produce a "space for action" within the film or its viewing conditions.[56]

In the case of the Books Not Bars movement, context was mobilized. While the youth appeal was yet again enhanced by the attendant

performances of spoken word and hip-hop artists, WITNESS and its partners developed an "Action Pack" that provided tangible ways for the audience members to participate in a prison-system reform movement. This includes such information as "10 Ways That You Can Fight for Books Not Bars," "Background of the Battle: The Campaign to Stop the Alameda County Super Jail," and "Ways to Find Out How Your State Rates on Funding for Schools and Jails." One handout ("What You Can Do") presents instructions for action, including "Call Arnold" (then California governor Arnold Schwarzenegger) day, which supplies the recipient with a phone number, the numbers to press to reach the appropriate staffer, and a script for the caller (in this case, the request that Chad youth prison be closed). The handout also asks that the recipient pass this message on to friends. Such a context enables an audience to channel their emotions into action rather than allow them to dissipate or get transformed into frustrated outrage. These options generated further possibility, as those most targeted by these processes could gain a sense of power and agency in action. The video project focuses on the key goal of mobilizing a grassroots campaign and offers both the audiovisual stimulation and exhibition strategy in this mission.

The overall campaign generated real results. A seventy-person protest at a Board of Corrections hearing resulted in the denial of earmarked state funding for construction of the facility ($2.3 million). Within two years, the campaign successfully derailed a "Super-Jail for Kids" proposal. The *Books Not Bars* video continues to be used in schools, along with a lesson plan that allows "high school students to examine incarceration-related issues within a human rights framework." In 2004 it received the Criminal Justice Award at the Media That Matters Film Festival.

System Failure

Although the campaign to address the wastefulness and violence found in California's Youth Prison system is far from over, these successes led to continued use of media advocacy by the EBC. WITNESS, along with the Books Not Bars project of the EBC, produced *System Failure*, which highlights the failures in the California Youth Authority (CYA) and calls for a complete reform of the system (specifically, adopting Missouri's model for a Youth Authority). Unlike *Books Not Bars*, this video was aimed at decision makers (probation officers, judges, California State Congress),

parents of imprisoned children, and community organizations. The appearance alone indicates the change in tactics when the audience and the function of the video (its immediate goal) have changed.

The piece opens with a montage of news reports occasioned by a surveillance camera's video capture of the beating of an inmate. The grainy black-and-white quality of the footage evokes the security camera gaze and produces the impression of life caught unaware, while the high angle position confers the position of monitor onto the viewer. The footage itself is a boon to the project. As noted earlier, it is rare for abuse to be caught on screen since it is more often relegated to the world off camera and behind closed doors. In addition, the body provides a profound source for viewer identification as well as form of truth-claim in itself. As noted in chapter 2, the (injured) body provides rhetorical force signifying the "truth and realness which seem to defy contextualization."[57] Both the content and the aesthetic of the video contribute to the evidentiary status and emotional effects of *System Failure.* Within the context of U.S. law enforcement, the video resurrects the King footage; here, again, the audience is presented with law officials battering a helpless body. In fact, the brief clip is made available on the Ella Baker Center website by clicking on a frame that boasts the heading "See for Yourself! Vicious Beating in CYA Youth Prison." And it is described as a "'Rodney King Style' Video of CYA Guards Beating Youth." Meanwhile, the evidentiary quality of the footage is granted additional heft as the security camera gaze suggests a neutral posture; the camera holds a static position that happens to capture the action that transpires before it. The lack of awareness by the parties on screen suggests the capacity of the camera to penetrate the dark corners and reveal the violations of acceptable behavior. In effect, this draws on the very implication of the "security camera" intended to monitor everyday life for criminal activity for purposes of general protection. By offering a brief iconic articulation of institutional abuse, the clip effectively sets the tone of the piece and appeals both to television news practices and to Internet distribution, which rely on its length and straightforward assertion.

The video, presented within the context of news reports, does more than produce a visual of the story of abuse for the audience of policy makers; it produces the story of a public relations disaster. Deployed in the documentary, the reportage offers an economic means of presenting the problem: an ineffective and violent CYA. More importantly, the multitude of reports demonstrates that this problem has been made public

and demands a public policy response. One finds here the strategy for "mobilizing shame" whereby this public monitoring body points out the behavioral lapse and demands a return to socially acceptable conduct.

The montage effect within this documentary context merits further note. Television is governed by the principle of flow, where programs follow one after the other, transforming the experience of spectatorship from the watching of a discrete event to the single experience of watching television.[58] Television news, one might note, is even further defined by this notion, as trauma after trauma is recounted until the end, where one receives the final update on the weather and perhaps a waterskiing squirrel. Even within the changed landscape, where viewers can switch channels or go online, the barrage of information, both repeated (viral video) and distracting (a new link), contributes to a surfing flow. In this ongoing replacement in search of the new item (a responsibility of both producers and viewers), an injustice may disappear. However, this documentary montage reminds the viewer of the potential of endless replay, as can happen to a story of sufficient interest, enacting the very experience of this replay on screen. And as with the case of the King footage, this replay allows a perception of relentless abuse. Presenting the crime as in process may very well excite the urge for intervention: it is not over.

The documentary moves beyond the replay of this footage and the potential public image crisis faced by the CYA when it returns to the emotional impact of individual testimonies. Former CYA inmates and their parents communicate the painful experience of the system and the effects on their families. Testimonies play a crucial role where, save for the security camera video and the news items, images of abuse are not forthcoming. The struggle for affective and effective footage is made clear when the cameras in *System Failure* travel through empty halls overcrowded with cots that serve as the temporary home to the juvenile detainees. Testimony helps to filter the institutional issue through a human lens.

The variations of testimony enhance the potential of this footage, offering not only the narration of the aggrieved, but also the statements of stakeholders and officials lobbying for change. In this case, the documentary presents footage from congressional hearings in which experts and other politicians deliver accounts of suffering to marshal the support of their colleagues and to defend against accusations of abuse. The film again introduces the very conditions that the decision makers may wish to avoid: hearings that question the conditions of the institution and the legitimacy of those in power. These testimonies also corroborate the stories of

the former inmates, whose experience may be devalued for the very conditions of discrimination that brought them into a system that treats them so poorly: they are most often poor, black or Hispanic, and aligned with criminality, whether by conceptual association or juvenile record.

While the practice of legitimizing the voices of the unprivileged through voices of authority remains a problem in representational strategy, it has its uses. Furthermore, the testimonies are still given a valuable and valid place within the documentary. These are not merely bodies on screen, crying children and crying families; these are stories told, and given an audience. Not merely articulating problems and threats, *System Failure* advocates solutions. Among the testimonies in the congressional arena are those who note the more effective and humane practices in the Missouri Youth Authority (MYA). With these testimonies, the documentary offers images of the homes that serve as the "stark visual contrast" Gillian Caldwell notes as one of the valuable elements of video.[59] Compared to the wide shots that emphasized the number of inmates and their depersonalization through the array of cots in a cold, open space, the footage of the MYA employs tighter shots, producing intimacy, although still wide enough to reveal wooden bunk beds draped with pastel blankets and pillows in colors that are vivid and warm. A teddy bear receives special note in a close-up in order to emphasize the fact these are children—not adult offenders. Such images produce a more appealing, safer space, and more importantly, as a chronicle of another project, a possible one. Titles that inform the viewer of comparative re-arrest and recidivism rates underscore the value of this alternative model. The cold institutional climate of the CYA does not achieve the rehabilitation demanded in its mission.

The distribution strategies for *System Failure* have led to screenings in multiple venues, from general and popular to specialized community screenings. The film has appeared in film festivals such as the Media That Matters Film Festival (June 2005), the Activist Film Festival (April 2005), and the Brooklyn Underground Film Festival (April 2005). The specialized community screenings have included a Books Not Bars Town Meeting (March 2005), a screening for parents of incarcerated youth in Stockton, California, cosponsored by Escuelas Si, Pintas No (ESPINO—Schools Yes, Prisons No) and a special screening for "faith leaders" in the San Francisco Bay Area (Oakland, California). For the family viewings, the redirection of shame might very well be edifying, redefining the subject for regulation. For these communities, the film does not so much mobilize shame as

"mobilize hope."[60] Here, the voices of complaint are given legitimacy and placed in the position of protagonist, as the incarcerated children and their families do not bear the stigma of criminalization in these films. They are unfairly treated and penalized, made to suffer in an unjust system—one that is subject to change.

Appearing in these popular and community venues, *System Failure* has also been screened for the decision makers, such as local juvenile justice officials including the district attorney and juvenile court judges and defenders. The video also became the first one ever to be screened at the state capitol when it was shown to an audience of California state legislators on January 19, 2005. It continues to be distributed among the legislators and representatives in order to encourage closing CYA facilities in favor of funding local community-based programs and establishing rehabilitation detention centers, such as those used in Missouri.

This campaign, too, has produced results. According to WITNESS, shortly after the January screening, Senate Majority Leader Gloria Romero (D–East Los Angeles) introduced legislation that would reform the department and reorganize the CYA according to the Missouri model. The CYA also responded to this campaign and to a lawsuit that was filed by the Prison Law Office committing to a new rehabilitative model with a plan deadline set for November 30, 2005.

What deserves note is the manner of intervention on the part of these organizations into the earlier human rights model of exposure and revelation. Media are recognized for a variety of properties and possibilities as visual traditions and cinematic language are invoked for different audiences and different goals—whether to pressure decision makers or to stimulate grassroots action. The "Rodney King"-like videotape is not merely delivered to the broadcast media of television news, but it is repurposed in multiple forums with a variety of goals: it can mobilize a grassroots public, angered by the image—a mobilization made effective through action packs or online letters; it can apply pressure to decision makers by producing the threat of a coming public relations catastrophe, and to be fair, by alerting them to the seriousness of the conditions. The testimonies serve to present what is unseen while humanizing the institutional situation, which may evoke empathy within the decision makers, and in different testimonies, empowerment within a disenfranchised community. It is the awareness of the variety of media, their formats and their reception, that contribute to effective use of visual media in the campaigns.

Publicity

WITNESS negotiates the media-related perils of compassion fatigue and desensitization through the work of "smart narrowcasting" whereby goals are determined, audiences targeted, and video and viewing contexts arranged accordingly. Although WITNESS prefers to highlight the grassroots potential of videos and the ways their projects enable the presentation of voices and positions that risk marginalization, they nonetheless advocate harnessing mass-media strategies and circuits to promote social action. Celebrities, for example, as instruments of publicity within the entertainment field, can also direct attention to advocacy campaigns. Angelina Jolie exemplifies this trend in her role as Goodwill Ambassador for the United Nations Refugee Agency. Jolie has also turned her high profile to the efforts of WITNESS. On December 5, 2005, she co-hosted a fundraising gala with founder Peter Gabriel, an event designated to highlight WITNESS's work in Sierra Leone. In May 2005, Jolie traveled with Executive Director Gillian Caldwell to Sierra Leone, where they used video from the recent Truth and Reconciliation Commission (TRC) to help secure commitments from the country's president to implement the recommendations. During this trip, Jolie attended a screening of *Witness to Truth,* the video that WITNESS coproduced with the TRC and which now supplements the TRC report, for a gathering of local organizations in Freetown. Her presence attracts overseas reportage and invites people to attend a screening that may have gone otherwise unnoticed. At the WITNESS fundraiser, Poniewozik asked Gabriel of Jolie's use as spokeswoman; to this, Gabriel responded, "Number one, you're here talking to me. . . . Also, when she went to Sierra Leone with us, straightaway we got into the President's office, which would have been very hard without her."[61] The WITNESS website echoed this awareness of her value, "because of Angelina's visit, the world took notice of what was happening in Sierra Leone—news of her trip and accomplishment circulated in broadcasts, newspapers and magazines around the world, reaching millions of people."[62] In other cases, WITNESS draws attention through the voice-over work of celebrities such as Susan Sarandon, or through public statements and petitions with "newsworthy" (infotainment-style) signatories. At the second Focus for Change event, sponsored by WITNESS, Peter Gabriel, along with Gael Garcia Bernal and Tim Robbins, called for a UN response to the military attacks on citizens in Burma. Others, including singer-songwriter Suzanne Vega and singer Kate Pierson of the B-52s, sent letters to the UN Security Council.[63]

WITNESS advocates piggybacking advocacy videos with screenings of feature films addressing a topic, although Gregory notes that this strategy is more often used by larger, established organizations. *The Lord of War* (Andrew Niccol, 2005), about an international weapons trafficker, provided a useful vehicle for Amnesty International to articulate concerns about the global arms trade. The organization sponsored screenings of the films in tandem with official presentations, securing audiences and broader reportage. Their website provides clips from the film in order to illustrate the text provided, while the DVD offers a short documentary on the international arms trade, using speakers from Amnesty International and Human Rights Watch to present the traffic in weapons as a human rights issue. One of the testimonies relates a story close to that depicted in the feature, both drawing connections between the political issues and the film and transferring the emotional engagement over a fictional case to this brief advocacy video. These additional platforms extend the engagement with the subject, taking advantage of the heightened interest and sympathy.

There are additional cases. Although flawed in its conflation of crises and subject to criticism for the manner of articulating its concerns, *Blood Diamond* (Edward Zwick, 2006) nevertheless provides a platform for multiple issues, including conflict diamonds and child soldiers, making it a useful tool for humanitarian agencies. The World Food Program appeared in the film in order to show its work and to show what its workers had witnessed in Sierra Leone.[64] To further bolster exposure of the program and their concern over global hunger, the organization developed a trailer featuring two of the film's stars (Djimon Hounsou and Jennifer Connelly) that would run before the film. UNICEF used a screening as an opportunity to call attention to the Convention on the Rights of the Child. And even those not directly involved with the film could take advantage of its visibility and its built-in public. Kalahari Bushmen of Botswana appealed to the film's star, Leonardo Di Caprio, in a full-page advertisement in *Variety*, asking that his support of those harmed in the diamond trade should extend to their present case—the eviction of the Gana and Gwi from the Central Kalahar as a result of the DeBeers company's diamond exploration.[65] In effect, activists and agencies harnessed the attention granted to the film and its stars, attention secured by their own marketing and publicity mechanisms.

For some, these forms of popular attention may suggest overexposure and the commodification of suffering, which in turn invoke fears of compassion fatigue, accusations of inappropriate (pornographic) affect, and

depoliticization of potential publics. Yet what happens here is not so much the commodification of suffering as much as the manipulation of commercial media resources to publicize issues, to make distant events causes for concern. The publicity savvy of celebrities, combined with their capacity to direct media attention and their function as vehicles for media product has led to intersections of the popular and the political that are both extreme and pervasive. This strategic harnessing of multiple media venues that promotes both the celebrity and the human rights issue can be seen as a form of synergy, in this case as humanitarian as commercial.

Hotel Rwanda (Terry George, 2004) offers a rich example of these commercial and celebrity synergies. Prior to its release, Amnesty International USA partnered with United Artists to produce an educator's guide for the film. With sections entitled "Counting on the Media, but Who Is Accountable?" (featuring a photograph of the character Jack [Joaquin Pheonix] holding his video camera) and "The International Community" (featuring a still of Paul [Don Cheadle] serving Colonel Oliver [Nick Nolte]), along with historical timelines, discussion topics, and activities, the guide uses the film to explore questions of individual and collective responsibility. Paul Rusesabagina has capitalized on the attention granted through this film with the Hotel Rwanda Rusesabagina Foundation, which states among its aims a Truth and Reconciliation Commission in Rwanda and the Great Lakes Region of Africa. The film is present throughout the mission description, where Rusesabagina is described as "the real life hero of the acclaimed film" as well as its consultant. And, of course, the film's title is in the organization's name. Hinted throughout this association is Rusesabagina's mission to continue saving more than the twelve hundred lives protected at Hotel Mille Collines. While his presence in the film's promotion secured its claims to truth, he has equally benefited from the attention, the same claims to truth, and his heroic characterization in the film in order to advance his own agenda.[66]

Such synergy is most pronounced in Don Cheadle's deployment of his celebrity and association with the story of genocide to publicize his concerns and advocate action in relation to another genocide, in Sudan. He joined a congressional mission to western Darfur and gave a news conference (with Representative Ed Royce, R-California) on Capitol Hill, calling for the United States and other nations to bring pressure against Sudan to end the massacres. Interviews and coverage that are an integral part of the Oscar publicity process were turned to Cheadle's concerns about Sudan.[67] An episode of *Nightline* that aired on February 9, 2005, boasted

that "art meets life," as Ted Koppel interviewed Cheadle regarding the situation. Cheadle's highly praised performance as the film's Rwandan protagonist Paul Rusesabagina was collapsed with Cheadle's own activism in Darfur. These interviews used film about the Rwandan genocide to promote interest in a present-day political issue, while at the same time this political issue served to promote interest in an Academy Award–nominated film and actor.[68] The political economy of awards shows afforded the opportunity for expression while the film secured an association with genocide and with those who act.

An early DVD release of *Hotel Rwanda* included a non-optional PSA about the situation in the Darfur region. This spot began to play upon the start of the DVD and completed with the opening of the menu page; the press of a button could not circumvent the screening. This mandatory sequence play has most often been deployed for trailers that advertise upcoming films. In this case, the sequence advocates awareness of an ongoing genocide prior to screening a film about a genocide that happened ten years past, and which was characterized by its visibility and attendant lack of action. Visibility and inaction haunt the narrative; a photojournalist films murders only to remark that news audiences will do little; a Romeo Dallaire (retired lieutenant general of U.N. Peacekeepers) stand-in does the same. Although the sequence precedes the film and thus cannot draw on the emotions to be evoked, it can position the viewer to consider a present-day conflict in light of the story to be told. This story of Rwanda is not simply a story of past conflict, but has resonance in today's world. At the same time, the narrative's focus on the heroic actions of Rusesabagina risks soothing viewer agony over inaction: someone is there to do something. Nevertheless, the use of Don Cheadle's celebrity and the DVD of *Hotel Rwanda* as occasion to publicize concerns about Darfur have aided in making the crisis in Sudan an ongoing concern, even as news media allow the story to take the back pages. Indeed, since the release of the DVD, the atrocities taking place in Sudan have crept into the media spotlight, and have maintained a presence since—a situation to be discussed in further depth in the following chapter.

Conclusion

The films of chapter 3 called attention to the numerous anxieties around media witnessing, as terrible events took place on the world stage to little response. A crisis of faith in the power of visuality to lead to rational action

came to the fore. However, their reflexive turn not only signaled cracks in conviction, but also yielded portraits of a field of witnessing. The presumed transparent exchange of seeing, believing, and acting was in fact replete with actors, institutions, and practices. But even in the midst of this revelation, other concerns developed around the treatment of images: were popular modes of expression, in particular those associated with audiovisual media, inevitably damaging to the cultivation of genuine publics? For many, advertising, public relations, marketing, and popular culture were seen as factors in apathy and depoliticization. These media practices did not produce witnesses but passive audiences substituting consumption for genuine engagement. In effect, the crisis intersected with and moved beyond the Enlightenment-style belief in the power of images. Photographic media either betrayed their promise or participated in institutions and practices too popular to be of political use.

However, these discourses of crisis and dismay are possibly misdirected, possibly too easy in the face of longstanding history of the use of film in the formation of public opinion and witnessing publics. WITNESS calls attention to the complications of these stances in its practical approach to the challenges of navigating media worlds to promote social justice campaigns. While their genre of choice is the documentary, the discourse of sobriety, the organization draws many of its tactics from fields of public relations, marketing, and popular entertainment. And there is every reason to do so. Such tools of publicity are not inherently damaging, but can provide means of navigating the field of witnessing and media multiverse portrayed in the previous chapter. Although the organization holds onto the presumption of transparency of the image with its arguments that video "shines a light on those most affected by human rights violations" or that "seeing is believing," the emphasis on simple visuality neglects the multiple logics deployed to enhance the production of a human rights claim. Here, it does not seem that WITNESS believes that revelation leads to action, but that processes of exposure must be tuned to considerations of goals, distribution mechanisms, exhibition contexts, and audiences. The organization advises strategic narrowcasting where audiences are targeted and the aesthetic and narrative style of the video, as well as the distribution and exhibition tactics, are shaped accordingly. These practices challenge waning compassion and politicization through strategic and contingent witnessing that hails the viewer by making the expression meaningful and by directing the course of action. Moreover, the simplicity of the slogan "SEE IT / FILM IT / CHANGE IT" masks WITNESS's crucial work in

building a global network of media advocacy producers and consumers/ activists through its partnerships and its program of seeding video advocacy. Their work contributes to a necessary infrastructure that can enable information and resource exchange among activists while also harboring the means to reach out to wider publics. The work of WITNESS reveals the work of witnessing.

5 iWITNESSES AND CITIZENTUBE

Focus on Darfur

IN APRIL 2007 YouTube launched the political video log (vlog) "Citizen-Tube," in order to "add fuel to the revolution that is YouTube politics."[1] The phrase "YouTube Politics" hints at a democracy of speech and ideas ostensibly enabled by the new media technologies that grant tools of video production, exhibition, and distribution to noninstitutional actors. The phrase equally posits YouTube as a site of civic engagement, a place where audiences can become publics. The claim raises questions around YouTube and, more broadly, the Internet as a platform for witnessing and for representing distant human rights abuses in efforts to cultivate witnessing publics and response. Photographic media have played a significant role in establishing an iconographic lexicon that contributes to popular, legal, and political understandings of genocide and human rights violations. These media have also aided in developing claims and activating sentiment in order to mobilize action. As the book has addressed so far, this witnessing function is best understood within a field of witnessing production, which takes into account the discursive terrain of testimony, the political economy behind the organization of the encounter, and the strategies of exhibition and reception. How does the terrain change with this shift to the Internet, something that is "at once technology, medium, and engine of social relations"?[2]

Useful to this new field are Pierre Levy's formulations of knowledge space, collective intelligence, and the *cosmopedia*, which present a dynamic field of encounter and exchange that result in shared knowledge, skills, and the potential for action. The *cosmopedia*, or "virtual agora" functions as a form of public sphere, where "members of this thinking community search, inscribe, connect, consult, explore," using the knowledge space as "a site of collective discussion, negotiation and development."[3] Henry

Jenkins's suggestion that "online fan communities are the most fully realized versions of Levy's *cosmopedia*" enriches the possibilities of thinking about the *cosmopedia* as a site for witnessing.[4] United by affinity, fan communities as active consumers or "interactive audiences" are primed for action and participation in their field of images. Even before the popularization of the Internet, fans interacted with their texts, attending conventions and writing fan fiction. Their interaction could have bearing on the content. Jenkins explains, "Star Trek fans were, from the start, an activist audience, lobbying to keep the series on the air and later advocating specific changes in the program content."[5] Over the years, this activity has increased, ameliorated by the rapid development of technology and the growth in users, leading Jenkins to observe, "cyberspace is fandom writ large."[6]

Such an observation has productive resonance for thinking through how the Internet has contributed to the representation of genocide and human rights violations, and how this new technology/medium/space produces witnessing publics. This chapter outlines the impact and possibilities of this new technology in representing and mobilizing response in relation to the ongoing crisis in the Darfur region of Sudan. Recognizing the vast array of media in the *cosmopedia,* the chapter looks at the work of websites, online games, and Internet video as sites of witnessing to genocide and the promotion of participation and action. Reading through the sites, I analyze content and interface to see how they cultivate communities of concern—intelligence communities as activist witnesses. How is the case represented to promote urgency and response and what are the spaces for interaction provided? With this perspective the chapter's survey of materials teases out the ways in which Internet technologies enable witnessing to an ongoing crisis and help to furnish tools and agents for social change.

Internet Activism

Broadly speaking, Internet activism refers to the use of online technologies such as e-mail, file sharing, and websites to organize communities, raise funds, and lobby for change. Even before the interactivity lauded in the arrival of Web 2.0, the advocacy potential of the new technologies was evident. Martha McCaughey and Michael D. Ayers's edited collection *Cyberactivism: Online Activism in Theory and Practice* offers a useful overview of the types of activism already coming to the fore in 2001 and earlier, and

introduces questions of how Internet interfaces and aesthetics affect sentiment and political organizing.[7] Among their examples is the Zapatista social movement in the 1990s and beyond. Located in Chiapas, Mexico, the movement drew on online tools to cultivate global support and solidarity in the struggle and to articulate their concerns. Listervs, followed soon by websites such as ¡Ya basta!, provided means to update academics and activists and to bypass government narratives as the Zapatistas reached international news outlets with their reports. Sharing experiences and strategies online, the group initiated spectacles to frame their concerns and to seize media attention to amplify protest. Such activities could also add items to the agenda, as their activities aided in bringing protest of neoliberal policies to the World Trade Organization meetings in Seattle in 1999. Deployment of spectacle in political mobilization is a commonplace by now, but Web technologies enabled new scope and reach of communication and capacity building—for good and ill, as these tools are available to violent and peaceful movements alike.[8]

With the 2004 U.S. presidential campaigns, cyberspace grassroots activity appeared to be on the rise and suggested the Internet could influence and transform public space, reaching out to those who had not yet recognized themselves as publics.[9] Although unsuccessful in his bid for the Democratic nomination, Howard Dean demonstrated this value during the Democratic primaries when he used the Internet to build a vast base of active volunteers and to solicit contributions. According to Klaus Marre, Dean raised the majority of his funds through small, Web-based donations.[10] Jim Moore, a senior fellow at Harvard University's Berkman Center for Internet and Society, suggests that the form of the Internet itself might be "'changing the culture of political fundraising' by allowing individuals 'who never considered making a contribution' to give money." Organizations like MoveOn.org used listservs both to call attention to issues (congressional resolutions) that eluded the spotlight and thus threatened to pass without notice, and to encourage people to petition their representatives to vote on these issues. The interactive technology made this contact simple and near immediate and enables established organizations to apply pressure to decision makers. Marre provides the following example:

> An industry source said organized labor's grassroots campaign on the overtime vote was aided by the unions' ability to set up a system in which a union member "only had to hit a button" to send an e-mail opposing the Bush administration's proposed changes to overtime regulation. The source

added that there is "no question" that the union's grassroots effort had an effect on the overtime vote in the House because organized labor and other groups managed to flood members' offices with e-mails and calls.[11]

"Hitting buttons" simplifies the situation, but the Internet offers routes to more information as well as to action, however brief and possibly unsustainable. The reach and convenience of the new technology has helped to draw new people into the political process while arming active groups with resources for increased action. The Internet not only offers modes of inviting communities centered around shared concerns and identities, but the technology of exchange and exhibition also provides means of bypassing gatekeepers and producing counter-histories that challenge official stories. To this end, the medium has value for cultural activism, in that it provides means to respond to "the structures of power that have erased or distorted their interests and realities."[12] Citizen journalism provides one form of this activism, with sites like the Memory Hole reporting on and posting photographs of Iraq war images withheld from mainstream venues, whether the flag-draped coffins of U.S. casualties or the photographs from Abu Ghraib. When the site posted the Abu Ghraib images after *60 Minutes* delayed its broadcast of the story at the behest of the U.S. Department of Defense, the mainstream news media, including *60 Minutes*, were compelled to respond and report accordingly.[13] In effect, not only did the site serve as a means of circumventing traditional gatekeepers of information, but it also created a source of pressure for reporters to cover this story.[14]

The mobilizing potential of this cultural activism becomes apparent in the online archives of the Armenian genocide, which combat denial with virtual collections of testimonies, images, and reports that are frequently tied to an official recognition movement.[15] Since the interwar period, the Armenian genocide has been subject to denial and omission from the official historical record, both in Turkey and elsewhere.[16] Richard Hovannisian frames this denial as an ongoing assault against the Armenian people and in doing so, advocates "creative strategies for memorialization."[17] The Internet provided such a venue. For instance, formed in response to the omission of the Armenian Genocide in the Museum of Tolerance at the Simon Wiesenthal Center in Los Angeles, the Museum of Amnesia used cyberspace as a means of providing information of a genocide absented from an influential institutional collection.[18] Playfully promising to cure "curatorial oversight," the tone carried into the presentation of an online

gift shop selling museum souvenirs, a practice that simultaneously paro-
died and exploited the institutional production of material memory. The
interface of the site played upon the idea of engagement and active re-
covery. On the home page, links were promised but not immediately evi-
dent; however, by dragging the mouse across the empty part of the page
on the left side, hypertext links appear, and clicking on them transports
the site visitor to the exhibition information.[19] Exploration over the blank
white page of this site yielded a hidden history excavated by the accidental
or intentional effort of the visitor. Other sites by individuals and institu-
tions—Armenian Genocide 1915, the Armenian National Institute, and The
Forgotten (now called The Ani and Narod Memorial Foundation and boast-
ing the slogan, "Working to Foster Social Change for Armenian Women
and Children Worldwide")[20]—provide online storehouses for information,
granting access to photographs and records, extending the reach of the
archive not immediately available to the community, whether through
distance or institutional neglect.

The curatorial strategies of the sites often filter the reports and photo-
graphs of the Armenian atrocities through the genocidal imaginary of the
Holocaust. Although official documents, frequently shown with depart-
mental stamps that signal their run through state channels, and the pho-
tographic image confer ontological proximity and truth, it is the framing
of the objects that helps to authorize the claims of genocide and to foster
moral engagement with the testimony of the archives. Almost every site
reports Adolf Hitler's exhortation to the troops on the eve of the Polish
invasion. Charging them to kill without mercy, he promised them these
crimes would be forgotten in history, asking them, "Who still talks now-
adays of the annihilation of the Armenians?" The citation's popularity
makes sense, combining recognition of a past genocide with the present-
day failure to remember. The speaker not only establishes a link between
the violence against the Armenians and the genocide against the Jews, it
establishes the violence as a template for genocide, and the amnesia as a
crucial component of recurrence. Memory, in this case, takes on more than
affective value; it carries an ethical and political charge and the collections
are put to explicit political use. On the website 15Levels, a short flash ani-
mation of photographs from the Armenian genocide concludes with a
request to recognize the Armenian genocide, and to "prevent it from hap-
pening again," after which links to action alerts fade in.[21] Amid its offerings,
TheForgotten.org posts a link that reads, "Will you allow history to be
rewritten? Take action." By clicking on these links the visitor arrives at the

Armenian National Committee of America (ANCA) Action Alert page. Following the case is a charge to engage, and this response is one click away.

What ANCA offers, only one click away, is an up-to-date listing of concerns for the American Armenian community, and possible actions to take. Ongoing concern includes "Armenian Genocide legislation," a recognition measure, and information about U.S. foreign policy regarding the Armenian state. ANCA supplements the requests with sample letters and the contact information for the appropriate addressee. ANCA also encourages printed letter campaigns and facilitates finding one's representative with a search engine/database. Typing in one's zip code, one receives a page of all specific action alerts in one's area along with the names and addresses of the local, state, and national representatives. When the U.S.-based public television service PBS was preparing to broadcast a round-table discussion featuring well-known genocide deniers Justin McCarthy and Omer Turan in conjunction with the airing of the documentary *The Armenian Genocide* (Andrew Goldberg, 2006), ANCA provided guides for protest as well as a link to a PBS "station finder," a search engine for affiliate stations and a means of connecting the web-surfer the local action. Throughout, action is made as easy as possible, the next step in a chain of information and affective appeals.

The concern is not limited to the past, or even to Armenians. ANCA actively encourages response of the atrocities in Darfur. An action alert link dated March 2005, called "Stop the Genocide in Darfur," delivered the visitor to a Webfax (an earlier form of e-mail) stating support of the Darfur Genocide Accountability Act of 2005, introduced in the Senate as S. 495, by Jon Corzine (D–New Jersey) and Sam Brownback (R–Kansas), and in the House of Representatives as H.R. 1424, introduced by Representative Donald Payne (D–New Jersey). The sample text offered pleas for sanctions, extended embargoes, and assistance for the African Union peacekeeping mission in Darfur, as well as a "call for the prompt prosecution and adjudication in a competent international court of justice of those responsible for violations of international human rights and humanitarian law." Before concluding with offers of additional information, the letter states, "I urge you to take action to end this cycle and move us to finally realize the call—'Never again.'" The combination of these elements allows the virtual archives to function as a site of counter-memory, a means of fostering community through shared past, and a mode of mobilizing the sense of shared community and responsibility into action for both self and others.[22]

Activists have continued to use Internet technologies to witness human rights abuses and genocide and to cultivate publics. Advances in file sharing and greater access to camera technologies provide even more potent opportunities to participate in online activist projects, particularly as visitors can contribute their own videos or accounts, as has been the case with Iran's Green Revolution (2009–10), the Arab Spring (2011), and the Occupy Everywhere Movement. Before these populist movements, WITNESS took note of digital possibilities and launched a Hub, where those who have collected images of human rights violations (a process radically augmented by the video component of mobile technology) can upload videos. The potential for increased visibility in limited conditions has its appeal. The Hub, WITNESS states, serves as "an interactive community for human rights, where you can upload videos, audio or photos, or simply watch, comment on and share what's in the site. You can use each media item on the site to encourage individuals to learn more and to get involved by providing direct links to resources."[23] In effect, as technologies for making films become more accessible, WITNESS has provided a virtual meeting space for communities of concern. Questions linger, however: How exactly are these cases represented in ways, and how does their appearance in virtual space work to promote action in real life? How can the model of strategic narrowcasting be deployed in cyberspace?

Darfur: Background

From the colonial period on, the Darfur region has been subjected to limited access to rights and privileges. In order to quash potential challenges to authority, the Khartoum-based Government of Sudan (GoS) has maintained these institutional ethnic-based entitlements as a policy of "malign neglect."[24] Overall, these structures have favored the Arab population of the North while committing the southern Fur, Masalit, Zaghawa, Nuer, and Dinka ethnic groups to political, social, and economic marginalization. In February 2003, the Sudanese Liberation Army (SLA) and one of its factions, the Justice and Equality Movement (JEM), accused the GoS of deserting the African Darfurians. They attacked the GoS military forces in April 2003. In retaliation, the GoS sponsored a militia known as the Janjaweed, who, with this government support, systematically targeted civilians and civilian communities who share an ethnic identity with the rebel groups. The Janjaweed have embarked on a campaign of murder, rape, and destruction, employing a scorched earth offensive that has left villages

decimated, livestock stolen, and water supplies polluted. The attacks have also produced a sizable population (approximately two million)[25] of internally displaced persons (IDPs) and refugees. Although Christian evangelical activists, drawing on the conditions of the thirty-year civil war, seek to highlight the religious dimension of the violence and the Christian identity of the victims in particular, this is overplayed. Given the regional and ethnic components of this genocide, both killers and victims are Muslim.[26]

Despite the seeming promise of a peace agreement in 2006 between the SLA and the GoS, the crisis has persisted and the civilians continue to suffer atrocities. In fact, this peace agreement led to the development of a splinter group of the SLA, led by Abdul Wahid al Nur (and JEM did not sign in the first place). Moreover, the government in Khartoum resisted implementing the promised changes. The ensuing proliferation of factions compounded the outbursts of violent conflict, even if the death toll did not reach that of 2003–5, the period of violence most often recognized as genocide. The International Crisis Group surmises that the National Congress Party (NCP) in Khartoum persists in its policies in order to maintain Darfur in crisis and disarray, thereby limiting the potential for the growth of an opposition party.[27] Efforts to negotiate cease-fires and attempts to deploy a joint United Nations–African Union peacekeeping force known as UNAMID have done little to alleviate the atrocities suffered by civilians. In 2008 the violence once again escalated. In one case, the government sent troops to attack an IDP camp in Kalma, claiming the lives of more than thirty IDPs. Over these years, the refugee crisis escalates as numbers of IDPs grow and their safety remains in constant question. This is widely recognized as a humanitarian disaster, demanding attention and intervention.

Unfortunately, the definition of what has happened and what is taking place is in question: calling the events transpiring between 2003 and 2005 in Darfur genocide brings one into fraught territory. Much of the dispute centers on the question of intention: was there a specific victim group targeted for systematic destruction, or can these attacks be understood as crimes against civilians caught up in the middle of a war? These are war crimes and gross human rights violations, but for some, including the UN, the African Union (AU), and Amnesty International, it is not genocide. At the same time, there are individuals and organizations that have declared genocide took place between 2003 and 2005. These include the United States Holocaust Memorial Museum Committee on Conscience, the International Association of Genocide Scholars, the Genocide Intervention

Network (comprising such activists and journalists as Nicholas Kristof and Samantha Power), the U.S. Congress via House Concurrent Resolution 467, and then U.S. secretary of state Colin Powell with then U.S. president George W. Bush.[28] In 2009 Prosecutor of the International Criminal Court Luis Moreno-Ocampo filed ten charges against the president of Sudan, Omar al-Bashir, including three counts of genocide, five counts of crimes against humanity, and two of murder, although the charges of genocide were dropped for lack of evidence. While I have endeavored to give some background on the (ongoing) subject, and to recognize the existence of a debate, I will not engage or unpack it any further. This project centers on the ways in which Darfur, as humanitarian crisis and genocide, is represented online, and how the new mediations seek to bear witness to distant events and to activate witnessing publics to the crimes depicted.

For instance, in summer 2004, WITNESS joined with Human Rights Watch (HRW) in a special project to produce a Rights Alert and short video to pressure the UN for increased response to the violence in Darfur.[29] Although the UN Security Council resolved to threaten Sudan with sanctions should the violence continue, WITNESS and HRW determined this insufficient in light of the massive human rights violations and abuses taking place. They sought oil and arms embargoes, an increased presence of the AU (which had decided to consider military intervention a few days before the resolution), an official recognition of the GoS as a responsible party for the crisis, and an official commission for inquiry into these crimes.

The collaboration functioned outside the standard framework of the Core Partnership. On occasion, WITNESS aids an NGO in a case where WITNESS can add value to a limited campaign that is already in motion (thereby minimizing the reliance on WITNESS resources). In this case, HRW approached WITNESS for postproduction (editing) assistance with footage shot in July and August 2004 by an HRW researcher, which depicted regions that had not been accessible to journalists and humanitarian aid workers, and would thus be of interest to media outlets and the UN Security Council. A clip reel was assembled for television broadcasters and was used by *ABC Nightly News*, CNN International, CNN en Español, Fox News, and NBC. In addition, the collaboration yielded a six-minute video, *Darfur Destroyed*. The video depicts the sheer devastation of the human and physical landscape in Darfur.

The outreach strategies for *Darfur Destroyed* point to the variety of intended audiences. In September 2004, WITNESS launched a Rights Alert on its website, providing a streaming video in Quicktime and RealPlayer

alongside a set of "Action Now" options. Clicking on this latter option delivers the viewer to the HRW website and a host of options for action, including resources for further education, instructions on hosting a community screening (the DVD is available for sale), and scripts and addresses for letter-writing campaigns to the UN Security Council, the Government of Sudan, United States representatives, and United Kingdom Members of Parliament. The video was screened for decision makers and activists including ambassadors and delegation representatives to the UN; congressional staffers in Washington, D.C.; the NGO Forum at the African Commission for Human and Peoples' Rights; and those attending the conference "Crisis in Sudan: The Intervention Imperative," organized by the Center for Humanitarian and Human Rights Law. HRW sought additional reportage by supplying the contact information for the editors of all major news outlets, prompting viewers to write requests for coverage of the Darfur crisis.

Darfur Destroyed makes eloquent and affective rights claims, arguing that crimes against humanity are taking place and, more importantly, that the GoS is responsible. The short opens in a wide shot, depicting a stark desert landscape littered with gun and mortar shells but devoid of humans. The sound of blowing wind emphasizes the desolation. A title informs the viewer that the GoS has committed crimes of war, crimes against humanity, and "ethnic cleansing" in the "systematic" targeting of a civilian population. The use of the word "systematic" indicates a program of intent, which indicates the production of a genocide claim.

A voice punctures the silence and the camera turns to its first testimony. A woman gives a fervent report regarding the burning of her village, the murder of her fellow citizens, and the aerial bombing that persisted for seventeen days. Her gestures are broad and demonstrative, providing a compelling performance within the limited frame of the streaming video broadcast. Her accusations of bombings are supported by images of shells and shell casings, the wide shot stressing the number of shells, and, thus, the extent and length of the bombing. Other villagers corroborate the testimony of this destruction, and add their own reports of the theft of livestock and of additional massacres.

"Who has done this?" an off-screen interviewer asks. "Omar Bashir [the president of Sudan] and the Janjaweed," she answers, asserting the alliance of destructive militia and government. These answers cast this violence as the acts of a government against its civilian citizenry, advancing the claims of genocide and crimes against humanity. An internally displaced

person (IDP) supports this accusation when she explains that "Omar Bashir will kill us if we return," creating a personalized threat of violence. *He* will kill them. Her fear is legitimized in the many shots of human corpses, captured in exceedingly vulnerable positions. They lay belly down, cradling their heads, or on their sides, as if to protect themselves. These figures look helpless and defenseless. These are not people engaged in battle, nor are they rebel members of the SLA: they are civilians who are being mercilessly slaughtered. The image of the helpless, destroyed body, a key component in generating identification and belief, now contributes to the recognition of the political body subject to violence: in this case, civilians, not soldiers, making the conditions resemble those of genocide and crimes against humanity, where civilians are subject to a governmental campaign of slaughter, deportation, and destruction.

The Rights Alert on the WITNESS website and the HRW website have since been dismantled. Although the HRW site has since changed, the organization did offer regular updates on the situation along with attendant steps to action. For months, they urged the visitor to the site to write letters to the UN, demanding that they implement a peacekeeping mission and reinforce the African Union civilian troops since dispatched. According to HRW, "the ongoing Sudanese government military operations in the region highlight the urgent need to secure Khartoum's immediate consent for an UN force." Later, with the bombing campaign threatening the African Union peacekeepers and impeding the UN deployment of forces, HRW advocated sanctions against government officials.[30]

Mitigating Invisible Evidence

HRW and WITNESS mobilized something rare in this context: footage from a largely inaccessible part of Darfur. At the time, as suggested by HRW's advocacy for increased reportage, the events in Darfur struggled to make it past the gatekeepers of the government (GoS) and news media in order to reach potential publics. However, other media and, notably, other histories provided both interpretive frameworks and platforms for introducing the genocide in Darfur as an issue demanding action.

Although the genocidal conflict in Darfur began in 2003, Sudan has experienced numerous humanitarian crises, including drought, famine, and displacement—all exacerbated by a thirty-year civil war between the predominantly Arab Muslim Khartoum government in the North and the largely black Christian and animist South. In 1994 the levels of malnutrition

were declared "among the highest ever documented,"[31] with 1.5 million "at risk of starvation."[32] Roughly a half-million Sudanese had fled the country, with almost 4 million internally displaced. "In 1992, alone, 1 million civilians were displaced as government forces from the North captured several towns previously held by the Sudanese People's Liberation Army (SPLA)."[33] The Sudanese not only suffered from these crises; they also suffered from the neglect of the American news media. Despite these statistics, which certainly matched, if not outdid, those of other nations in crisis, there were few reports, "slipping only occasionally into world view when Khartoum [was] accused of supporting terrorists."[34]

Steven Livingston attributes the inattention to three factors that can be understood as economies through which news travels. First, an economy of human value: few if any Westerners were in danger. Second, an economy of interest: U.S. news media focus on American foreign policy—indeed, most news media reflect a certain solipsism in the selection of items to present. Third, an economy of resources: the region's bureau staff was directed to other nations, leaving few reporters available to cover the Sudan. The size of the nation further aggravated the problems: "there are pockets of suffering spread out over great distances. This makes it difficult to cover, particularly for television."[35] Meanwhile, the GoS limited coverage through active gatekeeping. Few Western representatives were welcome. At the time, relief workers and the Sudanese mitigated these challenges by capitalizing on whatever presence was available. Already cited in the introduction, Livingston's recollection bears repeating: "Clusters of people form upon the arrival of a Westerner, with the older men pushing forward the more malnourished of the group, often children."[36] Whenever coverage was possible, attention was sought by presenting reporters and photographers with familiar images of famine and innocent suffering—pictures that cater to economies of interest and human value, even if only fleetingly.

Nevertheless, the overall lack of media coverage posed a serious impediment to publicizing the humanitarian crises in Sudan as a significant and actionable political concern for a global audience. This challenge was in part eased by the activism of Christian relief organizations and other interfaith alliances. Evangelical Christian Franklin Graham's international relief organization, Samaritan's Purse, whose name conjures up the mandate of Christian charity and aid to the suffering, has been an ongoing presence in southern Sudan. Much as in the Armenian case, ministry goals have come together with ministrations of aid, as churches were built and hospitals manned. iAbolish publicized the practice of slavery in

Sudan, where northern militia raid southern black African villages, often massacring the male population and taking women and children as slaves. Endorsing and working Christian Solidarity International (CSI), the organization has engaged in the following objectives: they have conducted fact-finding missions in slavery and human rights abuses; they have supplied aid to famine victims; they have promoted "the principles contained in the Universal Declaration of Human Rights"; and they have engaged in the highly controversial slavery redemption programs, sometimes called "buybacks."[37] Organizations like iAbolish and CSI purchased slaves to grant them freedom. The promotion of their human rights objective depends on the mobilization of a familiar subject: the former, or in this case "redeemed," slave who testifies on behalf of the organization and their abolitionist project. The testimonies are contained in reports, posted online, and delivered in community-based venues. Here the fungibility of the slave and testifying body is cast in stark relief.

Many of the activists have played up the religious dimensions of the persecution. John Eibner, acting executive director of CSI, sought to garner U.S. interest in Sudan by activating the trope of the persecuted Christian (as well as the "war on terrorism"). In an interview with iAbolish, he claimed "the victims of the September 11th tragedies and the Dinka people of southern Sudan are both victims of jihad terror. Our suffering is rooted in the same hate for that which is different. The terrorists hate everything that is from the United States just as they hate the Christianity and traditional African beliefs of the Dinka people."[38] Another interfaith alliance reveals its predominantly Christian focus in its name: the Passion of the Present.[39] While the website draws on the community building potential of the Internet to update visitors and to direct them to actions both on- and offline, the title invokes Christian martyrdom as a lens for understanding the crisis in Sudan.

Further aiding the publicity mechanisms for Sudanese relief operations and social justice movements was the phenomenon of the "Lost Boys." The Lost Boys were the approximately seventeen thousand victims of the Sudanese civil war driven from raids on their homes by northern militia in 1987. Without provisions, the boys trekked across the desert to Ethiopia, risking starvation, dehydration, exhaustion, and wild animal attacks. After Ethiopia fell into its own civil war, they went to Kenya, where they remained until aid agencies arranged their transport to the United States. Their stories appealed to Christian and non-Christian publics alike. While the Christian identity of the victims, the account of their tribulations in

the wilderness, and the innocence suggested by the group's name helped make the Lost Boys an effective evangelical cause, the name also suggested the lost boys of J. M. Barrie's *Peter Pan* books—innocent children in danger and in sore need of a mother.

Like the former slaves of the Sudan—and in a manner that recalls Aurora Mardiganian's participation in *Ravished Armenia*—many of these young men entered the lecture circuit. Some even appeared on popular television programs, many of which aired around the period of genocidal violence in Darfur. Benjamin Ajak, one of the coauthors of *They Poured Fire on Us from the Sky*,[40] appeared on the television show *Judging Amy* as a Lost Boy placed in foster care.[41] Jacob Puka and Nicodemus Lim operated within a more evangelical framework when they appeared on the Christian television show *7th Heaven* as refugees who educate the characters about their plight.[42] Puka and Lim, enrolled in the Christian Point Loma Nazarene University, were active participants in the university's lecture programs. Although their testimonial performance provides a solemn counterpoint to the subplot where Ruthie Camden, a regular character, gets lost in the fictional suburb of Glenoak, California, their story is arguably overshadowed by the show's real lost-and-found hero: the program's protagonist, Reverend Camden, who has recently overcome a crisis of faith. Within this context, the testimony served more as an object lesson in narcissistic gratitude than as a mobilizing tool for politics. The advocacy potential outside the context of the program was equally dismal; *7th Heaven* fulfilled its obligation to its real-world inspiration by concluding with a one-time display of contact information that was not reprinted on its own website. Though the site linked to abstinence and "Rock the Vote" websites, nothing could be found concerning the Lost Boys of Sudan.[43]

The limited mobilizing potential of the *7th Heaven* episode does not speak to an overall failure of the medium, or of screen media in general to activate publics. Television programs and films on the Lost Boys were used to build interest bases in the Sudan. Airing in 2004 on the PBS-TV series *POV, The Lost Boys of Sudan* (Megan Mylan and Jon Shenk, 2004), follows Lost Boys Peter Dut and Santino Chuor from Africa, where "they survived lion attacks and militia gunfire," to their new lives in America. Focused on the young men's struggle to adapt to life in the American suburbs, the documentary has been the centerpiece of a campaign to raise awareness, marshal support, and raise funds for refugee concerns. According to the film's website, *Lost Boys of Sudan* has been screened for the Congressional Refugee and Human Rights Caucuses as well as for the State Department's

Refugee and Migration Bureau, and it is used by both Amnesty International and the United Nations as an educational tool. The film has also circulated on a grassroots level as local committee organizations have used screenings to recruit volunteers for action movements dedicated not only to refugee issues, but also to the crisis in Darfur. And the film's website, under the section "Take Action," offers a list of links to websites where the visitor can "find out what you can do to end the Darfur crisis." Further information on the Lost Boys and refugee issues are also available, but it was Darfur that received the privileged top billing.[44]

These projects designed around the slavery and refugee crises in Sudan have helped to maintain public awareness in the Sudan and to diminish the failures of U.S. news media coverage. Although these programs are more attributable to the conditions of the civil war that preceded the genocidal crisis begun in 2003, their ongoing status and their timely appearance on the popular culture landscape helped prime an audience to respond to what many recognize as the genocide in Darfur.

Much as the evangelical presence in Sudan and the popular testimony of the Lost Boys cultivated an interest base, *Hotel Rwanda* provided a means for creating a case for genocide and mobilizing action. As touched upon in the previous chapter, Don Cheadle's celebrity provided a lightning rod for publicity, for both the film and Darfur in a case of mutual benefit or humanitarian synergy. From morning show interviews to his voice-over narration for a *Nightline* report on Sudan (ABC-TV), Cheadle advanced the cause of Darfur as well as the film.[45] This contribution inspired "the delight of marketing officials at the film's distributor, who helped arrange the collaboration. 'We wanted to seize every opportunity we could to draw attention to the movie,' said Eric Kops, executive vice president of publicity for MGM and United Artists."[46] This was not simply a case of celebrity advocacy as the film, its story, and his character, supplied the means to approach and understand the ongoing crisis. The genocide in Rwanda led to an interest in the genocide in Darfur, but while global inaction characterized the response to Rwanda, it need not be the case in Darfur. Cheadle's celebrity was augmented by his connection to the film's historical protagonist, Paul Rusesebagina, who aided in conferring legitimacy and urgency (ironic, in part given surfacing allegations of his genocide denial, affiliations with former genocidaires, and terrorist activities of the Rwandan opposition party).[47] Meanwhile, the characterization of the story as one of Rwanda's Schindler drew upon the Holocaust as a framework for understanding both African crises as it reminded the broader audience

that they, as normal people, could do something. Cheadle's assertion of the inspirational value of the film and its source material found its way into Oscar reportage: "Don Cheadle, for instance, nominated for a best actor Oscar for his work in *Hotel Rwanda,* was so disturbed by the 1994 mass killings at the heart of the film that he traveled to Sudan last month with a Congressional delegation and the man he portrayed in the movie, Paul Rusesabagina, to see a region where more than 70,000 people have been killed in civil war."[48]

The work of *Hotel Rwanda* extended beyond the public relations plan that offered a platform for publicizing the situation in Darfur. The content itself provided a powerful means for exciting emotions. Individual stories of suffering and fear could hail the viewer's interest and empathy, while the film's overall theme encouraged concern over the failure of response. As noted in chapter 3, characters in the film repeatedly express the sentiment that the world will see and still do nothing. Admittedly, the depiction of Rusesabagina's heroism and a comforting narrative of relative success can alleviate the shame of inaction. Even so, such depictions can also restore a sense of empowerment to the average viewer: in the face of inaction, it was neither mainstream media nor governmental bodies that provided effective response; instead, an average person became involved.

Nevertheless, as discussed in earlier chapters, and as was the case with *Ravished Armenia,* film alone is not sufficient to activate witnessing publics. Instead, one needs to put the film to use within a larger campaign, and this was certainly the case with "Hotel Darfur," a project launched by the Save Darfur Coalition (SDC) an alliance of organizations committed to ending the genocide. SDC advocated using *Hotel Rwanda* as a tool for building awareness and countering inaction. The past genocide on screen served as visualization of a present-day crisis, while the on-screen version of Paul Rusesabagina teamed up with the real man to take action. This was more than a story of a past history; it was conduit into the present day, and viewers could be invited to join in response: "*Hotel Rwanda* tells the story of something we promised would happen 'never again'—the world watching passively as genocide takes the lives of innocent civilians. Don Cheadle, nominated for an Academy Award for his role in the movie, and Paul Rusesabagina, the hotel manager he portrayed in the film, recently traveled to Darfur to experience first-hand how the horrors portrayed in the film are replaying themselves in real life. They went home committed to stopping the carnage. You can help them." Boundaries blur and connections are drawn between past and present day, one nation and another, an actor

and his real life counterpart, a docudrama and an active crisis, between them and the viewer. The website, a virtual place, becomes the new site for saving people from genocide.

This project does not begin and end with the production of these links. Rather, Hotel Darfur provided visitors with an action plan. Volunteers would set up information tables at theaters showing *Hotel Rwanda*. In between screenings, they would speak to the cinema patrons, provide information about the genocide in Darfur, and invite the moviegoers to participate in letter-writing campaigns to then President Bush and the U.S. Congress. The website supplied materials including information one-sheets to hand out, a letter to the viewer from both Don Cheadle and Paul Rusesabagina (allied and continuing to hail the viewer into action from off screen), and template letters that visitors could sign. Assuming that the volunteers were young (the site suggests that those manning tables "do homework" while waiting for the next flow into the lobby), the site provided guidance for the action and the language with which to present it. Hotel Darfur reminded the volunteers not to be pushy, but rather, to approach those exiting the cinema and ask "if they would like to take an easy step towards ending the genocide in Darfur." Volunteers were also given the following activities: "Ask if you may send their ticket stubs to the president, and ask each guest to write 'Not On My Watch' on the back. Offer the sample letter to President Bush, and ask the moviegoer to sign it. Ask if it would be okay for you to send a copy to the appropriate Congressional representative and senators. Tape the ticket stub to the signed letter. Explain that you will make the photocopies and mail the letters." There are conflations here that bear teasing out. "Not on My Watch" invokes vigilant visuality, but more importantly, it refers to a note scrawled by President Bush on a report on the Clinton administration's inaction in Rwanda. The phrase unites the two events as genocide and as subject to intervention; where it may be too late for one, there is still time for the other. And perhaps even more important, the phrase engages a hinted promise, endeavors to mobilize the shame of one capable of intervention, and grants a sense of participation and action among empathetic people (even if no practical effect comes of it).[49] After all, small media and hints of obligation worked when Paul sought the aid of Mr. Tillens, and those staying in the hotel faxed and phoned anyone they could.

The links and networks proliferate as the website creates real world extensions through the recruitment of volunteers and the provision of scripts and information that will meet with those exiting the cinema—an

audience primed to respond. They were interested in watching this film and likely, upon exit, to be moved by the conditions depicted. Hotel Darfur continues to cultivate action possibilities offline as it directs visitors to lists of events, introducing the potential for coordinated efforts, networking, and increased capacity building. Moreover, the project itself can serve as a means to bring greater visibility to the Darfur crisis. Hotel Darfur draws on *Hotel Rwanda* as a fulcrum for visualizing and acting upon the lesser-seen Darfur crisis, but the performance of activism can also serve as a means for gaining attention. The website encourages volunteers to contact the local media for coverage of their actions, capitalizing on the appeal of *Hotel Rwanda*, its star Don Cheadle (named as a broader representative of this project), and a local interest story. In effect, the website begins to instruct on how to create a media event that serves as a means of publicizing the goals of Hotel Darfur and, by extension, the SDC. There is something generative within this setup as coverage benefits the film (*Hotel Rwanda*), the activist project (Hotel Darfur), and the broader organization (Save Darfur Coalition), which broadcasts its intentions and through attention may well increase an activist base. The site promotes means of visibility in the deployment of a multiplatform campaign extending across a film, its exhibition site, reportage, and other events and activist meetings. The awareness brought on by visibility is only one component of this action, as the site provides instructions and tools for organizing and action.

Such practices are not without their problems. There is something self-congratulatory in this mission as these Western heroes care for an Africa in crisis and reassert their command over visuality and the globe. And the promotion of visibility is limited to only a certain type of film: indigenous documentaries without mainstream circulation go unseen, hidden in the shadow of the grand project and Hollywood film. At the same time, the possibilities for exciting political commitment, networking and enabling local engagement with for global events ought not to be dismissed.

Visible Witnesses

Since the release of *Hotel Rwanda,* there have been films about Darfur depicting scenes and testimonies from life in the region. Mostly documentaries and without mainstream circulation, these films maintain attention in the region through documentary and human rights film festivals, DVD sales, educational venues, and community events. *Darfur Diaries: Message from Home* (Aisha Bain, Jen Marlowe, 2006) offers an hour of compiled

interviews with Darfurians in refugee camps in eastern Chad. The film's focus on personal testimony helps to introduce physically and experientially distant publics as it maintains the voices so often lost in depictions of suffering. These are not the "speechless emissaries" of the (typical) humanitarian campaign,[50] but witnesses to events, granted a platform through camera technology. At the same time, the film focuses on women and children: while these are the victim group most frequently spared execution, they also carry with them the assumptions of a nonpolitical victimhood, making them innocents, or at least clear civilians, within the conflict. In order to extend the reach of the film, whose short running time limits its possibilities of feature film release, the *Darfur Diaries* website provides a link helping the visitor to "organize an event."[51] They explain how to secure screening rights and how to invite the filmmakers. They offer suggestions for advertising and promotion, indicating that faith communities and human rights organizations provide interested communities and a context of action; to this end they also recommend e-mailing the SDC, which will advertise the event in ways that support networking and fundraising. As with Hotel Darfur, the website provides instructions on organizing political activities around a film.

The back-story of *Darfur Diaries* focuses on the three activists who entered the region with a camera so these stories could be told. In that way, the film highlights witnessing and action like many of the other films released on the subject, including *Sand and Sorrow* (Paul Freedman, 2008), *Darfur Now* (Ted Braun, 2007), and *The Devil Came on Horseback* (Ricki Stern, Anne Sundberg, 2007). *Darfur Now* offers testimonies of survivors while also directing attention to the celebrity activists—namely, Don Cheadle and George Clooney, another celebrity presence in this mission—as well as to the efforts of Moreno-Ocampo in bringing charges against al Bashir. Recently released by HBO Documentary films, *Sand and Sorrow* joins Samantha Power, *New York Times* columnist Nicholas Kristof, and John Prendergast (ENOUGH and SDC) on a tour of refugee camps and mass graves before heading to the halls of U.S. government where they seek to create promise for response. The film's synopsis highlights the cause of fighting "indifference and denial," while the narrative suggests the connection between seeing with one's own eyes, the political activation, and the political actualization: the lobbying of government. Similarly, albeit more powerfully, *The Devil Came on Horseback* tells the story of a former marine and U.S. military observer for the African Union Monitoring Force, Brian Steidle, who photographed many of the horrors, supplying a profound

contribution to the relatively short supply of visible documentation of this genocide. The photographs demonstrate a transformative power for Steidle, as he moves from professional bystander-soldier to activist, taking his photographs to government officials and television news programs in an effort to mobilize response. The film opens up the various components of media witnessing as they show a witness to genocide and his ensuing efforts to bear witness in order to bring about change. In addition, the film provides an additional platform for the photographs in an effort to make witnesses of us all.

Joining this growing body of films is *Google Darfur* (Robert Simenthal, 2007), so-named (according to its producers) for the "large amount of information available online." The information mechanism plays a key role. "By encouraging the international community to *google 'Darfur'* [emphasis theirs] we hope to help create worldwide awareness about the atrocities happening in Darfur and Eastern Chad."[52] Without question, the Internet has enabled the transmission of information about Darfur, as evidenced by the HRW video. It has also supplied information and materials to facilitate activism around existing films and their exhibition sites. However, the Internet is more than an ancillary storehouse for community activism, it is increasingly a place where new forms of witnessing take place, with the virtual collections taking new and dynamic forms.

Virtual Witness

The United States Holocaust Memorial Museum (USHMM) has been particularly active in finding ways to bear witness to the genocide in Darfur through a variety of media. The gallery space has housed numerous exhibitions, including *Darfur: Who Will Survive Today?* (2006). This project, in conjunction with the traveling exhibition *Darfur/Darfur*, projected photographs taken by Brian Steidle, James Nachtwey, Ron Haviv, and Lynsey Addario, among others, against the exterior of the museum, using the site of memory to provide an alert to a present-day genocide. These images continue to be made available online in the USHMM website photo galleries under the name "Our Walls Bear Witness." While the onsite Wexner Center has been a place of experimentation for interactive teaching from the museum's start, the USHMM has taken some of these projects online. For example, there is "From Memory to Action: Meeting the Challenge of Genocide," an exhibit that confronts visitors with the responsibilities of witnessing. This section of the museum's active site provides videos of

testimonies, further images, options to donate money, and to "Learn more about the Museum's genocide prevention activities." Other online experiments have included a conference on Darfur held in the online virtual world Second Life (later posted on YouTube) and a mapping initiative conducted with Google Earth.

Google Earth is an application that allows the viewer the sense of complete command, via satellite imaging. As the site boasts, "Google Earth lets you fly anywhere . . . from galaxies in outer space to the canyons of the ocean. You can explore rich geographical content, save your toured places and share with others." The layers feature, a component of the application, "provides a variety of data points of geographic interest that you can select to display over your viewing area."[53] In April 2007, the USHMM launched the layer *Crisis in Darfur,* in order to track the destruction in the region, providing maps of villages that were damaged or destroyed and offering the visitor the opportunity for a closer look: testimonies (typically text) and photographs, with the occasional video. A second Google Earth mapping initiative, *World Is Witness,* was launched a year later, in order to broaden the scope to contemporary genocide. There are challenges for this seemingly dynamic presentation, which relies on the authoritative visuality of satellite technology. It is difficult to navigate and interpret, and the appearance is one that is relatively fixed, dependent on infrequent updates from the museum; there is no capability for user upload. Nevertheless, the site provides an educational resource and contributes to the case for genocide. According to an announcement dated July 30, 2009, the layer offers "before and after" imaging, as well as new information from the State Department. The press release notes: "The new data show that more than 3300 villages have been damaged or destroyed in the Darfur region of Sudan from 2003–2005. This is more than twice the number that was identified in previous U.S. government assessments, and strengthens the evidence of a vast, targeted campaign of destruction against civilians in the region. The updated data come from recent analysis of high-resolution satellite imagery, released by the Humanitarian Information Unit of the U.S. Department of State in July 2009."[54]

This application provides the visitor with the valuable opportunity to look and learn, and to visit other sites for action, but there is little else within this application. There are new visions and new forms of reading as the navigator moves through the information to produce a narrative, but the interactivity and capacity for action is otherwise limited. It is surprisingly static given its dynamic position online. In some ways, the older media

usage prevails as this site functions as a self-contained combined multi-platform campaign, with the main feature (disaggregated and recombined) linked to further options for information and how one can help.

An intriguing use of online interactivity, education, and action comes in the form of the Take Action Games video game *Darfur Is Dying* (designer Susana Ruiz), launched in 2006 at a "Save Darfur" rally on the National Mall in Washington, D.C. The game functions as a form of "subjunctive documentary," providing information about the real world but engaging in the possibility of change, on screen and off.[55] According to its mission statement, the site aims to provide a "window into the experience of the 2.5 million refugees in the Darfur region of Sudan" through interactive play. "Players must keep their refugee camp functioning in the face of possible attack by Janjaweed militias. Players can also learn more about the genocide in Darfur that has taken the lives of 400,000 people, and find ways to get involved to help stop this human rights and humanitarian crisis." The ludic meets the sober as visitors are challenged to maintain the health of a refugee camp. The visitor selects an avatar from a range of options of adult men and women to boys and girls (Figure 12). By weighing the potential risks and benefits associated with each demographic, the user fuses education with strategic game play. An adult woman, for instance, can carry a heavier load than a child, but is at greater risk for rape. To enhance the stakes, the avatar is not granted an endless supply of lives (do-overs) in order to achieve the goal of maintaining the camp. If a life is lost the decedent is no longer an option, and another avatar is chosen from the list. The instructions continue to remind the player of the real-life impossibility of a return, asking, "As someone at a far off computer, and not a child or adult in Sudan, would you like to try again?"

Upon choosing an avatar, the user is given only one option: to forage for water, thereby immersing the player in the highest stakes component of the game. Water is essential to the functioning of the camp, as one will learn later. But the search for water is fraught with danger, as the avatars must run and hide from roving militia in order to escape murder, rape, or abduction. Taking too much water can slow a player, opening him or her to increased risk. As a game, the project interpellates the visitor into the narrative of life in the camp, suggesting from the start that the actions of the user have an impact on these otherwise distant events. Moreover, to continue in the game narrative, to learn more or to experience more or even to play more, one must survive, engaging numerous drives to engage, merging documentary epistemephilia with game mastery.

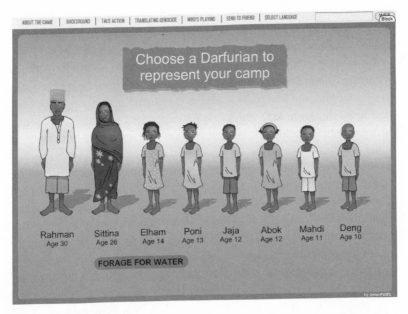

Figure 12. The array of available avatars for *Darfur Is Dying*. The banner in red instructs the visitor to "Choose a Darfurian to represent your camp." Below, one is offered a choice of avatars (from left to right): Rahman, Age 30; Sittina, Age 26; Elham, Age 14; Poni, Age 13; Jaja, Age 12; Abok, Age 12; Mahdi, Age 11; and Deng, Age 10. To begin, one clicks on the link that reads, "Forage for Water."

With a successful return, the avatar can enter and wander the camp, clicking on question mark icons to learn more about its inhabitants and functioning (Figure 13). One can read brief descriptions of injured refugees or learn how soldiers from the GoS police the camp ("one of the complex-ities and injustices" to be endured, according to the legend) while engag-ing in activities necessary to the camp survival, namely carrying water from the pump to the farm plots where food is grown and livestock are raised. At the bottom of the screen, one can read the various levels, letting the player consider what actions are necessary. A low food supply sug-gests water needs to be taken to the plots. Running low on water indicates that one again needs to take that dangerous but necessary trip outside the camp. All the while, measurements also exist for overall camp health and the existing threat level, which is always on the rise. Shortly after the arrival in the camp, a warning of an imminent Janjaweed attack appears on screen. The player is given a choice: to continue (as the character) or to take action (as him or herself). Choosing to take action leads the player

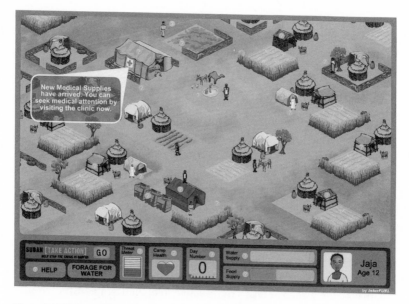

Figure 13. Navigating the camp (*Darfur Is Dying*). Various points on the map are marked with question marks. Clicking on these will provide further information. Below is a dashboard on which one can measure the well-being of the camp through instruments such as "Threat Meter," "Camp Health," "Day Number," "Water Supply," and "Food Supply." On the left are buttons that lead the player to improve camp health. These read "Forage for Water" and "Sudan [Take Action] Help Stop the Crisis in Darfur."

to other options, such as sending a message to U.S. President Obama (an option that takes the player to the SDC website), requesting legislation from a congressional representative, (an option that takes the player to the Genocide Intervention Network [GIN] website), or starting a divestment movement on campus (an option that takes the player to game sponsor mtvU). As with other sites that provide materials and information, these deliver useful materials. GIN provides instructions including "5 Tips for Effective Congressional Communication," an "Advocacy How-to Guide," and an "Advocacy Action Chart" that identifies types of action, their time investment, their efficacy, their optimal usage, and tips for increasing their value in a campaign. In the process of the game, it becomes clear that clicking on this link and choosing an action can temporarily reduce the threat level to the camp, but it never permanently wards off attack. To minimize casual clicking and return, the game requires a more thorough investigation of potential action, ensuring, at the least, the production of some activist awareness. Attacks remain a constant threat, however, and the tasks

associated with maintaining the health of the camp accumulate. For instance, the player returns to make bricks (a task that demands water).

The game structure hails the player as actor, within two narratives enabled by the multiplatform travel enabled in cyberspace. The player chooses an avatar, directing a character through the challenges of game play, one of which involves the prolongation of life. This is, for the most part, accomplished by collecting water and then using water for additional tasks. One could argue that submitting the avatar to control is problematic, either for diminishing the agency of the Sudanese figure or enhancing the sense of power of the (U.S. citizen) player. However, the choice can also encourage identification and recognition of daily tasks of subsistence and the challenges faced by a refugee camp dweller. At the same time, the player is hailed as a citizen or potential activist who can affect the structure of the game itself: taking action by applying pressure to the U.S. government pushes back the attack threat level, something that cannot be accomplished from within the game. One cannot, for instance, fight against the Janjaweed or take a more active role, such as an on-the-ground African NGO employee or AU peacekeeper (nor, to my knowledge, has the game been hacked to allow this or other options). The button launching the game hints at this doubled identification; it reads, "Help Stop the Crisis in Darfur, Start Your Experience."

YouTube, CitizenTube, and the Focus on Darfur

YouTube may well provide the most fully realized version of the *cosmopedia*. Its increased potential for participation through downloading, uploading, remixing, commenting, and remediation, and the growing archives of photographic material make it a striking forum for practicing politics and activating witnessing publics for Darfur. Launched in 2005, the video-sharing site has become "the world's most popular online video community . . . [that] provides a forum for people to connect, inform and inspire others across the globe."[56] Its reach and centrality in the field of online video is significant. Few, if any, video-sharing sites have been able to compete. Users continue to post and view videos at the site, and many of the videos available through other sites and blogs have been embedded through YouTube. Online reportage in the *Guardian* posts a list of popular videos—most, if not all, found on YouTube, while television programs such as *Rude Tube* (Channel 4–UK) have relied on YouTube videos for content. In its early years, the growth rate was impressive, receiving 60 percent of

all online video traffic in 2006, an increase of 43 percent from the year before.[57] Pelle Snickars and Patrick Vonderau note its centrality, writing, "YouTube has rapidly established itself as the default site for online video . . . [it] was and is both node and network."[58]

YouTube's centrality in an otherwise diversified virtual space is due to a few practical measures that also appear to increase its force as site for fostering witnessing publics in addition to amassing viewers. Most importantly, YouTube cleared up the bandwidth and file format annoyances experienced in early efforts of video exchange. In earlier days, videos were shared through e-mails (a severe tax on small servers) or small websites that would freeze and crash in the onslaught of Internet traffic. Successful downloading did not guarantee viewing. Some files required plug-ins, and compatibility issues between Macs and PCs further aggravated matters. To resolve this, YouTube converted all videos into Flash, which could be played on most platforms without plug-ins.

Further aid came in the form of video limits: in its early days, YouTube videos were restricted to a maximum of a nine-minute running time. This limitation likely proved a boon given the challenges of maintaining attention while "watching" the Internet. The cinema has the benefit of being a large dark room, capable of enveloping the viewer—at least enough so that a discourse on spectatorship and somnambulism could emerge. Television introduced the problem of live space, as the frame had to compete with domestic and ambient worlds, while flow introduced questions of whether one watched the program, the medium, or the object. The computer compounds the competition and the questions with the sheer number of frames. Not only do the computer and the lived world vie for attention, but the computer screen itself usually houses numerous frames; rarely does a viewer have only one application running, but instead, multiple windows can hold the screen. And Internet video isn't large. More often than not, the video screen for that is one small box in the browser window, a frame within a frame within a frame. Short and readily streaming maintains attention in an environment designed to distract.

Tagging, meanwhile, offers a means of sustained distraction, or alternately, promotion of additional videos that will most likely continue to engage the user. This practice refers to the application of a "tag" or keyword that describes the content of the video. Keywords optimize searches, allowing a community of taste to build around topics, whether "kittens" or "human rights." Such connections are markers of fan and knowledge communities that are "voluntary, temporary, and tactical affiliations, defined

through common intellectual enterprises and emotional investments . . . defining their membership through affinities rather than localities."[59] Developing Internet technologies and platforms support this confluence of affinity. Social utility platforms such as Facebook offer links from the favorite books, films, interests, and activities, allowing those within the same network to do quick searches based on taste alone. The option of becoming a "fan" of a concept, person, or organization positions one for regular updates and information for sharing. Meanwhile, an algorithm creates a continual list of suggestions for pages and people (fan and friend options) based on already established friendships and interests. A visit to the network is enough to provide a person with information, updates, and announcements regarding rallies and actions to take. Similarly, on YouTube, tags generate a feed of "related videos" to appear as frames on screen, catering to niche publics with niche interests in a way that recalls "the long tail" of a commercial strategy,[60] and possibly the "strategic narrowcasting" of WITNESS. If you liked this video, you may also like this one; in the process, one becomes immersed in both content and a community of other users. Tags such as "Darfur" and "Genocide" maintain the ongoing presence of videos on the page, for viewing, for sharing, and for commenting. This narrowcasting sustains visitor presence in the virtual space of YouTube as it also promotes the production of a network of communal concern.

A casual approach to copyrighted materials has proven a great help to YouTube's popularity. Notoriously slow to pull items down, YouTube has provided videos with a long exhibition life, allowing for increased hits and a viral spread of embedded videos and links. This benefits the makers of Darfur videos who repurpose the existing images they find online—in the USHMM virtual galleries, or in the online proffers of major media management companies. It is not uncommon for a still in the video to bear a watermark, indicating no purchase or acquisition of rights (although one wonders who would pull down these videos, so often made, as I will discuss below, with the best intentions). The lengthier lifespan of the material dovetails with preexisting DIY and remix cultures, appealing to generations accustomed to performing self through taste and other media. Jenkins describes fans as "textual poachers," whose affiliations and appreciations are expressed through the interaction with the original text. Susan D. Blum observes that present-day university students tend to disregard copyright, not out of a distaste for legality or appropriate academic conduct, but because of a practice in which quoting and manipulation of materials without attribution offers a means of maintaining social networks.[61] Seeing a

community as influenced by the software it uses, Craig Hight posits a "cut, copy and paste" generation who see text as always subject to reuse and transformation.[62] This framework for understanding one's relationship to media content has repercussions for thinking through these videos as works of witnessing. Here the YouTube users can see themselves as part of a community centered on the concern for Darfur; they share and exchange information, imprinting their contribution with their own expression, producing their own form of testimony in the videos. They bear witness to what they have learned about Darfur through the existing media. And at the same time, for the users, it may not only be texts, but the wider environment subject to manipulation through this material engagement.

The possibilities of YouTube became evident in December 2005 when the video "Lazy Sunday" went viral. The short aired on the NBC-TV late night television show *Saturday Night Live*. The video was uploaded onto YouTube and circulated online, with websites embedding the video to extend viewership. By that Monday, the video reached an audience many times larger than that of the initial broadcast, and within the first ten days was seen 1.2 million times (and more than 5 million times by February 2006).[63] YouTube users began making their own versions of the short in response, riffing on the original item, a clip showing two comedians singing /rapping about going to see the film *The Chronicles of Narnia* (Andrew Adamson, 2005) and extolling the virtues of all services aiding them in their pleasure, from Google Maps to Magnolia Bakery. Although NBC-Universal, the owners of the clip, sought to have the video removed, the attraction of a viral spread that extended the reach of the corporation did not go unnoticed. Soon, NBC established a channel on YouTube in order to harness the publicity potential of the Internet and the efficacy of YouTube as platform. On this channel, they post clips from television programs and more digital shorts from *Saturday Night Live*, some labeled as "uncensored" versions of broadcast videos, thereby increasing appeal and extending the interest of viewers. As Jenkins notes, "Media companies are learning how to accelerate the flow of media content across delivery channels to expand revenue opportunities, broaden markets, and reinforce viewer commitments."[64]

The above sections have outlined the ways organizations use Internet technology, deploying transmedia, multiplatform campaigns in order to extend the reach of testimony, broaden volunteer bases, and reinforce political commitment. One can see, in this way, how YouTube would appeal to activists, and indeed, alongside the corporate presence, one finds advocacy organizations. NGOs and coalitions have produced pages and

channels, seeking to harness the Internet's capacity for viral transmission for purposes of witnessing and promotion—to pass on information neglected in the mainstream broadcast media. This advocacy presence led to a YouTube response: first in CitizenTube, a political video log launched in April 2007, and second in YouTube's invitation to not-for-profit organizations to "Broadcast your cause," a variation on YouTube's slogan "Broadcast Yourself."

YouTube's appeal to both political activists and corporate publicists is not surprising. The platform offers a free mode of distribution and exhibition often circumventing the limitations of the broadcast media economy. Moreover, the site exists in a networked field that combines exhibition space with distribution mechanisms and avenues for action. Links to action can be activated by clicking on the hypertext in the information box, or by entering the address into the navigation toolbar. YouTube enhances options of continued viewer engagement through "replay" and "share"— whereby a user sends this video to others, distributing it beyond the initial reach of the YouTube platform. Through the site, viewers can send links, link to, or even embed the video on their own sites (as well to various social utility networks). The viral aspect combines with available technology and viewer participation to reach greater audiences; in the case of the advocacy post, even beyond the video content, the site itself hails audiences as publics upon completion of viewing, asking them to pass on the message and extend awareness of issues. In effect, the platform allows a viewer to be a witness—to see something—and to bear witness to its truth by passing it on, by presenting the testimony to others.

Seeking to intensify their outreach, organizations once limited to their own websites, to pubic service announcements, or to one-off appearances on news or public affairs programs have set up channels on YouTube. Beyond video content, the context offers a means to amplify a virtual presence and bolster networking. On its page, GIN invites visitors to "Be our anti-genocide friend" on Facebook and MySpace. As frivolous as it sounds, these networks may be accomplishing something. U.S. high school student Nick Anderson set-up a Dollars for Darfur drive on Facebook, where SaveDarfur .org is one of the top draws as a page and in the Causes application. This application enables users to create groups and pages that promote activist goals—these pages are also used to solicit and track donations. Anderson raised over three hundred thousand dollars in a school year.[65]

Institutions and advocacy organizations aid in providing the necessary content. Refugees International offers the eleven-minute documentary

On Our Watch—A Documentary about Genocide in Darfur, narrated by actor Sam Waterston. The video includes interviews with IDPs, chronicling their loss, and with those working for change. Meanwhile, the framing mechanism of the viewing site restates the key points, including the statistics of death and displacement. "President Bush has accused the government of Sudan of genocide, but the U.S. has taken few concrete actions to stop the fighting," they assert, continuing: "Go to www.refugeesinter national.org for more information on what you can do to help the people of Darfur." The USHMM provides numerous genocide-related videos, including footage from a public interview with Steidle called "In Darfur, My Camera Was Not Nearly Enough," based on "the testimony and photographs [offered as] eyewitness evidence." Running over just eight minutes, the documentary provides a sketch of information before launching into Steidle's own account, accompanied by a slideshow of the photographs (offering one of the rare occasions in which a pictured person is named). SDC has uploaded "Video from Darfuri Refugee Camps (Save Darfur)," which opens with the standard textual overview of the conditions, explaining that the death toll of four hundred thousand grows daily, as a government sponsored militia "systematically slaughters" men, women, and children. The text continues with the stated goal, the establishment of peacekeepers in the regions, and a description of what we'll see: David Rubenstein, executive director of SDC, and Mia Farrow, goodwill ambassador, visit "to witness and report on tragedy."

A traditional documentary format struggles in this medium. The length of the videos seems to pose a deterrent to viewing, with the numbers of views, favorites, and links considerably less than those of shorter fare. Items with longer running times rarely achieve more than ten thousand hits, which is a significant number, especially if seeking a niche market, but small within this context where video hits number in the hundreds of thousands to millions. Only recently, with the thirty-minute-long *Kony 2012* video a component of a campaign of the same name sponsored by the organization Invisible Children, has this barrier been broken—and most spectacularly with one hundred million "views" within six days of posting.[66] (Even so, "hits" are not likely the best way to measure efficacy.) Another possible deterrent is one of engagement: the faces of speaking victims are difficult to make out on a small screen, interrupting the point of identification this form of video testimony requires. Language poses an additional challenge, because subtitles are too small, and simultaneous translation provides yet another distraction from what's on screen. To best accommodate

the constraints of the venue, the testimonial encounter most often occurs on a register of visual shorthand: women, children, the dead body, and the eagle-eye picture of burning villages. Typically, these videos privilege the observer, whether camera or monitor, as the "speaking" witness.

News items fare somewhat better for their short running time and their economic narrative. The most popular of the news items, however, are those entertainment news programs covering the advocacy work of celebrities like Cheadle and Clooney. The tagging of these helps create a wider net for catching visitors and their attention: Someone doing a search using the terms Cheadle, Clooney, or even *Oceans 13* can end up with Darfur-related videos. The celebrity name in the tag increases the potential for hits—while celebrities maintain an online presence and formulate a star-persona affiliated with advocacy, both of which enhance their career status. Nevertheless, little is offered in the way of action.

More popular, more typical, and likely more appropriate for the YouTube venue are reposted public service announcements (PSAs), which run no longer than a minute on average. SDC, in particular, is active, reposting PSAs that already aired on television, allowing YouTube to extend viewership beyond the limits of local television markets or airtime allotment. In each case, the videos declare the events in Darfur genocide, before promoting a line of action. "You're Making a Killing in Darfur" depicts a couple meeting with their financial adviser to go over their investments. "You've taken a hit in Real Estate," the couple hears as they page through the portfolio, "but you're making a killing on genocide." And here, the couple stops on a page with photographs from a refugee camp. As the connection between personal finance and distant suffering is forged, both narratively and visually, the video concludes with the question, "Is your mutual fund funding genocide?" Then comes the suggestion for direct action: to visit savedarfur.org, where a person can learn about the divestment campaigns (instructions for which are linked to on the GIN channel).

In each case, the problem is identified along with a course of action. The PSA "Never Again" opens with a collage of faces, portraits of victims from the Holocaust, as a voice-over recalls the pledge of this phrase. The failure of that promise is made clear in repeated episodes depicting portraits of the victims in Bosnia, and in Rwanda. Now there is a chance to keep that promise, the voice lets the viewer know. The short effectively makes a case for the label genocide by placing the crisis in Darfur within a historical continuum of the crime, a strategy employed by other videos. Where it differs, however, is in the choice of portraits over atrocity footage.

Presenting those about to die suggests a point of intervention as well as a point of identification. At the same time, these likely mitigate the broader absence of present-day atrocity footage and images of mass graves that could otherwise make a visceral, shocking connection between past and present genocides.

While "Never Again" forges links between past present, "Voices from Darfur" bridges the gap between here and there, or us and them, as Americans read from passages of survivor testimony. These characters perform the attenuation of witnessing that takes place on YouTube: they read testimony and then broadcast it. The video itself will replay this performance. And all is done with the goal to reach others, to alert them, to speak to them of the world, and in doing so, to change it. Transformation is paramount, both for testimony and the SDC PSAs, which clearly state what they want from the viewer—requests for divestment and a peace-keeping force—and where to go to start realizing that goal (savedarfur .org). Visiting the site, which has, in the past, provided information and materials for an array of actions, is straightforward, especially from this venue: one need only click on the hyperlink in the information box to visit the YouTube page, and after that find the formal site; or one can copy and paste the URL into the browser tool bar.

Basic themes emerge in these videos. They make the case for genocide, typically relying on descriptions of "systematic," government-sponsored violence against civilians and the historical precedent of the Holocaust with references to the later genocides of Cambodia, Rwanda, and Bosnia. They tend to offer at least one action plan, even if only in the form of a link. And all advance the role of observer as witness, one who bears responsibility to continue transmitting the truth of these circumstances in order to enact change. Embedded in all these presentations, explicitly or implicitly, is the charge to the viewer to become a witness in his or her own right, to become a broadcast node in a wider project of visibility and capacity building.

Beawtiness.org activates this charge in its name as well as in the content of its video condemning broadcast news for covering TomKat and runaway brides when genocide is taking place. "You can't stop a genocide, if you don't know about it." The video advocates a visit to the organizational website where instructions are given on how to make television be a witness to genocide. The site offers a template letter, addresses of news stations and names of program managers, and further links. Beawitness .org extends its mission beyond television news, encouraging the visitor to action by writing to political representatives. Here, as with other sites,

materials and instructions are readily available, in this case in the form of legislation outlines, template letters, and means for sourcing congressional representatives and their addresses. Like SDC, the organization has also begun to request divestment, and accordingly, they provide information about businesses. This witnessing project extends past pressuring major media outlets and politicians for respective forms of representation, as the site offers the visitor means of publicizing the cause—to be a witness for Beawitness. The tools for attenuated witnessing are readily available in this technology. A visitor is invited to include an e-mail signature—not unlike those offered by free webmail services such as Yahoo, or by technologies such as the BlackBerry. Each e-mail sent carries a small message and link. In this case, linking helps to create networks and maintains heightened visibility and a potential discursive presence.

Two YouTubers, Lazydogs and Jlucas112, adopted the spirit of the mission by reposting the video onto YouTube. Although there is little reason to doubt their earnest commitment to the goal—to confront and circumvent the broadcast news economy that limits reportage on Darfur—their posting is just as much tied to participatory practices around media consumption and engagement. I refer again to the fan culture, whose expressions of interest and allegiance rely on the replay or remix of the original content, such as is found in fan fiction. This practice fits well with the technological interface that increases the speed and ability with which one can share materials, assert one's place as producer as well as consumer, and still maintain the self as a member of Jenkins's fan-activists who create forums for "debating interpretations, networks for circulating creative works, and channels for lobbying producers."[67] Beawitness.org's request capitalizes on both the technologies that enable distribution and response as well as the existing cultures of fandom, where audiences are poised as active consumers, ready to network, lobby, and exchange materials and ideas. They are prepared to become witnessing publics, and these technologies enhance their ability.

The publicity for these advocacy organizations takes a creative turn on YouTube. The viewers here not only extend the witnessing activity of the organizations through links, sharing, and embedding; they produce their own videos as a mode of publicizing the cause. In the title of this chapter, "CitizenTube" refers to this kind of civic engagement found on YouTube, whereby viewers and audiences become citizens and publics, even if temporarily. At the same time, the title refers to a very specific moment in YouTube history, the launch of CitizenTube and the alert video "Focus: Darfur,"

which enjoined viewers to act on behalf of the distant suffering by visiting the site of an NGO called ENOUGH and by making videos to produce awareness of the issue. The video itself animates the work of CitizenTube, in its conceptual or literal formation: It begins with a testimony of a Darfur survivor, in her own language. An English-language voice-over comes in to provide translation—the mediation or attenuation of testimony begins. Steve Grove, the political producer, enters in direct address to explain what is happening in Darfur (the brief that includes mention of targeted persecution and the work of the Janjaweed). After the testimony and the framing of the testimony as genocide, he introduces ENOUGH, an organization seeking forms of intervention into Darfur. The use of one of their videos (already posted on YouTube) clarifies ENOUGH's mission: they find out what is happening on the ground, they devise policy recommendations based on this information, and they advocate their implementation to decision makers. Steve returns with his own action recommendations for the viewer who has heard information about the violence in Darfur, represented by the brief survivor testimony, and the NGO activity, explained by John Prendergast of ENOUGH. The action recommendations are straightforward: First: visit the ENOUGH website and develop knowledge. Second: Make your own videos; act like CitizenTube, and spread the information. The video concludes with a sample video by Mollie Tarnow called "Darwhere?"—a user video that demonstrates what can be done while demonstrating why awareness needs to be promoted. Through vox pop segments, the video shows the ignorance that necessitates YouTube witnessing on behalf of these distant publics and on behalf of the activist campaigns.

The brokering function of YouTube and CitizenTube is illustrated in the polyphony of the video, which incorporates the different registers of advocacy video, from the survivor testimony, to the policy video of the NGO, to the amateur video at the close, which supports the necessity of the first two iterations. The video embodies YouTube as more than a storehouse for videos; it also offers a place where relationships between survivors, NGOs, and audiences are mediated and organized. This video by CitizenTube seeks to mobilize disparate (predominantly U.S.) local publics into a community of concern, activating their compassion for distant suffering communities, introducing ideas of policy and policy work, and animating their self-awareness as a public. These witnessing publics are asked to continue the work by bearing their own attenuated witness, reimagining the testimony they've received by repurposing and remediating available

materials; they are producing fan nonfiction in this *cosmopedia* of political realities and social advocacy.

A variety of save Darfur videos populate the virtual world. Users directly address the camera, producing confessional pleas. Others' sing songs. Some are inevitably inappropriate or puzzling, such as a video in which a young man streaks, having reached a target for members on his Darfur-related Facebook group,[68] or the volunteer-based social network neddotcom's series of "Darfurby" videos, in which Furby dolls are used to visualize genocide and grassroots action.[69] Even so, one genre dominates. The music video comprises three basic components: (1) a photographic montage of stills drawn from a variety of online sources, from humanitarian websites, from news organizations, from media management agencies, and possibly from other videos; (2) textual information in an image macro or through intertitles, providing such information as location, statistics, historical briefs, pleas to act, and occasionally action recommendations with an URL for an advocacy organization (Figure 14); (3) music of varied selection, offering unidentified African children's choirs, the occasional heavy metal power ballad, or most often, music of conscience, including songs by John Lennon or U2. Joining this repertoire is the omnipresent "Mad World," a song written by Roland Orzabal of Tears for Fears in 1982, but covered two decades later by Gary Jules, and repopularized in the cult film *Donnie Darko* (Richard Kelley, 2001) about a young man given the chance to save the world. This format is ideal for the media economy of YouTube users: stills are readily collected and edited into image macros with a minimum of computer memory and skill and the running time is short: rarely more than five minutes, a length that maintains attention in a medium where multiple screens and the lifeworld just beyond compete for attention, and where, in spite of technological developments, bandwidth continues to be taxed.

YouTube is not the place for congestions of readability or challenges to previous assumptions or innovations in witnessing. Here, similarity and repetition reign, perhaps due to the limit of available images. Steidle's photographs, in particular the eagle eye view of the burning village, the Janjaweed militia on horseback, and the horrifying pictures of the slain (each bearing a time and date stamp) repeat across all of these videos. Although this repetition is likely due to the limited number of available images of the violence, other aspects may be due to the appeal of familiar motifs. The trope of a mother and child cuts across all the videos, possibly for its evocation of religious imagery, as a suffering Madonna and child, or as a Pietà recast in the refugee camp (Figure 15). Children also appear

Figure 14. "The Darfur Genocide" (Jesusfreak864, 2006). Text onscreen reads, "Signs of genocide began to show early of 2003," and the information box offers, "Genocide was said to happen 'never again.' But what they meant was 'Never again will Jews be killed in 1940's Germany by Hitler.'"

frequently as innocent victims, in danger of injury and malnutrition. Multiple meanings converge on these suffering bodies. The infant, a human without explicit politics, stands for the civilians endangered by this war while the skeletal features draw on the iconography of famine coverage and Holocaust liberation photographs: this is both a political and a humanitarian crisis needing a response. A photograph taken by Wendy Stone in southern Sudan is particularly popular, showing an injured child lying among others suffering: it communicates personal violation and well as the greater population at serious risk (Figure 16).

User-generated videos often draw their rhetorical cues from existing work. Mikimaster9 states that he adapted his video from "'Never Again':

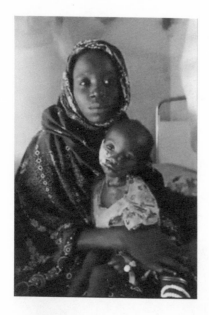

Figure 15. Images of women and children are popular. Pictured "Crisis in Darfur/Sudan" (NFLBaller2008, 2006) and "Save Darfur" (Mcar2374, 2008).

Figure 16. Particular stills, such as this one by photojournalist Wendy Stone, appear in a number of videos, such as "A New Sudan (Darfur Genocide)" (Ryguy637, 2006) (pictured here), "Darfur" (InsipidNight, 2007), "Darfur Slideshow" (Ballerfitz, 2007), and "Wanted for Genocide" (Md0506, 2007). Glimpses of other videos using this still can be seen to the right, in the suggestion sidebar.

The Permanent Anti-Genocide Movement," posted by GIN, a claim that provides attribution while directing the viewer back to the action site. Like the PSA "Never Again (Save Darfur)" by the SDC, GIN's video as well as those of Mikimaster9 and others place the crisis in Darfur within a historical genocide continuum. Through this borrowing, motifs emerge and intensify, with the phrase "Never Again" and a history of genocide providing the dominant rhetorical structure. These two videos, like many others, begin with the Holocaust and note the promise of "Never Again." A slide show of other images and titles follow, mentioning the genocides in Cambodia, Rwanda, and Bosnia. Some even introduce the Armenian genocide at the start, allowing the history and iconography that make an economic case for Darfur as genocide do the same for the Armenian case. The invocation of "Never Again" bolsters this case and it seeks to impel viewer response through obligation ("Because 'Never Again' should be more than an empty promise," notes GIN) or encouragement ("You can help make 'Never Again' a reality," states mikimaster9). Anappy's video, "One-U2 and Mary J. Blige (Save Darfur)," builds on this trope with associative editing and textual instruction. It happened before, the text reads, before an image of concentration camp internees takes the screen. It happened again, it continues, with an image of a young boy behind barbed

wire (Figure 17). The theme continues through the use of images of mass death from the past and present, as rows of corpses evoke the repetition of genocide in the present day. The title of the video further demonstrates the accumulation of rhetorical and materials, bearing the addition "(Save Darfur)," the title element used by SDC to indicate original use. The popularity of this item, particularly as compared to the long-running documentaries posted by USHMM and International Refugees, is striking: Anappy received over 100,000 hits within the first months of posting, and the video was "favorited" 810 times. This framing strategy appears multiple times over in the network of Save Darfur videos, including Ryguy637's "A New Sudan (Darfur Genocide)" and Capenobvious's "The Genocide in Darfur." Even Craig Warner's video "Save Darfur," which differs from the music video format, incorporating photographs and the spoken testimony of reporter Nicholas Kristof, aims to provide "a brief history of genocide and our responsibility today." This repetition of rhetorical strategy and images returns me to my earlier suggestion of fan fiction, whereby style, form, and content are borrowed to extend engagement with the represented world. Textual poaching enables collaboration between YouTube's citizens and online organizations, in the practice of witnessing.

Although images of the Holocaust loom large, the cycle of videos focused on the genocide continuum expands the iconography to include other genocides as they resignify "Never Again." No longer is it a comforting axiom; it is recognized as an empty promise and thus works as an alarmed vision—a guard against complacency. The invocation is not one to comfort us about a possible future, but to produce outrage and remind us of ongoing atrocity and the demand not simply to archive and commemorate, but also to act.

The videos are frequently positioned in a context of action, working typically as only one of many components within a larger campaign. As already mentioned, YouTube enables immediate response through increased circulation made possible through a technology that combines a platform for exhibition with tools for distribution and commentary. Meanwhile, the content of the video and the information box (an integral component of the exhibition site) direct visitors and viewers to larger programs and avenues for action. Anappy provides a long list of possible sites to visit. Capenobvious and Craig Warner both incorporate the URL for the SDC at the end of their videos, while Hiljam9 (a Hillel organization) goes further, providing the URL but also posting information about an upcoming rally. Accordingly, many of the videos intended to promote events can

Figure 17. Associative editing linking the past with the present in YouTube video, "One-U2 and Mary J. Blige (Save Darfur) by user Anappy (2007).

outlive their intended use. However, additional possibilities reside in the information box. Ryguy637 does not include URLs in his video, but the information section offers addresses of the SDC, Stand Now (a student organization), and "www.darfurgenocide.org." Ryguy367 tells the viewer to "feel free to encode/post this video wherever you like. I encourage you to spread the word . . ." Capenobvious offers similar information, focusing attention to the SDC. Indeed, the majority of these videos link to other sites, providing information about organizations in the textboxes and supplying URLs as a textual element and action recommendation in the video. Even if not exactly witnessing publics, they are witnessing publicists.

This trend reflects a refreshing change in the popular perception of visuality in relation to human rights witnessing. Instead of assuming that visuality automatically brings about justice, these videos indicate the conviction that something more is needed in the way of direction. Admittedly, many amateur videos often simply state "Do Something," or ask that the video be passed along, allowing the faith in visuality to dominate. Yet just as often, the videos are attached to other projects: to rights organizations and advocacy programs, to action recommendations, or to real world rallies and fundraisers.

As I discussed earlier in the book, social advocacy media have long relied on existing interpretive frameworks and extra-textual practices to channel sentiment into action. What has changed is the amplification and acceleration of witnessing as the tools of broadcast and exchange become more accessible. However, with this attenuated witnessing through repurposing and remediating, I wonder whether the YouTube users always know what they bear witness to. These videos serve an important publicizing function, but do little for historical witnessing. The denotative clarity of the image is lost in favor of the connotative function; there is rarely attribution, nor provision of names, dates, or circumstances—even when they are available. Yet this, too, is not new: in the aftermath of the Holocaust, the British and American papers had trouble with attribution of the liberation photos. But these amateur videos foster uncertain designations, often failing to distinguish between Janjaweed, SLA, or African Union. Men with guns (and possibly more troubling, *black* men with guns) simply mean violence and danger.

The slippage in signification takes on even greater risks when the photographs don't even represent the particular crisis at hand. In videos posted by Hiljam9 ("Save Darfur"), InsipidNight ("Darfur") and Md0206 ("Wanted for Genocide"), there appears a photograph of a young girl crouched over

as a vulture lurks in the background (Figure 18). One can see how it fits with the iconography of the humanitarian crisis—a child makes her way to the feeding station, although her weakness and the vulture threaten her journey to safety. The narrative of the photograph opens a space for the viewer to position oneself as rescuer, to shoo the vulture, to carry the child. It's a remarkably affective and effective image. And yet it's not in Darfur. It's not even in the same time as the crisis. The photograph was taken in Sudan, but in 1993—and it won a Pulitzer for Kevin Carter, a photojournalist who killed himself a short while after. To further burden the photograph with meaning, it was a case study that launched Susan Moeller's book, *Compassion Fatigue*, making it representative of a crisis and the failure of visibility. The repetition and the acceleration into the connotative may provide economic means of mobilizing sentiment and broadening the genocide imaginary, but this extreme attenuated witnessing risks becoming disarticulated from the original point of testimony. Can

Figure 18. Kevin Carter's 1993 Pulitzer Prize-winning photograph appears in a few videos as well, including "Darfur" (InsipidNight, 2007) (pictured here), "Save Darfur" (Hiljam9, 2006), and "Wanted for Genocide" (Md0506, 2007).

one be an activist without a witness? Turning back to neddotcom's Darfurby videos, one sees the extreme end result of this kind of project. The video "Darfurby: Grassroots Action, Get Loud!" explains through intertitles that people are needed to protest, to get loud and make their voices heard. To visualize this imperative, the video uses stills of Furby dolls, staged in protest and placed in relation to landmarks of Washington, D.C. (Figure 19). Neddotcom articulates a goal beyond simply providing a voice, explaining the need for peacekeepers, but at no point does the video aim to visualize or fully explain what is being protested: it is as if one no longer needs to see what is happening.

The networks are in the right place, and visual testimony can move with a speed and scope not seen before, and yet in this movement, there are risks. The acceleration into the connotative realm threatens to forget history and to erase witnesses whose voices are already in peril. While there is significant dynamism in the construction and reconstruction of the world and its information, there remains a need to connect this *cosmopedia* to

Figure 19. "Darfurby: Grassroots Action, Get Loud!" (neddotcom, 2007). The signs carried read "End Mass Atrocity," "Stop Genocide Now," and "Not on Our Watch."

an outside world, to not allow this virtual space to be the only one considered. I conclude on an ambivalent note, not simply because this is a crisis in progress and a media technology accelerating at a rate well past the speed of publication, but also because I want to encourage this manner of tempered examination in the exploration of media witnessing. The discourses of condemnation and celebration take us nowhere. However, explorations into the range of Internet activities that take into account interface, rhetoric, and links to the real world allow us to better understand its potential as a sphere of civic engagement and a site of witnessing.

CONCLUSION

Testimonial Encounters and Tempering the Celebratory Narrative

THIS TRANSHISTORICAL ANALYSIS consistently returns to two key points. First, from early on, screen media have played a significant role in constructing the popular, political, and legal imaginary of genocide and human rights. Second, these acts of film, video, and Internet witnessing need unpacking and exploration. This study emphasizes that it is not the mere fact of visuality that catalyzes the chain reaction of exposure, revelation, and justice; rather, the processes and players of visuality generate a testimonial encounter from a spectacle of suffering, and that intertextual and extrafilmic practices help ferry the responsibility of witnessing publics into political action. Strategically deployed aesthetic and formal elements—themselves drawn from visual traditions, popular film, and historical and social contexts—anchor the meaning of the atrocity display and produce ethical claims. These rhetorical choices rely on the circuits that relay the visual material, circuits comprising producers, distributors, venues, and, most importantly, audiences. The formal and narrative components contribute to the construction of emotional and ethical claims but, as is also argued, the programs and activities designed around screenings are crucial in channeling that sentiment into action. Far from a streamlined process, these practices of media witnessing and advocacy are best understood as taking place within a dynamic field of cultural production: a field of witnessing.

Mapping out fields of witnessing is a challenging project, not least for the dynamism. Political and technological landscapes are constantly changing, testing all efforts to stay current. The scholarship, too, has developed since the launch of this project. Early on, the crucial literature on witnessing was characterized by a distinctly literary and psychoanalytic thrust, resulting in a focus on trauma's impact on the testimonial narrative;

film seemed a nascent and inchoate presence. Shoshana Felman's discussion of *Shoah* supported Claude Lanzmann's claim that he eschewed images in favor of testimony, in part disregarding the degree to which the film was a film. She recognized film's place as art and its role as historian, but the cinematic aspects of witnessing took a decidedly secondary if not tertiary role. Cathy Caruth discussed Alain Resnais's *Hiroshima Mon Amour,* but focused on the dialogue, neglecting the provocative relationship between the sound and image tracks, the rich and multimedia aesthetic, and the elliptical editing that is the director's signature. This was not a fault, but rather, a fault line in the field, where a 2001 *Screen* special debate called "Trauma and Screen Studies" made an essential intervention.[1] In other works influenced by these questions of trauma, questions of representing the Holocaust centered on the possibility and propriety of representation, particularly representation in the popular realm; although these concerns dovetailed with the necessary work examining how popular cinema forges popular memory. The contribution of this scholarship will always be valued, but a need for more sustained examinations of what it means to witness with, through, and by the camera remained. And such works have emerged with *The Image and the Witness: Trauma, Memory, and Visual Culture* (ed. Frances Guerin and Roger Hallas) and *Documentary Testimony: Archives of Suffering* (ed. Janet Walker and Bhaskar Sarkar), which broaden the landscape, often engaging in the explorations of more peripheral global film and media projects. There is also *Media Witnessing: Testimony in the Age of Mass Communication* (ed. Paul Frosh and Amit Pinchevski), which includes an essay that, like this book, advances the value of Bourdieu's field of cultural production in the study of witnessing.[2]

Equally exciting has been the groundswell of (renewed) interest in screen media advocacy, focused on film, video, and Internet, where questions of practices, methods, and ethics have come to the fore. Interest in the politics of representation has been an ongoing concern, but a welcome addition (or return) has been the interest in documentary as a means of witnessing and of action. Stimulating investigations continue as scholars address the role of database aesthetics in activism, the work of distribution as a means of solidarity, the function of the YouTube layer of Google Earth as a site of culture jamming, and the contributions of popular documentarians into social change. Ethics, too, have become a serious question in an age where media migration and resignification are more possible than ever. To this end, people are asking essential questions about the responsibilities that attend remixing and recirculation, as well as about the implications these

practices hold for accuracy, perspectives, and the potential to endanger those pictured. With social media platforms such as Twitter, Facebook, and YouTube taking prominent roles in revolutions as tools for organization and mobilization, the attention proliferates. Mapping interactions, tracing the testimonies of viral witnesses, and assessing the attendant practices are crucial projects.[3]

The trajectory of this book now runs a risk of creating a celebratory narrative of progress in danger of falling into an Enlightenment-style delight in the capacity of media and reason as technologies of deliverance. My appreciation of the new developments in scholarship and my chronological structure are not intended to suggest a narrative of success. Nor is the book's focus on mainstream films and screen media from the Western world intended to locate reason or justice in a particular region, technology, or industry. Celebration of a job well done is not the goal here. After all, as I write this, the other Enlightenment-style conviction in the link between visuality and justice persists.

By way of anecdote, I turn to an event held in 2009 and sponsored by the USC Shoah Foundation Institute for Visual History and Education. Entitled "Genocide Survivor Testimony in Documentary Film: Its Afterlife and Its Legacy," the panel featured filmmakers who have tacked the subject of genocide, including James Moll (*The Last Days*), Anne Aghion (*Gacaca: Living Together in Rwanda*), and Ted Braun (*Darfur Now*). The introduction praised the filmmakers and their films, averring the redemptive power of speech—or, in other words, the transformative power of testimony, as well as the capacity of these films, and the archives to act as "storehouses of memory." In doing so, the speaker articulated the dual imperative of film, as archive and advocate. As I have indicated in the book, this is indeed a function of film. However, the work of film as either historical or activist witness is fraught as agendas of the present day and industrial practices shape the look and narrative, and inform the path the images will take, whether they will be seen, or how they will be read. Films like *No Man's Land* and *Before the Rain* represent the vicissitude of the circuits, showing how ulterior motives or sheer distraction can result in bodies never seen, and in narratives that appear to be set but remain unsettled. In addition, questions of images, and their capacity to evoke emotion demand greater attention: How are the images of atrocity made comprehensible? As I have discussed, iconographic lexicons and tropes play a large role in cultivating a visual shorthand that cues recognition of suffering and injustice and thus makes emotional and ethical claims. And even if these images do

provoke an emotional response, questions persist. How can this sentiment be channeled into productive action? How can films be used to maximize their potential impact?

Such questions are not always at the forefront, even today, where a discourse of compassion fatigue carries on. At the event, when the filmmakers were asked about the ways their films could make a difference, the answers were disappointingly vague. (Admittedly, the venue may not have been optimal for the desired in-depth exploration.) Ted Braun noted his film would be circulated in a number of venues, but it remained unclear which ones: who would see the film and under what circumstances, and how did he envision his film prompting a response? James Moll spoke of his appreciation for cameras today, and lamented none were around at the time of the Holocaust. Although it is certainly true that the camera technology was nowhere near as advanced or as ubiquitous as today, he is mistaken: there were cameras there, and possibly more there than he might wish to acknowledge. Many Nazis filmed attacks and purges, as the eight-millimeter atrocity footage suggests, and which can also be seen in such films as *Meanwhile Somewhere 1940–43* . . . (Peter Forgacs, 1994), a video that intercuts home movies with amateur footage of the concentration camps. Their photographs may be more prevalent than many think. The famous photograph of the boy in the Warsaw ghetto was taken and exhibited by Nazis, as a way of celebrating the successful liquidation of the ghetto. Today it stands as a symbol of their profound malevolence.

Signification issues aside, what happens with photographs is of equal consequence. In 1999, an exhibit entitled *Mémoire des Camps* was on view in Paris. Among the works presented were photographs taken by Sonderkommandos to show the work of execution and cremation. Made possible by a camera smuggled into Birkenau by the Polish resistance, these pictures were part of a plan to broadcast the horrors in order to push for intervention. The attendant letter, which requests additional film and includes descriptions of the photographs (unable to "speak for themselves") makes this clear: "Send these photographs immediately to Tell—We think the photos could be sent even further abroad."[4] The belief in the power of images to produce change is implicit within the demand that the photos be sent out and that there are those, "out there" who would be interested. However, these photographs languished in the home of a Polish resistant, and were only uncovered in 1985 by his widow. More disturbingly, the photographs of the women prepared for execution had been retouched so as to lift their breasts, and give their bodies a youthful appearance. These

"corrections" suggest the production of a more desirable victim, and the use of titillation and attraction to excite spectators and generate urgency.[5] One can only guess at the intention behind the manipulation; however, the question of how images are presented, circulated, and put to use remains: it is not enough to have a camera. Getting the images out there is not enough. There are relationships between visuality, genocide, human rights violations, and action. And as I suggest in this initial research, the processes that cultivate the interactions and the testimonial encounter must be studied in order to better understand how to foster a witnessing public.

NOTES

Introduction

1. Stanley Cohen, "Government Responses to Human Rights Reports: Claims, Denials, and Counterclaims," *Human Rights Quarterly* 18 (1996): 517–43; Thomas Keenan, "Mobilizing Shame," *South Atlantic Quarterly* 103 (Spring/Summer 2004): 435–49.
2. Johanna Neuman, *Lights Camera, War: Is Media Technology Driving International Politics?* (New York: St. Martin's Press, 1996).
3. Cited in Keenan, "Mobilizing Shame," 438.
4. Keenan, "Mobilizing Shame," 438.
5. Helen Fein, "Testing Theories Brutally: Armenia (1915), Bosnia (1992) and Rwanda (1994)," in *Studies in Comparative Genocide*, ed. Levon Chorbajian and George Shirinian (New York: St. Martin's Press 1999), 63.
6. Marita Sturken, *Tangled Memories: The Vietnam War, the AIDS Epidemic, and the Politics of Remembering* (Berkeley: University of California Press, 1997).
7. Meg McLagan, "Principles, Publicity, and Politics: Notes on Human Rights Media," *American Anthropologist* 105 (2003): 605–12.
8. *Convention on the Prevention and Punishment of the Crime of Genocide*, adopted by Resolution 260 (III) A of the United Nations General Assembly on December 9, 1948.
9. Diane F. Orentlicher, "Genocide," in *Crimes of War: What the Public Should Know*, ed. Roy Gutman and David Rieff (New York: W. W. Norton, 1999), 153.
10. Samantha Power, "Bystanders to Genocide," *Atlantic Monthly*, September 2001, http://www.theatlantic.com/doc/200109/power-genocide (accessed February 28, 2012).
11. Cited in Mark Huband, "Rwanda—The Genocide," in *Crimes of War: What the Public Should Know*, ed. Roy Gutman and David Rieff (New York: W. W. Norton, 1999), 314; and in Power, "Bystanders to Genocide."
12. Jim VandeHei, "In Break with U.N., Bush Calls Sudan Killings Genocide," *Washington Post*, June 4, 2005, http://www.washingtonpost.com/wp-dyn/content/article/2005/06/01/AR2005060101725.html (accessed February 28, 2012).
13. From a personal communication with WITNESS program manager Sam Gregory in 2005.
14. International Criminal Court, "International Criminal Court Launches Video Channel on YouTube," press release, March 31, 2010; International Criminal Court Press

Release, "International Criminal Court Launches Twitter Account to Keep Followers Updated," press release, July 16, 2010.

15. Shoshana Felman, "The Return of the Voice: Claude Lanzmann's Shoah," in Shoshana Felman and Dori Laub, *Testimony: Crises of Witnessing in Literature, Psychoanalysis and History* (London: Routledge, 1992), 204.

16. John Durham Peters, "Witnessing," *Media, Culture and Society* 23 (2001): 714.

17. George Yúdice, "Testimonio and Postmodernism" in *The Real Thing: Testimonial Discourse and Latin America,* ed. Georg M. Gugelberger (Durham: Duke University Press, 1996), 44.

18. Dwight A., McBride, *Impossible Witness: Truth, Abolitionism and Slave Testimony* (New York: New York University Press, 2001).

19. Felman and Laub, *Testimony,* 81, 204. Also see Cathy Caruth, *Unclaimed Experience* (Baltimore: Johns Hopkins University Press, 1996); Geoffrey Hartman, *The Longest Shadow: In the Aftermath of the Holocaust* (Bloomington: Indiana University Press, 1996); Dominick La Capra, *Writing History, Writing Trauma* (Baltimore: Johns Hopkins University Press, 2001).

20. Lawrence Langer, *Holocaust Testimonies: The Ruins of Memory* (New Haven: Yale University Press, 1993); Janet Walker, "The Traumatic Paradox: Documentary Films, Historical Fictions, and Cataclysmic Past Events," *Signs* 22 (1997): 803–25. Saul Friedlander's collection, *Probing the Limits of Representation: Nazism and the "Final Solution"* (Cambridge, Mass.: Harvard University Press, 1992), as the title suggests, is based on this understanding of challenge and the potential inadequacy or impropriety of representation.

21. Michael Rothberg, *Traumatic Realism: The Demands of Holocaust Representation* (Minneapolis: University of Minnesota Press, 2000); Miriam Hansen, "Schindler's List Is Not Shoah," in *Spielberg's Holocaust: Critical Perspectives on "Schindler's List,"* ed. Yosefa Loshitsky (Bloomington: Indiana University Press, 1997), 77–103.

22. John Beverly and Marc Zimmerman, *Literature and Politics in Central American Revolutions* (Austin: University of Texas Press, 1990), 173.

23. Paul Frosh and Amit Pichevski, "Introduction: Why Media Witnessing? Why Now?," in *Media Witnessing: Testimony in the Age of Mass Communication,* ed. Paul Frosh and Amit Pinchevski (New York: Palgrave Macmillan, 2009), 1.

24. The Foundation is now known as USC Shoah Foundation Institute for Visual History and Education.

25. Felman and Laub, *Testimony,* 3.

26. Robert Stam, "Television News and Its Spectator," in *Regarding Television: Critical Approaches—An Anthology,* ed. E. Ann Kaplan (Frederick, Md.: American Film Institute, 1983), 23–43.

27. Paul Frosh, "Telling Presences: Witnessing, Mass Media, and the Imagined Lives of Strangers," in *Media Witnessing: Testimony in the Age of Mass Communication,* ed. Paul Frosh and Amit Pinchevski (New York: Palgrave Macmillan, 2009), 49.

28. Cited in Diane K. Shah, "Steven Spielberg, Seriously: Hollywood's Perennial Wunderkind Confronts History, Sentiment, and the Fine Art of Growing Up," *Los Angeles Times,* Sunday Magazine, December 19, 1993, 20.

29. Cited in Tom Shales, "The Man at the Top of Schindler's List; Spielberg Didn't Add Drama—He Gave the Film His Heart," *Washington Post*, December 15,1993, B1.

30. It is also likely that these materials helped to transform the image of Spielberg from director of popular genre films to a serious "auteur."

31. See Rory Brand, "Witnessing Trauma on Film," in *Media Witnessing: Testimony in the Age of Mass Communication*, ed. Paul Frosh and Amit Pinchevski (New York: Palgrave Macmillan, 2009), 198–215; Roger Hallas, "Sound, Image and the Corporeal Implication of Witnessing in Derek Jarman's Blue," in *The Image and the Witness: Trauma, Memory and Visual Culture*, ed. Frances Guerin and Roger Hallas (London: Wallflower Press, 2007), 37–51.

32. James Nachtwey, *Inferno* (New York: Phaidon Press, 2000).

33. Douglas Cruickshank, "James Nachtwey's 'Inferno': Pictures from an Exhibition in Hell," *Salon.com*, April 10, 2000, http://www.salon.com/2000/04/10/inferno/ (accessed March 1, 2012).

34. Cited in Alexander Linklater, "The Last Witness," *Glasgow Herald*, January 29, 2000.

35. Ann Gerhart, "War's Unblinking Eyewitness," *Washington Post*, April 11, 2000, C01.

36. Michael Kimmelman, "Poignant Faces of the Soon-to-Be Dead," *New York Times*, June 20, 1997, C1.

37. Barbie Zelizer, *Remembering to Forget: Holocaust Memory through the Camera's Eye* (Chicago: University of Chicago Press, 1997), 7.

38. Ibid., 221.

39. Although the word "holocaust" had been used to describe large-scale massacres at the time of the Armenian genocide (as discussed in chapter 1), the word did not take on its specific historical and political resonance as reference to a genocide until the 1940s.

40. I discuss the political and memorial uses of the Holocaust as interpretive framework for Armenian Genocide recognition projects in "Since We Forgot: Remembrance and Recognition of the Armenian Genocide in Virtual Archives," in *The Image and the Witness: Trauma, Memory and Visual Culture*, ed. Frances Guerin and Roger Hallas (London: Wallflower Press, 2007), 82–97.

41. Luc Boltanski, *Distant Suffering: Morality, Media and Politics*, trans. Graham D. Burchell (Cambridge: Cambridge University Press, 1999), 191–92.

42. See Zelizer, *Remembering to Forget*.

43. Allen Feldman, "Violence and Vision: Prosthetics and Aesthetics of Terror," in *Violence and Subjectivity*, ed. Veena Das, Arthur Kleinman, Mamphela Ramphele, and Pamela Reynolds (Berkeley: University of California Press, 2000), 46–78.

44. Richard Allen, "Psychoanalytic Film Theory," in *A Companion to Film Theory*, ed. Toby Miller and Robert Stam (Malden, Mass: Blackwell Publishers, 1999), 123–45. For Sergei Eisenstein and Walter Benjamin, montage creates dynamic experiences that shock and stimulate viewers, exciting dialectical processes, critical thinking and new world perspectives (Sergei Eisenstein, "The Dramaturgy of Film Form," in *Film Theory and Criticism: Introductory Readings*, 5th ed., ed. Leo Braudy and Marshall Cohen [Oxford: Oxford University Press, 1999], 25–42; Walter Benjamin, "The Work of Art in the Age of Mechanical Reproduction," in *Illuminations: Essays and*

Reflections, ed. Hannah Arendt, trans. Harry Zohn [New York: Schocken Books, 1968], 217–52). Tomás Gutiérrez Alea finds dialectic exchange in the encounter between spectator and spectacle, which can stir the viewer to responses of ecstasy and alienation. The intense emotional response takes the viewer out of himself, transforms his perspective, and encourages him to change the world (Tomás Gutiérrez Alea, "The Viewer's Dialectic, Pt. 1," trans. Julia Lesage, *Jump Cut* 29 [February 1984]: 18–21; Tomás Gutiérrez Alea, "The Viewer's Dialectic, Pt. 2," trans. Julia Lesage, *Jump Cut* 30 [March 1985]: 48–53). Jane Gaines, meanwhile, advances a notion of "political mimesis" in order to account for film's capacity to inspire response. She synthesizes Eisenstein's "agitation of the spectacle" and Tom Gunning's "Cinema of Attractions" with Linda Williams's "body genres," which produce an "almost involuntary mimicry of emotion or sensation of the body on screen." In this formulation, the realism of the documentary image can drive audiences to engage with the political action on screen (Jane M. Gaines, "Radical Attractions: The Uprising of '34," *Wide Angle* 21 [1999]: 101–19; Jane M. Gaines, "Political Mimesis," in *Collecting Visible Evidence*, ed. Jane M. Gaines and Michael Renov [Minneapolis: University of Minnesota Press, 1999], 102).

45. Boltanski, *Distant Suffering;* John Ellis, *Seeing Things: Television in the Age of Uncertainty* (London: I. B. Tauris, 2000).

46. Thomas Keenan writes that overexposure has generated claims of "voyeurism, sometimes compassion fatigue, sometimes the obscenity of images and sometimes 'disaster pornography'" ("Mobilizing Shame," 438).

47. Arthur and Joan Kleinman, "The Appeal of Experience; The Dismay of Images: Cultural Appropriations of Suffering in Our Times," in *Social Suffering*, ed. Arthur Kleinman, Veena Das, and Margaret Lock (Berkeley: University of California Press), 19. These notions proliferate: David Levi-Strauss observes the tendency for art critics and journalists to disarticulate aesthetics and politics, viewing authenticity and action as somehow antithetical to aesthetics, and the transformative dimensions of representation (David Levi-Strauss, *Between the Eyes: Essays on Photography and Politics* [New York: Aperture, 2003], 3–11). In *This Time We Knew: Western Responses to Genocide in Bosnia* (New York: New York University Press, 1996), editors Thomas Cushman and Stjepan G. Meštrović argue that the flow of images contributes to an overall derealization, passivity, and inaction.

48. Susan Moeller, *Compassion Fatigue: How the Media Sell Disease, Famine, War, and Death* (New York: Routledge, 1999).

49. Benedict Anderson, *Imagined Communities: Reflections on the Origin and Spread of Nationalism* (London: Verso, 1991).

50. Jürgen Habermas, *The Structural Transformation of the Public Sphere: An Inquiry into a Category of Bourgeois Society* (Cambridge: Polity, 1989 [1962]).

51. Nancy Fraser, "Rethinking the Public Sphere: A Contribution to the Critique of Actually Existing Democracy," *Social Text* 25/26 (1990): 57.

52. Arjun Appadurai, *Modernity at Large: Cultural Dimensions of Globalization* (Minneapolis: University of Minnesota Press, 1996).

53. Further complicating this issue of borders are the categories of victim groups,

organized by ethnic, racial, or religious categories within the Genocide Convention. This is, as Alexander Laban Hinton observes, problematic for privileging certain social formations over others (introduction to *Genocide: An Anthropological Reader*, ed. Alexander Laban Hinton [Malden, Mass.: Blackwell Publishers, 2002], 5). The need to contest such rubrics engenders further challenges to borders.

54. Patrice Petro and Mark Philip Bradley, introduction to *Truth Claims: Representation and Human Rights*, ed. Mark Philip Bradley and Patrice Petro (New Brunswick, N.J.: Rutgers University Press, 2002), 1.

55. Andrew Cooper, *Celebrity Diplomacy* (Boulder, Colo.: Paradigm Publishers, 2007); John Street, "The Celebrity Politician: Political Style and Popular Culture," in *Media and the Restyling of Politics: Consumerism, Celebrity and Cynicism*, ed. John Corner and Dick Pels (London: Sage Publications, 2003), 85–98.

56. Max Horkheimer and Theodor Adorno, "The Culture Industry: Enlightenment as Mass Deception," in *The Dialectic of Enlightenment: Philosophical Fragments* (Stanford, Calif.: Stanford University Press, 2002), 94–136; Daniel Boorstin, *The Image: A Guide to Pseudo-Events in America* (New York: Harper and Row, 1964 [1962]); Neil Postman, *Amusing Ourselves to Death: Public Discourse in the Age of Show Business* (New York: Penguin Books, 1985); Clifford Bob, *The Marketing of Rebellion: Insurgents, Media, and International Activism* (Cambridge: Cambridge University Press, 2005); James Poniewozik, "The Year of Charitainment," *Time*, December 26, 2005. Jon Simons offers an excellent review of the scholarship in "Popular Culture and Mediate Politics: Intellectuals, Elites, and Democracy," in *Media and the Restyling of Politics*, ed. John Corner and Dick Pels (London: Sage Publications, 2003), 171–89.

57. Liesbet Van Zoonen, *Entertaining the Citizen: When Politics and Popular Culture Converge* (Lanham, Md.: Rowman and Littlefield Publishers, Inc., 2005); John Corner and Dick Pels, ed. *Media and the Restyling of Politics: Consumerism, Celebrity and Cynicism* (London: Sage Publications, 2003); Joke Hermes, "Hidden Debates: Rethinking the Relationship between Popular Culture and the Public Sphere," javnost-the public 13 (2006): 27–44; Nicholas Garnham, "The Media and the Public Sphere," in *Habermas and the Public Sphere*, ed. Craig Calhoun (Cambridge, Mass.: MIT Press, 1992), 359–76.

58. Henry Jenkins discusses the participatory culture of fandom in *Textual Poachers: Television Fans and Participatory Culture* (New York: Routledge Press, 1992) and in *Convergence Culture: Where Old and New Media Collide* (New York: New York University Press, 2006). In the latter text, he opens up the potential for grassroots political action within the realms of fandom.

59. Hermes, "Hidden Debates."

60. Craig Calhoun, "Introduction: Habermas and the Public Sphere," in *Habermas and the Public Sphere*, ed. Craig Calhoun (Cambridge, Mass.: MIT Press, 1992), 1–50. Fraser, "Rethinking the Public Sphere"; Michael Warner, *Publics and Counterpublic* (New York: Zone Books, 2005).

61. Fraser, "Rethinking the Public Sphere," 63.

62. Garnham, "The Media and the Public Sphere," 361.

63. Warner, *Publics and Counterpublics*, 73. Although he begins with the text-based

medium, he concedes the growing work of the audio and visual text. And, one could argue, the eventual concatenation of all these texts and media in Web-based technology.

64. Calhoun, introduction, 37.

65. Pierre Bourdieu, *Outline of a Theory of Practice* (Cambridge: Cambridge University Press, 1977). In *Producing Public TV, Producing Public Culture* (Princeton, N.J.: Princeton University Press, 1998), Barry Dornfeld uses Bourdieu's concept of a field of cultural production in order to better conceptualize the role of producers in producing documentaries. Within this paradigm, one can understand the motivations of producers in both being and imagining their audiences. This notion of witnessing as a field has also been advanced in Tamar Ashuri and Amit Pinchevski, "Witnessing as a Field," in *Media Witnessing: Testimony in the Age of Mass Communication,* ed. Paul Frosh and Amit Pinchevski (New York: Palgrave Macmillan, 2009), 133–57.

66. Sam Gregory, "Transnational Storytelling: Human Rights, WITNESS, and Video Advocacy," *American Anthropologist* 108 (March 2008): 198.

67. Steven Livingston, "Suffering in Silence: Media Coverage of War and Famine in Sudan," in *From Massacres to Genocide: The Media, Public Policy, and Humanitarian Crises,* ed. Robert I. Rotberg and Thomas G. Weiss (Cambridge, Mass.: World Peace Foundation, 1997), 77.

68. Meg McLagan, "Spectacles of Difference: Cultural Activism and the Mass Mediation of Tibet," in *Media Worlds: Anthropology on New Terrain,* ed. Faye D. Ginsburg, Lila Abu-Lughod, and Brian Larkin (Berkeley: University of California Press, 2002), 90–114.

69. This phrasing comes from Henry Jenkins's entry "Transmedia Storytelling 101," on his blog *Confessions of an Aca/Fan,* March 22, 2007, http://www.henryjenkins.org/2007/03/transmedia_storytelling_101.html (accessed March 3, 2012), which clarifies and updates ideas outlined in *Convergence Culture: Where Old and New Media Collide* (New York: New York University Press, 2006).

70. Pierre Levy, *Collective Intelligence: Mankind's Emerging World in Cyberspace,* trans. Robert Bononno (Cambridge, Mass.: Perseus Books, 1997), 13.

71. Ibid., 174–75.

72. Ibid., 213.

73. Human Rights Watch, *Genocide in Iraq: The Anfal Campaign against the Kurds: A Middle East Watch Report,* 1993, http://www.hrw.org/legacy/reports/1993/iraqanfal/ (accessed March 4, 2012).

74. Rithy Panh's other films include *La Terre des âmes errantes* (1999), *Bophana, une tragédie cambodgienne* (1996).

75. Lindsey French writes about this exhibit when it was on display at MoMA in summer 1997 in "Exhibiting Terror," in *Truth Claims: Representation and Human Rights,* ed. Mark Philip Bradley and Patrice Petro (Rutgers, N.J.: Rutgers University Press, 2002), 131–56.

76. These include not only the popular film *Rabbit-Proof Fence* (Philip Noyce, 2002), but also Darlene Johnson's documentary *Stolen Generations* (2000) and Sally Riley's

short feature, *Confessions of a Headhunter* (2000), a playful meditation on both the effects of this ethnocide and the creation of public memory.

1. To Acquaint America with Ravished Armenia

1. Peter Balakian, *The Burning Tigris* (New York: HarperCollins, 2003), xiii.
2. Erik Barnouw, *Documentary: A History of the Non-Fiction Film*, 2nd ed. (Oxford: Oxford University Press, 1993), 13.
3. Although this chapter centers on the work conducted in the United States with some attention to the UK, the reach of the organization was indeed global. Vicken Babkenian writes of the Armenian relief work NER conducted in Africa, South America, and Asia in "Cuba, China, Korea, Hawaii and the Armenian Genocide," *Armenian Weekly*, November 10, 2010, http://www.armenianweekly.com/2010/11/10/cuba-china-korea-hawaii-and-the-armenian-genocide (accessed March 5, 2012).
4. "Unlike the European powers, each a colonial empire vying for greater influence in Turkey, the United States had not vested political capital in the Armenian Question. If anything, the United States had stood on the sidelines of the Armenian issue and had been engaged only with matters related to humanitarian assistance in response to earlier crises," writes Rouben Paul Adalian, "American Diplomatic Correspondence in the Age of Mass Murder: The Armenian Genocide in the U.S. Archives," in *America and the Armenian Genocide of 1915*, ed. Jay M. Winter (Cambridge: Cambridge University Press, 2003), 146.
5. Paul Gordon Lauren, *The Evolution of International Human Rights: Visions Seen* (Philadelphia: University of Pennsylvania Press, 2003), 65.
6. Ibid., 66.
7. "The War in Turkey: Execution of Bulgarians in the Streets of Philippopolis," *Illustrated London Times*, August 12, 1876.
8. Lauren, *The Evolution of International Human Rights*, 67.
9. Tessa Hofmann and Gerayer Koutcharian, "'Images That Horrify and Indict': Pictorial Documents on the Persecution and Extermination of Armenians from 1877–1922," *Armenian Review* 45, nos. 1–2/177–178 (Spring–Summer 1992): 53–184.
10. "Another Armenian Holocaust: Five Villages Burned, Five Thousand Made Homeless, and Anti-Christians Organized," *New York Times*, September 10, 1895, 1.
11. Cited in Thomas G. Leonard, "When News Is Not Enough: American Media and Armenian Deaths," in *America and the Armenian Genocide of 1915*, ed. Jay M. Winter (Cambridge: Cambridge University Press, 2003), 294n.
12. Hofmann and Koutcharian, "'Images That Horrify and Indict,'" 66.
13. Ibid., 67.
14. Roland Barthes, "Rhetoric of the Image," in *Image, Music, Text*, ed. and trans. Stephen Heath (New York: Hill and Wang, 1977), 32–51.
15. See images in "The Crisis in Constantinople," *The Graphic* (London), October 26, 1895, 514–15. Also available in Hofmann and Koutcharian, "'Images That Horrify and Indict,'" 68–71.
16. "The Crisis in Constantinople," 514–15.

17. Balakian, *The Burning Tigris*, facing page 236.

18. "Foreign Affairs in the Senate," *Harper's Weekly*, February 22, 1896, 170.

19. Balakian, *The Burning Tigris*, 71.

20. Balakian avers that these discussions were "the first time in American history that Congress made a statement beyond advocating 'temporary relief,' urging 'political action' in order to ameliorate a human rights tragedy happening thousands of miles from home" (ibid., 73).

21. Ibid., 160–63.

22. Telegram to Department of State dated May 29, 1915, Record Group (henceforth RG) 59, 867.4016/67. This telegram is available for viewing at the Armenian National Institute website: http://www.armenian-genocide.org.

23. Letter to Secretary of State dated July 20, 1915, RG 59, 867.4016/103.

24. Telegram to Department of State dated April 30, 1915, RG 59, 867.4016/59.

25. Telegram to American Embassy–Constantinople dated July 16, 1915, RG 59, 867.4016/74.

26. Telegram to Department of State dated July 16, 1915, RG 59, 867.4016/76.

27. Cited in James L. Barton, *Story of Near East Relief (1915–1930): An Interpretation* (New York: Macmillan, 1930), 4.

28. Before NER was incorporated by Congress, it went by a number of names including Armenian Relief Committee, Armenians and Syrian Relief Committee, and American Committee for Relief in the Near East (ibid., 6). Not listed by Barton, but also used were American Committee for Armenian and Syrian Relief and the Armenian Atrocities Committee. Near East Relief operates today as the Near East Foundation, an NGO.

29. For example, Rabbi Stephen S. Wise sat on the board of the Ways and Means Committee of Near East Relief (ibid., 13n.).

30. Ibid., 8.

31. Ibid., 4.

32. Meg McLagan, "Spectacles of Difference: Cultural Activism and the Mass Mediation of Tibet," in *Media Worlds: Anthropology on New Terrain*, ed. Faye D. Ginsburg, Lila Abu-Lughod, and Brian Larkin (Berkeley: University of California Press, 2002), 90–111; Meg McLagan, "Human Rights, Testimony, and Transnational Publicity," *The Scholar and Feminist Online* 2, no. 1 "Public Sentiments" (Summer 2003), http://barnard.edu/sfonline/ps/mclagan.htm; Thomas Keenan, "Publicity and Indifference: Media, Surveillance, 'Humanitarian Intervention,'" http://roundtable.kein.org/files/roundtable/keenan.publicity.pdf.

33. Barton, *Story of Near East Relief*, 383.

34. Suzanne Elizabeth Moranian discusses the wealth of the missionary testimonies and their function as witness to genocide, in "Bearing Witness: The Missionary Archives as Evidence of the Armenian Genocide," in *The Armenian Genocide: History, Politics, Ethics*, ed. Richard G. Hovannisian (New York: St. Martin's Press, 1992), 103–28.

35. Barton, *Story of Near East Relief*, 9–10.

36. Ibid., 12.

37. Barton writes, "newspapers were of invaluable assistance" (ibid., 383), and "the press of the entire country has been sympathetic, helpful, and liberal to the last degree" (14).

38. Ibid., 14.

39. Merrill D. Peterson, *Starving Armenians: America and the Armenian Genocide, 1915–1930 and After* (Charlottesville: University of Virginia Press, 2004), 57.

40. Samantha Power, *A Problem From Hell: America and the Age of Genocide* (New York: Basic Books, 2002), 9.

41. Barton, *Story of Near East Relief*, 15. The Video News Release, or VNR, is addressed in chapter 4.

42. Barton, *Story of Near East Relief*, 384.

43. "Turks have Killed 500,000; Evidence, Taken from State Department, Shows Quarter of a Million Women Violated," *New York Times*, October 18, 1915.

44. Barton, *Story of Near East Relief*, 384.

45. "Women Seized for Harems" reads a subheading for the article "Bryce Asks US to Aid Armenia," *New York Times*, September 21, 1915. Another headline offers "Turks Have Killed 500,000; Evidence, Taken from State Department, Shows Quarter of a Million Women Violated," *New York Times*, October 18, 1915. An article reports "Armenian women and girls, in considerable numbers, have been carried off into captivity by the Kurds" ("500,000 Armenians Said to Have Perished," *New York Times*, September, 24 1915).

46. Barton, *Story of Near East Relief*, 390.

47. It is quite likely that such photographs appeared in the booklets and pamphlets prepared by the campaign, but my present sources disarticulate the images from the source of their original display, making statements about use tentative at best.

48. Henry Morgenthau, *Ambassador Morgenthau's Story* (London: Taderon Press, 2000 [1918]), 203.

49. Ibid., 210.

50. Ibid., fig. 50.

51. Ibid., fig. 53.

52. Ibid., fig. 46.

53. Ibid., fig. 51,

54. The detail of the serial found in "To Release Armenian Film," *Variety*, February 21, 1919, 70.

55. Anthony Slide, *Ravished Armenia* (Lanham, Md.: Scarecrow Press, 1997), 3.

56. As reprinted in ibid., 19.

57. Reprinted in ibid., 22.

58. Peterson, *Starving Armenians*, 59–60.

59. "Charity Has War Film Show with Admission $10 a Throw; Ravished Armenia Coast Made Eight Reels to Have Simultaneous Showing in Twenty-One Cities—Receipts to Go to Armenian Sufferers Fund—Admission by Invitation Only," *Variety*, January 24, 1919, 49. The average cost for admission to a film in the early 1900s ranged from five to ten cents. A later public release was anticipated, with admission at a dollar for a ticket.

60. "*Ravished Armenia* in Film; Mrs. Harriman Speaks at Showing of Turkish and German Devastation," *New York Times,* February 15, 1919, 4.

61. Slide, *Ravished Armenia,* 25.

62. Ibid., 29.

63. Ibid., 12–14.

64. Ibid., 16.

65. Felman and Laub, *Testimony;* Walker, "The Traumatic Paradox," 803–25.

66. Gaylyn Studlar, "Out-Salomeing Salome," in *Visions of the East: Orientalism in Film,* ed. Matthew Bernstein and Gaylyn Studlar (New Brunswick, N.J.: Rutgers University Press, 1997), 99–100.

67. Edward Said, "Orientalism Reconsidered," *Cultural Critique* (Fall 1985): 103.

68. These are but a few of the types Ella Shohat discusses in "Gender and Culture of Empire," in *Visions of the East: Orientalism in Film,* ed. Matthew Bernstein and Gaylyn Studlar (New Brunswick, N.J.: Rutgers University Press, 1997), 19–66.

69. "Foreign Affairs in the Senate," *Harper's Weekly,* February 22, 1896, 170.

70. Rape has long been a tool of war, but it has only recently come to be recognized as such in the Rome Statute of the International Criminal Court.

71. Gregory Topalian, "Anthony Slide, ed. *Ravished Armenia and the Story of Aurora Mardiganian* (Review Essay)," *Armenian Forum: A Journal of Contemporary Affairs* 1 (1998): 76–78.

72. In *Scenes of Subjection: Terror, Slavery, and Self-Making in Nineteenth-Century America* (New York: Oxford University Press, 1997), Sadiya Hartman discusses this problem with the performance of the slave body in the testimony of suffering. For her the troubling economy of slavery was reenacted as yet again, as a slave body was put to use for a project even as the violence intended to upset was also intended to arouse in order to garner the greatest number of spectators.

73. Those mobilizing on behalf of the Armenians describe the religious dimension of the persecution as minimal. James L. Barton, the director of Near East Relief cites Arnold Toynbee, writing, "There was no Moslem passion against the Armenian Christians. All was done by the will of the Government, and done not from any religious fanaticism but simply because they wished, for reasons purely political, to get rid of a non-Moslem element which impaired the homogeneity of the Empire" (*Story of Near East Relief,* 20).

74. Cited in Slide, *Ravished Armenia,* 6.

75. Cited in ibid., 30.

76. One might consider the appeal of persecution as related to the scapegoat and the work of violence as a central act of community formation, concepts addressed in René Girard *Violence and the Sacred* (Baltimore: Johns Hopkins University Press, 1977).

77. Elizabeth A. Castelli, *Martyrdom and Memory: Early Christian Culture Making* (New York: Columbia University Press, 2004). In her article "Shockwave! New Media Prayer Warriors to Shake the World" (*The Revealer: A Daily Review of Religion and the Press,* March 4, 2004, http://www.therevealer.org/archives/feature_000224.php [last accessed March 8, 2006]), Castelli describes the recent phenomenon of

Shockwave, which encouraged "privileged Christian youth to enact situations of persecution as part of a purportedly prayerful solidarity with their benighted core-ligionists."

78. Advertisement posted by First National Exhibitors Circuit in *Moving Picture World*, May 3, 1919, 1296–97.

79. Ironically, these aspects also bore a detrimental effect on the film's circulation. In London, in January 1920, Scotland Yard threatened to prosecute the League of National Unions should *Auction of Souls* be screened at Albert Hall. According to "Against Auction of Souls" (*Variety*, January 24, 1920), "Exception is taken to certain scenes dealing with women," and refers to the film as having been banned "on account of political and religious reasons" (66).

80. Balakian, *The Burning Tigris*, 29.

81. Barton, *Story of Near East Relief*, 386.

82. Hanford C. Judson, "Auction of Souls: Tremendous Historical Picture of Armenia's Heartbreak Released by First National," *Moving Picture World*, May 31, 1919, 1379.

83. Cited in Slide, *Ravished Armenia*, 12–13.

84. National Board of Motion Pictures, cited in Slide, *Ravished Armenia*, 11.

85. "Ravished Armenia Opens Campaign for the Helpless," *The Moving Picture World*, February 15, 1919, 884.

86. For example, in recent years, editorial cartoons challenging Israeli policy have deployed images of Christian martyrdom to express the condition of Palestinians. The artist Boukhari presents the image of a pietà, with the fallen Christ wearing the scarf of the Fatah party; an Israeli solider is poised with a bloody bayonet, and the legend reads, "Do not Kill Him Twice" (see *Arabia.com* April 7, 2002). The legend anchors the intended reading of this already clear pietà frame and produces the Palestinian people, or cause, as martyrs like the Christ. Palestinians need not be Christians in order to activate the visual tradition of morally outrageous suffering. Indeed, this cartoon relies more on the problematic charges of deicide that translate the Passion play into a present-day scenario of unjust suffering at the hands of a God-killing people. Much as in the case of the "Unspeakable Turk," a visual campaign need not rely on a specifically Christian victim group if an effective villain, suitably contrary to the values of a Christian (cum secular) humanity, can be summoned.

87. Morgenthau, *Ambassador Morgenthau's Story*, 334.

88. Ibid., 335.

89. The script and stage directions are printed in full in Slide, *Ravished Armenia*, 203–6.

90. Ibid., 203.

91. Ibid.

92. Ibid., 204.

93. Ibid., 205.

94. "At New York's Plaza Hotel on Sunday," *New York Times*, February 16, 1919; Slide, *Ravished Armenia*, 12.

95. Such poems seem to have saturated the landscape. Katherine Lee Bates, author of "America the Beautiful," penned one such poem that refers to Armenia as "martyr

nation" and as a "figure on a cross / Pale, wasted, bleeding with imploring eyes." The obligation is conveyed in the final phrase, "All Christendom, shamed in her sacrifice." The poem is cited in Peterson, *Starving Armenians*, 58–59.

96. "Voluntary Advertising Is Given First National Feature Picture; *Auction of Souls* Has Active Support of Committee for Relief of Near East (Armenian Branch) throughout Country," *Exhibitors Herald and Motography / Motion Picture Herald*, May 31, 1919, 35.

97. The letter is printed in its entirety in the article.

98. Barton, *Story of Near East Relief*, 390.

99. Ibid., 391.

100. Barton lists a number of titles, but gives no dates. Sadly, many of these films are no longer available.

101. Barton, *Story of Near East Relief*, 391.

102. This use of "Golden Rule" suggests the ongoing strength of Christian allegories of charity, such as the Good Samaritan, in encouraging publics to take on the burden of others. The term also appeared in such NER titles as *A Great Achievement or Uncle America's Golden Rule*.

103. Barton, *Story of Near East Relief*, 392.

104. The League of Nations Preliminary Peace Conference also explored prosecution of Kaiser Wilhelm II for the Rape of Belgium.

105. For a more involved history of what is often called "The Great Betrayal," please see Vakhan Dadrian, *The History of the Armenian Genocide: Ethnic Conflict from the Balkans to Anatolia to the Caucasus*, 6th ed. (Oxford: Berghahn Books, 2003).

2. Witness for the Prosecution

1. A few months after the first IMT was launched, the International Military Tribunal for the Far East (IMTFE), also known as the Tokyo Trials, took place. Although significant, these met with less support than the IMT and ensuing Nuremberg Trials for a range of possible reasons, including the sense of an American bias (a single prosecutorial team led by an American, United States funding) and discomfort in light of the U.S. attack on civilian populations through the atomic bombings of Hiroshima and Nagasaki. Charges of "crimes against humanity" were brought against some of the defendants, but the primary focus was that of crimes against peace and Japan's waging aggressive war against China, France (Indochina), the United States, the USSR, the British Commonwealth, and the Netherlands, as well as the treatment of POWs.

2. Lawrence Douglas, *The Memory of Judgment: Making Law and History in the Trials of the Holocaust* (New Haven: Yale University Press, 2001).

3. Paula Rabinowitz, "Wreckage upon Wreckage: History, Documentary, and the Ruins of Memory," *History and Theory* 32 (1993): 121.

4. Dwight D. Eisenhower, *Crusade in Europe* (New York: Doubleday, 1977 [1948]), 408.

5. Zelizer, *Remembering to Forget*, 64.

6. Jeffrey Shandler, *While America Watches: Televising the Holocaust* (Oxford: Oxford University Press, 1999), 7.

7. "They Died 900 a Day in 'the Best' Nazi Death Camp," *PM,* April 16, 1945. http://www.jewishvirtuallibrary.org/jsource/Holocaust/murrow.html (accessed March 8, 2012).

8. The production of this iconography is the subject of Zelizer's *Remembering to Forget.*

9. Saul Friedlander, *Reflections of Nazism: Essays on Kitsch and Death,* trans. Thomas Weyr (Bloomington: Indiana University Press, 1993), 105.

10. From "Material Needed for Proposed Motion Picture on German Atrocities," cited in Elizabeth Sussex, "The Fate of F3080," *Sight and Sound,* Spring 1984, 92.

11. Cited in ibid., 92.

12. Project F3080, sometimes known as *A Painful Reminder,* was eventually recovered and screened under the title *The Memory of the Camps,* on the PBS-TV series *Frontline* in May 1985. Information on the recovery and screening available on the *Frontline* website. http://www.pbs.org/wgbh/pages/frontline/camp (accessed March 8, 2012).

13. The Russian footage has since been edited and released as *Holocaust: The Liberation of Auschwitz,* accompanied by interviews with a surviving Soviet camera operator, Captain Alexander Vorontsov (ArtsMagic DVD, 2005).

14. Other Hollywood notables contributing to the collection of footage and the production of military documentaries included Frank Capra, Samuel Fuller, and John Huston. Samuel Fuller, known for *The Big Red One* (1980), shot and narrated footage at the liberation of Faulkenau, a concentration camp in the former Czechoslovakia; this footage appears in a documentary of the same name.

15. Hannah Arendt, cited in Douglas, *The Memory of Judgment,* 39.

16. Ibid., 3.

17. Cited in Timothy L. H. McCormack, "Conceptualizing Violence: Present and Future Developments in International Law: Panel I: Adjudication Violence: Problems Confronting International Law and Policy on War Crimes and Crimes against Humanity: Selective Reaction to Atrocity: War Crimes and the Development of International Criminal Law," *Albany Law Review* 60 (1997): 702.

18. McCormack, "Conceptualizing Violence," 704.

19. *Nuremberg Trial Proceedings,* vol. 1, *Charter of the International Military Tribunal,* section II, article 6c.

20. David Luban, "A Theory of Crimes against Humanity," *Yale Journal of International Law* 29 (Winter 2004): 86.

21. Luban also observes this oscillation of meaning (ibid., 87).

22. *Trials of War Criminals before the Nuremberg Military Tribunals under Control Council Law No. 10,* vol. 4 (October 1946–49): 497.

23. This act of introducing and yet not fully defining a term is widespread in such bureaucratic affairs. Frequently, UN committees introduce a term with the understanding that its meaning will be determined in practical deliberations and future uses. I am grateful to Valdimar Hafstein for this information.

24. Shoshana Felman, "Theaters of Justice: Arendt in Jerusalem, the Eichmann Trial, and the Redefinition of Legal Meaning in the Wake of the Holocaust," *Theoretical Inquiries in Law* 1 (July 2000): 3.

25. *Trial of the Major War Criminals before the International Military Tribunal, Blue Series,* vol. 7, 576.

26. Zelizer, *Remembering to Forget,* 5.

27. *Trial of the Major War Criminals before the International Military Tribunal, Blue Series,* vol. 3, 400.

28. Joel Sayre, "Letter From Nuremberg," *New Yorker,* December 1, 1945, 106.

29. *Trial of the Major War Criminals before the International Military Tribunal, Blue Series,* vol. 3, 400.

30. Bill Nichols, *Representing Reality* (Bloomington: Indiana University Press, 1991).

31. Elizabeth Cowie, "The Spectacle of Actuality," in *Collecting Visible Evidence,* ed. Jane M. Gaines and Michael Renov (Minneapolis: University of Minnesota Press, 1999), 19.

32. This argument, as well as examples of how to read these strategies, is the subject of Nichols's *Representing Reality.*

33. Anne Cubilié and Carl Good, "The Future of Testimony," *Discourse* 25 (Winter/Spring, 2003): 8

34. Felman and Laub, *Testimony;* Walker, "The Traumatic Paradox," 803–25.

35. Jennifer R. Ballangee, "Witnessing Video Testimony: An Interview with Geoffrey Hartman," *Yale Journal of Criticism* 14 (2001): 224–25.

36. Jessica M. Silbey, "Judges as Film Critics: New Approaches to Filmic Evidence," *University of Michigan Journal of Law Reform* 37 (Winter 2004): 493–575.

37. Jennifer L. Mnookin, "The Image of Truth: Photographic Evidence and the Power of Analogy," *Yale Journal of Law and the Humanities* 10 (Winter 1998): 69–70.

38. *Trial of the Major War Criminals before the International Military Tribunal, Blue Series,* vol. 2, 431.

39. Curt Schleier, "Steven Spielberg's New Direction," *Jewish Monthly* 108 (January/February 1994): 12.

40. The other two affidavits were from Commander Donovan and Colonel Erik Tiebold.

41. Douglas, *The Memory of Judgment,* 29.

42. Bill Nichols, "'Getting to Know You . . .': Knowledge, Power and the Body," in *Theorizing the Documentary,* ed. Michael Renov (New York: Routledge), 190.

43. Rabinowitz, "Wreckage upon Wreckage," 119–37.

44. Douglas, *The Memory of Judgment,* 38.

45. Ironically, IBM was also responsible for facilitating the systematization of the Nazi genocide with its punch-card technology. This contribution is chronicled in Edwin Black, *IBM and the Holocaust* (Boston: Little, Brown, 2001).

46. All words and phrases in quotes taken from the English titles made available in *The Nazi Plan,* which otherwise appears in the original German.

47. "Nazi Days of Pomp; Films Show at Nuremberg; Incriminating Scenes," *The Times* (London), December 12, 1945, 4.

48. "Extermination by Work Laid at Nazis' Door," *Washington Post,* December 12, 1945, 13.

49. Tania Long, "Nazis Glory in Film of 'Good Old Days,'" *New York Times,* December 12, 1945, 4.

50. *Trial of the Major War Criminals before the International Military Tribunal, Blue Series*, vol. 3, 401.

51. Joel Sayre, "Letter from Nuremberg," *New Yorker,* December 1, 1945, 110. The dates indicate he was granted a preview show.

52. Including, according to other reports, "filthy rascal" and "pile of filth."

53. Long, "Nazis Glory in Film," 4.

54. "Nazi Days of Pomp," 4.

55. *Trial of the Major War Criminals before the International Military Tribunal, Blue Series*, Vol. 3, 536.

56. *Trial of the Major War Criminals before the International Military Tribunal, Blue Series*, Vol. 3, 537.

57. Donovan, according to the transcript, reads the following scenes: 2, 3, 5, 14, 16, 18, 24, 32, 37, 39, 44, 45.

58. Douglas suggests that the evidentiary value of such witnessing scenarios lies in the presentation of additional eyewitnesses.

59. Douglas, *The Memory of Judgment*, 80–89.

60. "Nazis on Trial See Horror Camp Film," *Washington Post*, November 30, 1945, 2.

61. "Atrocity Films in Court Upset Nazis' Aplomb," *New York Herald Tribune*, November 30, 1945, 11.

62. "Nazis on Trial see Horror Camp Film," 2.

63. G. M. Gilbert, *Nuremberg Diary* (New York: Da Capo Press, 1995 [1947]), 49.

64. "The Nuremberg Show," *Newsweek*, December 10, 1945, 50–51.

65. "Atrocity Films in Court Upset Nazis' Aplomb," 11.

66. Gilbert, *Nuremberg Diary*, 49.

67. Raymond Daniell, "War-Crimes Court Sees Horror Films: Motion Pictures of German Concentration Camps Are Displayed as Evidence," *New York Times*, November 30, 1945, 6.

68. Long, "Nazis Glory in Film,"4.

69. Reported in Long, "Nazis Glory in Film," 4; Gilbert, *Nuremberg Diary*, 68.

70. Gilbert, *Nuremberg Diary*, 67.

71. Douglas, *The Memory of Judgment*, 99.

72. As noted above, appetite played a role in the remarks on Nazi response at the 1945 trial. Their capacity to eat, or not, seems fixed to their response. Gilbert, who followed the prisoners to the cafeteria, noted, "Keitel was eating, having just returned from a conference with his defense attorney. He appeared to have forgotten the film until we mentioned it" (*Nuremberg Diary*, 47).

73. Zelizer, *Remembering to Forget*, 1.

74. Torchin, "Since We Forgot," 82–97.

3. Reflections on the World Stage

1. Marija Gakicki, "New Experience in the Process of Facing the Past," *VIVESECT.* The cooperation of Novi Sad's provincial and city authorities, the Ministry of the Interior, and the support of the president of the Assembly of AP Vojvodina, Nenad Čanak were also key in the organization of this event.

2. Stanley Cohen, *States of Denial: Knowing about Atrocities and Suffering* (Cambridge: Polity Press, 2001), 162.
3. Bourdieu, *Outline of a Theory of Practice*.
4. Susan Sontag, *On Photography* (New York: Farrar, Strauss and Giroux, 1997), 20.
5. Orentlicher, "Genocide," 153.
6. Power, "Bystanders to Genocide."
7. David Rieff, *Slaughterhouse Bosnia and the Failure of the West* (New York: Touchstone, 1996), 23.
8. Thomas Cushman and Stjepan G. Meštrović, introduction to Cushman and Meštrović, *This Time We Knew,* 3.
9. Keenan, "Publicity and Indifference."
10. Cited in Philip Gourevitch, *We Wish to Inform You That Tomorrow We Will Be Killed with Our Families: Stories from Rwanda* (New York: Farrar, Straus and Giroux, 1998), 163.
11. Cited in Samantha Power, "Inhabiting the Horror: Foreword," in Lieutenant General (Ret.) Roméo Dallaire, *Shake Hands with the Devil: The Failure of Humanity in Rwanda* (New York: Caroll and Graf, 2003), ix.
12. Power, "Inhabiting the Horror," x.
13. Susan Moeller, *Compassion Fatigue: How the Media Sell Disease, Famine, War, and Death* (New York: Routledge, 1999).
14. Allen Feldman, "On Cultural Anesthesia: From Desert Storm to Rodney King," *American Ethnologist* 21, no. 2 (1994): 404–18.
15. Cohen, *States of Denial*, 88–90; Kleinman and Kleinman, "The Appeal of Experience," 19. See introduction n.47 for other references to various forms of emotional fatigue.
16. Horkheimer and Adorno, "The Culture Industry," 94–136; Boorstin, *The Image*.
17. Cited in Ella Shohat and Robert Stam, *Unthinking Eurocentrism: Multiculturalism in the Media* (New York: Routledge, 1994), 130.
18. Jean Baudrillard, "La Guerre du Golfe n'a pas eu lieu," *Liberation*, March 29, 1991.
19. Scott MacKenzie, "Lists and Chain Letters: Ethnic Cleansing, Holocaust Allegories and the Limits of Representation," *Canadian Journal of Film Studies / Revue Canadienne d'Études Cinématographes* 9, no. 2 (2000): 28.
20. See Paul Virilio, *War and Cinema: The Logistics of Perception* (London: Verso, 1989).
21. Sturken, *Tangled Memories,* 132.
22. Ibid., 134.
23. Pierre Bourdieu, "The Field of Cultural Production; Or: The Economic World Reversed," *Poetics* 12 (1983): 311–56.
24. Thanks to Mick Broderick for this observation.
25. Keenan, "Mobilizing Shame," 438.
26. Paul Fischer, "A Serious Film with a Sense of Humor; Interview with Danis Tanovic," *iofilm,* February 14, 2002, http://www.iofilm.co.uk/feats/interviews/d/danis_tanovic.shtml (accessed March 17, 2012).
27. Their nudity also suggests that identity itself is imbricated in logics of perception. They no longer look "Serbian" or "Bosnian" when they are two men stripped down to their underpants.

28. See Martha Nussbaum, *Hiding from Humanity: Disgust, Shame, and the Law* (Princeton, N.J.: Princeton University Press, 2004). Roger Kimball responds in "Does Shame Have a Future?" *New Criterion* 23, no. 1 (2004): 4–9.

29. Pam Grady, "Between the Lines: Bosnian Filmmaker Exposes the Minefield That Is No Man's Land," *Reel.com*, ca. 2001, http://www.reel.com/reel.asp?node=features/interviews/tanovic (accessed August 6, 2009).

30. The report extends its condemnation of UN edicts to the weapons embargo. The narrator intones that "today, Bosnians are still denied the right to defend themselves by an imposed UN weapons embargo," as more images of corpses and human remains take the screen.

31. The French film *Un Dimanche* à *Kigali* (Robert Favreau, 2006), based on the novel *Sunday at the Pool in Kigali* by Gil Courtemanche, and the Canadian film *Shake Hands with the Devil* (Roger Spottiswoode, 2007) had not been released at the original time of writing.

32. Survivors of the Hotel Mille Collines have thrown this heroic depiction into question. These issues are outlined in François-Xavier Destors, *Images d'après: Cinéma et Génocide au Rwanda* (Lormont: Le Bord de l'Eau, 2010), 58–59. Additional questions regarding Rusesabagina's self-presentation are mentioned in chapter 4, n.66.

33. This footage, too, suggests that this character is based on Nick Hughes, who according to Michael Dorland may have been the only photojournalist to film such a massacre ("PG—Parental Guidance or Portrayal of Genocide: The Comparative Depiction of Mass Murder in Contemporary Cinema," in *The Media and the Rwanda Genocide*, ed. Allan Thompson, [London: Pluto Press, 2007], 417–32, available at International Development Research Centre website, http://idl-bnc.idrc.ca/dspace/bitstream/10625/30283/9/123840.pdf [accessed March 17, 2012]).

34. See Sven Lindqvist, *Exterminate All the Brutes*, trans. Joan Tate (New York: New Press, 1997).

35. The projects conducted under the heading of Rwandan cinema deserve attention. Eric Kabera, the producer of *100 Days*, founded the Rwanda Cinema Center as a means of fostering a local film culture by training local filmmakers and establishing a traveling film festival (called "Hillywood" as a reference to the "Mille Collines," for which Rwanda is known). One of the missions is to present a Rwanda beyond the genocide. More information on the RCC can be found at their website, http://rwandacinemacenter.wordpress.com.

36. Nick Hughes, interview with Brooke Gladstone, *On the Media*, National Public Radio, WNYC, New York, November 22, 2002.

37. Zelizer, *Remembering to Forget*, 206.

38. Keenan, "Mobilizing Shame," 2004; Robert F. Drinan, *The Mobilization of Shame: A World View of Human Rights* (New Haven: Yale University Press, 2001).

39. The documentaries of Anne Aghion explore this project of citizen-based justice. These include *Gacaca: Living Together again in Rwanda* (2002), *In Rwanda We Say . . . The Family That Does Not Speak Dies* (2004), and *My Neighbor My Killer* (2009).

40. Nick Hughes, "Director's Statement," *100 Days Press Kit*.

41. Quoted in Arthur Asiimwe, "Rwanda's Kagame Downplays Criticism of Genocide

Film," *Reuters Report,* March 29, 2006, http://www.daikynguyen.com/eet/print_archive/united_states/new_york/2006/04-Apr/06/B4.pdf (accessed March 18, 2012).

42. Janet Walker, "The Traumatic Paradox: Documentary Films, Historical Fictions, and Cataclysmic Past Events," *Signs* 22, no. 4 (1997): 803–25.

43. Hughes, "Director's Statement."

44. Arthur Asiimwe, "*Shooting Dogs* Kigali Premiere," *Shooting Dogs Blog,* March 30, 2006, http://shootingdogsfilm.blogspot.com/2006/03/shooting-dogs-kigali-premiere-rwandas.html (accessed March 18, 2012).

45. It is worth noting that the collection of skulls as an icon of atrocity and genocide was an image also made familiar through reportage of the Cambodian genocide, or more likely, the reportage associated with the memorials of the Cambodian genocide.

4. The Work of WITNESS

1. Barnouw, *Documentary;* Brian Winston, *Claiming the Real: The Documentary Film Revisited* (London: BFI Publishing, 1995); Gaines, "Political Mimesis."

2. The information this chapter provides on WITNESS is drawn from WITNESS reports and case studies made available through the group's website, http://www.witness.org, although older case studies, such as those addressed in this chapter, are no longer available for viewing. Other information has been provided by program manager Sam Gregory, who has been exceedingly patient and generous with his time.

3. Moeller, *Compassion Fatigue;* Feldman, "Violence and Vision," 46–78; Keenan, "Mobilizing Shame," 438; Carolyn Dean, *The Fragility of Empathy after the Holocaust* (Ithaca, N.Y.: Cornell University Press, 2004).

4. Dean, *The Fragility of Empathy after the Holocaust,* 16.

5. E. Ann Kaplan, *Trauma Culture: The Politics of Terror and Loss in the Media and Literature* (New Brunswick, N.J.: Rutgers University Press, 2005).

6. Karen Halttunen, "Humanitarianism and the Pornography of Pain in Anglo-American Culture," *American Historical Review* 100, no. 2 (1995): 303–34. In the introduction to her collection *Compassion: The Culture and Politics of an Emotion,* ed. Lauren Berlant (New York: Routledge Press, 2004), Lauren Berlant declares that "the relation of compassion to sadism cannot be overlooked" (10).

7. John Berger, *Ways of Seeing* (London: Penguin Books, 1972), 149. Levi-Strauss, *Between the Eyes.*

8. Robert McChesney, *The Political Economy of Media: Enduring Issues, Emerging Dilemmas* (New York: Monthly Review Press, 2008). Filmmaker and activist Robert Greenwald outlines the relationship between corporate practice and the nature of journalistic coverage in documentaries such as *Outfoxed: Rupert Murdoch's War on Journalism* (2004).

9. Daya Thussu, *News as Entertainment: The Rise of Global Infotainment* (London: Sage, 2007), 20.

10. The bloodless landscape, which persists today, seems to have been brought about in the first Gulf War, where, having learned from the uncontrolled images of Vietnam ("the living room war") the Pentagon actively controlled the broadcast of the

war so as to promote identification with and support of the goals. See chapter 3, as well as Sturken, *Tangled Memories,* and Shohat and Stam, *Unthinking Eurocentrism.* Barbie Zelizer recently commented on this phenomenon, noting its conflict with the journalistic mandate to cover events, in her contribution to the panel "Response and Responsibility" at *Picturing Atrocity: Photography in Crisis,* a colloquium in memory of Susan Sontag, December 9, 2005.

11. Simons, "Popular Culture and Mediated Politics," 173.

12. Keenan, "Publicity and Indifference"; McLagan, "Spectacles of Difference," 90–111; McLagan, "Human Rights, Testimony, and Transnational Publicity."

13. Theodore Levitt, *The Third Sector: New Tactics for a Responsive Society* (New York: AMACOM, 1973). According to Levitt, the New Third Sector's public tactics distinguish it from the Old Third Sector: "But the tactic that distinguishes it most from other groups is the calculated reliance on staged, attention-getting publicity. The New Third Sector leans for its effectiveness on the creation of instant TV visibility for itself and at the expense of its adversaries" (77–78). He continues: "The youthful members of the New Third Sector have been well trained by the advertisers whose commercials they have watched on television since childhood" (78).

14. McLagan, " Spectacles of Difference," 91.

15. Faye D. Ginsburg, Lila Abu-Lughod, and Brian Larkin, introduction to *Media Worlds: Anthropology on New Terrain,* ed. Ginsburg, Abu-Lughod, and Larkin (Berkeley: University of California Press, 2002), 7.

16. Terence Turner, "Representation, Politics, and Cultural Imagination in Indigenous Video: General Points and Kayapo Examples," in *Media Worlds: Anthropology on New Terrain,* ed. Faye D. Ginsburg, Lila Abu-Lughod, and Brian Larkin (Berkeley: University of California Press, 2002), 75–89. Although unsuccessful in the campaign, the use of video was strategic and effective in navigating media worlds and receiving attention enough to build capacity for opposition.

17. This is the subject of Bob's *The Marketing of Rebellion.*

18. Margaret Scammell, "Citizen Consumers: Towards a New Marketing of Politics?," in *Media and the Restyling of Politics,* ed. John Corner and Dick Pels (London: Sage Publications, 2003), 118.

19. Jo Littler, *Radical Consumption: Shopping for Chance in Contemporary Culture* (London: Open University Press, 2009).

20. Simons, "Popular Culture and Mediated Politics," 172–73.

21. I write about the Live 8 and the Make Poverty History Campaign in "White Band's Burden: Humanitarian Synergy and the Make Poverty History Campaign" in *Sensible Politics: The Visual Culture of Nongovernmental Activism,* ed. Meg McLagan and Yates McKee (Brooklyn, N.Y.: Zone Press, 2012).

22. Sam Gregory, Gillian Caldwell, Ronit Avni, and Thomas Harding, ed., *Video for Change: A Guide for Advocacy and Activism,* foreword by Peter Gabriel (London: Pluto Press, 2005), x.

23. Cheryl Dahle, "Social Capitalists: The Top 20 Groups That Are Changing the World," *Fast Company,* January 2004, 51.

24. WITNESS, "Peter Gabriel, WITNESS launch at Reebok Human Rights Ceremony," press release, December 10, 1992.

25. Cohen, *States of Denial*, 186.

26. This pervasive oscillation between conviction in video as visible evidence and the recognition of polysemy occasioned numerous projects in the study of documentary. For instance: Paula Rabinowitz, *They Must Be Represented: The Politics of Documentary* (London: Verso, 1994); Jane Gaines and Michael Renov, eds., *Collecting Visible Evidence* (Minneapolis: University of Minnesota Press, 2000).

27. Nancy Fraser outlines these issues usefully in "Transnationalizing the Public Sphere: On the Legitimacy and Efficacy of Public Opinion in a Postwestphalian World," in her book *Scales of Justice: Reimagining Public Space in a Globalizing World* (Cambridge: Polity Press, 2008), 76–99.

28. Stanley Cohen and Bruna Seu, "Knowing Enough Not to Feel Too Much: Emotional Thinking about Human Rights Appeals," in *Truth Claims: Representation and Human Rights*, ed. Mark Philip Bradley and Patrice Petro (New Brunswick, N.J.: Rutgers University Press, 2002), 188.

29. See Richard Wilson, ed., *Human Rights, Culture, and Context: Anthropological Approaches* (London: Pluto Press, 1997); Mark Philip Bradley and Patrice Petro, eds. *Truth Claims: Representation and Human Rights* (New Brunswick, N.J.: Rutgers University Press, 2002). McLagan, "Human Rights, Testimony, and Transnational Publicity."

30. This language recalls that of Human Rights Watch, as noted in the introduction.

31. Halttunen, "Humanitarianism and the Pornography of Pain in Anglo-American Culture," 305.

32. This question has been raised by both Patricia R. Zimmermann and Sam Gregory and is, to some extent, addressed in the following chapter. Recent issues too big to fully address within a note, but which arose after the writing of the book, include the Arab Spring and Occupy Everywhere movement worldwide—populist movements that relied heavily on social media (Facebook and Twitter) and mobile technology. These technologies also enabled the formation of the Iranian Green Movement during the protests following the election of 2009. They served as powerful mechanisms for communication in light of a media blackout, but at the same time could contribute to putting lives at risk. While footage of the death of Nedā Āghā-Soltān circulated on YouTube and became a powerful image for galvanizing support, the image of Neda Soltani was circulated in error—an action that placed this Neda's life in danger, and prompted her to seek political refuge in Germany (Cameron Abadi, "Neda Lives: The Little-Known Story of Iran's Other Neda Soltani and How a Picture Changed Her Life Forever," *Foreign Policy*, June 14, 2010, http://www.foreign policy.com/articles/2010/06/14/neda_lives? (accessed March 30 2012). However, at the time of writing this is a newer question and one that demands attention.

33. In 2005 The Ella Baker Center for Human Rights launched a flash animation online entitled "Action Heroes in Office: A Parody in One Act," featuring then California governor Arnold Schwarzenegger as himself and as a number of characters he has played in film; an "advocacy soap opera," *Sexto Sentido* (prod. Amy Bank), plays on

Nicaraguan television; and Breakthrough TV conducts its outreach projects through music videos designed to emulate Hindi musicals, the online component allowing for outreach to an Indian diaspora.

34. Nichols, *Representing Reality*, 4–5.

35. Ibid., 107.

36. See WITNESS Partnership Application Evaluation Criteria, a section of the Partnership Application Process, http://www.witness.org/training/resources.

37. WITNESS launched a "Seeding Video Advocacy" initiative, which mitigates the seeming stringency of the selection process. Through this program WITNESS provides short-term training to multiple organizations and individuals (approximately two hundred each year), including those who did not initially meet the criteria for being a Core Partner. According to WITNESS, this new program "acts as a catalyst to stimulate wider and more effective use of video in advocacy efforts worldwide" and "enables us to share lessons learned from our Core Partners' experiences with the broader social justice community" (http://www.witness.org).

38. Gregory et al., *Video for Change*, 2.

39. Ibid.

40. Walker, "The Traumatic Paradox," 803–25.

41. Quite literally, in fact, as the first part of the WITNESS Video Action Plan requires outlining objectives and audience, what they note "duplicates the last segment of your application" (*WITNESS Video Action Plan—Core Partners*, March 2005, 2).

42. Ibid., 1.

43. Sam Gregory, "Transnational Storytelling: Human Rights, WITNESS, and Video Advocacy," *American Anthropologist* 108, no. 1 (2006): 195–204. Gregory offers a case study of this organization within his essay, which expands on the topics introduced here (and made possible through my interactions with Gregory). His essay also reflects many of the concerns of WITNESS and the challenges that are negotiated in the project of video advocacy.

44. Gregory, "Transnational Storytelling." Part of this success is attributable to the mobilization of shame, and the fact that the authorities were subject to this form of pressure, which is not universally applicable. In "Mobilizing Shame," Keenan notes its limitations in a case where Serbian militia waved at the cameras in the midst of looting the town of Mijalic (445). Ronit Avni discusses the inefficacy in "Mobilizing Hope: Beyond the Shame-Based Model in the Israeli-Palestinian Conflict," *American Anthropologist* 108, no. 1 (2006): 205–14.

45. The film *Seeing Is Believing: Handicams, Human Rights and the News* (Katerina Cizek and Peter Wintonick, 2002) chronicles many of the occasions where electronic information technologies enabled activism. The revolutionary capacity of small, analog media is chronicled in Annabelle Sreberny-Mohammadi and Ali Mohammadi's *Small Media, Big Revolution: Communication, Culture, and the Iranian Revolution* (Minneapolis: University of Minnesota Press, 1994), which explores such small media as leaflets and audiocassettes as a public sphere for political engagement and articulation.

46. Barry Dornfeld's formulation of producers as audiences proves useful here, as

indeed, these editorial decisions are made with an imagined audience in mind, and frequently, such imaginaries are informed by the producer's or editorial board's own tastes and expectations. See Dornfeld, *Producing Public TV.*

47. Greg Hazley, "Ethics Questioned, VNR Pros Sound Off," *O'Dwyer's PR Services Report* 18, no. 4 (2004): 1.

48. Gregory et al., *Video for Change,* 103.

49. Ibid., 104.

50. I have conducted another case study regarding Roma activism for education integration in "Influencing Representation: Equal Access and Roma Social Inclusion," *Third Text* 22 (March 2008): 387–96.

51. Gregory, "Transnational Storytelling," 197. This is hardly surprising within the U.S. context, given the refusal to ratify the International Covenant on Economic, Social, and Cultural Rights, although President Carter did sign the covenant in 1978. See Drinan, *The Mobilization of Shame,* 7. Drinan also writes, "If the U.S. had not distinguished between political and economic rights, the principal areas of contention in the world today might have been the rights of poor people to food, shelter, and medical care" (11).

52. Gregory, "Transnational Storytelling," 197.

53. "It places these issues within the framework of human rights education and encourages [viewers] to think critically about those civil and human rights implicated by the incarceration of youth in America" (WITNESS Case Study, http://www.witness.org [accessed September 30, 2006]).

54. Gaines, "Political Mimesis," 90.

55. Gregory et al., *Video for Change,* 75.

56. Ibid., 76.

57. Rabinowitz, *They Must Be Represented,* 21.

58. See Raymond Williams, *Raymond Williams on Television: Selected Writings* (New York: Routledge, 1989).

59. Gregory et al., *Video for Change,* 5.

60. Avni, "Mobilizing Hope."

61. Poniewozik, "The Year of Charitainment," *Time,* December 19, 2005, http://www.time.com/time/magazine/article/0,9171,1142281,00.html (accessed March 30 2012).

62. See "Witness to Truth (Excerpts)," WITNESS, The Hub, http://hub.witness.org/en/WitnesstoTruthExcerpts (accessed April 2, 2012).

63. WITNESS, "Peter Gabriel, Tim Robbins and Gael Garcia Bernal Call for UN Action on Burma," press release, December 15, 2006.

64. "*Blood Diamond* Stars Speak Out against World Hunger," *Medical News Today,* January 27, 2007, http://www.medicalnewstoday.com/articles/61381.php (accessed March 19, 2012).

65. "Bushmen Appeal to Leonardo di Caprio," *Survival: The Movement for Tribal Peoples,* September 18, 2006, http://www.survival-international.org/news/1872 (accessed March 19, 2012).

66. Information about the organization can be found at http://hrrfoundation.org. Debates have emerged, however, regarding Rusesabagina's characterization as selfless

hero as well as champion of genocide memory. Holocaust scholar Deborah Lipstadt has interpreted his refusal of the word "genocide" in favor of "massacres" and his characterization of the violence as taking place amid ongoing Tutsi violence as a form of denial ("Rwanda: A New Form of Genocide Denial," November 19, 2007, http://lipstadt.blogspot.com/2007/11/rwanda-new-form-of-genocide-denial .html [accessed March 19, 2012]). Discussing these debates in *Images d'après*, François-Xavier Destors also notes that some survivors of the Hotel Mille Collines attest to his having charged them for entrance, and evicting those who could not pay (58–59). And accusations have surfaced regarding his affiliation with former genocidaires as well as with Rwanda opposition leader Victoire Ingabire, arrested on October 14, 2010, for terrorist activities and denial of the Rwandan genocide. The situation is decidedly fraught, particularly as criticisms surface in the context of Rusesabagina's vocal opposition to Rwanda president Paul Kagame, but Rusesabagina's benefit from *Hotel Rwanda* persists.

67. Bill Husted, "For Cheadle, Sudan Ranks above Oscar," *Denver Post*, January 30, 2005, F2.

68. The actor continues to advocate today for Sudan, and now more broadly, against genocide in general. *Businesswire.com* (October 19, 2005) reported on one of his efforts, in which he designed an African-themed boot bearing the slogan "Stomp out Genocide" to raise awareness of the suffering in Darfur. It is not for sale, but distributed among those who work for African charities. In this case, the celebrity and item are perhaps not effectively mobilized; certainly, the action generated from this promotion is unclear, as the proposed goal to "stomp out genocide" is facile at best. The boot seems more to supply publicity for Timberland boots and its act of corporate philanthropy. This may be one of the risks of publicizing humanitarian concerns through commercial products and broadcast media: the topic of suffering becomes a means of selling the product and producing consumer complacency rather than promoting humanitarian response.

5. iWitnesses and CitizenTube

1. YouTube, "Introducing Citizentube," press release, April 5, 2007, http://youtube-global .blogspot.com/2007/04/introducing-citizentube.html (accessed March 20, 2012).

2. Steven G. Jones, ed., *Cybersociety 2.0: Revisiting Computer Mediated Communications Community* (Thousand Oaks, Calif.: Sage Publications, 1998), 11–12.

3. Levy, *Collective Intelligence*, 213.

4. Henry Jenkins, "Interactive Audiences," in *The New Media Book*, ed. Dan Harries (London: BFI Publishing, 2002), 158.

5. Ibid., 159.

6. Ibid.

7. Martha McCaughey and Michael D. Ayers, ed., *Cyberactivism: Online Activism in Theory and Practice* (New York: Routledge, 2003).

8. Thomas Olesen, *International Zapatismo: The Construction of Solidarity in the Age of Globalization* (London: Zed Books, 2005); See also http://www.zapatista.org, a clearinghouse of information and links.

9. Anne Travers, *Writing the Public in Cyberspace: Redefining Inclusion on the Net* (New York: Garland Publications, 2000).

10. Klaus Marre, "Grassroots Growing Fast in Cyberspace; Web Adds Pressure on U.S. Lawmakers," *The Hill*, October 15, 2003, http://www.hillnews.com/news/101503/grassroots.aspx (accessed March 15, 2006).

11. Marre, "Grassroots Growing Fast in Cyberspace."

12. Ginsburg, Abu-Lughod, and Larkin, introduction to *Media Worlds*, 7.

13. The request for the delay was made public in an announcement posted at the end of a broadcast: "Two weeks ago, '60 Minutes II' received an appeal from the Defense Department, and eventually from the Chairman of the Joint Chiefs of Staff, Gen. Richard Myers, to delay this broadcast—given the danger and tension on the ground in Iraq. 60 Minutes II decided to honor that request, while pressing for the Defense Department to add its perspective to the incidents at Abu Ghraib prison. This week, with the photos beginning to circulate elsewhere, and with other journalists about to publish their versions of the story, the Defense Department agreed to cooperate in our report."

14. Wikileaks, a phenomenon that developed after the composition of this chapter, is a worthy addition to this discussion.

15. I have written about this in "Since We Forgot," 82–97.

16. Taner Akçam, "The Genocide of the Armenians and the Silence of the Turks," in *Studies in Comparative Genocide*, ed. Levon Chorbajian and George Shirinian (London: Macmillan, 1999), 125–46. Richard Hovannisian, "Eighty Years: Memory against Forgetting," in *Problems of Genocide*, Proceedings of the International Conference on "Problems of Genocide", April 21–23, 1995, National Academy of Sciences, Yerevan, Republic of Armenia (Cambridge Mass.: Zoryan Institute, 1997).

17. Hovannisian, "Eighty Years," 19. This trauma is also addressed in *A Crime of Silence: The Armenian Genocide*, by the Permanent People's Tribunal (London: Zed Books, 1984), which makes the case for the genocide while addressing the conditions of denial. Fatma Müge Göçek reconstructs the Turkish historiography of the massacres, recognizing extreme nationalism in addition to Western imperialism as motivators of this denial ("Reconstructing the Turkish Historiography on the Armenian Massacres and Deaths of 1915," in *Looking Backward, Moving Forward*, ed. Richard Hovannisian [New Brunswick: Transaction Publishers, 2003], 209–30). Atom Egoyan's film about the memory of the Armenian Genocide, *Ararat* (2001), highlights the insidious effects of silence and forgetting on individual and collective levels. In fact, it could and has been argued that many of Egoyan's films address the painful ramifications of memory denied and revised; see Lisa Siraganian, "'Is This My Mother's Grave?': Genocide and Diaspora in Atom Egoyan's *Family Viewing*," *Diaspora* 6, no. 2 (1997): n.p.

18. The group's website was at http://www.museumofamnesia.org (accessed August 6, 2007).

19. As of September 27, 2005, the site functioned mostly as a cyberary (a host of links to other resources) and in 2012 it no longer exists, although a Cafe Press store makes the items available.

20. See http://www.genocide1915.info, http://www.armenian-genocide.org/, and http:// www.ani.org, respectively (all accessed March 20, 2012).

21. See http://www.theforgotten.org (accessed March 20, 2012).

22. The evidence of action is difficult to trace, even in the face of results, such as the list of PBS affiliates who declared they would not air the denial panel following the documentary. Yet action is perceivable, at least on the anecdotal level. In August of 2000, the *Chronicle of Higher Education* reported that the Turkish government had threatened Microsoft with "serious reprisals" unless all mention of the Armenian genocide was removed from the Microsoft Encarta entries on "Armenia" and "Geno-cide." Microsoft, in turn, pressured the authors of each segment, Ronald Grigor Suny and Helen Fein, respectively, to rewrite their entries "to cast doubt upon the historical facts of the Armenian Genocide." Reports were posted on ANCA and Human Rights Action–Armenia (http://www.hr-action.org/armenia), which sum-marized the article by Jeffrey Sharlet and Scott Heller and offered avenues for action under the heading "What you can do." Two separate letters were advised, and again, both text and addresses were supplied. The first was a letter to the *Chronicle of Higher Education*, thanking them for "revealing the Turkish govern-ment's campaign to pressure Microsoft Encarta to deny the Armenian Genocide" and "drawing the attention of academics and the general public to Turkey's shame-ful efforts to cover-up this crime against all humanity." The second letter was directed to Microsoft Encarta and urged them to include the Armenian genocide in their online encyclopedia. Jeff Sharlet (in personal communication) reported that he received approximately two hundred letters in response to his article, all virtually identical. Although the precise connection between the action alert and the action is not available, this example hints at the possibilities of response mobi-lized on the Internet; possibilities that could expand as Webfaxes, Webmail, and other forms of electronic communication become the prevalent mode of corre-spondence and contact. Whatever the link between alert and response, the desired result of this action did come to fruition. At present, Microsoft Encarta, in its entry "Genocide," includes a brief description of the Ottoman Empire's national policy that led to the death of an estimated 1 million to 1.8 million Armenians through massacre, deportation, rape, and extreme privation. In addition, Encarta addresses Turkey's denial, but notes the affirmation of the genocide by the European Parlia-ment—which reflects the value of official recognition in relation to the cultural ter-rain—the Vatican, and several genocide scholars.

23. "About the Hub," The Hub (Beta), http://hub.witness.org/en/AboutHub (accessed March 20, 2012).

24. Nicholas D. Kristof, "Genocide in Slow Motion," *New York Review of Books*, Febru-ary 9, 2006, 14.

25. This is according to former UN secretary general Kofi Annan's estimation in "Dar-fur Descending: No Time for Apathy on Sudan," *Washington Post*, January 25, 2006, A19.

26. Kristof, "Genocide in Slow Motion," 14.

27. International Crisis Group, "Crisis in Darfur," updated March 2009, http://www

.crisisgroup.org/en/publication-type/key-issues/country/crisis-in-darfur.aspx (accessed April 2, 2012).

28. Jerry Fowler, "In Sudan, Staring Genocide in the Face," *Washington Post* (June 6, 2004). "Darfur: Not Another Hotel Rwanda!" action alert, Institute for the Study of Genocide, http://www.instituteforthestudyofgenocide.org/oldsite/action/alert/sudan/darfur/20050217.html (accessed March 21, 2012). Nsongura J. Udombana, "When Neutrality Is a Sin: The Darfur Crisis and the Crisis of Humanitarian Intervention in Sudan," *Human Rights Quarterly* 27, no. 4 (2005): 1149–99.

29. The information regarding this campaign was obtained in a discussion with WITNESS program manager Sam Gregory.

30. Human Rights Watch, "UN: Darfur Resolution Only a First Step," September 1, 2006, http://www.hrw.org/fr/news/2006/08/31/un-darfur-resolution-only-first-step (accessed March 30, 2012).

31. Livingston, "Suffering in Silence," 71. He cites from the 1994 World Refugee Survey (United States Committee on Refugees, Washington, D.C., 1995).

32. Jennifer Parmelee, "Sudan's Hidden Disaster: Africa's Longest War Leaves Millions at Risk," *Washington Post,* January 26, 1994, A1. Also cited in Livingston, "Suffering in Silence," 71.

33. Livingston, "Suffering in Silence," 71.

34. Parmalee, "Sudan's Hidden Disaster," A1.

35. From a telephone interview with Jennifer Parmelee cited in Livingston, "Suffering in Silence," 77.

36. Livingston, "Suffering in Silence," 77.

37. "Christian Solidarity International (CSI) Visits Northern Bahr El Ghazal, Sudan, Focusing on Slavery, Including Personal Testimonies, and Military Mobilization," iAbolish: The American Anti-Slavery Group, January 8–13, 1999 (excerpts), http://www.iabolish.org/slavery_today/sudan/csi.html (accessed October 5, 2007).

38. "Making the Connection between Terror and Slavery in Sudan," iAbolish-Activist Center, http://www.iabolish.org/activist_ctr/abolitionists/john-eibner.html (accessed October 5, 2007).

39. The group's website is at http://www.passionofthepresent.com (accessed March 21, 2012).

40. Alphonsion Deng, Benson Deng, Benjamin Ajak, and Judy A. Bernstein, *They Poured Fire on Us from the Sky: The True Story of Three Lost Boys from Sudan* (New York: Public Affairs, 2005).

41. "Sixteen Going on Seventeen," CBS-TV, airdate February 18, 2003.

42. "Lost and Found," CW, airdate May 3, 2004.

43. I have written more extensively on this subject in "Lost Boys in 7th Heaven," *The Revealer: A Daily Review of Religion and the Press,* June 17, 2004, http://www.the revealer.org/archives/timely_000434.php (accessed 15 February 2011).

44. Information about the film and its uses is found on the website http://www.lost boysfilm.com (accessed March 21, 2012).

45. "Paul Rusesabagina, Actor Don Cheadle, and Director Terry George Discuss the Movie, the Real-Life Crisis in Rwanda, and the Current Crisis in Sudan and Darfur,"

The *Today Show*, transcript, December 22, 2004 (interviewer, Katie Couric); Sharon Waxman, "In Films Begin Responsibilities," *New York Times*, December 28, 2004; Dana Stevens, "Don Cheadle Cub Reporter? The *Hotel Rwanda* Star Turns Journalist in Darfur" *Slate.com*, February 11, 2005.

46. Michael Janofsky, "Social Issues Fuel Race for Oscar," *New York Times*, February 22, 2005.

47. See chapter 4 n.66.

48. Janofsky, "Social Issues Fuel Race for Oscar."

49. Thank you to Sue Breckenridge for this last observation.

50. Liisa Malkki, "Speechless Emissaries: Refugees, Humanitarianism, and Dehistoricization," *Cultural Anthropology* 11, no. 3 (1996): 377–404.

51. See http://darfurdiaries.org/screening (accessed March 21, 2012).

52. From the Google Darfur "About" page, http://www.googledarfur.com/ (accessed March 21, 2012).

53. "Using Layers," Google Earth User Guide, http://earth.google.com/userguide/v4/ug_layers.html (accessed January 3, 2008).

54. USHMM, "United States Holocaust Memorial Museum Adds New Data to Google Earth Showing Twice as Many Destroyed Villages in Darfur," press release, July 30, 2009.

55. The term "subjunctive documentary" comes from Mark J. P. Wolf, "Subjunctive Documentary: Computer Imaging and Simulation," in *Collecting Visible Evidence*, ed. Jane M. Gains and Michael Renov (Minneapolis: University of Minnesota Press, 1999), 274–91.

56. YouTube, "YouTube Fact Sheet," http://www.youtube.com/t/fact_sheet (accessed January 3, 2008).

57. Nick Douglas, "YouTube's Dark Side," *Slate.com*, July 18, 2007.

58. Pelle Snickars and Patrick Vonderau, introduction to *The YouTube Reader*, ed. Pelle Snickars and Patrick Vonderau (Stockholm: National Library of Sweden, 2009), 12.

59. Jenkins, "Interactive Audiences," 158.

60. Chris Anderson, "The Long Tail," *Wired* 12 (October 2004), http://www.wired.com/wired/archive/12.10/tail.html (accessed March 21, 2012).

61. Susan D. Blum, *My Word! Plagiarism and College Culture* (Ithaca, N.Y.: Cornell University Press, 2009).

62. This usage of Lev Manovich's "Software Studies" was put forward by Craig Hight in his paper "Cultural Software, User Performance and Documentary Practice: Examining Online Documentary Culture," in the panel "Online Documentary," Visible Evidence XVI, Los Angeles, Calif., Saturday, August 15, 2009.

63. These numbers are cited in Jean Burgess and Joshua Green, *YouTube: Online Video and Participatory Culture* (Cambridge: Polity Press, 2009), 3.

64. Jenkins, *Convergence Culture*, 18.

65. Alan Krauss, "My Network, My Cause," *New York Times*, November 12, 2007.

66. "Update: Kony Social Video Campaign Tops 100 Million Views," *The Visible Measures Blog*, http://corp.visiblemeasures.com/news-and-events/blog/bid/79626/Update-Kony-Social-Video-Campaign-Tops-100-Million-Views (accessed March 30, 2012).

I have written briefly on the subject in an item called 'Marketing Joseph Kony" in *Souciant,* http://souciant.com/2012/03/marketing-joseph-kony/ (accessed March 30, 2012).

67. Jenkins, "Interactive Audiences,"159.
68. Streakerz, "Streaking (In Boxers) for a Good Cause," http://www.youtube.com/watch?v=hovgLfnXByY.
69. neddotcom, "Darfurby: Grassroots Action, Get Loud!" http://www.youtube.com/watch?v=GGfTUgziaW0; "Darfurby: And Then There Were None," http://www.youtube.com/watch?v=9hOGRSu20mM&feature=channel.

Notes to Conclusion

1. This reports and debates section in *Screen* 42, no. 2 (Summer 2001): 188–216, included Susannah Radstone, "Trauma and Screen Studies: Opening the Debate"; Thomas Elsaesser, "Postmodernism as Mourning Work"; E. Ann Kaplan, "Melodrama, Cinema and Trauma"; Maureen Turim, "The Trauma of History: Flashbacks upon Flashbacks"; Janet Walker, "Trauma Cinema: False Memories and True Experience."
2. Tamar Ashuri and Amit Pinchevski, "Witnessing as a Field," in *Media Witnessing: Testimony in the Age of Mass Communication,* ed. Paul Frosh and Amit Pinchevski (New York: Palgrave Macmillan, 2009), 133–57.
3. Many of these issues were raised at the conference Visible Evidence XVII (Los Angeles, Calif., 2009) by Angela Aguayo, Roger Hallas (Google Earth), Liz Miller (solidarity through distribution), and Sam Gregory and Patty Zimmermann, who continued the exploration of the viral witness at Visible Evidence XVIII (Istanbul, 2010).
4. Cited in Georges Didi-Huberman, "Images Malgré Tout," in *Mémoire des Camps: Photographies des Camps de Concentration et d'Extermination Nazis,* ed. Clément Chéroux (Paris: Marval, 2001), 227.
5. These photographs, and their story, can be found in *Mémoire des Camps.*

INDEX

ABC, 148, 186

ABC Nightly News, 180

ABC World News Tonight, 10

Abdul Hamid II, 25, 26, 36–37

abolitionism, 6, 44, 143; in Sudan, 183–84. *See also* slavery

Abu Ghraib, 175, 244n13

activism: consumer, 140; Internet, 173–78; media, 4–6, 16, 137, 139. *See also* human rights organizations; WITNESS

Adalian, Rouben Paul, 227n4

Addario, Lynsey, 191

Adorno, Theodor, 6, 13

advertising, 190, 239n13; "advotainment," 149; of Armenian activism, 7, 32, 35, 50, 56–58; by Bushmen, 167; by WITNESS, 138, 144–45, 169–70, 239n13. *See also* public relations and publicity

African Commission for Human and Peoples' Rights, 181

African Union (AU): definition of genocide by, 179; and Sudan, 177, 180, 182, 190, 196, 212

Aghion, Anne, 218, 237n39

aid, humanitarian, 115, 122, 123, 131, 180, 184. *See also* relief organizations

Ajak, Benjamin, 185

Alice in Hungerland, 57

Allied Powers: in First World War, 51; in Second World War, 64, 67, 69–71, 76–80, 86, 90. *See also individual countries*

Amazon: video activism in, 139, 153, 239n16

Amazon Watch, 153

Ambassador Morgenthau's Story (Morgenthau), 35–36, 37

American Board of Commissioners of Foreign Missions (ABCFM), 23–24, 30–31, 53

American Committee for Armenian and Syrian Relief (ACASR). *See* Near East Relief

American Committee for Relief in the Near East (ACRNE). *See* Near East Relief

American Physician in Turkey (Ussher), 39

Amnesty International, 148, 167, 168, 185–86; definition of genocide by, 179; Human Rights Now! Tour of, 141; mission of, 1–2

Anderson, Benedict, 12

Anfal campaign, in Iraq, 19

Annan, Kofi, 103, 245n25

anti-Semitism, 67, 82, 83–85, 231n86. *See also* Holocaust

Apfel, Oscar, 38

Appadurai, Arjun, 12

Arab Spring, 178, 240n32

Ararat (Egoyan), 244n17

Arendt, Hannah, 67

Armenia, 50–52, 54–57, 231–232n95; modern Republic of, 177; Wilsonian Mandate for, 59. *See also* Armenian crisis; Armenian genocide; Armenians; Ottoman Empire; Turkey

Armenian Atrocities Committee, 228n28

Armenian crisis, 3, 13, 18, 21–60, 227n3; and Christianity, 8, 23–26, 28–29, 30–31, 40–42, 44–55, 58–60, 61, 62, 68–69, 101, 183, 230n73, 231–232n95; documentaries about, 57–58, 177, 244n17, 245n22; Hamidian Massacres, 3, 21–22, 25–28, 42; and international law, 29–30, 59, 68; news coverage of, 10, 21–27, 29, 30, 32, 35, 37, 40, 46–47, 57, 60, 63, 228n34, 229n37, 229n45; photographs of, 23, 26–28, 31, 32, 34–37, 46–47, 54, 57, 62, 176, 229n47; U.S. policy toward, 28, 32–33, 35, 53, 177, 227n4, 228n34, 229n45. *See also* Armenian genocide

Armenian genocide, 3, 7–8, 16–17, 22–23, 28–41, 53–60, 61, 68, 175–77; comparison of, to other genocides, 10, 94, 98, 176, 209, 223n40; denial of, 175–77, 244n17, 245n22; use of word "holocaust" for, 25, 223n39. *See also* Armenian crisis

Armenian Genocide, The (Goldberg), 177

"Armenian Genocide 1915" (website), 176

Armenian Massacres (Greene and Northrop), 25–26

Armenian National Committee of America (ANCA), 176–77, 245n22

Armenian National Institute, 176

Armenian Reform Agreement, 29

Armenian Relief Committee, 228n28

Armenians: charity on behalf of, 26, 33–34, 51, 55–59, 176, 183, 227n3; diaspora of, 29–30, 176–77; nationalism of, 25. *See also* Armenia; Armenian crisis; Armenian genocide; Ottoman Empire; Turkey

assassination plot, against Hitler, 86, 235n52

Auction of Souls, The. See *Ravished Armenia*

Avni, Ronit, 241n44

Ayers, Michael D., 173

Babkenian, Vicken, 227n3

Balakian, Peter, 22, 50, 228n20

Baldwin, Alec, 96

Balkans, 29, 100, 102, 148; revolt in, 24–25. *See also* Bosnia and Herzegovina; Kosovo; Macedonia; Serbia; Slovenia

Barthes, Roland, 26

Barton, James L., 30, 31–34, 57, 228n28, 232n100; on Christianity, 51; on Muslims, 230n73; on newspapers, 229n37; on Turkey, 59–60

Bashir, Omar al-, 180, 181–82, 190

Baudrillard, Jean, 104, 108, 134

BBC, 108, 120, 148

Beawitness.org, 203–4

Before the Rain (Manchevski), 15, 100–101, 106–8, 134, 218

Belgium, 113, 126–27; colonialism in Africa by, 122, 128; peacekeepers from, 120, 122, 123; "Rape" of, 68, 232n104; in Second World War, 78

Bell, James, 158

Benjamin, Walter, 223–24n44

Berger, John, 138, 141

Berkman Center for Internet and Society, Harvard, 174

Berlant, Lauren, 238n6

Berlin, Treaty of, 25

Bernal, Gael Garcia, 166

Bernstein, Sidney, 65

Big Red One, The (Fuller), 233n14

Bitorajac, Rene, 109

Bliss, Edwin M., 26

blogs, 132, 195

Blood and Honey (exhibition), 99

politics, 174; genocide memorials on, 175–77; letter-writing campaigns via, 155, 165, 195; museums and, 191–92, 198, 210; videos on, 17–18, 155, 156–57, 172–78, 180–81, 191, 195–215, 217; WITNESS on, 140, 148–49, 155, 157, 166, 167, 178, 180–82. *See also* media, social; YouTube
Interpreter, The (Pollack), 1, 2
Intolerance (Griffith), 42
Investment in Futures, 57–58
Iraq: genocide in, 19; U.S. wars in, 104–5, 175, 244n13
ITV, 108

Jackie Coogan in Athens (film), 58
Jackson, Robert H., 67, 69–70, 96–97
Janjaweed, atrocities by, 178–79, 181, 201, 205, 212; in *Darfur Is Dying*, 193, 194, 196; photographs of, 206
Japanese Americans, internment of, 100
Jenkins, Henry, 199; on online fandom, 172–73, 198, 204, 225n58; on "transmedia storytelling," 16, 226n69
Jennings, Peter, 10
Johnson, Darlene, 226n76
Jolie, Angelina, 166
Jones, Van, 160
Judging Amy, 185
Judgment at Nuremberg (Kramer), 67, 75, 94–96
Judson, Hanford C., 51
Justice and Equality Movement (JEM), 178–79

Kabera, Eric, 117, 132, 237n35
Kagame, Paul, 103, 131–32, 243n66
Kaplan, E. Ann, 137
Karadžić, Radovan, 99, 114, 115–16
Katyn massacres, 72
Kayapo, 139, 239n16
Keenan, Thomas, 2, 31, 102–03, 224n46, 241n44
Keitel, Wilhelm, 92, 235n72

Kellogg, E. R. "Ray," 66, 75–76, 82
Kellogg-Briand Pact, 69
Khartoum, 178, 179, 182
Khmer Rouge, 19
Kidman, Nicole, 1
King, Rodney, 142–44, 162, 163, 165
Kleinman, Arthur and Joan 11, 104
knowledge space, 17–18, 172
Kony 2012 (video), 201
Koppel, Ted, 168–69
Kosovo, 99, 101
Kristof, Nicholas, 179–80, 190, 210
Kurds, 19, 29, 229n45

L.A. Evening Express, 51–52
Lambeth, Thet, 19
landmines, 109–13, 152–53
Lansing, Robert, 30
Lanzmann, Claude, 100, 217
Last Days, The (Moll), 7, 218
Laub, Dori, 5, 73
Lauren, Paul Gordon, 25
Lauterpacht, Hersch, 70
law, international, 3–4; and Armenian crisis, 29–30, 59, 68; and Darfur, 177, 190; and former Yugoslavia, 148; and Nazis, 61–62, 67–71, 74, 81, 86–87, 96–97; rape in, 230n70; and Rwanda, 127–31. *See also* genocide; Nuremberg Trials; United Nations
Lawyers Committee for Human Rights, 142
"Lazy Sunday" (video), 199
League of Nations, 59, 68, 232n104
Lennon, John, 206
letter-writing campaigns, 31, 148; during Armenian crisis, 31, 33, 56–57; against Armenian genocide denial, 245n22; for Darfur, 177, 181, 182, 188; online, 17, 155, 165, 177, 188, 203–4
Levi-Strauss, David, 138, 224n47
Levitt, Theodore, 139, 239n13
Levy, Pierre, 17–18, 172–73
Lim, Nicodemus, 185

museums, 3, 13, 18, 210; photographic exhibits in, 10, 88, 191, 226n75; virtual, 175–76, 191–92

Muslims: Bosnian, 102, 114; Macedonian, 106; in Sudan, 179, 182

My Neighbor My Killer (Aghion), 237n39

Nachtwey, James, 9–10, 191

NAKAMATA, 154–55

narration, voice-over, 95, 96; in *Before the Rain*, 108; in *Hotel Rwanda*, 128; in *Nazi Concentration Camps*, 75–78, 81; in *No Man's Land*, 115; in videos, 153, 156, 157, 201

narrative, 5–6, 15, 140, 144–45, 216; in film, 8, 23, 39, 63, 73, 80–81, 151; fragmentation in, 6–7

"narrowcasting," 144–45, 154, 166, 170, 178, 198

National Congress Party (NCP), Sudan, 179

nationalism, 12; Armenian, 25; Turkish, 45, 244n17

National Socialist German Workers' Party. *See* Nazis

Nazi Concentration Camps (Stevens), 15, 17, 66, 74–81, 87, 88–89; news coverage of, 91–93; use of, in dramatic films, 63, 94–97; witnessing in, 90–91

Nazi Plan, The (Kellogg), 66, 72–73, 74, 82–87, 88, 114; courtroom reaction to, 92–93

Nazis, 67, 72–73, 77–97, 101, 133; film documentation by, 72–73, 82–90, 92–93, 219; propaganda by, 66, 67, 82–87, 92–93. *See also* Germany; Holocaust; Nuremberg Trials

NBC, 121, 180, 199

NBC Nightly News, 121

N'Dour, Youssou, 141

Near East Foundation, 228n28

Near East Relief (NER), 16–17, 23, 30–39, 50, 55–59; global reach of, 101, 227n3; name of, 228n28; National Motion Picture Committee of, 38, 57–60, 61, 62; Ways and Means Committee of, 228n29

Neumann, Johanna, 1

"Never Again (Save Darfur)" (video), 202–3, 209

"'Never Again': The Permanent Anti-Genocide Movement" (video), 207–9

"New Sudan (Darfur Genocide), A" (video), 210

New York American, 37

New York Herald Tribune, 91–92

New York Times, 84, 92, 190; coverage of Armenian crisis, 25, 32–33, 35, 43, 229n45

news media, 3, 8, 11–12, 138, 166; in activist strategy, 147–53, 155–56, 166, 174–75, 200, 203–4; coverage of Armenian crisis, 10, 21–27, 29, 30, 32, 35, 37, 40, 46–47, 57, 60, 63, 228n34, 229n37, 229n45; coverage of Balkans, 10, 98, 101, 104, 110–16, 124, 133–35; coverage of Darfur, 181–83, 186, 191; coverage of Holocaust, 10, 63–65, 212; coverage of Rwanda, 123–30, 133–35, 168–69; coverage of U.S. wars, 104–6, 124, 175; depiction in film, 106–8, 109–13, 117–21, 124; documentaries about, 238n8. *See also* newspapers; television

newspapers, 147, 166; coverage of Armenian crisis, 24–27, 30, 32, 37, 40, 57, 60, 228n34, 229n45; coverage of Holocaust, 10, 63, 212; coverage of Nuremberg Trials, 84, 87, 91–93; religious, 32

newsreels, 9, 57, 63–65, 100; by Nazis, 66, 83–84

Newsweek, 91–92

Nichols, Bill, 73, 78, 234n32

Night and Fog (Resnais), 75

Nightline, 168–69, 186

Nkaaga, Abby Mikiibi, 129

landscape of, 101, 105; and law, 90, 96, 100; and literal seeing, 8; mass, 64–65; mediated, 105; representation of, 93–97, 106, 118; as situated, 14; spectacle of, 89–92; transformative capacity of, 90, 95–96; and trauma, 7; without a witness, 100

witnessing, media: 7–11, 63, 100–101, 134–35, 169–70, 191, 215; in Africa, 131, 133, 196, 199; and Armenian crisis, 60, 63; and the popular, 13; and technology, 8, 15, 63–64, 101, 116, 128, 134, 139, 145, 173, 203–4, 212; viral, 149, 200; virtual, 11, 15, 17–19, 172–73, 191–97, 200, 204–5, 216; and WITNESS, 137–42, 169–71

witnessing publics, 3, 12–20, 32, 117, 135, 158, 204–6, 212, 216; in Africa, 121, 130; and Armenian crisis, 52, 55–56, 58, 60; contingency of, 14, 170; production of, 12, 16, 60, 98, 137, 170, 172–73, 180, 187, 196–97, 220; as witnessing publicists, 17, 212

Witness to Truth (video), 166

Witness: Voices from the Holocaust (Greene and Kumar), 7

Wolf, Mark J. P., 247n55

World Bank, 139

World Food Program, 167

"World Is Witness" (Google Earth project), 192–93

World Trade Organization, 174

¡Ya Basta!, 174

Yalta Memo, 67

Young, Loretta, 94

"You're Making a Killing in Darfur" (video), 202–3

Youth Law Center, 158

YouTube, 4, 18, 196–200, 202–14, 217–18; and CitizenTube, 172, 200, 204–5; and Iran, 240n32; and NGOs, 199–200, 204–5; and Second Life, 192

Yúdice, George, 5

Yugoslav People's Army (JNA), 114

Zapatistas, 174

Zelizer, Barbie, 10, 64, 72, 124, 233n8, 239n10

Zimmermann, Patricia R., 240n32

Leshu Torchin is lecturer of film studies at the University of St. Andrews.